Icon and Image

Denis Williams

ICON AND IMAGE

A Study of Sacred and
Secular Forms of
African Classical Art

New York University Press

First published in the United States by
New York University Press

Copyright © 1974 by Denis Williams
All rights reserved

Library of Congress catalog card number: 174-405
ISBN: 8147-9158-1

Printed in Great Britain

To Saburi Biobaku

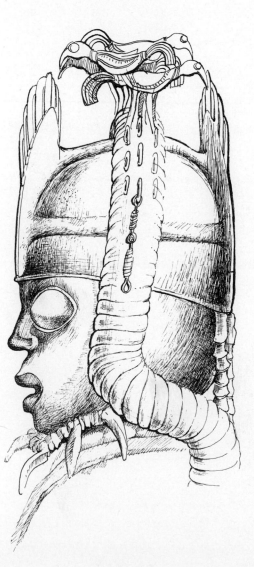

1. Near life-size bronze
figure from Tada showing
union of sacred and secular
elements in the concept of
ancestral form

Contents

Part One THE FORMS OF THE CULT OBJECT

1	A Critical Terminology	1
2	Ethnological and Aesthetic Factors	4
3	The Genesis of Form in African Sacred Art	13
4	The Interpretation of Sacred Forms	20
5	The Forms of the Cult Object	25
6	Illusion and Disillusion	35
7	The Conventions of African Art	41
8	Processes of Style Change	46

Part Two IRON AND THE GODS

9	Iron in African Antiquity, *c.* 700 BC–AD 500	51
10	The Iron Age and the Iron Bar, *c.* 500–*c.* 1650	68
11	The Ritualising of Iron, *c.* 1530–1900	78
12	The Ritual Basis of Sacred Forms in African Iron Sculpture	87

Part Three COPPER, BRONZE, GOLD

13	African Bronze Workers and the Western Sudan *c.* AD 950–1484	103
14	The Bronze Schools and their Techniques: Introduction	114
15	Ifè-Benin	121
16	The Benin Bronze Chronologies	136
17	The Benin Canon and the Basis of a Benin Bronze Chronology	149
18	Technique and the Ifè-Benin Relationship	179
	The Ifè Bronze Technique	188
	Ifè bronze Metallurgy and Ifè bronze dating	203
19	The Ọbọ School	211
20	The Jebba-Tada Bronze	218
21	The Yoruba Sacred Bronze	234
22	The Ijèbú Smith and Bini Tradition	251
23	An Art of Ọyọ-Ilé?	261
24	The Maghreb in the African Bronze	266

25 The Dating of the African Bronze 269
 The crotal 269
 The chain of iron or of copper 276
 The smoking pipe 278
 The steel file 278
 The influence of the European workshop 279

Part Four SUMMARY AND CONCLUSIONS

26 Iconology, Technique and the Schools 283
27 Icon and Image 292

 Appendix 299
 A Yorubo ìjálá chant 299

 Bibliography 301
 Notes and References 303
 A. *Literary Sources* 317
 B. *Museums, Sites and Shrines* 323
 C. *Local and Oral Traditions* 326

 Index 329

List of Illustrations

Jacket: The Jebba *Warrior*

1. Near life-size bronze figure from Tada v
2. Ṣàngó worshipper 16
3. Ogboni worshipper 16
4. Type-motifs in the cult of the *òrìṣà* 20
5. Variation in cult idiom: type-motifis of the *òrìṣà* Ṣàngò 23
6. The Ṣàngó double-axe type-motif on a Ṣàngó ritual urn 26
7. Ṣàngó ritual urn: the Èṣù-Ṣàngó theme 27
8. Detail of fig. 7 28
9. Bead doublet of a Ṣàngó 'priest' 28
10. Ṣàngó theme with Èṣù type-motif 29
11–14. The theme of threes and fours 30
15. Labà Ṣàngò on a wooden pot: threes and fours 31
16. Phallic symbolism: Èṣù-Ṣàngó 31
17. Èṣù: the theme of threes and fours 31
18. The theme of threes on two Ṣàngó staffs 32
19. Motifs in Benin art: the Portuguese face (?) 33
20. Yoruba Gèlèdé mask, twentieth century 48
21. Yoruba Gèlèdé mask, nineteenth century 48
22. Iron-smelting furnace fragments from Meroë 55
23. Reconstruction of a Meroitic iron-smelting furnace 57
24. Some African shaft furnaces of the 'Meroitic' type 58
25. Domed iron-smelting furnace, western Nigeria 59
26. Domed smelting furnace in operation, Nigeria 59
27. Domed furnace: tuyères in the furnace mouth 60
28. Two African iron mines 61
29. Celto-Roman furnace, South Westphalia 62
30. The domed furnace: comparative designs 62
31. Catalan furnaces 64
32. Aṣante ironwork, seventeenth century 76
33. Aṣante basketwork, seventeenth century 77
34. Yoruba war clubs and throwing-stick 78
35. Iron arrowheads sacred to Ògún 79
36. Miniatures of European slave manacles 79
37. Miniature bow for a Yoruba war-chief 79
38–39. Amulets bearing type-motifs of *òrìṣà* Ògún 80
40. Iron pendant for a war-chief 81
41. Hunter's doublet with 'medicines' and charms 85
42–45. Iron cult figurines, western Nigeria 88

46. Ritual iron staff for *Òrìṣà* Ọsányìn 89
47–48. Iron figurines, Yoruba 90
49. Ritual iron staffs for *Òrìṣà* Erinlẹ̀ 91
50. Ritual iron staffs for *Òrìṣà* Ògìnyán 92
51. Construction of ritual iron staff for *Òrìṣà* Òkò 92
52. Standard lamp, Afemai 93
53. Detail of fig. 52 93
54. Iron figurine, Dahomey (Yoruba) 94
55. Iron figurines, Bushongo, Congo 94
56. Ritual iron staffs, Yoruba 95
57. African iron gongs 97
58. Filigree gold work, Aṣante 109
59. Copper ingot from Maranda 110
60. Open mould for casting brass or copper ingots 111
61. Gold weights, Ghana 115
62. Bronze dish, provenance unknown (southern Nigeria) 116
63. Bronze head, provenance unknown (southern Nigeria) 116
64. Brass bell, Cameroon 117
65. Bronze mask, Ghana 117
66. Gold mask, Ghana 117
67. Bronze reliquary, Ghana 118
68–69. Bronze figurines, Tiv tribe, Nigeria 119
70. Bronze crescentic vessel, Igbo-Ukwu, Nigeria 119
71. Bronze bowl, Igbo-Ukwu, Nigeria 119
72. Bronze animal skull, Niger delta 120
73. The *Òbàlùfoǹ* bronze mask, Ifẹ̀ 123
74. Bini bronze head with high collar 124
75. Benin, bronze figure with Maltese cross 127
76. Comparative inconographic motifs: Jebba-Tada, Benin, Ifẹ̀, Yoruba 128
77. Benin, bronze plaque of an Ọba with everted legs 129
78–79. Bronze head-rest, Jukun 130
80. Shield plaque with Bini-type crotals 131
81. Shield plaque with European-made crotals 131
82. Tada, collar of teeth 131
83. Benin, collar of teeth 131
84. Comparative iconographic motifs: Jebba-Tada, Benin, Ijẹbú-Òde, Igbo-Ukwu 132
85. Tada, standing male figure, bronze 134
86. Tada, Ifẹ̀-type seated figure 134
87. Tada, bronze figurine of a staff bearer 134
88. Brass bracelets, northern Yoruba 145
89. Cast brass neck-collar, Yoruba 146
90. Benin, plaque figure of a standing man 153
91. The Law of Frontality 154
92. Rotation of the median plane illustrated in the *Triumph of Ọrhọgbua* (?) 155

93. Interpretations of arms in the human figure 156
94. Foreshortening by drawing: horsemen preparing for the *Panathenaic Procession*, Greek 157
95. Rotation of the median plane 157
96. Attempt at foreshortening by drawing: relief on a bronze armlet, Yoruba 158
97. Conventions for rendering the standing figure full-face, Benin 159
98. Dominance of the base plane: plaque figure of a warrior, Benin 160
99. The median plane in an equestrian profile, Benin 161
100. Renderings of soldiers discharging muskets, Benin 161
101. Foreshortening by drawing: *St Christopher* from a Westminster Abbey psalter, English, late twelfth century 162
102–4. Benin, plaque figures of soldiers discharging muskets 163
105. Foreshortening by transposition, Benin 163
106. Combination of two- and three-dimensional rendering: bronze goblet, Benin 164
107. Benin, the *Triumph of Ọrhọgbua* (*?*), bronze plaque 165
108. Fragmentation of the median plane: the Parthenon frieze, Greek 165
109. Foreshortening by drawing: the *Mildenhall Dish*, British 166
110. Foreshortening by drawing: *Madonna and Child*, Italian 166
111. Benin, a royal procession, bronze plaque 167
112. Comparative tribal markings, Nigeria 168
113. The Bini bronze stereotype 169
114–18. Benin, bronze plaques, Hieratic Period 170
119. The dominance of the base plane in three-dimensional sculpture, Benin 172
120. Planar articulation of the human figure: relief from a pyramid chapel, Meroë 173
121. Bronze figurine of a girl running, probably Spartan 174
122–23. Benin, soldiers discharging muskets, bronze 175
124–25. The Bini 'wig' and brow marking of the sixteenth century 175
126–27. The mastery of convention: bronze heads, Benin 178
128. Benin, bronze casting cores 180
129. Section through *cire-perdue* mould 181
130. Yoruba, laying the wax investment 181
131. *Euphorbia kamerunica*, the latex plant used in bronze casting 183
132. Latex thread for a bronze object 184
133. Latex model for a bronze object 185
134. *Cire-perdue* casting, section of the mould-cum-crucible 186
135. Ọbọ and Ìfẹ̀ cores and moulds 187
136. The Ifẹ̀ *Lafogido* bronze bust 188

137. Benin, Portuguese soldier, bronze 190
138. The Benin bronze armature 190
139. Reinforcing bronze members: Benin and Ifẹ̀ 191
140. Benin, securing the bronze casting core 192
141. Benin, buttressing an equestrian piece 193
142. Section through a Yoruba bronze 194
143. The core of the Ifẹ̀ *Lafogido* bronze bust 196
144. Water vapour in an Ifẹ̀ core during casting 196
145. The Jebba *Warrior*, the platform pedestal 197
146. Unification of core and mould, Jebba-Tada 198
147. Unification of core and mould, Ifẹ̀, Jukun 199
148. Ifẹ̀ *King and Queen*, bronze 200
149. Casting a bronze bracelet on a terracotta core 202
150. The trade manilla 205
151. Bronze plaque, Benin 207
152. Ọbọ Aiyégúnlẹ̀, bronze kola-nut bowl 212
153. Ọbọ Aiyégúnlẹ̀, *King and Queen* 212
154. Gourd 'crockery' from an Ọbọ household 213
155. Equipment of a smithy, Ọbọ 214
156. The tools of the smith, Ọbọ 214
157. The architecture of a smithy, Ọbọ 215
158. Section of a forge, Ọbọ 215
159. Bronze kola-nut pedestal bowl 216
160. The degeneration of the Ọbọ idiom 217
161. The Jebba *Warrior* 218
162. The Tada *Warrior* 218
163. Benin *Warrior* 219
164–65. Tada ostriches 220
166. Tada *Elephant* 220
167. Yoruba bronze, the Ogboni sacred sign 223
168. Yoruba bronze, the Òbàlùfòn sacred sign 223
169–70. Comparative design motifs: Nubia, Benin,
 Jebba-Tada 225
171. Horned caps: Funj, Yoruba, Benue, Blemmye 226
172. Benin, bronze mask, the horned head-dress 226
173. Benin, bronze bracelet, the motif of everted reptiles
 issuing from the nostrils 227
174. Horned deity on Blemmye pottery 227
175. Ancestor shrine, Badagry, Nigeria 230
176. Egyptian chain-link (after Petrie) 231
177. Yoruba, Ogboni bronze 236
178. Location of the Ilẹ̀ in the Ilédi 237
179. Yoruba, bronze, the Ogboni pair 237
180. Yoruba, bronze, *ẹdan* Ogboni 239
181. Construction of the *ẹdan* Ogboni 243
182. Spiked *ẹdan* Ogboni 244

183. Free-standing *ẹdan* Ogboni 244
184. *Ẹdan* Ògún 247
185. Type-motifs in the evolution of the *ẹdan* Ògún 248
186. Serpent and frog motifs, Benin 251
187. Meroë, serpent motif from the Lion Temple at Naqa 252
188. Frog motifs: Blemmye, Meroë 252
189. Wreathed and horned human skulls, Benin 253
190. Yoruba, bronze mortuary stool 253
191–94. Motifs from fig. 190 254
195. Western Ijo, bronze replica of a wooden personal cult
 object, emblem of Pẹrẹ title holder 255
196. Bronze huntsman, southern Nigeria 256
197. Ifẹ̀, quartz stool 256
198. Warri, Niger delta, an *akaton* 257
199. Motifs on a Benin mortuary stool 257
200. *Avbiama* bronze bell, Yoruba (?) 258
201. Articulated bracelets 258
202. Yoruba, bronze armlet 259
203–4. Yoruba, bronze mask, *Alákoro I* 262
205–6. Yoruba, bronze mask, *Alákoro II* 262
207. Igbòhó, bronze mask, *Alákoro II* 263
208. Interlace motif 266
209. Ceremonial brass cutlass 267
210. Moorish chain-link motif 267
211. Arab-type brass stirrup 268
212. Nilotic design 268
213. Some types of crotal 270
214. Josse Eriksson and St Erik, from the Våsteräs Cathedral,
 Sweden 271
215. Sixteenth-century mass-production of crotals in
 Scandinavia 272
216. Bronze figure from Tada 284
217. Tada bronze 288
218. Benin bronze 292
219. Yoruba bronze 294

Maps

220. Distribution of the crotal and of the domed iron-smelting
 furnace in West Africa 296
221. Some recent finds of brasswork in the Niger delta 296

Tables

1. Type-motifs in the Ritualising of Iron among the Yoruba 81
2. Chronologies of Benin Bronze Art: 1958, 1963 137
3. A Chronology of Benin Bronze Heads: 1960 142

4. Metallurgical Analysis of Ifẹ̀ Bronze Heads 203

5. Lead–zinc Ratios in Ifẹ̀ Bronze Heads 204

6. Lead–zinc Ratio in a Benin Bronze 206

SOURCES OF ILLUSTRATIONS

Nigeria Museum, Lagos: 9, 15, 47–8, 52–4, 68–75, 77–81, 98, 102–104, 106, 114, 117, 123–6, 133, 136, 142, 145, 148, 150–1, 153, 173, 182–3, 202, 218; *British Museum, London:* 61–3, 65, 67, 90, 94, 101, 103, 107–9, 111, 115, 116, 118, 121–2, 127, 137; *Institute of African Studies, University of Ibadan:* 82, 85, 87, 130, 161–2, 164–6, 217; *National Museet, Copenhagen:* 21, 32–3, 215; *University of Ibadan, Medical Illustration Unit:* 168, 177; *Wallace Collection, London:* 66, 110; *Ministry of Information, Ibadan:* 179; *Robin Horton, University of Ibadan:* 195; *Museum für Völkerkunde, Berlin:* 163; *Historiska Museum, Stockholm:* 214.

Photographs not acknowledged were taken by the author. The line drawings in the text are also by the author. John Picton supplied the cover photograph of the Jebba bronze figure and it is reproduced by permission of the Nigeria Museum, Lagos.

Abbreviations used in the captions for the sources of line drawings in the Benin chapter (ch. 17) are:

VLP Luschan, plates (Bibliography 109)

PR Pitt-Rivers (Bibliography 117)

R & D Read and Dalton (Bibliography 119)

Acknowledgements

I am indebted to the Sudan Antiquities Service for allowing me the freedom of their museum storerooms and reference library, and for permitting my study of Meroitic sites and sharing in the Wad ban Naqa excavations; to the University of Ifẹ for a grant to study the African bronze in the British Museum; to the University of Lagos for a similar grant; to the International African Institute, London, for a grant for fieldwork in compiling a Corpus of Yoruba Bronze Art, on which I have drawn heavily for sections of the present work. The Vice-Chancellor of the University of Lagos, Professor S. O. Biobaku, has been a patron in the true sense. I owe deepest thanks to the late Oliver Myers and his wife for the use of their excellent library of Egyptology, and for a great friendship, and to Robin Horton for most instructive discussion and criticism, particularly on the ancestor sculptural concept among the Kalabari. Dr F. Korman of the U.S. Peace Corps, University of Ifẹ, kindly arranged Table 5 from a study of Table 4.

I have acknowledged assistance on specific issues – the furnishing of references, correspondence, personal communications – where they occur, but record special thanks to Margaret Amosu of the University of Ibadan Library for general very valuable assistance, and to Richs Meyer-Heiselberg of the National Museet, Copenhagen, who furnished important data on the incidence of the crotal in Scandinavia before 1600, as well as various illustrations.

I am grateful to my wife for a devotion greater than the many ideas she contributed in the interpretation of sacred forms in African classical art.

Part One

THE FORMS OF THE CULT OBJECT

1 A Critical Terminology

The question of the appropriateness of the expression *art* as a name for all those forms, that total form about to be discussed, and many another of art history could arise, in the African experience, if one finds oneself unwilling to speak of idiom and style and form and meaning, of vision, and icon and image, sacred and profane where such terms constantly need to be so revised or refined as to render them, too often, meaningless in any acceptable sense. This, incidentally, may be to acknowledge a certain weakness in the assumption that African art might be, might become, is, or ever was an intelligible object of study. In discussing African art it may even be questioned whether the word *art* itself – like idiom, style, form, meaning, vision, icon and image, sacred and profane, all terms at present needing this constant redefinition in the context of African experience—will in fact survive the inevitable replacing of a Eurocentric scholarship by an African one.[1] For how could a critical terminology be applied indefinitely to a body of work from which it has not organically emerged—a terminology in any case laden with meaning, inflection and circumstance derived from quite another culture? Form, pure form, significant form – these are the web-scaffolding of a critical architecture enfolding, shrouding, illuminating the structure of art, and are as evocative, as associative as art itself – as associative as are the references of cult to the 'creator' of a Şàngó figurine. Yet who would doubt that in this total of forms is form? And should the concept be revised, refined – or simply enlarged? Form is found in the Ogboni sacred bronze and in Cézanne's painting. On what deeper level of creative subjectivity do they meet? How are we to define idiom when, in the forms of this art, idiom is moulded in inflexible law; for does the idiomatic not also suggest natural and unrestricted development? And how to conceive of style in which there is no agent but ancestral reference stabilised in stereotypes which live in time like some great forest in which a variety of species in ecological balance continually flourish, multiply and decay without disturbing that balance or the forms in which it is expressed? What precise and illuminating term can be found to enclose the concept of forms bound forever in ancestral time by ancestral law, immutable and history-less? In what structure of history can one interpret inherently ahistorical form, when problems of meaning, function and interpretation are so closely interrelated? Is meaning, to the student of these forms, the meaning of their creators? Try as he may, the anthropologist cannot shed the scales of his culture and time to see with the naked eye of primitive belief. Does not the same difficulty confront

the historian of art whose conceptual apparatus and critical terminology he supposes adequate to getting to the bedrock and substance of primitive form? Between anthropologist and aesthete, between champion of meaning and champion of form, a love–hate relation has arisen which feeds on imputation and careful misunderstanding. We try for the stance of dignity, to make at least mutual sense of intention and utterance, to bridge the unbridgeable, but the truth of the matter lies unacknowledged in difference of function.

The intention of the ethnographer is not that of the art historian, nor are his methods, nor his utterance. But over the body of their inscrutable love-child battle is joined in mutual incomprehension. In defence of the pioneer ethnological studies in primitive art of the past eighty or so years Fagg observes that they made no claim to provide a complete theory of primitive art and that in particular they rigorously eschewed value-judgments, holding that aesthetics, in an absolute sense (as distinct from the relative study of tribal aesthetic attitudes) was beyond the scope of scientific investigation, at least at the time.[2] One wonders whether aesthetics since the turn of the century has come much closer to being scientifically investigated, and what difference in any case the results would make to a bushman's response to a Crivelli! Would scientific advance in the study of the aesthetic process make all men equally responsive so that the only thing required of the puzzled ethnographer in the face of art – his own or that of the bushman – would be recourse to a few quick formulae? For what is art scholarship without the aesthetic eye? Is this neglect of aesthetic considerations by the early ethnographers entirely to their credit? This attitude has confounded the discussion of African art and produced quite the most curious of literatures ever penned. For much of the writing of ethnographers (and anthropologists and archaeologists and wordy dilettantes) has eschewed not just the aesthetic but the historic too: and we are confronted with an art of social process yet not of time, of ritual context yet not of growth, of diverse forms yet not of form, a literature of styles but not of style – for in what should style consist where time-depth itself is wanting?

But to seek time-depth in the study of African classical art is to deny for the moment many of its forms of expression. How can historical appraisal apply to forms in wood so perishable that 'antique' material may have been living within the present century?[3] The forms of ivory are comparable with those of wood, and who can say what are the forms of stone, what form informs image and usage in the statuary of Esie or in the *nomoli* figurines of Sierra Leone.[4] What technique of research can be developed appropriate to the study of African terracotta, when its finest examples, at Ifè, at Benin, and in Aṣante are indistinguishable from forms in bronze whose secrets call for a quite distinct research method? These media must at present be left out of account in any purely historical treatment. But great though the loss may be, our interpretation of sacred and secular forms need suffer little, for the forms of true antiquity – forms in iron and in bronze – are also those of the great masterpieces, and these are neither few in number nor lacking in

material for their study in time. Concepts developed in the reading of their conventions might well one day come to be regarded as constants in the creation and interpretation of form in all the media of expression employed in African classical art.

2 Ethnological and Aesthetic Factors

Any work of art inevitably relates to the processes by means of which it came into existence. To put it another way, its existence implies processes outside itself, linking it to the life from which it has emerged and whose product it is. The social implications of these processes are the concern of the ethnologist whose methods, based on objective analysis, are inductive, and whose results can be supported only by observed facts. Nothing need be added to Fagg's estimate of the ethnological view with its entirely honest assessment of its limitations for appraising that which most matters in the art object – the aesthetic content. For ethnological study appraises the art object, or any other object, chiefly in its functional relationship with the culture and not as a phenomenon in the life of art; its methods make no attempt at aesthetic evaluation or comparison. Form, with its particular grammar of harmony, proportion, balance, rhythm – to state its more verbally explicable attributes – is in no way the concern of the ethnologist, though interest and individual taste may lead him to a personal consideration of these values. But are there any absolute criteria of a scientifically verifiable nature which can be applied to the study of these values? How is one to penetrate the barrier of idiom, to see through the telescope of style, in order to experience that state of involuntary responsiveness without which the work of art cannot operate? At what point does the rational process yield to another and higher form of appraisal? 'In the last analysis, in art as in contemplation, intellectuality at its peak goes beyond concepts and discursive reason, and is achieved through a congeniality or connaturality with the object which love alone can bring about.'[1]

Form in plastic art is an aspect of thought whose expression is not verbal and not rational. Ethnographical description and ethnological interpretation are purely rational tools for appraising the means through which form manifests itself in the life of the society which gives birth to the work of art; they do not and cannot explain the relevance of the art object within the general human phenomenon of art. 'The ethnologist's approach was essentially deductive (*sic*) and scientific; he was not, as an ethnologist, moved by beauty of form.'[2] And yet those values which constitute form in the work of art are inherent in the work, coterminous with its material existence – harmony, balance, proportion, rhythm, etc. – they have no reference to values outside the work; their field of operation lies in the aesthetic sensibility of the spectator, who brings to the work his individual

apparatus – his training in aesthetic and symbolic perception – for appraising it. The higher the development of this faculty on the part of the spectator, be he ethnographer or art historian, the greater the training of his aesthetic-critical faculties, the more fully he consequently partakes of formal values inherent in the work, in the elements of its expression as art. The solution to the problem of a synthesis suggested by Trowell[3] would lie entirely in what Wolfflin has called the power of 'imaginative beholding' on the part of the ethnographer on the one hand, and a greater inductive rigour on the part of the aesthete on the other.

Ethnological analysis is alone insufficient to explain the existence of the object as art, and refers only to those states and processes through which the work came into being; it provides context in a purely spatial sense. Such analysis may illumine the meaning of a particular work but it does not, by its nature, impinge on our receptiveness to the object as art. As Herbert Read has already pointed out, on our first contact with it the work of art has already performed to capacity: an aesthetic experience has taken place which further explanation as regards meaning and function will neither increase nor diminish. If for instance on entering an old village church the first object inside the door strikes us with this shock of aesthetic recognition, it cannot subsequently matter, so far as this experience goes, if we are later informed that the object is a baptismal font. The explanation may be welcome as revealing an aspect of factual truth, as informing us of meaning and function surrounding the object while at the same time explaining its relation to its society by making clear one of the fundamentals of Christian belief; but such explanation could make no difference to the nature of our initial response, which was purely aesthetic and made in the absence of social data. In just the same way our response to the sculpture of Easter Island, say, or to a prehistoric 'fertility' figurine produces an aesthetic impact in ignorance of meaning and function in their respective societies. Should a subsequent reading of the data produce an altered explanation of the meaning and function of the baptismal font – that it was, in the light of new evidence, more likely to have been an execution block, for instance, or a stone for solemnising marriage – it would still not make the slightest difference to the quality of our initial response, or to our capacity to respond to the same aesthetic stimulant in the future. It would merely provide us with information as to the process which had brought the object – execution block or marriage altar – into being; it would modify our purely rational appraisal of the object by placing it, as object, in its particular social setting. Ethnology provides this rational approach to the spatial context of an object, be it work of art or other, and nothing more. Should the object possess none of the attributes of art or only some of its elements, as in the case of certain utensils, ethnological analysis would be useful in treating of the processes which had brought the object into being while disclosing something of the pattern of the society in which it was made, and in providing comparative data for viewing similar societies in the future. Should the object on the other hand possess all the values of art and live primarily

as an aesthetic object, ethnological analysis alone would be powerless to deal with these values and to relate them to the phenomenon of art as cause or symptom in the general culture of mankind; it would refer always to values in the art object which lie outside the sphere of its operation as art. Such analysis being of a purely social nature can be of value only after the work has functioned as art irrespective of the intentions of its maker. Because it inevitably freezes 'style' into 'a style', and must deal with idiom in purely descriptive terms, ethnology is concerned only with that which has been deposited by the processes of culture, i.e. with 'crystallised history' – to use an expression of Roger Fry, who puts the case thus:

> When we look at ancient works of art we habitually treat them not merely as objects of aesthetic enjoyment, but also as the successive deposits of the human imagination. It is indeed this view of works of art as crystallised history that accounts for much of the interest felt in ancient art by those who have but little aesthetic feeling and who find nothing to interest them in the work of their contemporaries where the historical motif is lacking and they are left face to face with bare aesthetic values.[4]

It is not wholly the admitted unwillingness or incapacity on the part of the scientists to face bare aesthetic values, or the idea of art as 'a concept to be avoided' by the ethnologist, which accounts for their failure to discover the purely aesthetic virtues of the non-European art which they had been studying; it is that however intensively they went into the scientific study of these works of art they could produce only scientific results – results which, having their valued place is ethno-history are nevertheless of limited use to the art historian concerned with the phenomenon of style as an expression of the life of forms in time.

A post-nuclear art historian would probably be bewildered to discover a certain iconographic motif recurring over several centuries of modern history in various artistic media – in stone, in wood, metal, ivory, in woven fabrics and on painted surfaces, in mosaic, glass, even in the plans of certain buildings – and distributed in varying densities over the surface of the globe. This motif, cruciform in shape, often bearing in addition the portrayal of a human male in a posture of anguish or of resignation, would perhaps suggest to him the spread of an ancient pre-nuclear religion similar in its distribution among folk of several racial stocks to that of the megalithic wanderers whose obscure rituals have left stone tombs scattered all over Atlantic Europe to as far north as Scandinavia. He would find this cruciform motif surviving the various art styles and idioms of the many racial groups who had followed this particular religion all over the earth: a central theme symbolising the faith would be seen running unchanged through the most elaborate regional interpretations. He might name this the religion of the 'God of the Cross' and set about reading its associated iconographic data in order to define style and idiom in an art produced by the 'Folk of the Cross' – a term he might use collectively to denote the several races identi-

fiable through this form of worship. In the process the artistic characteristics of an individual hand would shrink to insignificance in face of the prevailing coherence of regional styles. In the welter of expression-media he would distinguish style sequences of varying degrees of complexity, all definable by their orientation to the central theme expressed in the cruciform image. He might perhaps classify this particular theme, in its orientation to an archetypal image, as iconic, and examine its phenomena principally from this angle. For the particular image represented by any one of his specimens would be understood with reference to this archetypal cruciform theme whatever the quality of its rendering as art and whatever the idiom employed. This iconic identification would be of the greatest value to him in determining style in the particular art, whether expressed in carving, casting, painting, or in architecture. He might find the rendering of the theme as rudimentary as two lines crossing each other at right angles or as complex as the Isenheim crucifixion; their significance as *icon* would be the same.

Over and above this expression of the iconic theme might enter values specific to the existence of a particular object as a work of art. The art historian could then well choose to discriminate between these values on the one hand and their iconic orientation on the other. He would do this by a study of the several styles through which the theme had manifested itself in time: by an examination of its evolution, its interpretation in different hands. But in considering the phenomenon of style as objectivised in the various renderings before him, he would inevitably come up against process and pattern in the various societies to which the objects had belonged, and he would need to take into account differences which had existed between these societies. These differences being social would refer to attributes of the art object which are of purely local significance, and to the manner in which particular societies controlled the conception and rendering of the theme as image. His researches would lead to a consideration of idiom as it appears in one society after another, i.e. the manner of rendering the iconic theme peculiar to each society, its particular method of expression. Thus he would find that the art object already identified in an iconic sense carries in addition a specific and local social reference, and that both are bound up with its existence. Where the iconic reference defines in the art object those general characteristics common to all renderings of the theme in a given society and introduces the concept of *style* (of ongoing, of process), the social reference materially identifies it with function in that society and introduces the concept of *idiom* (spatial distribution, regional adaptation).

Style in art is, like time, inseparable from the idea of duration; sequence and succession are normally the modes of its expression. Idiom on the other hand is expressed spatially. In the art object it is represented in a particular and distinctive ordering of space; it does not inherently refer to time: its reference is always local, in which sense it may be compared to dialect within a language. We can experience the full implications of idiom from contact with a single example of an altogether unfamiliar art, but this we

may not do in considering style. For this we need to be acquaintanced with several examples of work in the same idiom, so that the characteristics of idiom in a given art may be set in temporal relationship with all their implications of process, direction and intention.

These words *idiom*, *style*, are descriptive terms of no intrinsic aesthetic reference: they have nothing to say of the aesthetic content of a given work of art; they can be used, and often are, to describe activities whose purpose is not the production of art at all, for example basketry, weaving, and so on. In all periods there have been artists who have understood style and conformed to the requirements of a given idiom while remaining incapable of achieving aesthetic expression. Yet style and idiom remain the external referents of art, or to put it another way, the appraisal of an art is inconceivable without reference to the idiom and style in which it is expressed. In assessing a particular work of art we habitually, if unconsciously, refer it to the style system to which it belongs. We evaluate the particular work, for example an Impressionist painting, in terms of the general achievement of the style as such and its expression in the finest works produced by that style system. Sisley is a lesser Impressionist than Monet: Monet exemplifies the possibilities of the Impressionist style at its highest state.

We project on to a given work the full implications of the style system of which it is an expression. The entire style as it recedes in time and becomes crystallised as a historical phenomenon takes on the quality of an emotive entity, retaining its peculiar charge over decades or centuries. For this reason we tend to be contemptuous of examples of art which appear outside their historical style context, whatever their intrinsic aesthetic merit – a quaint phenomenon but a very real one. Whatever their aesthetic merit we are unable to accept Van Meegeren's Vermeers in the twentieth century, and Dali's mid-twentieth-century *Crucifixion* might have occasioned a great deal less stir in a style context proper to the Isenheim altar. Our suspicion, our fear, almost, too, of contemporary art, can be explained by this emotive aspect of style, by our preference for style that has crystallised and settled down so that we may safely refer its individual manifestations to the general phenomenon. In this way works of art considered most hostile in their day (we may recall the story of the Parisian gentleman punishing his wife by forcing her to look at a Van Gogh) come eventually to be acceptable, and even venerated, as the whole phenomenon of the style proper to it takes shape as a particular process in time.

In its iconic implications the Christian cross conveys its meaning to each believer irrespective of its aesthetic content or of the idiom in which it happens to be fashioned. Conversely, each believer receives this meaning irrespective of the measure of his capacity for aesthetic experience. The cross evokes associations of a religious nature and feelings of reverence. But emotions called into play by contact of believer with cross are not in themselves necessarily aesthetic; a cross on a grave, lashed together from two rudely fashioned poles, could be as religiously affective as one exquisitely carved on a Renaissance tomb. The aesthetic qualities which

distinguish the one from the other are concerned with values beyond the immediate iconic meaning. But to both belong the purely iconic reference – a reference which is inevitably bound up with the symbolic reference of idiom: with the formal means of expression peculiar to a given society. Thus identification by idiom enables the art historian to relate a given configuration of motifs or symbols to a given society, idiom being defined by this peculiar spatial reference. As Boas puts it in *Primitive Art*:[5]

Many formal elements are integral parts of every art style and these give it its specific character. The New Zealander, the Melanesian, the African, the Northwest American, the Eskimo – all are in the habit of carving human figures in the round. They are all representative, and still the provenance of each is easily determined on account of very definite formal characteristics.

Though Boas nowhere uses the word, this is a close definition of idiom. For the concept *idiom* he variously employs words such as *fixed types*, *customary types*, or *customary forms*, all of which he sees as resulting from the conservative mental attitude of the primitive artist. It is a pity that Boas's equation of the art content of a given work with the perfection of the technical processes involved in its production prevented him from arriving at an equally clear concept of style; for if as he claims, 'the judgment of perfection of technical form is also an aesthetic judgment', style need never be explained: aesthetic significance could be found in a beehive. Indeed he regards as works of art such undecorated implements as stone axes, chipped arrow- or lance-heads, iron spear-heads, spoons, boxes, 'in short any object of daily use, provided only the form which we may recognise as conceived in crude specimens is worked out in a perfect technique'. But as an explanation of the phenomenon of style he is forced to invent, without supporting evidence, notions of the inspiration of the individual artist, in the European sense of the term. 'It would be an error to assume,' he believes, 'that this attitude is absent among tribes whose artistic productions seem to us so much bound up by a hard and fast style that there is little room for the expression of individual feeling and for the freedom of the creative genius.' Boas's idea of the 'hard and fast style' represents a confusion with the concept of idiom, and this confounding of idiom and style runs through his work and the works of several later scholars. But despite his early attempt at defining these very important concepts it is surprising how little attention has since been paid in the literature to questions of the nature of style in African art; work after published work has ignored the issue, attention being mostly directed to classification, description, and general ritual comment, usually tedious in the extreme, whether written by ethnologist or art historian. Yet the satisfactory appraisal of any art remains impossible without a consideration of its time-depth; style as a measure of change in African art is closely bound up with the nature and intention of this art.

Fagg has recently claimed that in West Africa the choice of wood as the main material, and its frequent and beneficent destruction by ants and by

natural decay, ensured that style was never fixed for the carvers by the admonitory presence of immemorial archetypes but was renewed from generation to generation.[6] Style in art can never be fixed; in order to remain style it must be 'renewed from generation to generation', or even several times within a generation. But there is a sense in which 'a style' is loosely used to denote a category – e.g. French Romanesque style – to define a total phenomenon and not a process of change. In treating style as a phenomenon of change it must be considered as a process expressing itself through various *states*. Thus we may speak of the state of a style, denoting thereby a term in a series. What is fixed in any plastic culture is idiom – the type defined by specific characteristics – and it is this which is the subject of style-change while remaining the expression of that cultural context and of no other.

As Focillon has pointed out, there is 'a style' and there is 'style'.[7] The connotations are on the one hand spatial, on the other temporal. It is in the first sense that we speak of French Romanesque style, and in this sense too it is commonly employed in the literature on African art, i.e. Bambara style, Bini style, categories determined by specific attributes. It is on this plane that confusion arises between idiom and style, where the latter is used as a descriptive term with no temporal implications. But *style* is nothing if not temporal, implying a subject which is in process of change, and this subject is *idiom*. Style as state or stage or process is a concept which must accompany the assessment of any art, even so conservative an art as that of Egypt. It is an expression of that *intention to aesthetic utterance* which raises a true or absolute art above artistic phenomena, such as child art, insane art, naïve art, Boas's utilitarian art of polished stones, which may be called art only by analogy. If these arts do at times attain some aesthetic value this is always fortuitous and can occur in spite of the labours of the artist to quite different ends. The achievement of this accidental aesthetic value does not in itself constitute a sufficient criterion for the designation of such works as art, a point which is of relevance in the study of African art where so often the meanest utilitarian object – the canoe-paddle or pot-lid – is cited as a plastic masterpiece without thought of any distinction between the absolute and the analogous.

In an absolute art evidence is required of this intention to aesthetic utterance as objectivised in style. True, a pre-literate society lacks the means of verbalising such intention, but this in no way implies a lack of consciousness of its operation or the absence of aesthetic norms, for in the absence of such norms style simply could not exist. Idiom and style are concepts necessary in the appraisal of any art; but these terms, being purely descriptive, do not in themselves constitute sufficient criteria for evaluating the art-content of a given work. If we say of an object for instance that it is 'late Benin' we have merely stated that it is in the Bini idiom and of a late state in the style to which that idiom is subject; we have made no comment of an aesthetic nature. It is a statement which could equally well be made of a bronze horse-bit as of a bronze figure, a statement which fixes the object

in space and in time and nothing more. For the valuation of the work as art and for comparative appraisal we need a further term of reference, and this is form.

Form – that absolute condition to which all art aspires, the exclusive attribute of art itself – is inherent in the idiom by means of which it is made manifest and in the style which explains processes of change in the particular idiom. By its means the art object achieves that unique autonomy which distinguishes it within all human activity. It is that frame of reference in our evaluation of the art object which is neither spatial nor temporal, transcending as it does both these categories of apprehension. It is 'our brightest token of universality'. Focillon's perceptive definition further reads:

We are always tempted to read into form a meaning other than its own, to confuse the notion of form with that of image and sign. But whereas an image implies the representation of an object, and a sign signifies an object, form signifies only *itself*. And whenever a sign acquires any prominent formal value, the latter has so powerful a reaction upon the value of the sign as such that it is either drained of meaning or is turned from its regular course and directed toward a totally new life. Form has a meaning, but it is a meaning entirely its own, a personal and specific value that must not be confused with the attributes we impose upon it. Form has a significance, and form is open to interpretation. An architectural mass, a relationship of tones, a painter's touch, an engraved line, exist and possess value primarily in and of themselves. Their physiognomic quality may closely resemble that of nature, but it must not be confused with nature. Any liking of form to sign is a tacit admission of the conventional distinction between form and subject-matter – a distinction that may become misleading if we forget that the fundamental content of form is a formal one.[8]

Idiom as that attribute of the art object which represents a society's system of symbolising reference is open to various interpretations in time, both by members of the society and by the outsider – ethnographer, historian, or philosopher. Like style it stands in a definite relation to a given society. Form does not. Identified with the non-temporal, non-spatial values in a work of art, form is the only means we possess of freeing ourselves from the inexorable nature of time and the limitations of space, which is why we value the phenomenon so highly and seek its existence in cultures other than our own. Possessing this peculiar spatial and temporal independence, form in art strictly lies outside the methods of history. Faced with an Easter Island carving or a prehistoric 'fertility' figurine we may know next to nothing of their particular idiom, yet we may be capable of a response to the object *as art*, of receiving its form content as an independent aesthetic experience.

Through the exercise of a catholic aesthetic faculty in the spectator, and because of this temporal and spatial autonomy of form, where conditions exist for the exercise of this faculty the art object as cause or symptom in human culture becomes the property of mankind at large. The values which constitute form in art, universal and constant, are wholly independent of idiom and style which, being always of local reference, associate the art

object with particular processes in the various societies of man. But as a total of absolute formal values the art-object is not limited in this way; it transcends these limitations and is as universally communicable as thought which, similarly clothed in the limitations of language, i.e. of space and time, is nevertheless intrinsically independent of these limitations and capable of attaining to universal significance. Form in art is indeed an aspect of thought; it is thought which has no purely verbal reference.

Where idiom and style come to be identified with their product, form, where the process comes to be confounded with the product, the part with the whole, the result is a confusion of values relating to *seeing* the product, art, and to experiencing it as the most absolute of human phenomena. It is this confusion which is expressed in the division between the 'ethnological' and the 'aesthetic' viewpoints in the study of African art – a division implicitly acknowledged by Denise Paulme: 'to set out to judge a mask or a statue of the African continent purely on the aesthetic plane – wilfully ignoring the artist's motive force – is no less absurd than to pretend to study medieval sculpture while disregarding Christianity.'[9] The trouble obviously lies in confusing the study of a work of art with experiencing it – two processes which have little to do with each other. For there are two distinct methods of appraising any object of art: (1) the formal-aesthetic based in the psychology of perception, in aesthetic and symbolic experience, and (2) the functional-intellectual based in inductive reasoning as to place, process, and meaning, and relating the art object or composition to its period and social setting. A failure to distinguish between the two attitudes has been the bane of much of the writing on African art. The champions of meaning may well fight shy of the terminology of an art criticism which, even in the hands of the protagonists of form, is often only approximate. An independent rationale is wanted by means of which we can approach the object of study, but since we are dealing with a body of work in which the very concept *art* is inherently alien, our examination of style in sacred and secular forms will need to be structured on concepts equally alien to it. For in African art the very notion of style lacks its principal evolutionary determinant – the vision of the individual artist. It will therefore be necessary to seek constants of an entirely new order for apprehending the ongoing process in its operation.

3 The Genesis of Form in African Sacred Art

Despite various studies carried out over the past eighty years or so the life of forms in African art remains an entirely unknown quantity. We have had them severally illustrated, they have been explained in terms of meaning and function. But do they grow? How are they born, how do they die? In what relationship do they stand to the intuition and beliefs of their makers? What is the language of symbols employed, whence their various motifs, and what are their equivalents in belief?

In realising the genesis of sacred form in African art the cult is worth some consideration. The tribe presents too amorphous a frame of reference; in any case explanations offered in purely tribal terms result in a stultification of method in which a given medium of expression might be divorced from its technical origins, its technical development, its iconic orientation, and its spatial distribution. These considerations apart, the greatest obstacle to the use of the tribe as a unit of inquiry is the lack of precise definition. Yet it provides the basis for most studies so far made.[1] A further difficulty is that a given tribe might exhibit works in various expression-media difficult to reconcile to a common rationale, each being related to an idiomatic language peculiar to itself and dictated by its particular cultural environment. These media could even be found to refer to separate temporal levels within a given tribe, each following its own line of technical development within limits prescribed by the relative cult.

It is true that the tribe as a natural division in ethnographic studies furnishes those primary classification data without which the study of African art could hardly have been undertaken in the first place, and it is all to the good that the data have thus been classified, 'for before one can determine what function is fulfilled by art it must be established what artistic expressions are in actual use in a given society'.[2] But as Schmalenbach has further correctly pointed out, the division of African cultures and art by tribes occurs on only one level; it takes the continent as a flat structure, with tribe ranged against tribe in a sort of bright mosaic of peoples, cultures and styles. Against this lateral division into tribal styles Schmalenbach proposes a division in depth, by cultural levels, an archaeological division so to speak, and questions whether the culture-layer structure expressed in successive types of economy is also observable in art – whether there is any particular structure of artistic attitudes corresponding to given economic levels. 'Purely theoretically one is immediately inclined to answer in the

affirmative, since it can scarcely be otherwise', but for want of evidence he is unable to correlate such an art historical sequence with successive culture-layers. 'What we lack is the support of a clear and coherent chronology . . . the manifold influences to which Africa was exposed created a cultural confusion difficult now to disentangle.'[3] But implicit in Schmalenbach's culture-layer structure is that concept of 'progress' or 'development' evident in the history of European art, against which, until the evidence warrants otherwise, we ought to be on our guard in the study of African art.

In attempting to establish categories for his study Griaule, proceeding from what the work meant to those for whom it was intended, divided Dogon material in terms of the way in which it affected the member of the tribe.

The Negro behaves in a way which is both religiously and aesthetically actuated; religiously in front of the objects of the sanctuaries (statuettes), aesthetically in front of the mask in the public square. Between these two extremes there are many degrees where both types of behaviour can be found in varying proportions.[4]

From this he concludes that 'religious feeling diminishes from the sanctuaries to the public square in inverse ratio to the aesthetic', thus confusing the function of the object as it affects the member of the tribe with its intrinsic aesthetic content. It is an assessment which, in any case, is more enlightening about the response of the audience than about the nature and value of the art object.

Trowell's classification: Spirit-Regarding Art, Man-Regarding Art, and an Art of Ritual Display, owes something to Griaule's three categories, for having dispensed with the temptation to divide the material into religious and secular, or pure and applied categories, the author again proposes a classification based on meanings the objects are considered to have held for the audience for which they were first produced, and so perpetuates the confusion between form and content.[5] Himmelheber's classification is also made along these lines: (1) works of art with a religious content; (2) those with a practical purpose; and (3) those whose function is purely aesthetic[6] – a classification which tells us no more about the intrinsic nature of the object than the outmoded classification of European painting into the categories history-, landscape-, and portrait-painting tells us about the nature of European painting. For if classification is made according to the effect of different categories of object on the audience, it would seem necessary to define the particular plastic qualities in any given category by means of which this effect is likely to be secured; what formal characteristics define each category, making it possible to determine whether an object possesses aesthetic attributes or not. Following on this, how are such characteristics employed in a comparative sense in the interests of reference? Classification systems based on audience-response separate the use to which an object is put from its intrinsic aesthetic content – an aesthetic content which could exist in it *despite* the immediate needs of the artist or

the audience for which he works. More, such systems, lacking in time-depth, are for this reason incapable of extension in morphological studies.

The cult considered as the activating element in a given medium (wood-carving, say) seems to offer a more satisfactory basis for classification. It is the functioning of cult which accounts, spatially, for idiomatic differences in a given medium even within a single tribe (the *oṣẹ* Ṣàngó, for example); and differentiation in a given medium can be great, even though subject to an inflexible iconography, fig. 5. These differences may reflect adaptation across tribal sub-groups, or may merely represent the vagaries of an individual hand. But in spite of at times very extensive spatial adaptation (the Yoruba *ibẹji*) the cult stereotype will remain an absolutely stable configuration of type-motifs. This cult stereotype also remains temporally stable over considerable periods, figs 20, 21. A given cult stereotype might thus be fixed in the temporal and spatial context with a broad degree of certainty. The cult stereotype is often further restricted as to the medium in which it is fashioned, an observation also recently made by Richardson (*Etruscan Sculptures*, Collins, 1966) in regard to Roman and Etruscan sculpture. This interesting point will be mentioned in somewhat greater detail presently. The cult as a unit of classification offers the advantage of being the generating element in the production of sacred, and many forms of secular, sculpture, in stereotypes which are stable in the spatial, temporal and material context. The Abbe Bouché found among the Yoruba that 'every object becomes an *òrìṣà* as soon as it has got the appropriate consecration . . . the *òrìṣà* object acquires a kind of personality; what was only earth, wood or iron becomes *òrìṣà*, i.e. superhuman power'. Herskovits also observed that Dahomeans

translate *vodun* by the word god, yet within a shrine will point to a particular spot where a large jar is embedded and will say that the *vodun* is there. Quite apart from the concept of *vodun* which regards it as a deity the fact remains that a *vodun* is also thought of by a Dahomean as something localised – and that a spirit, while philosophically conceived as existing everywhere in space, must also have definite places to which it can be summoned, where it can be commanded by the proper formulae to aid its worshippers, and from which it can go forward to achieve those things desired of it.[7]

'Every person, animal, plant and thing has its guiding spirit', Horton found among the Kalabari of Nigeria,

and people in their turn are moved by the multitude of their own guiding spirits. It is men who make the gods important, the Kalabari people say. In worship the spirits of men influence a god through invocations; the god must be provided with a material vehicle which brings him down on to the same plane as the spirits of his worshippers. And it is here that sculpture is so important. The sculpture is *the forehead of the spirit*, which implies not just something which is intimately linked to a spirit, but something which exercises a kind of control over it. When men invoke the gods it is the guiding spirit of the invoker that ensures the desired effect. The human spirit cannot contact the god until the object of its address is at least temporarily bound to a material substrate, and thus localised.[8]

This localising of the spirit in sculpture is noticeable too in Yoruba Ṣàngó and Ogboni wood-carvings in which an attribute of the god, objectivised in a fixed iconographic motif, is incorporated in a 'representation' of the worshipper, thus identifying in one and the same object the spirits of worshipper and worshipped (figs 2, 3). In Ogboni worship, similarly, the

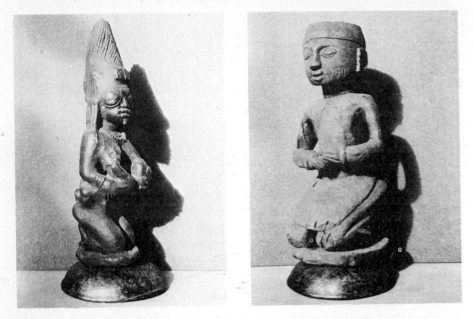

2. Sàngó worshipper

3. Ogboni worshipper

Earth-goddess Onílé is positioned on the earth floor of the *ilédi* (the inner sanctuary), marking the spot where the substrate, Ilè (which comprises specific natural substances containing the attributes of the earth-goddess) is buried (fig. 178).[9]

Elsewhere Horton notes that in the Kalabari masquerade of the Ekine society it is the sculpted mask atop the dancer's head that is the 'name' of the masquerade – everything else being simply decoration. It is because of the presence of the mask that the dancer becomes possessed by the play's spirit owner: the function of the mask is first and foremost to establish the presence of the spirit, rather than to impress spectators. For this reason it is of no importance that it is most often out of the view of the spectators, its principal features facing the sky and visible only when the man bends. At times concealment is increased when it is set in a great ruff of cloth with tassels sewn to its frame, while in other cases it is entirely enclosed in 'decoration' and is thus totally invisible from any angle.[10]

Among the Dogon Griaule found the mask to be the material support for an invisible force which plays the vital role in the drama, its wearer being no more than an unknown actor.

The mask, the statuette [he says] spring from the same idea. The first 'great mask', in the image of a serpent, was carved as a substitute for the first ancestor at the time of his death. An image was carved of the dead person, its head sculpted as a mask. It was very large, larger than a person could wear. It was taken into a

cave and consecrated by sacrifices which had the effect of fixing in it the soul and the vital force of the ancestors.[11]

By way of explaining this vital force Verger has examined the Yoruba concept of *Àsè* – the force itself.

The real title of an *òrìṣà* priest, the title that indicates his functions, is *Ìyáláse* or *Bàbáláse*, Mother or Father of the *Àsè*. And *Àsè* is the vital power, the energy, the great strength of all things. Such a priest is entrusted by the community to take care of the *Àsè*, to keep it active. *Àsè* is neither good nor bad, neither moral nor perverse, neither pure nor impure, any more than are electrical or nuclear energy . . . it is not a definite or definable power, it is Power itself in an absolute sense, with no epithet or determination of any sort . . . *Àsè* has a multiplicity of forms. There is the vital *Àsè* in the blood of animals sacrificed. There is the *Àsè* of plants and that of the earth where they grow. In an oral civilisation where the word itself is *Àsè*, the very names of plants and animals are *Àsè*.[12]

Since all share in this 'beholding', matter is conceived of as universally potentially active; its expression is often personalised: 'The door *doesn't agree* to open', etc. Among Yoruba blacksmiths the anvil (stone), the furnace (clay), and the metal are all equally regarded as charged with this spiritual force. It is everywhere potentially present and the working of matter into a mask or a figure changes nothing of its nature – the indwelling force is there all the time.

Needless to say such attitudes are unthinkable to the European artist, whose most studious interest in his material may from time to time extend to a curiosity concerning the chemistry of his pigments, or to the occasional visit of a sculptor to his bronze founder (possibly at work in another country). The overwhelming concern of the European artist is to *change* matter, to transmute a base material into a spiritual entity. And where the spectator consciously reminds himself of the material, the matter in which his art is vested, it is precisely for its materiality – for the pigmenty quality of pigment, the metallic quality of bronze, *as matter* – the artist must not depart from truth to his material. In Europe the aesthetic experience lies perhaps in the transmutation of matter into spirit, as it were somehow between the surface of the object and the eyes of the beholder. To return from time to time to the material, the surface, to the cold bronze, the dried pigment, constitutes a jolt of memory: it *is* after all metal, paint, ordinary matter. But is there spirit indwelling there? Certainly not. Is there energy dormant there? Heavens, no! For the European, the energy apprehended in nature is clenched within the *forms*, not the matter, of art. European art is a continual equivalence, African art an established actuality. I have known a young African try to leap in terror from a moving car after suddenly discovering on the rear seat a pair of sacred Ogboni bronzes!

This attitude to matter in European art underwent no fundamental change as a result of the African contact; despite the changed orientation to nature manifest in the creations of the modern movement, we admire (or not) the brushwork of a Picasso in just the same way as we do the glazes of a Rubens – as evidence of the artist's virtuosity in handling ordinary

matter, and of the treasured private universe lying between material and method. No African would dream of touching a cult-bronze or carving as an extension of aesthetic experience any more than would a Yoruba farmer, in traditional times, use his cutlass or hoe direct from the smithy without a preliminary propitiation of the spirit still considered to be active in the metal. For this reason agricultural tools could not be refashioned from old ones, or forged from foreign iron; the farmer's safety, his very life, depended on his relation to the spirit always dormant in his tool. The reluctance of the African smith to use European iron for ritual and agricultural artifacts has been noted by writers for many parts of the continent – a reluctance which, strangely, does not appear to operate in the use of brass, invariably of foreign provenance. The distinction illustrates, possibly, the development of spiritual and emotional attitudes in conformity with the exigencies of environment. Nevertheless among the Yoruba, as among the Etruscans and Romans, various materials are each considered to have particular attributes which dictate their use in cult-objects: iron for cult-furniture associated with the *òrìṣà* Ògún, Erinlẹ̀ and Ọ̀sányin: lead for rendering certain attributes of the god Ògún; brass for the Ogboni; copper for Oṣun; steel for Òrìṣà Òkò[13] etc.

In the same way Horton points out that among the Kalabari different kinds of wood are associated with different spiritual attributes, the *Odumdum* (*Newbouldia laevis*) being the most favoured for the carving of pieces representing the dead and the village heroes. Verbal explanations are hard to come by and are not invariably reliable, but attributes associated with the material in other contexts, or a consideration of the qualities they are intended to express, often suggest the value considered to be inherent in the material. Thus among the Kalabari the *Odumdum* is associated with orderly human social life: hence its appropriateness as a sign for those categories of spirit which underpin the established social order. Among the Yoruba the *Akọ Òrúpa* (*Hymenocondia sp. acida*) and the *Erun* (*Erythro-phloeum Suaveolens*) trees are specially selected for the preparation of charcoal in iron-smelting. The *Akọ Òrúpa* is of ritual significance in the cult of Ògún, god of iron; a forked stake of it is traditionally placed on the grave of a deceased hunter. The association of iron with Ògún, god of war, god of iron, will be obvious. But for the significance of brass as an enduring alloy among the Ogboni I could find no satisfactory explanation until I came across the following incantation sung by a senior Ogboni member:

> The *ẹdan* does not die, rocks never crumble.
> The *ogri sakan* does not die from year to year.
> I become the hill, I become the rock beneath the sea,
> I die no more.
> May it please God that I become like the rock beneath the sea.

Brass of course is the least corrosive of the ritual 'metals'. The *ẹdan*, the well-known anthropomorphic brass staff of the Ogboni cult, is held to *be* the spirit of the Earth-goddess, Ilè; like Earth herself its attributes are indestruc-

tible. Though the spirit of Earth is not considered to be inherent in brass, there is a stage in the casting process when the *ẹdan* itself signifies to the brass-caster that his efforts have been successful and the spirit has assumed spatial identity in it.

This difference between the two artistic systems, African and European, is reflected in the relative standpoints of the artist in the separate cultures. Where the practice of art for the European is individualistic and auto-biographical, for the African it is anonymous and social. Where for the European artist the occurrence of stereotype forms spells the death of art, for the African the practice of an art which does not conform to a stereotype is unthinkable. It is interesting to note that, with the contemporary breakdown of cult-organisation in African belief, the African artist of the twentieth century has come more and more to adopt the standpoint of individual inspiration and egocentricity which has characterised European art from the Renaissance to the present day. As a result of modern European contact a profound re-orientation can be seen to have taken place in the practice of art in Africa. In Europe, by contrast, the restless course of experiment since 1906 has continued to change the forms of art to such a degree that the brief African liaison is now all but forgotten.[14] It was a liaison which, however, could only have been brief for, as has been seen, beliefs and attitudes which, through the various cults, generate form in the African plastic, could never have been embraced in the normal meanings of the words *art* or *sculpture* as understood in Europe.

4 The Interpretation of Sacred Forms

We now examine certain concepts necessary in the interpretation of sacred forms in African art in their relation to the operation of cult: type, stereotype, archetype, and icon.

1. *Type*. In the iconography of many Yoruba cults appear certain motifs typical of a given cult which exemplify or 'name' particular attributes of the *òrìṣà* concerned; they determine the idiomatic language proper to the cult. These may be designated type-motifs of the cult. Examples of type-motifs are the double-axe of the *òrìṣà* Ṣàngó, the twin arrowheads of the *òrìṣà* Ògún, the bow with triple arrows of the *òrìṣà* Ṣopona, etc. (fig. 4,

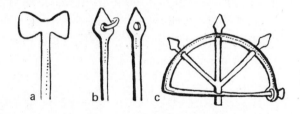

4. Type motifs in the cult of the *òrìṣà* (a) Ṣàngó; (b) Ògún; (c) Ṣopona

a–c). More than one type-motif may be associated with a given cult; thus attributes of Ṣàngó are also named in the sacrifice to him of the ram, or in the gourd-rattle used by the Ṣàngó priest to summon the *òrìṣà* during worship. *Ògún* is similarly named by seven bits of iron, the number representing the seven areas of operation of the *òrìṣà*, i.e. each stands for the particular aegis under which a given category of worshipper serves the god.[1] The god is also represented in motifs, such as hammers, hoes, etc., derived from the implements and weapons of the hunter or the farmer. These type-motifs do not in themselves constitute objects of worship, they are mere identifying emblems of the attributes of a particular *òrìṣà*, names by the use of which these attributes may be brought under the control of the priest or worshipper.

In considering the genesis of these type-motifs we may remember that in many African religions the Supreme Power has no counterpart, though his various attributes may find particular expression in several lesser spirits seen as the personifications of such attributes. Thus the Yoruba pantheon is presided over by the High God Olódùmarè, never directly addressed, never figured in the forms of art, but manifest in the lives of men through

the various *òrìṣà*, or lesser spirits, who personify his attributes. As in the European euhemeristic tradition, these *òrìṣà* are seen by the Yoruba as having once been men – heroic figures, leaders and pioneers of civilisation deified for extraordinary or supernormal endowments. 'All the *òrìṣà* were men of past days: we remember each for the greatness of his spirit. Each had his own kind of greatness: Ṣàngó breathed fire; Ògún taught iron-working; Ṣopona cured smallpox, etc.' As every man, animal, or thing created is regarded as possessed of spirit, the *òrìṣà* as super-human spiritual beings stand in a particular relationship between the creatures of earth and the source of all being – the ineffable Olódùmarè. The Dyula-Serer both believe in a unique, invisible God, master of all but living in heaven. Neither of them addresses God directly; they believe in the existence of intermediary genies, equally invisible, and with whom they are in direct relationship.[2] A similar structure is described among the Ibo by the Nigerian novelist Achebe: 'Chukwu made all the world and the other gods. We appear to pay greater attention to the little gods but that is not so. We worry them more because we are afraid to worry their master. Chukwu is supreme.' Every Aṣante temple is a pantheon in which repose the shrines of the gods, but the power or spirit that on occasion enters these shrines is directly or indirectly derived from the one God of the sky whose intermediaries they are.[3] In Verger's interpretation of the concept of *Àṣè* among the Yoruba not only the gods are animated by *Àṣè*, but *Àṣè* is:

the principle of all that lives or acts or moves . . . everything which exhibits power, whether in action or in the winds and drifting clouds, or in passive resistance like that of the boulders lying by the wayside The *òrìṣà* is only part of such forces, the part that is disciplined, calmed, controlled, the part that forms a link in the relations of mankind with the indefinable The *òrìṣà* cult is addressed jointly to the tamed natural force and to the deified ancestor (who was able to establish control over that force) both of these links being considered as a unity. This alliance is represented, but not materialised, by a witnessing object which is the support of the *Àṣè*. Among such objects are meteorites and neolithic axes – thunder-axes for *Ṣàngó*, *òrìṣà* of thunder and King of Koṣo and Oyọ, pebbles of the River Niger for *Oya*, pebbles of the River *Oṣun* for the *òrìṣà* of that name, seven pieces of iron for *Ògún* – the *òrìṣà* of blacksmiths and warriors.[4]

Such are the objects exemplified by the type-motifs which we find in the imagery of their respective cults, each distinguishing the cult objects of one *òrìṣà* from those of another. These cult-objects may be semi-utilitarian, such as pots, mortars, wooden combs; or purely ceremonial, such as staffs, cutlasses, bracelets, etc. They name, or witness to, an attribute of the undifferentiated spirit of the *òrìṣà* by particularising the attribute in a visual image.

2. *Stereotype*. Type-motifs such as those defined above provide, in various combination, the elements of the stereotype: – cult-objects such as pots, mortars, human figures of priest or worshipper, etc. In its configuration of type-motifs such a stereotype fulfils the necessary conditions for

localising the spirit without which the cult-object is ineffective. In the absence
of suitably rendered type-motifs the object, whether wood-carving or brass-
casting, and whether of utilitarian or purely ritual use, cannot be considered
by the priest as open to habitation by the spirit. Thus the *àgbá* drums
in the Ogboni sanctuary at Ìjèbú-Òde among the Yoruba, and the collection
of brass images held in the same shrine, are both sacrificed to as abodes of
the spirit of the earth-goddess Ilè, each by virtue of bearing the sacred
insignia of the Ogboni cult. In the process of manufacture the artist, in
contact with the forces to be confined in his rendering, often in fact assumes
the nature and powers of a priest.[5]

This stereotype, resulting from spirit control of the forms incorporated
by the artist, is always a standard rendering, always a copy, never an original
construct or personal invention; it is an individual piece only in the quality of
the rendering of the type-motifs employed, in the degree of their decoration
or elaboration; it is never a product of the free play of the artist's imagina-
tion. As in the *oṣe* Ṣàngó, the *labà* Ṣàngó, the *odo* Ṣàngó, or the figure of a
Ṣàngó worshipper it does not necessarily incorporate all the type-motifs
associated with a given *òrìṣà*, but only that characteristic selection associ-
ated with a specific attribute or specific attributes of the *òrìṣà*, and which
defines the particular function of the piece. Such a rendering might be sub-
ject to regional variation in its selection from the body of acknowledged
type-motifs, and their treatment in sculptural form, fig. 5. A familiar Ṣàngó
stereotype is represented among one group, or by one carver, by a promi-
nent rendering of the double-axe type-motif on the head-dress of the wor-
shipper carrying the rattle of the *òrìṣà* and the ritual staff itself; among a
different group or at the hands of another carver a more conventionalised
figure of the double-axe appears on the worshipper's forehead as a defining
or identifying type-motif and without the rattle or staff. Each of these
stereotypes serves the local carver in his group as a model for the multi-
plication of similar renderings, so that hundreds of identical examples are
produced, sometimes by several hands in the same workshop, each type-
motif conforming to the standard and explicit requirements of a sign: a
predetermined 'response set' is evoked by any given configuration of type-
motifs. In a non-literate culture the evocation of such responses is achieved
by visual formularies as determined as are those of the Christian liturgy, and
herein lies the *raison d'être* of the cult stereotype. It therefore lacks the title
and exegesis by means of which a modern audience might come to grasp the
'message' of the artist; in the cult-stereotype, as in the stereotype symbols of
medieval Christian art (serpent, lion, peacock, etc.) the message must be
implicit in the motifs selected and such motifs must be universally ack-
nowledged as signs. A cult-devotee would see no point in demanding a
personal variation on this standard product: we may venture so far as to
conceive it as outside the collective capacity to imagine such a variation. In
the mind of the African artist, as in that of the European or any other, we
may assume a limited range of type-motifs drawn from the collective 'be-
holding' of his people, operating in the schema in which his images are

5. Variation in cult idiom: some type-motifs of *Òrìṣà* Ṣàngó

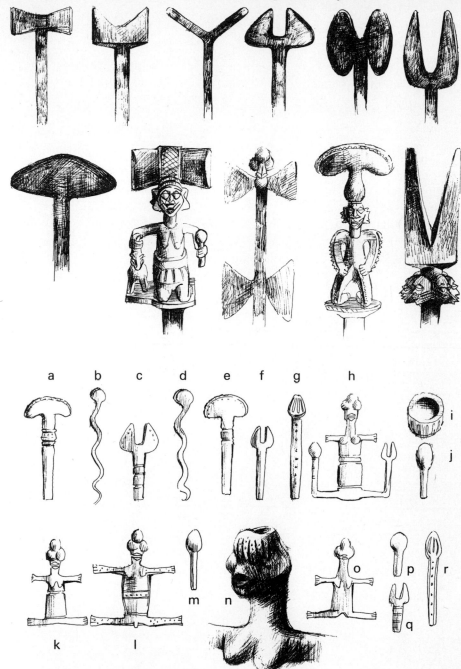

(*a*) oṣe (staff); (*b*) serpent (significance unknown); (*c*) oṣe; (*d*) serpent; (*e*) oṣe; (*f*) oṣe; (*g*) unidentified; (*h*) the Èṣù-Ṣàngó theme; (*i*) odo (mortar); (*j*) ṣere; (*k*) Èṣù-Ṣàngó; (*l*) Èṣù-Ṣàngó; (*m*) ṣere (gourd rattle); (*n*) Èṣù-Ṣàngó; (*o*) Èṣù-Ṣàngó; (*p*) ṣere (gourd rattle); (*q*) oṣe; (*r*) unidentified. (These type-motifs all occur on a single urn)

understood, and outside which he cannot reach by any exertion of the personal imagination. In his individualising, autobiographical orientation the European artist may appear to enjoy a greater liberty in the treatment of his type-motifs, in the ordering of the geometrical constants of form proper to his culture, in their expression as dimension, proportion, and so on; ultimately however this very liberty subsumes the concepts by means of

which his work is 'understood' (concepts such as growth, extension, continuity), and which constitute the schema in which his images appear and are apprehended in his society. The ethnography of European society is as implicit in its works of art as in any other. Subject in its limited way to regional adaptation and differentiation the stereotype also reflects the interpretation of forms in time and thus, in African art, constitutes a measure of style.

3. *Archetype*. This we may regard ás the aboriginal material in which the spirit of the *òrìṣà*, or god, having been first invoked in the cult, assumed spatial identity. This is not a human construct but merely an expression in matter of the various attributes of the *òrìṣà* – attributes which are thought of as being inherently contained in certain substances, each valued for qualities proper to itself. Thus in the Yoruba Ogboni cult the Ilè – the Earth Principle – is localised, buried in the inner sanctuary, indwelling in such substances as chalk, mud, camwood, charcoal and the skulls of various animal sacrifices. These are the ultimate determinants in the sanctification of the shrine: they symbolise the four elements of the *Ogboni* system – Olórun (the Sky God), Ilè (Earth), blood (judgment), and human being, respectively represented by powdered chalk, pure black mud from the river, powdered camwood, and powdered charcoal collected from fires on which food has been cooked for members of the cult.[6]

These natural substances, materialising the concept of the *òrìṣà*, or god, are not subject to change or regional adaptation. Verger has described such substances as 'objects which transmit from generation to generation those secrets which gave the first priest power over the *òrìṣà*: coercive words pronounced at the time of the cult's establishment, elements which enter its mystical constitution – leaves, earth, animal bones, etc.'[7] Herskovits records that the Dahomean layman, asked about the nature of the *vodun*, replies: 'The *vodun* itself is in the ground. One does not know what it is. It is a power . . . the force that goes about in the temple.' Such substances, buried in the earth floor or the earth wall of the shrine, are held to contain the spirit of the *òrìṣà*; they localise this spirit and render it open to communication and control.

4. *Icon*. The position of such substances, beyond physical contact by the initiate, is sometimes marked on the floor of the shrine by some object, natural or artificial, by means of which the worshipper or priest can enter into a more immediate relationship with the *òrìṣà*, or god. Where this object is an anthropomorphic image I have designated it an icon, it being the material manifestation of the spirit and its vessel, the form in which the spirit is brought into contact with men; it confines the indefinite spirit and shares in its power and is therefore itself seen as numinous and impersonal. It is the recipient of prayer and sacrifice.

5 The Forms of the Cult-Object

The forms of the cult-object have their sanction in the spirit-archetype: the archetype itself determines the forms in which it comes to be spatially represented, whether they are human or animal. Observations on the genesis of forms in their relation to spirit-archetypes are not common in the literature; Horton's work among the Kalabari is therefore especially valuable in this respect. Apart from a rigorous classification of motifs as they are connected with (a) universal use, (b) with uses confined to the Dead and the Heroes, (c) uses confined to Heroes and Water Spirits, (d) uses confined to the Dead, and (e) uses confined to the Water Spirits, he gives an illuminating picture of the relationship existing between the spirit-archetype and the forms in which this archetype is objectivised in cult-sculpture.

The spirit to be represented enters the head of his medium and dictates to the carver the motifs he wishes to see on his cult-object. The carver may have a little latitude in his *arrangement* (italics mine) of these motifs, but by and large the process is closely guided by the medium. Moreover, the motifs *selected by the medium* are nearly always drawn from among the limited number of alternatives (*i.e. the type-motifs*) traditionally associated with the category of spirits to which the 'owner' of the cult belongs. Here, as in the case of the new ancestor sculptor, the element of innovation is little more than that involved in reproducing an old cult-object. When a carver is commissioned to copy an old cult-object, he is in a situation where an original warrant of appropriateness has already been given, so he has no need to seek the direction of the spirits [i.e. he works from a *stereotype*], but when he has to produce sculpture for a new cult, he needs spiritual authority before he can proceed (i.e. in 'creating' new *type-motifs*).[1]

The concretising of spirit-archetypes in *òrìsà-* and ancestor-forms is effected by pinning down spiritual attributes by means of those type-motifs through which the spirit may always be identified; these type-motifs in varying combination constitute stereotypes referring to the given cult. The relation of the artist to such stereotypes explains the apparent sameness and uniformity of idiom as expressed in particular cult-objects; that is to say, the various stereotypes associated with a given cult will refer to an obligatory group of type-motifs for that cult. Adherence to the requirements of such stereotypes on the part of the artist limits the degree of invention, represented in style change, to which the artifact will be subject in the life of forms; that is, the relationship of the artist to the body of type-motifs associated with a given cult determines the forms in which the stereotype might appear. Thus it is that this relationship accounts for the emergence of the image, as well as for the range of imagery, in objects associated with

a given cult. Granted these limitations, what then accounts for idiomatic variation in the stereotype, since obviously, even among the most conservative groups, it is not produced with the frozen uniformity of coins from a mint? Comparative analysis of type-motifs as they appear in two well-known stereotypes, the *oṣe* Ṣàngó and the Ṣàngó ritual urn, might be illuminating.

The *oṣe* Ṣàngó, the ritual staff used in the Ṣàngó cult among the Yoruba, incorporates the principal type-motif of the cult, which expresses an attribute of the god of thunder and lighting; it is the double-axe motif symbolising the 'thunderbolts' (usually stone celts) which the god is considered to hurl as he sees fit upon the habitations of men during his periodic visits to earth, and which are to be found in most Ṣàngó shrines. The type-motif takes the shape \bowtie , and this in its simplest form is represented on the *oṣe* in combination with a short staff, fig. 5.[2] As the diagrams show, this type-motif occurs in a wide range of interpretive variations, from examples in which the type-motif is merely reproduced, through examples of partial anthropomorphism, to examples of full anthropomorphism in which an image of the worshipper is identified with a type-motif of his cult.

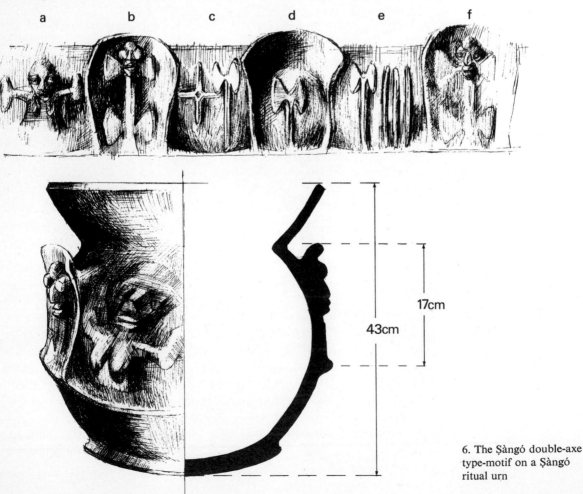

6. The Ṣàngó double-axe type-motif on a Ṣàngó ritual urn

Each of these examples constitutes a stereotype of which hundreds of exact copies by several hands may be found to occur among a given group. The union of the image of the worshipper with a type-motif of the god worshipped is often further extended in autonomous anthropomorphic renderings in which the type-motif appears either as an identifying adjunct, or is expressed in the thematic conception of the figure itself, figs 2, 8.

Designs of the *oṣe* Ṣàngó also occur on certain ritual urns used in Ṣàngó shrines. In fig. 6 the sections a, c, e, are modelled directly on to the walls of the urn and alternate with vertical panels, b, d, f, disposed around it.[3] In these urns the ratio of the width of the panels to the spaces between them varies; in some cases the panels entirely dominate the design idea. Besides the wide range of interpretation of the double-axe motif occurring on these urns there also appear type-motifs which do not specifically refer to the thunder-attributes of the god. Meanings connected with these latter type-motifs lead us to consider the alternative attribute of Ṣàngó – that of the god of lightning. Wescott and Williams have found in the design on the *labà* Ṣàngó (the pouch of the priest) a swastika-shaped type-motif symbolising in their opinion Ṣàngó's role as avenger in which he uses lightning, his particular expression of energy, as a punishment. This lightning-flash motif is at the same time anthropomorphised into a representation of the trickster-god, Èṣù, seen by the Yoruba in some of his functions as complementary to Ṣàngó. In the view of the authors the attributes of Èṣù are denoted on the *labà* by the swirling restless nature of the design, by its colour symbolism, and by the phallic symbol worn as a cap, which is often to be seen on Èṣù carvings. 'Through the provocation of Èṣù, Ṣàngó's thunder-bolts are loosed upon mankind.'[4] Whether or not the swastika is acceptable as a type-motif in Ṣàngó iconography it is clear from the authors' evidence

7. Ṣàngó ritual urn. Cult stereotype expressing the interrelationship between two cults – Èṣù and Ṣàngó

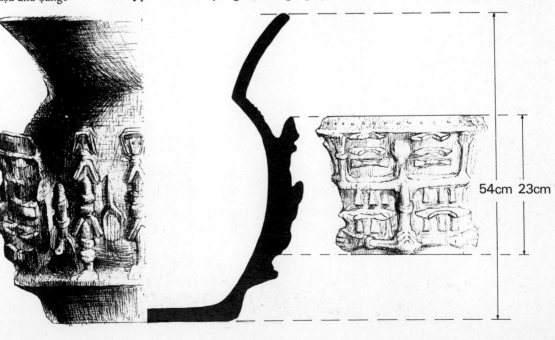

54cm 23cm

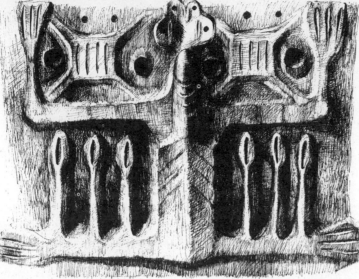

8. Detail of fig. 7

that Èṣù symbolism is closely linked with that of Ṣàngó, and this explains
in the latter a great deal which might otherwise be incomprehensible. The
most obvious of these links is the figure represented on successive panels
of the Ṣàngó ritual urns in figs 7, 8 and on the bead doublet at fig. 9.
The similarity of these figures to the conventionalised rendering of Èṣù on
the *labà* is striking. Where, however, the image of the trickster-god is shown
in the Èṣù dance position, identified by Wescott and Williams, of one

9. Bead doublet of a Ṣàngó
'priest'

forearm pointing upwards and the other downwards, it appears on the Sàngó urn in a strict bilateral symmetry of arms and legs, expressing perhaps the double-axe theme in human form. It is difficult not to conclude that these figures separately represent variations on a common theme, and whether or not the theme be the swastika motif suggested by Wescott and Williams, its expression in the two cults – that of Èṣù and that of Ṣàngó – has produced stereotypes exclusively associated with each of these cults among a subgroup of the Yoruba, at Ọyọ. Idiomatic variation in the stereotype might thus result (*a*) as in the *oṣe* Ṣàngó, from local adaptation of type-motifs in the interpretation of a given form, or (*b*) as in the Ṣàngó ritual urn, where such variation is dictated by the interrelationship of two or more cults. We shall later observe in a triad of Yoruba forest cults this inter-relationship as it determines not only the idiomatic language employed, but also the medium obligatory in the relationship.

This modification of the stereotype by borrowing type-motifs from an associated cult is further illustrated at fig. 10, in which a conventional rendering of a Ṣàngó worshipper incorporating the usual Ṣàngó type-motifs of the gourd rattle and staff is presented with the long conical head-dress denoting the trickster-god, Èṣù. In this example the double-axe Ṣàngó type-motif is anthropomorphised in two opposed faces forming, along with that of the worshipper, three faces on the head of the cult-object. This

10. Ṣàngó theme with Èṣù type-motif

statement of three might also suggest an association with the Earth Principle in Yoruba cosmology.

The number three to the Yoruba is part of the symbol complex of the deified Earth, the home of the ancestors, and signifies mystery. The *labà* as a container for the thunderbolt that Ṣàngó hurls to the earth is symbolically equivalent to the earth which receives Ṣàngó's lightning. In such number symbolism among the Yoruba the symmetry and order of the number four express attributes of Ifà, the god of divination, of the ordering of human affairs. In the *labà* these two groups of numbers symbolise, in the number seven, the creation of a new form from the union of opposites.[5]

This statement of threes and fours is also to be found in the imagery of a Ṣàngó urn, fig. 6, in alternating designs of which are the motifs at fig. 11:

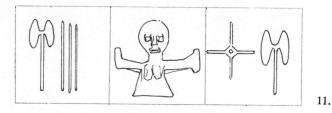

11.

In successive panels of another, fig. 7, we find the motifs at fig. 12:

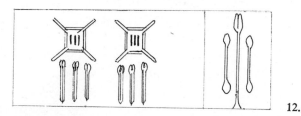

12.

i.e. the theme of fours combined with threes.

Similarly, in successive panels of the urn at fig. 7, we find at fig. 13:

13.

11, 12, 13, 14. The theme of threes and fours

i.e. again the theme of fours combined with threes.

This combination of fours with threes, suggested by Wescott and Williams as explaining the traditional seven tags on the *labà*, also appears in the carving of a wooden Ṣàngó pot cited by them (fig. 14), and claimed to represent the association of Ṣàngó with the Ifá oracle (four) and the Earth Principle,

Ilè (three); the motif also occurs in the representation of a *labà* on the carved wooden pot at fig. 15.

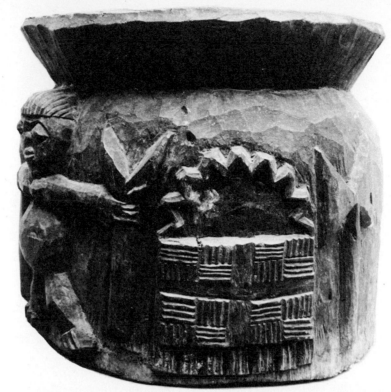

15. Laba Ṣàngó on a wooden pot: threes and fours

The association of Èṣù type-motifs with those of Ṣàngó also appears borne out in the phallic imagery of both Ṣàngó and Èṣù cults. 'The phallus is prominent in the imagery of both Ṣàngó and Èṣù; Èṣù's head-dress . . . is sometimes carved as a phallus.'[6] In the Ṣàngó urn at figs 7 and 8, the central figure on the panels is little more than an enormous phallus bearing limbs and a head. In addition to these also occur the motifs at fig. 16:

16. Phallic symbolism: Èṣù-Ṣàngó

17. Èṣù: the theme of threes and fours

Owing to its penetrative attributes the African comb is a symbol of universal reference among the Yoruba.[7] Thus it occurs on a hunter's leather doublet associated with Ògùn, god of iron, god of war fig. 41; on the Ṣàngó ritual urn at fig. 7; and as an appendage on the Èṣù staff cited by Wescott and Williams. In this example from Èṣù three human figures are combined with sixteen teeth on the comb, i.e. with four groups of four, fig. 17. (Four is also the number of days in the Yoruba week.)

The theme of threes occurs likewise on two Ṣàngó staffs illustrated at
fig. 18.

18. The theme of threes on
two Ṣàngó staffs

The employment of type-motifs in the creation of the stereotype now
becomes clear. Variation in the idiomatic language of the stereotype is to be
accounted for either by local interpretation or by the association of related
cults. This latter illustrates the intrinsically spiritual meaning of the idio-
matic language of the Yoruba cult-stereotype. The Ṣàngó ritual urn consti-
tutes a repository of type-motifs each bearing its own spiritual reference
and whose several 'meanings' are intended to induce respective attitudes,
in use, on the part of the cult-devotee; it concentrates the spiritual impli-
cations of the cult at a single focal source. In differing ways the various
stereotypes of the cult particularise various attributes, or combinations
of attributes, of the òrìṣà for specific functions; i.e. oṣe Ṣàngó, odo Ṣàngó,
etc. Thus whatever its idiom, the stereotype perpetuates the iconic theme in
much the same way as the Christian cross.

While this theme by its nature is not subject to change, the idiomatic
language in which it is vested is subject to change in the ways examined.
For purposes of appraising the 'ongoing' processes of such change, i.e. for
style scrutiny, are we in any position to examine these various manifestations
of idiom chronologically? Given the conservative nature of the various
cult requirements it would be out of place to interpret such change in terms
of a developing series. Idioms might flourish and die in a given group
while in another the same idioms, spatially adapted, might retain their
purpose and strength. So that though we may conceive of the operation of
'schools' in African art as conservatories of idiom in its stylistic impli-
cations, it is not often that we can relate such schools to areas of closed
spatial and temporal reference. Iconic necessity in African art ensures

a non-developmental continuity which is vested nevertheless in temporal forms – forms subject to change, decay, and spatial extension while continuing in an inexorable present. The picture in time is rather like that of a great forest comprising various species in ecological balance which continually flourish and multiply and decay without disturbing this balance or the forms in which it is expressed. So it is that in African art, sacred or secular, the appraisal of style is inconceivable without a corollary understanding of the 'continual present' in African notions of time, expressed for instance in the role of ancestors in the affairs of the living. Eliade opposes a 'mythic time' (a time which has no trace of history) to a 'profane time'. It is perhaps the preoccupation in many African cults with 'the plenitude of a present which has no history' (Eliade) which accounts for the negation of decay in African art by the continual renewal in perishable materials of an iconic figuration which is itself imperishable. Egyptian art similarly achieves this negation of decay, but by means of the use of the most imperishable of materials to hand.

From a study of the type-motif in its reference to the art object it is tempting to deduce notions of style succession, even though such notions would be alien to the view of the cult artist. Thus Dark, employing a motif in Bini art considered to derive from a European head, attempts to establish from a variety of examples a form-sequence in which he feels a time-sequence to be implied, fig. 19.[8] In the absence of definite evidence for determining the first term in the series, or its direction, the attempt appears

19. Motifs in Benin art: apparently based on the faces of 15th and 16th century Portuguese traders, they may or may not indicate a chronological sequence

to be of no value at all: the motifs could all have been roughly contemporaneous with each other and have no more than a spatial significance, i.e. they need not necessarily represent a linear series. The same would apply too to such a form-series as may be structured from examples of the Ṣàngó ritual staff, fig. 5, where, though our first term – the double-axe motif – might appear to be related to a known archaic Egyptian symbol, we cannot be certain that succeeding motifs indicate a temporal rather than a spatial pattern. In African art we cannot necessarily 'date' an object as earlier than another simply by the occurrence on it of a given term in a putative series, even less so when the longevity of motifs, as signs, is taken into account.

Style in the cult-object is best understood in the life of the cult which gave it birth. In the absence of written sources we can understand little of the development of the cults in their interrelation without reliance, where it exists, on the oral tradition. Where such tradition is lacking for a particular cult we are in a poor position for attempting a morphology in its associated cult-objects, and recourse must be had to notions of 'influences' at

times operating between styles. In such influences the requirements of cult might at times be subordinated to the iconography of the parent style, as we shall note for Ògún imagery in its borrowings from the Ogboni bronze. But in all cases idiom and style in African art, sacred or secular, are rooted in an attitude to nature very different from that of Europe. It might be fruitful now to examine this attitude in the light of that vision which has given it modern significance to the student both in Europe and in Africa.

6 Illusion and Disillusion

In the closing years of the fifteenth century Portuguese sailors, intrigued with the ingenuity of Sierra Leone carvers, started up a curio trade that continues to the present day. Throughout the seventeenth and eighteenth centuries collectors continued to amass those curios of tribal craftsmanship which, along with classical and oriental objects of art, were later to form the basis of the great national collections of Europe, and to provide the subject of early ethnological research towards the close of the nineteenth century. Various methods of study had already been developed when, to the annoyance of these scholars, the painters of the School of Paris 'discovered' tribal art all over again. But it must be remembered that the interest of the European artist in the exotic has no less long a history than that of the gentlemen amateurs who built the historic collections. Dürer's astonished interest in 'the subtle Ingenia of men in foreign lands' was to be felt by many a major European artist in the four hundred or so years after him. In the mid-seventeenth century Rembrandt studied Indo-Persian miniatures. Delacroix and Ingres both sought inspiration in Moorish themes, the Impressionists turned to the Japanese print, the Cubists (Braque, Picasso) to Negro art, Picasso to prehistoric and classical art, the German Expressionists (Die Brücke) to various 'tribal' arts, mostly Oceanic, and Gauguin died in the South Seas after revolutionising European aesthetic ideas in painting, all before the discovery of tribal art was popularly credited to the painters of the School of Paris.

Why then did the foremost painters of Europe at the turn of the century with a long, brilliant and very different art history behind them develop this apparently sudden interest in tribal and particularly African art? For a historical interpretation it will be necessary to recapitulate very briefly some of the principal ideas behind the development of European art since the Renaissance. I have called the history of these ideas 'Illusion and Disillusion' for reasons which I hope will be obvious.

We may bear in mind that Leonardo was born in 1452 just as the first Portuguese were exploring the mysteries of the West African coast, and that he died in 1519 as the Bini state was entering its great period, a lifetime spanning the fertile stretches of the High Renaissance. His contemporaries were Raphael (who died the following year), Michelangelo, Piero della Francesca, the architects Alberti and Brunelleschi (the former of whom initiated the study of perspective) and, in the field of action, Columbus and other precursors of the Great Navigations. From such a list of innovators it would be churlish to exclude the dethroned Uccello whose studies in fore-

shortening in this period also helped to lay down principles that would characterise the European canon for the next four hundred years, and which give to European art its peculiar originality and greatness.

Contact with Africa in the fifteenth and sixteenth centuries had no effect whatever on European art, though it is not unlikely that, as with oriental objects during the Crusades, European artists were for the first time brought face to face with artifacts from those distant shores. African sculpture of the seventeenth century certainly found its way into the *cabinets* of gentlemen amateurs, but we have no evidence that Europeans ever saw the art of Ifẹ̀ which is generally regarded to have been contemporaneous with that of the Early Renaissance. It was an art which would readily have been understood by men whose culture was striving for the rebirth of the classical ideal, for the distinguishing and most astonishing aspect of the art of Ifẹ̀ is its ready correlation with Greek classicism. By the end of the Renaissance in Europe Islam had brought to North Africa an art and decoration which determined the artistic climate of the western Sudanese states, and which overlaid in the eastern Sudan the Monophysite Christian culture succeeding in the sixth century to that of the antique Napatan-Meroitic civilisations of the Nile. A Byzantine-inspired art and architecture stood in ruins from Dongola in the north to Soba near present-day Khartoum, while in Ethiopia the Christian culture of Axum had realised forms in architecture developed over the previous two thousand years. Iron was mined and smelted in most parts of the continent, but everywhere in insufficient quantities and fashioned chiefly into tools and weapons, ritual staffs and minor domestic objects, and used as currency. Over an area roughly coterminous with the present extent of the *Kwa* group of languages – from Liberia to the Cameroons – bronze casting was probably known, though the great schools of West Africa, those at Benin and Ifẹ̀ and Ìjẹ̀bú-Òde were either still in their naked infancy or not yet conceived.

In Renaissance Europe three main disciplines had been developed in art theory which would remain unchallenged for centuries to come. These were the study of anatomy by means of which the human figure came to be articulated in three-dimensional space, the study of perspective which was the science of rendering that space, and the study of chiaroscuro by means of which the optical behaviour of objects in three-dimensional space was realised. Contemporary African art of the period was of course concerned with none of these issues, linked as they were in Europe with man's changed judgment of himself in the context of nature and realised in an art of visual illusion. With the flowering of the sciences during the seventeenth and eighteenth centuries European art took on that corresponding infiniteness noted by Spengler in mathematics, and in a different way in music. The extension of an unseen and intangible spatial world came to be revealed, represented by concepts of infinity in number and by the rise of landscape painting as an end in itself rather than as a mere support for the portrait piece. In the academies of the nineteenth century was accumulated the knowledge inherited from Renaissance inquiries in the arts of painting, sculpture, and

architecture, while the effects of the Industrial Revolution now shifted patronage from the aristocracy to the *bourgeoisie*, just as the Renaissance had earlier shifted patronage from the Church to the aristocracy. The development of style in the plastic arts was reflected in the various schools, and the principles behind the mastery of visual illusion continued to be refined by one school after another until the researches of the great Realist painters of the nineteenth century brought to a head the quest for naturalism begun several centuries earlier. With the invention of the camera an instantaneous record of visual appearances became possible, and European plastic art lost a role which had been central to it from the beginning; the dream dreamt by the men of the early Renaissance exhausted itself in a moribund academism.

What followed was a jumble of aesthetic disputation among painters accompanied by their gradual alienation from society. Suddenly the principles of the Renaissance were seen to be wrong: perspective was wrong, chiaroscuro was wrong, anatomy most wrong of all; plastic art seemed headed for the darkness of an enveloping uncertainty; but there were those who eventually in their laboratories, as the studios were now becoming, saw the light. The secret lay in light. All art was light – nature, colour, atmosphere, all was light. Without light nothing was, matter was dead. Light, light, and yet more light. The Impressionists all but blinded themselves with it in quasi-scientific theorising. As with the 'Optical' artists of the present moment no one saw until it was too late that Impressionism was merely a further essay in the mechanics of objective vision and not an art born of a new orientation to nature, or of a fundamentally new metaphysical vision. Its history was short, and brilliant in the manner of an explosion that dies to rapid darkness. And this darkness was the darkness of disillusion naturally following upon the drying up of the Renaissance vision.

What had gradually been taking place throughout the nineteenth century was the disintegration of the space-time structure of the Renaissance cosmology, and sensitive artists were of course the first to feel its effects. The physicist was busy doing away with the Newtonian space which had until now provided the frame of reference for traditional European painting, which saw its role as representing volumes poised in a neutral void behind the picture plane. With the breakdown of the Newtonian world, perspective, anatomy, and chiaroscuro all came to be seen as relative systems rather than as absolute laws. In the science of perspective the locus of observation was itself now set in motion with the accompanying instant destruction of the horizon line and its vanishing points; each visual moment came to be seen as composed of multidimensional facets projected on to the retina, as happens in everyday life, by a continually changing locus of observation. The compositions of Degas (1834–1917) for instance became increasingly haphazard and 'photographic' with figures in arbitrary postures at times cut off by the picture frame in such accidental and unposed images as the camera had by now made commonplace. Curiosity concerning the changing properties of the human mass in motion culminated in Muybridge's two

compendious photographic studies of human and animal locomotion which now illustrated the visually relative nature of the anatomy of the classical schools. In these albums the human figure took on its own dynamic autonomy as an object in space expressed in changing masses which were frequently so unfamiliar as to seem grotesque and unreadable. The ultimate effect of these researches in the visual relativity of the human form, engendered in violent action, was most eloquently to be realised among the Italian Futurist painters – Boccioni (1882–1916), Balla (1874–1958), etc., – and reached contrapuntal expression, a musical and architectonic interrelation of masses, in Duchamp's clashing *Nude Descending a Staircase* of 1913.

The 'scene' or 'view' of traditional painting came now to be seen as no longer a faithful statement of objective visual experience; matter behaved in a far more dynamic way in its spatial implications and in its relation to ourselves than the Renaissance vision had permitted. Its very contours, as Cézanne was discovering, were deceptive. Matter in fact, as the physicists were about to reveal, is instinct with energy – an innate energy such as we begin to experience in Cézanne's later paintings, an energy pregnant with spatial implications; every particle was bursting with it, it threatened to explode the contours of familiar forms, it activated space itself from which it was no longer considered distinct. If Cézanne is now considered the father of the modern movement it is most obviously due to this vision of innate natural energy expressed by him in the rigour of the cube, the cone, and the cylinder. But though Cézanne felt that he was merely doing all over again the art of the museums he had in fact set himself in an entirely new relationship to nature – a relationship which in the event proved to be far nearer to primitive metaphysical concepts than to the concepts which had produced the illusionist art of his own immediate past. Disillusioned with the art of the museums his successors would turn outwards from Europe to seek that charter which would further this vision of innate energy suggested by him. Cézanne was in fact still alive when the pioneer young painters of the School of Paris, first Matisse in 1906 and in the following year Picasso, recognised in African art the expression of that same instinct energy which they had sensed in the work of the pioneer of Aix-en-Provence. Cézanne's revolution, in which the 'atmosphere' of the Impressionists had been scrutinised for a more rigorous realisation of its spatial, purely pictorial, attributes, was one of 'seeing' as profound for the history of European art as was Giotto's before him.

So the contact between European and African art at the turn of the century was inevitable, and one which could have taken place at no earlier moment despite four hundred years of association between the two continents. It had to await the new relationship to matter achieved by Europeans at the close of the nineteenth century, a relationship which, perceived in Europe as a result of physical inquiry, had long been apprehended in Africa in terms of the metaphysical. If Picasso's *Les Demoiselles d'Avignon* 'provoked' (to use John Berger's word) Cubism, it was a provocation for which European art in 1907 was very ready. But it is important to

point out that the discovery of African art represents for European art
not so much the saving of an exhausted Europe from its own visual re-
finements as the answer to questions already posed within the development
of the European plastic and inevitable to it. With the decay of the Renais-
sance vision, revolutionary plastic thought came to be centred in this very
changed relationship to nature, this abandonment of art in which matter
was conceived of as inert volumes occupying a neutral space. The schema
for rendering this concept was the window open on nature; every picture
was a view through a window-frame seen in the manner of a theatre stage;
in his studies of chiaroscuro Rembrandt had in fact based his compositions
on small models in boxes lit by candlelight. Now the researches of painters
at the turn of the nineteenth century proposed that mass was itself dynamic,
paralleling in the physical world the investigations of Max Planck and
Einstein. Matter was energy. The picture came then no longer to portray life
but to express its indwelling energy. The subject of painting became the
expression of the energy conceived to be locked in nature. 'Colour alone is
both form and subject', wrote the painter Delaunay, and the Futurist
manifesto of 1910 declared: 'All forms of imitation should be held in con-
tempt and all forms of originality glorified.' The painting became self-
determined and autonomous – it lived with its own immanent life. Not that
the Cubist and futurist painters worked to a 'programme' determined by
contemporary physics. Their researches were merely directed towards
redefining themselves in the context of a changing view of nature; their
apprehensions of the properties of matter were instinctual rather than
scientific.

Although Planck published his Quantum Theory in 1901 [wrote John Berger
in his *Success and Failure of Picasso*] its implications were not understood until
the 1920s at the earliest, and by that time all the Cubist innovations had been made.
Nor is it likely that the Cubists read Einstein in 1905. The Cubists reached their
conclusions independently. In their own subjects they too felt the challenge of
the new mode of thought originating in the nineteenth century and now stimu-
lated by the new technological inventions; they too were concerned with what
was interjacent.

They discovered in the object a sense of instinct life which is *par excellence*
an attribute of much African sculpture – that entirely conceptual art to
which European art was now turning in its quest for adequate forms of
expression ('raisonnable', Picasso called it). Cubism finally married the
vision of Cézanne to the form-language of African art.

But African art merely provided confirmation to the painters of Europe
of the new relationship in which they now stood in regard to nature. It is
possible to make too much, as is often done, of the 'influence' which African
art exerted on European art of the twentieth century. Impulse and necessity
in the two aesthetic systems are very different. Even if he so desired, the
European painter could never achieve with his material that absolute em-
pathy which is the *sine qua non* of practice for the African artist. The art of

the African issues from a metaphysical 'beholding' in which spirit and matter are seen as coterminous. 'Simply anything can become a god,' a Yoruba informant once remarked. 'This button' (pointing to the dashboard of the car in which we were), 'it only needs to be built up by prayer' (by invocation). That is to say all matter is dormant spirit with potential expression as a good or evil force depending on the manner of its propitiation – an apprehension of matter which will be pivotal to our reading of sacred forms.

7 The Conventions of African Art

In any given culture the artistic process is selective, being governed by only a limited range of forms at the disposal of the artist. The artist, even the most restlessly enquiring European artist, needs to select from forms which have a specific symbolic value in his culture. He develops unities (in Europe space, volume, light, etc.) for the symbolising of experience, and these he shares with the experience of his culture at large, though the time-gap involved in striking a common understanding between the forms he chooses and those comprehensible at large might at times be great. In European art, even in that of the present day, these unities are always related to a visually objective attitude to nature; the most experimental work of European art is referable to nature for the validity of its forms, even though a Mondrian, a Malevich, might choose to express these entirely in number, in purely formal relationships of non-objective content. In African art the carver is related, on the other hand, to nature's spiritual forces and is not essentially bound by his visual or perceptual experience or by the 'laws' of nature. His images too are constrained to immediate understanding by, and assimilation in, his culture. What unities has the African artist developed for exteriorising his relationship with nature? What do particular forms mean to him? We are familiar for instance in European art with the symbolic value of the sphere as a generative element in natural form. It is the shape of the earth, the minimal volume in which a given quantity can be accommodated; thus it governs the shape of many fruit, of eggs, the human cranium, the female breast, etc. In European art, in the work of Rubens for instance, it is associated with the sensuous, a quality notably lacking in most African art in which as an element of structure it is virtually unknown. The elements of structure in African art can in fact be correlated with remarkably few geometrical constants. Of these the cylinder and the cone predominate. So that before the question: What factors have traditionally governed the selection of forms for the African artist? can adequately be answered we should need to investigate in African societies modes in the perception and symbolising of space, systems for the externalising of the experience of colour, and the concept of time: these can all be assumed to be different between what we understand by 'high' cultures, and so-called primitive cultures. An understanding of those concepts that lie beneath the manifestation of form in the African plastic would safeguard the investigator from applying to this plastic such art-critical ideas (e.g. space, volume, movement, etc.) as are properly taken for granted in the mental attitudes of a European culture.

A great deal has been made of the cylindricality of African sculpture as opposed to, say, the 'cubism' of Egyptian, and this cylindricality is felt to result from the dominance in the mind of the African artist of the primary tree-form – an all too facile explanation. If Egyptian art most readily conforms to the cubic it is not because blocks of stone invariably arrive in the hands of the sculptor in that shape, but is evidence rather of a deliberate intellectual attitude to the treatment of mass. The cube is conceived as a comprehensible unit of space each of whose six planes is a square side – four faces and plan – subdivided into constituent squares which determine the module for the articulation of the figure conceptually hidden within the block. In terms of this block the figure is seen as a composite image of successive *alto* reliefs, one cut from each face. Egyptian proportion is thus strictly arithmetic and ideal, in contrast to the system of geometric and approximate ratios which governs the structure of the human figure in nature. The Egyptian artist can be assumed to have been well aware of this in his forging of a canon which saved him the need to invent new shapes afresh at the varying and perhaps confusing dictates of the objective visual world, a canon which could be relied upon whether the visual world was to be treated in two dimensions or in three – a schema or formal codification which, together with his spectator, he might apply to the variegated visual data furnished by his perceptions.[1] Artistic form, as well as aesthetic appraisal, as Gombrich has wisely pointed out, is inconceivable without the operation of some such schema to which to refer visual experiences for both the artist and his spectator. 'It makes no sense to look at a motif unless one has learned how to classify and catch it within the network of a schematic form.'[2]

It is possible that in similar fashion the cylinder as a purely intellectual concept (since by no means every tree-trunk is cylindrical and, in African art, the cylindrical theme operates anyway in metal and in stone *as well as* in wood) represents the most fundamental of unities developed by the African artist in his rendering of the human figure, expressing for him that comprehensible measure of space through which he reduces the complexities of natural form to his own ends. Lavachery sees in the 'bloc mère' an ideal cylinder attested by the circular pedestal in much African wood-carving, and attributes the richness of African art to the need on the part of the sculptor to cut on all sides simultaneously on a curved surface. He feels, however, that the intrinsic character of Negro sculpture cannot be explained by these means alone. 'Les Noirs ont des dons particuliers de sculpteur que nous ne pourrons tenter de définir que plus tard, lorsque nous aurons fait, endroit par endroit, le tour des manifestations de leur génie plastique.'[3]

Such 'dons particuliers' would seem rooted in the concept of the cylinder as a spatial measure in the mind of the African artist.[4] The surface of the cylinder provides a lateral limit in uniform and constant relationship with its vertical axis and it may be that with the vertical division of this axis it also provides the mensurational rationale by means of which, in African art, imagery is visualised and expressed. For in any art imagery must be

visualised within measurable limits of one sort or another. The process of creating form hinges very intimately on the possibility of referring to that measure which both contains form and regulates its expression. It is perhaps with reference to such a cylindrical schema that can be explained (*a*) the apparent uniformity of African sculpture, (*b*) its stasis about a vertical matrix, (*c*) the severity and paucity of its elements of structure, and (*d*) its frontality.

Frontality in African sculpture has likewise been the subject of insistent comment much as though it is a phenomenon confined to the African continent. But this frontality, which Frankfort characterises along with Egyptian, Babylonian, and Mexican art as of a 'pre-Greek' manner of rendering nature,[5] would seem closely linked with the nature of the schema conceived in each case for the treatment of the image. Gombrich has explained the revolution of vision achieved in Greek art in terms of the freeing of the artist from the imperatives of such a schema; the Greek artist *corrected* the schema in the light of the mechanics of visual observation, an understanding of perspective being of the profoundest importance in this process. The timeless reference of the image had to be discarded in favour of the record of a fleeting moment; so that in painting the reduction to one angle of view and one moment of time involved a certain loss.[6] In Frankfort's pre-Greek cultures such freeing did not take place; the artist remained bound to the schema in an immutable relationship; for want of the need to adopt an independent system for verifying and correcting the schema in the light of variable experience the schema remained for him the only way through to the image. In so far, then, as the schema remained a function of the block, or of the cylinder, the image could be determined only in relation to the unit of space in which it was conceived to be locked: Egyptian sculpture remained cubic, African cylindrical; neither could be freed into the variably extending space of everyday experience which constitutes the ambience of Greek art. It is possible that the African artist though empirically aware of the phenomenon of perspective (as was also for instance the Babylonian), nevertheless chose in this manner to confine and restrain the image and hence the spirit for which it serves as a vessel. For his own ends it was preferable for him so to do; the unrestrained mobility of the image expressed in multiple axes and viewpoints he would hardly consider desirable, though it was certainly within his capacity to adjust his schema to the dictates of visual fidelity where this end was required, as is shown by the Ifẹ heads, the Yoruba second-burial figures, bronze masks in the idiom of the Ghana Kalakari gold trophy head, and the 'portrait' statuary of Baluba kings.

Griaule has described the carving of images from dead persons among the Dogon,[7] and among the Kalabari Horton has illustrated an equivalence between ancestor sculpture and a moribund man.[8] Horton has further described the pointing of the face of the sacrifice towards the sculpture which contains the spirit. The present author has observed the role played by the eye of the cult-sculpture in its relationship with the worshipper in

Ogboni ritual.[9] This orientation of the cult-sculpture to the regard of the spectator, with its implications of response, seems to go a long way towards explaining the incidence of frontality within the general schematic space defining form in African art.

But it is a frontality which in certain instances, as in the Yoruba *Èpà* mask, is often qualified by a contrapuntal treatment of form. An *Èpà* mask is frontal only in the barest sense; its forms are articulated circumferentially with regard to the vertical axis. This axis seems to operate as a matrix for the penetration of voids in the cutting process; it refers to varying radii facing in all directions organised on several vertical levels; that is, in the cutting process the artist has moved around the cylindrical block and up and down its vertical face doubtless with an eye to its universal visibility at the centre of a crowd, in the festival dance.

More important perhaps than any other consideration in the subservience of the African artist to the spatial schema in which he works – whatever its nature – is the control exercised by the 'priest' of the cult in his relationship with the icon. That the African artist has never developed the mechanism for liberating his vision from the schema and correcting it in terms of everyday spatial experience is to be attributed to the demands of the stereotype by means of which imagery is stabilised and propagated. I shall describe later, among the Yoruba, the function of the Ogboni priest in this respect as his duties safeguard the iconographic rectitude of the sacred image in its reference to the Earth Mother, Ilè.[10] In another culture, and for a different medium, Horton has described a similar function of the priest in the carving of the Kalabari ancestor screen. In this instance the artist himself can sometimes become in effect the priest, controlling by his skills the spirit in its 'naked' state during the carving process, and making the necessary invocations and offerings on behalf of any suppliant who might visit the shrine. During the period of the casting of the Yoruba *ẹdan* Ogboni the smith performs a similar function on behalf of the initiate; he may take no personal liberties in his rendering of the sacred image but must at every stage respect the iconic theme meant to be realised in his work. An example from the field of music is provided by the contemporary Nigerian composer, Fela Ṣowande who claims that for Nigerian traditional man sound too was in this way stereotyped: 'words of power', 'mantrams', used to produce tangible results, terrible vocal forms, were handed on by the forefathers, such as the Àásán, the Ògèdè, or the Òfò, through whose mediumship he might invoke and handle psychic forces of tremendous potency which his will could then direct as it suited his purpose.[11] These 'words of power', these 'mantrams', these terrible vocal forms can only be described as musical stereotypes of much the same import as the form-stereotypes of African plastic art. So too there is the literary stereotype – the ancestor or the hero whose praise-songs 'name' him as the type-motif names the cult-sculpture. Even in modern African literature the stereotype, on being invoked, brings his attributes with him readymade; characterisation in the European sense is therefore unimportant. It is the

demands of such stereotypes which determine the subservience of the African plastic artist to the schema in which he works, and the operation of the stereotype in this way would account for Schmalenbach's observation that 'the imagination of the Negro is not inexhaustible in the continual discovery of new forms'. In so far as it touches on aesthetic appraisal this observation conveys no more meaning than does the statement that Rembrandt's range of colours amounted to four; but it is one which is of the utmost importance in assessing style in African art.

8 Processes of Style Change

A closer examination of the role played by the individual European artist as an agent in the evolution of style might perhaps provide contrasts against which we may attempt an appraisal of the processes of change in African art. The liberation from the schema described by Gombrich and the resulting freedom of the artist to correct the schema in the interests of visual illusion provided him with that egocentric viewpoint which has so dominantly characterised European art, more especially since the Renaissance – a viewpoint which places responsibility for the selection of his forms on the vision, actual or metaphysical, of the individual artist. He refers these forms to the particular way in which he and he alone is gifted to 'see', and hopes that his society will sooner or later come to see in this way with him. More explicitly than in the letters and pronouncements of many a painter or sculptor Virginia Woolf describes the intimate nature of this seeing:

> She would not have considered it honest to tamper with the bright violet and the staring white, since she saw them like that, fashionable though it was . . . to see everything pale, elegant semi-transparent. Then beneath the colour there was the shape. She could see it all so clearly, so commandingly, when she looked: it was when she took her brush in hand that the whole thing changed. It was in that moment's flight between the picture and her canvas that the demons set on her who often brought her to the verge of tears and made this passage from conception to work as dreadful as any down a dark passage for a child. Such she often felt herself – struggling against terrific odds to maintain her courage; to say: 'But this is what I see, this is what I see', and so to clasp some miserable remnant of her vision to her breast, which a thousand forces did their best to pluck from her.[1]

Hence the *oeuvre* of every European artist is in a sense an autobiography; the history of European art is essentially biographical in nature, a history in which the individual artist proposes concepts with whose validity it might take his society a greater or lesser period of time to catch up. This catching up with the vision of a particular artist might take place almost immediately or it might come about only after a considerable time-gap during which society has gradually adjusted to the vision of the artist. Whether in Europe the assimilation of a new style-language by society takes place immediately or otherwise makes no essential difference to either artist or society. The variation in the work of a given artist from the demands of the schema is expressed in his style; a particularly inventive artist might create several styles in a lifetime, the process being often quite conscious: 'I'm trying to forge a new style', or 'He's changed his style', etc. The more creative of such styles in due course become norms which are themselves

superseded by even more revolutionary variants. Thus style as the measure of idiomatic change in European art is centred in the vision of the individual artist, whose experimental egocentrism provides the dynamic of such change and whose anxiety therefore is that the forms he employs – the forms of his art – should *not* become stereotyped. For him the emergence of the stereotype spells the end of creativity, the death of art. The technological dynamism of modern society is itself a determinant in such change and where for one reason or another the maturing of the artist's vision covers too long a period he may well find that the forms which eventually answer to his purpose have already been superseded by new ones – they have lost their 'now-ness', to use an expression of David Jones's – and he must flee the stereotype by seeking new signs.

This relationship to the stereotype illustrates the fundamental difference between the European artist and the artist in African society. For the African the practice of art is inconceivable without the existence, physical or mental, of the stereotype; he works by copying from a previous work, his range of variation on this model being limited by the requirements of his cult. 'S'il y a le rêve, le rêve est donné.'[2] So there is little scope for the free play of that personal vision, of imagination or inspiration, which the European artist regards as the *sine qua non* of his practice. For the African artist the vocabulary of forms employed is limited in the ways examined; from forms current in such a vocabulary cult-imagery is maintained in the stereotype. Far from being the result of haphazard choice or of individual inquiry these are signs functioning in accordance with the iconic requirements of the cult: a suitable configuration is needed before the stereotype becomes valid, before the carving is open to occupation by the spirit, and this spirit-occupation is the ultimate measure of the validity of the cult-sculpture. It is also a term in aesthetic appraisal.

The archetypal reference of the cult-image is projected in time by means of the stereotype, and stabilised in it. The conservatism of form in the stereotype is also explainable by the need for the immediate assimilation into the culture of the image invoked by the artist or priest. No time-gap can be permitted between the making and the functioning of the image; making and functioning are often in fact integrated in the creative process, i.e. the sculpture itself may dictate the way in which its forms will be disposed, since in sacred art a just disposition of forms is a prerequisite to its occupation by the spirit. Thus cult-sculpture plays for religion much the same preserving and stabilising role as that played by oral tradition in the society at large; the priest of the shrine (or the artist) is the historian of the cult-icon: each work of cult-sculpture as the representative of a religious tradition secures, and cannot therefore at the same time attempt to destroy, that tradition.

Though in a given instance a particularly powerful artist might leave his handwriting on a number of works and thus place them open to subsequent treatment as a personal *oeuvre*[3] we cannot apply to such an *oeuvre* the methods of style analysis appropriate to a European artist. Because of that

absence of variation on, or correction of, the schema in terms of empirical visual experience which we have seen to lie at the root of the African artist's approach to his image, no evolution of forms is possible within such an *oeuvre*. The African artist at any point in time shares his forms with every other artist of his cult or culture and with those who preceded him (figs 20, 21). The individual work of African art is therefore one without a history;

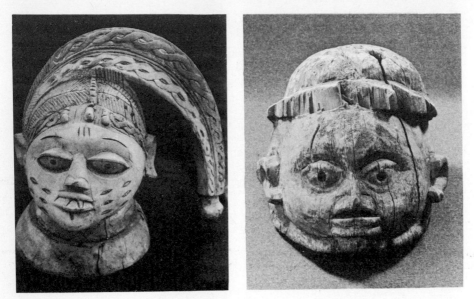

20. Yoruba Gèlèdé mask, twentieth century; employed in a Yoruba female cult

21. Yoruba Gèlèdé mask, nineteenth century

it is not, as with the individual work of European art, a term in an auto-biographical series. We cannot as with, say, Giotto or Picasso, conceive for the African artist a work which is at the same time pivotal to the further development of his personal vision and to the evolution of style in his culture as a whole. It is not the individual work of art or the *oeuvre* of an individual artist, but the stereotype itself – implying the body of type-motifs from which the current or local selection is made – which is most properly the subject of the study of style as it is adapted and modified, both spatially and temporally, at the behest of variable interpretations within the cult.

We are now in a position to examine the concept of form, sacred or secular, as it has developed historically. Such constants as we have been able to isolate in the operation of cult – constants of the type, the stereotype, the archetype and the icon – represent our attempt to arrive at a critical terminology from the body of examples observed. They appertain, largely in the forms of wood, to the functions of cult in the generating of idiom and style. But in African art wood is no historical medium: we have no means of studying its forms in time-depth because older examples are simply lacking. So with observations drawn from the shrine as the still vital arena of study we turn now to those truly historical media – iron and bronze – by means of which we might interpret a few concepts in the traditional world view.

Part Two

IRON AND
THE GODS

9 Iron in African Antiquity: *c.* 700 BC–AD 500

Indications of the sporadic use of iron in Egypt go back to iron beads from pre-dynastic Gerzah dated at around 3500–3000 BC,[1] but like similar small artifacts of primitive peoples, these were wrought from meteorites containing only varying amounts of the metal. Eskimos, Mexicans, South American Indians, Africans in Tanganyika and in Senegal, all have used flakes from meteorites, with no knowledge of the processes of the extraction of iron from its ores. But meteoric iron besides being extremely difficult to work rarely occurs in quantities sufficient to supply the various needs of man; objects fashioned from it were usually of a luxury or a ritual nature rather than purely utilitarian.

It is not until towards the end of the second millennium, around 1200 BC, that objects of wrought iron became common in Egypt, and not for another five hundred years or so do we find evidence of iron being locally smelted. At Tell Defenneh in the Eastern Desert are the remains of what appears to have been an extensive iron industry which probably flourished as early as the seventh century BC. Here Petrie recovered workmen's scrapheaps of iron and 'astonishing' quantities of slag including 'a complete crucible bottom of slag mixed with charcoal', which led him to regard Defenneh as important an iron-working centre as Naukratis.[2] Defenneh, which Petrie identifies with the Greek military settlement and fort at Daphnae founded by Psamtik I shortly after his accession (671 BC), lay on the main caravan route across the Eastern Desert, and constituted an advance guard against enemies from the east. The fort and the camp which sprang up around it are dated at about 664 BC. Here the bulk of the population seems to have been Greek.

Greek pottery abounds, not only painted vases in the palace, but all the pottery appears by the potters' marks to have been made by Greeks. Iron works and iron tools are abundant, just as at Naukratis, and there is on the whole more evidence of Greeks than of Egyptians in the place It is evident that the Greek troops were not merely settled in a strange country, but were a base of communication with the Greek world.[3]

At Naukratis Petrie had earlier excavated the remains of another industry, 'a great centre of the iron trade if not indeed the principal source of manufactured iron to the Greeks of the sixth century'. Situated in the Eastern Delta, Naukratis was at this time the only centre of Greek trade in

Egypt and apparently an emporium of international importance. Here gold, silver, lead, bronze and iron were worked, and that iron was perhaps traded in bulk is suggested by an iron ingot, three inches square and a foot long, recovered in excavation. And there is also evidence to support the conclusion that certain iron objects common at the time in Etruria may have originated at Naukratis, whose trade connections may also have included Cyprus, Bethlehem, and Assyria.[4]

Though iron had been used in Egypt from the very earliest times, at first from meteoric sources and later as a foreign import, it is striking that the only evidence so far discovered of local extraction of the metal should come from these two Greek settlements, and that here production far from being primitive was large-scale and efficient. The camp at Defenneh, founded under Psamtik I, fell into ruin during the hundred years following his accession, i.e. 671–*c.* 570 BC. The Pharaoh Aahmes (570–526 BC), politically conservative, then repressed Greek trade in Egypt and confined it to Naukratis. Herodotus was later to observe the ruins of the town and the many docks attesting to its past importance as a trading port (Hdt. II, 154). After the accession of Aahmes the fort at Defenneh was manned first by Egyptian troops and later by Persians, but from the whole period of these successive occupations Petrie associates the iron industry with the hundred years or so of the Greek period.

At Naukratis Petrie excavated a number of iron tools at levels which he dates to the sixth century BC. 'What renders these iron tools of the greatest interest is the large quantity of iron slag in the old strata of Naukratis, and occasional pieces of specular iron ore; these prove that iron was actually smelted and manufactured on the spot.'[5] Under Psamtik II Greek troops penetrated Nubia (591 BC) to the Dongola bend of the Nile, reduced it, and sacked Napata. It has been suggested, and it seems not unlikely, that it was these Greek troops who introduced iron into Nubia, if they did not actually transmit to the Nubians the techniques of smelting.[6] It seems fairly certain that prior to the recruitment of mercenary troops from Caria and Lydia by Psamtik I the smelting of iron was unknown in Egypt. Psamtik appears as something of an innovator, a Hellenophile bent on modernising Egypt, with much the same kind of relationship with Greece as African states today have with the European West. Diodorus notes that he gave his sons a Greek education in admiration of the Hellenes;[7] the foundation of his dynasty saw a revolution in classical Egyptian writing with the introduction of demotic; the material reorganisation of Egypt during his reign and her ensuing prosperity have been compared with the increase of wealth and power in England under Henry VII after the Wars of the Roses.[8] If having found it necessary to recruit foreign troops to secure his rise to power, Psamtik I also needed iron-founders and armourers to maintain his ascendancy there would certainly have been no lack of mentors in the Asia Minor of his day. The peak of iron metallurgy in the area had already been reached and passed by a good century or so, and the Phoenicians had already for some time been disseminating its techniques around the Mediter-

ranean. The Nubian kings of the Twenty-fifth 'Ethiopian' Dynasty, who had ruled Egypt for some hundred years or so before Psamtik I, do not appear to have taken a knowledge of iron smelting back to the Sudan from whence they had come, possibly for the good reason that this knowledge did not then exist in Egypt. Their two defeats on Egyptian soil against the Assyrians are explained as having been at least partly due to their lack of modern iron weapons.[9] It is also occasionally claimed that they were smelting iron so early as 700 BC,[10] or were at any rate in possession of the knowledge before the Egyptians,[11] and even that they were instrumental in disseminating the knowledge,[12] but from the archaeological evidence alone these claims seem unlikely. Iron does not appear as a commonplace metal at Napata – the northern kingdom of the Nubian Pharaohs of the twenty-fifth Dynasty – before the end of the fourth century BC, and certainly not during the eighth and seventh centuries BC. Though as a result of the presence of Greek mercenaries and traders garrisoned with Egyptian troops at the second cataract after Psamtik's invasion iron had possibly come into use in Nubia, little use seems to have been made of it. Of over 1500 graves excavated there of this period, possibly representing a span of some 350 years, only eighteen contained any iron objects at all, all small and unimportant.[13] For an even later date we have Herodotus' famous observation that 'Ethiopian' troops in Xerxes' army used only stone-tipped arrows and that their spearheads were mere sharpened gazelles' horns.[14] So it seems that well into the fifth century BC the Nubians were still without the effective possession of iron. But a hundred years later iron appears in the foundation deposits of the royal pyramids at Napata, and by the middle of the first century BC there is evidence of an already accomplished smelting industry in the southern area of the Nubian kingdom, at Meroë, the site to which the Napatan kings had by now transferred their seat, doubtless producing the spears, swords and knobkerries already noted by Agatharcides *c.* 130 BC.

The palace of the Meroitic queen, Amanishakete, at Wad Ban Naqa, eighty miles from Khartoum, yielded in recent excavation a number of iron objects suggesting that the metal had been locally worked there during her reign (45–15 BC) and possibly for considerable periods earlier. Apart from the characteristic spear- and axe-heads, such objects as iron nails (about three inches long), door hinges, and bolts testify to a varied and everyday use of the metal in her time.[15]

In addition three or four successive floor levels to this palace indicate a fairly long occupation before its destruction by the Axumites early in the fourth century AD, probably *c.* 324, though the exact floor corresponding to Amanishakete's occupation must await publication of the excavation. At least one of these floors seems to have been laid down before her time. The Lion Temple at Naqa, built during the reign of King Nakatamani (2 BC– AD 23), Amanishakete's successor, was evidently erected at a time when vast quantities of iron slag were already strewn across the Meroitic landscape – then green and fertile and not the exacting desert of the present day. It stands on a type of mound familiar in the area and farther afield – at Kerma,

Kawa, Napata, and Argo in the north, mounds composed solidly of slag to depths of several feet. The circumstances surrounding the transfer of the Napatan Kingdom to Meroë in the south and the date of this transfer are not yet clear, but it has been suggested that the importance of the Meroitic iron industry may have been one of the factors accounting for the transfer.[16] If we rule out the possibility of the independent discovery at Meroë of the techniques of iron smelting – and this has nowhere occurred in the history of the industry – we should need to seek an explanation of its introduction there in influences exercised either from the north (Egypt), or from the east (Ethiopia). But despite its proximity to the ancient centres of iron smelting in Western Asia the Ethiopians seem to have come relatively late to the knowledge of the metal, which they may have seen for the first time only in the weapons of Ptolemaic elephant hunters, or merchants based at Adulis.[17] To the first century AD Greco-Roman traders were selling iron artifacts along the present-day Tanzanian coast and even farther south, whilst Indian iron was being imported at Axum, a trade which continued at least until the late sixth century. Until the eighteenth century natives around Fazogli on the Blue Nile were importing Sudanese iron, possibly from around Senaar, which was itself importing the metal from Kordofan farther to the west.[18] Thus at whatever date it occurred the establishment of an iron industry at Meroë seems more likely to have resulted from a northern (Egyptian) influence, and for such an influence we can adduce (admittedly slight) evidence in the 'crucible bottom of slag mixed with charcoal' excavated by Petrie at Naukratis.

In considering the origins of iron smelting at Meroë it will be necessary to study the design of the Meroitic iron smelting furnace in relation to furnace types of Mediterranean antiquity; while an examination of other traditional furnace types occurring in tropical Africa may provide a means of determining the earliest influences operating in the development of African iron metallurgy. We shall examine the three furnace types occurring in the area and try to determine their possible relation to furnaces known in the antique world and elsewhere. (1) The Meroitic furnace is conceivably the prototype of the most common and most widely distributed of furnaces in Tropical Africa; (2) the domed furnace is of perhaps Celto-Roman origin and of limited distribution in an area bounded by the course of the Niger and the Gulf of Guinea; and (3) the Catalan-type furnace has been recorded so far only on the lower reaches of the Niger but possibly occurs elsewhere in West Africa.

1. *The Meroitic furnace.* Petrie's description of 'a crucible bottom of slag mixed with charcoal' excavated at Naukratis raises a question of terminology, for iron is never smelted in crucibles but in furnaces of one sort or another. His 'crucible bottom' would therefore most probably have been the base of a clay furnace fired to pottery during the reduction process, to which waste products in the form of slag and bits of charcoal had adhered after the re-

moval of the bloom. Such a structure, diagrammatically reconstructed from excavated fragments, appears to have been used at Meroë. On account of the wide distribution of the type and its possible significance in the rise of metal industries in tropical Africa, it will be useful to examine this furnace in detail.[19]

These fragments, excavated by Garstang in 1911, are the only remains of Meroitic iron-smelting yet to hand; they form a small collection which includes pottery tuyères associated with the industry, as well as fragments of charcoal recovered at the town site. They may or may not be the remains of a single furnace, but their shapes, thicknesses and textures suggest that they are not unlikely to have been all from the same structure. Only six of them, measuring between 13 cm and 23 cm across, were large enough for the purposes of diagrammatic reconstruction, fig. 22. They indicate a thick-

22. Iron-smelting furnace fragments from Meroë

ness for the walls of between 3 cm and 4 cm, which suggests a furnace of rather small size when compared with the giant structures later to appear in the western Sudan and West Africa. In some areas the thickness is as little as 2 cm. Clay used in the plastic state at such restricted thicknesses would impose a limit to the height of the structure beyond which it would collapse – in this case possibly not much more than a metre or so. On one fragment measuring 18 cm by 21 cm appears a small hole about 1·5 cm in diameter. That its position was rather low in the structure is indicated by the remains of smelting waste (gangue) adhering on the inner side to a height of between 6 cm to 12 cm. As the direction of flow of this gangue is downward this particular fragment was obviously in the actual smelting area. That it was also above ground-level is indicated by a hole which seems

to have been one of several spaced at intervals around the furnace just above a series of larger holes which would have accommodated the tuyères, providing an artificial draught during reduction. On the inside of this fragment and about 6 cm distant horizontally is another hole of similar diameter which however is 'blind', that is to say it does not open on to the outer surface. This relationship between an open and a 'blind' hole occurs on another fragment 20 cm by 11 cm, also from the smelting area as again evidenced in gangue adhering to its inner surface. It is possible that some of these small ventholes were plugged with clay at some stage during reduction to control the force of the draught and thus the temperature of the furnace; this may have been done a few minutes after the lighted charcoal had begun to burn sufficiently powerfully to receive the first charge of ore, as has been observed in more recent practice. For whatever purpose certain of these small holes were plugged, it is evident that they were smeared with clay from the outside at a stage when the furnace wall was itself no longer in a plastic state. Altogether six of the fragments of furnace wall carry these holes of which two are blind and five open. These open holes seem to have been made by passing a stick through the furnace wall during its construction, while the clay still remained plastic. The same can be said of the larger tuyère holes, from their peripheral indentation on the outer surfaces only. Tuyère holes appear on two, possibly three, of the fragments. The presence of gangue on the inner surface of all six fragments indicates that they were all rather low in the furnace, in the actual smelting area. This is to be expected as the tuyère holes would be low enough to receive the nozzles of the bellows which are worked on ground level. One fragment of tuyère which had been inserted too deep in the fire is entirely vitrified and embedded in a flow of gangue.

The curvature at the top end of one fragment over 20 cm indicates a diameter at this level – the smelting area – of about 40 to 50 cm. As the vertical curvature in none of the fragments is particularly great we may envisage a structure with a slight inward slope, probably not much more than waist high, judging from the depth of the actual smelting area and considering the thinness of the walls, fig. 23. At some point around its base, at ground level, would be an aperture or furnace door for recovering the bloom and drawing off the quantities of slag still accumulated today in enormous mounds at the town site, but no remains of such an aperture have been recovered. In this type of furnace bellows are not invariably used; their use here cannot necessarily be inferred from the presence of tuyère fragments: these may have been employed merely to provide a forced draught as has been the practice in later African furnaces of similar design. No bellows have been recovered, though bellows used at Meroë would most probably have been of the bowl or pot type known in Egypt since the eighteenth dynasty and common in the Sudan and throughout tropical Africa to the present day. The tuyères recovered appear to have been made in the same manner as that still used in other parts of the continent – by building a clay cylinder round a stick which is withdrawn while the clay

23. Reconstruction of a
Meroitic iron-smelting
furnace

is still wet; the insides are all smooth while the outsides are rough and
evidently worked by hand. The thickness in a given example varies greatly,
the larger of them tapering to a point for insertion into the inlet apertures.

In the closing centuries of the first millennium BC, probably as a result
of a trade in grain, slaves, and gold, Nubia came to some extent under the
influence of the Hellenistic and Roman cultures of Egypt. At the town site
at Meroë is still preserved a copy of a Roman bath with the remains of
several Meroitic stone carvings in the Greco-Roman idiom; the palace of
Amanishakete yielded various Hellenistic bronze objects, pottery lamps,
amphorae, etc., while inland from the Nile in the present-day *Butana* region
known to the ancients as the Island of Meroë, stands a sacred building
which is an architectural congeries of Greek, Roman, and Egyptian
structural and decorative elements. Under the floor of one of the palaces
at Meroë was excavated a fine bronze head of Augustus, probably pillaged
by the Kushites from Syene (Aswan) during their uprising against the
Roman Prefect Cornelius Gallus in 25 BC. In AD 61 Meroë was still sufficiently
important for Nero to have dispatched a party of *exploratores*, it is said to
ascertain whether it was worth the trouble of conquest, but as it was already
then on the course of its long slow decline their report would have done
small credit to this home of kings whose early greatness is nevertheless
inscribed in the pages of holy writ.

Attested trade and culture contact from Ptolemaic into Roman times may
have had some effect on Meroitic iron smithing as it certainly did on bronze
casting, sculpture and architecture. But in considering the possible influ-
ences of Meroitic iron technology on industries in tropical Africa suggested

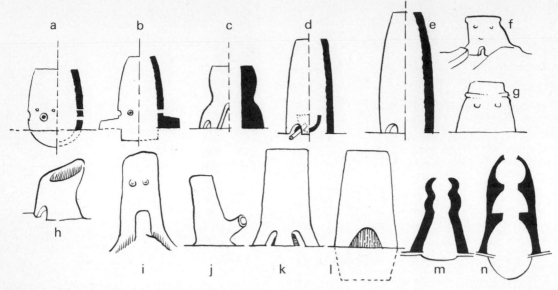

24. Some African shaft furnaces of the 'Meroitic' type. (*a*) Meroitic (reconstruction); (*b*) Uganda (Roscoe); (*c*) Togo (Rattray); (*d*) Dahomey (Foa); (*e*) Songhai (Barth); (*f, g*) Congo (Maquet); (*h, i*) Rhodesia (Clarke); (*j*) Upper Volta (Fr.-Boeuf); (*k*) Mali (Fr.-Boeuf); (*l*) Upper Guinea (Fr.-Boeuf); (*m*) Sudan (Bower); (*n*) Sudan (Bower)

by the wide distribution of the Meroitic-type shaft furnace, fig. 24, we are left with the problem of explaining, purely in the realm of technique, the apparent absence of similar influences affecting the practice of bronze-casting in the area. For a good thousand years separates the emergence of the iron industries of the western Sudan from the earliest evidence of bronze working there. Areas in East and Central Africa too, in which the Meroitic-type furnace has traditionally been widely distributed, have remained entirely unaffected by Meroitic bronze-casting practice. We should therefore exercise some caution in considering possible Nilotic influences on tropical African metallurgy.

For the ultimate origins of the Meroitic shaft furnace we now turn a speculative eye on an early furnace type from the Mediterranean: a shaft furnace apparently in use in the Aegean and in Italy as early as the sixth century BC. This was possibly of the same type as that used at Daphnae (Defenneh) and Naukratis. Such a design would appear to explain the 'complete crucible bottom of slag mixed with charcoal' excavated at Naukratis. It is a furnace which achieved a wide distribution under the Romans but one which, like that of the La Tène Celts, they had inherited from a people of an older metallurgy.

2. *The furnace of the La Tène Celts and the western Sudan.* The major schools of *cire-perdue* brass casting in tropical Africa are located in a distribution area roughly coterminous with that of an important iron-smelting furnace type found nowhere else on the continent – a fact of possible importance in the study of the history of both these industries. This is a domed furnace of very different design from the shaft furnace common elsewhere, fig. 25, comprising a hemispherical combustion chamber, or dome, opening into a narrow chimney, the whole sited over a shallow basin in which the bloom is formed. From the centre of this basin a drainpipe

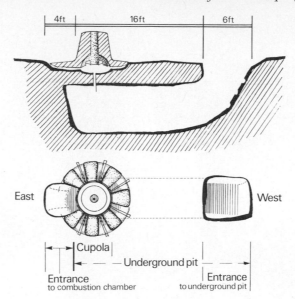

4ft 16ft 6ft

East West

Cupola
Underground pit
Entrance
to combustion chamber
Entrance
to underground pit

25. Domed iron-smelting
furnace. Isundunrin,
western Nigeria

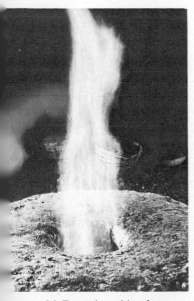

26. Domed smelting furnace
in operation, Nigeria

the diameter of a broomstick passes into an almost man-high underground
pit with a separate access some feet away at ground level behind the furnace
mouth. The slag is collected in this underground pit during reduction of the
ore. Around the base of the structure six large inlet holes, each accommo-
dating a pair of tuyères, provide a forced draught. The ratio of the com-
bined areas of these inlet holes to that of the chimney outlet is between 1:2
and 1:3 so that in full blast the resulting draught is capable of generating
temperatures at which, in the absence of control, the metal would run in
a liquid state – a contingency which the African smelter was always anxious
to avoid, liquid metal being regarded as undesirable.[20] Excessive heat is
indicated partly by the state of the flame escaping the flue to impressive
heights, at times as much as ten to twelve feet, and partly by the humming
sound of the draught itself, fig. 26. During reduction the furnace mouth,
an aperture about 60 cm square, is walled up with clay ventilated by tuyères,
fig. 27. Reduction is achieved between thirty-six to forty-eight hours.

The domed furnace provides a more convenient means of tapping slag
during reduction than obtains in either the shaft or the Catalan furnaces of
traditional African smelting; the controlled tapping of slag is a matter of
extreme importance in the success of the smelt. Slag in the molten state,
bearing the non-ferrous impurities of the ore, must run free of the metal as
it begins to fuse and collect in a spongy mass at the bottom of the furnace.
In primitive metallurgy the freeing of slag is achieved with varying degrees
of thoroughness, at times by means of a drain opened at the base of the
furnace, which is at the same time used for the recovery of the bloom; at
other times, as in some of the giant shaft furnaces of the western Sudan, an
elaborate passage is dug for this purpose, which slopes downward from the
base of the furnace into a separate pit provided for the smelting waste. This
latter device is sometimes also encountered in examples of domed furnaces
in West Africa, but more characteristically in these furnaces a device is

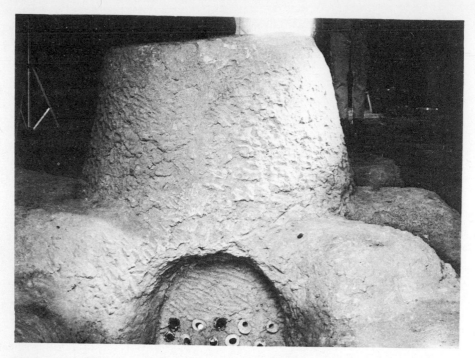

27. Domed furnace: tuyères in the furnace mouth

incorporated for draining the slag direct from the base into an underground pit; the advantage of this is that tapping can be carried out at predetermined intervals and the amounts drawn off on each occasion exactly controlled. The drainpipe shown in the example at fig. 25 is blocked at its lower end during reduction by means of a conical plug made from a mixture of powdered charcoal and clay. During reduction the smelter from time to time removes this plug and allows a run of liquid slag into the underground pit. The ore might thus be tapped six to eight times during a smelt; between successive tappings slag accumulating around the aperture at the bottom of the basin drips slowly down the passage in the manner of a stalactite. The first product of such tapping, high in silica and low in iron content, is discarded, as are the products of all subsequent tappings to the last two or three; these last are collected by the smelter before the furnace door is broken open at the end of reduction, and crushed and stored to be used as a flux in further smelting.

Until about 1925 batteries of this domed furnace provided centres of extensive iron working among the Yoruba of Nigeria. Around the same date it was still in use among the Koranko of Sierra Leone where it was recorded (1920) by Dixey.[21] For Upper Guinea it was recorded in 1910 by Campbell,[22] and on the Upper Niger by Desplagnes (1907).[23] Within this triangle, echoing the giant triangle formed between the course of the Niger and the Guinea littoral, the domed furnace has also been recorded by Francis-Boeuf at Futa Jallon (Upper Guinea),[24] among the Mossi of Upper Volta,[25] and at sites in the Gold Coast and Aṣante.[26] It is interesting to note that the easterly limit of distribution of this furnace type occurs in the southwest corner of Nigeria, and that it is elsewhere unknown in that vast country. From sources

around the headwaters of the Niger movements of peoples into the region appear to have taken place from remote periods; the Koranko of Sierra Leone recall invasion from this source within the past two hundred years under one Diallo,[27] and in the middle Volta area of Ghana the villages of the proto-Dyula tribes – Hwela, Ligby, Numu – show signs of ancient habitation. The Numu, specialist blacksmiths, apparently regard the Niger bend as their home; it is possible that the other groups too came in from the Malinke-Bambara area of the Upper Niger.[28] From possibly as early as the fifteenth century a great trade route linked Begho in (present-day) Ghana with Jenne on the Upper Niger; during the seventeenth century this route was extended to the coast to meet European trade demands there. At Diam a site not far from Jenne, Desplagnes recorded a domed furnace around the turn of the present century. A twin version of this domed furnace was sometimes used for increasing the yield of a given smelt; examples have been recorded as far apart as Sierra Leone and Nigeria.

The distribution of this furnace design suggests a diffusion point located along the Upper Niger – an area in which excavation has revealed the remains of a sophisticated culture. Here brass and iron had been used in breastplates for horses, horse-bits, sabres, lances, arrows, hatchets and various other weapons and implements associated with the culture of ancient Ghana[29] which, as recent research has now established, was known to the Mediterranean world as early as 780 AD, though the date of its foundation remains obscure.[30] Of the possible role of ancient Ghana in transmitting early smelting techniques from the Mediterranean we can say nothing, but the presence in this area of the domed furnace, still in 1908 to be observed 'in hundreds' on the Niger-Senegal divide, seems to link the metallurgy of the Upper Niger with more northern iron smelting industries. In methods of mining the ore similar links are to be observed between practice in the western Sudan and in the Guinea forest. Francis-Boeuf has recorded the method of mining illustrated at fig. 28a, employed according to him in Mauretania, at Bamako on the Upper Niger, and at Koroko, northern Ivory Coast. Similar mines have been described for Dedougou, Upper Niger, and Togo. The present writer has observed such a mine in western Nigeria, associated with workings at a domed furnace, fig. 28b. From a pit at times as much as thirty metres deep a gallery high enough to accommodate a stooping man leads off in a roughly horizontal direction following the ore seam. Frequently this gallery connects with or intersects another so that an underground network may link various shafts. On a rope attached to a nearby tree the miner descends by means of niches cut into the wall. This method of mining is recorded nowhere in tropical Africa except in the distribution area of the domed furnace, and is conceivably exclusively linked with it.

Mauny has suggested, on presumptive evidence only, that at around 300 BC the knowledge of iron working was being taught to the Negroes of the western Sudan by southern Berbers who had themselves acquired the knowledge from North Africa where iron would have been smelted at

28. Two African iron mines. (*a*) western Sudan (Fr.-Boeuf); (*b*) western Nigeria. This latter is associated with the domed furnace of fig. 25

Carthage from the time of its foundation.[31] This hypothesis seems doubtful when we consider that the prototype of this African furnace is probably the domed furnace inherited from the La Tène Celts by the Romans, under whom it achieved a wide distribution in Imperial times. In the Celto-Roman furnace illustrated, fig. 29, the hearth might be flat or dished, and the

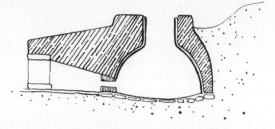

29. Celto-Roman furnace (Coghlan, after Weiershauser) from Engsbachtal, South Westphalia

domed combustion chamber leads into a short chimney or flue. The type relied on natural draught; examples of it built into hillsides were provided with a large wind duct which also served for the tapping of slag. Free-standing types carried a number of ventholes around the base such as we find in the African designs. These furnaces are described as late rather than early in the La Tène period of the Iron Age,[32] i.e. *c.* 50 BC and into the Roman period.[33] Similarities between the design of this Celto-Roman furnace and examples from the Upper Niger make it difficult to avoid the conclusion that the African designs reflect a Mediterranean influence on native metallurgy at an early date, perhaps exercised by Romans in North Africa in the early years of the Christian era, fig. 30. Very possibly Mauny's

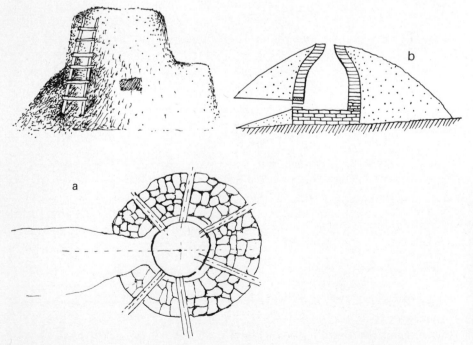

30. The domed furnace; comparative designs.
(*a*) Celto-Roman, Noricum (Schmid in Grenier);
(*b*) Celto-Roman (Coghlan);
(*c*) Sierra Leone (Laing);
(*d*) Upper Niger (Desplagnes); (*e*) western Nigeria (Williams); (*f*) Upper Guinea (Fr.-Boeuf);
(*g*) Sierra Leone (Dixey);
(*h*) Upper Guinea (Campbell)

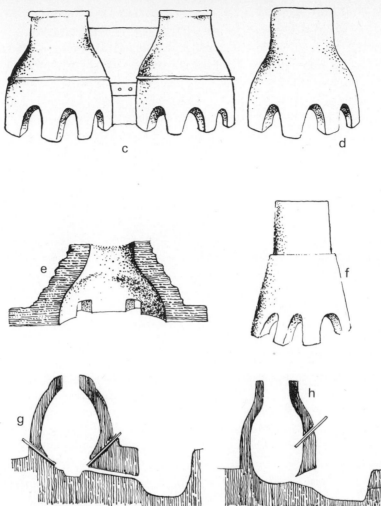

date for the introduction of iron working to the western Sudan from a northern source will need to be advanced.

3. *The Catalan furnace on the Lower Niger.* According to their own traditions the Nupe Kingdom was founded by the culture hero, Tsoëde, early in the fifteenth century when the Nupe were grouped in various small chieftaincies all subject to the Atah of the Igala at Idah on the lower Niger. All Igbira groups lower down the Niger likewise claim colonisation from the Atah. Among these groups – those of the north and those of the south – occurs a furnace type reminiscent of the Catalan furnace. A Catalan furnace comprises essentially an open reduction area below ground level into which a giant tuyère is inserted for introducing the air blast by means of bellows operated behind a free-standing wall; through this the tuyère passes. It is a type apparently developed in Spain where it was probably used from

antiquity and continued in use into the seventeenth century, fig. 31a. The Nupe and Igbira examples do not seem to have been of important occurrence in western Nigeria; though they conceivably occur elsewhere in West Africa the author has been unable to trace any reports or records of their existence outside the area cited.[34]

Ruins of a Nupe example recently observed, fig. 31b, comprise an eroded wall still rising some 90 cm above ground level, (a), penetrated at its base by a vent-hole about 30 cm in diameter for accommodating the giant tuyère usual in these furnaces, (b); in the front base of the wall a tunnel, (c), probably used for the charge of ore and charcoal led, with (b) into the reduction chamber (d), an area about 90 cm high, at the base of which a narrow aperture gave on to a large pit, (e), in the front of the furnace; into this the smelter dragged the bloom after reduction. The Afemai example was recorded not far from the Niger confluence, fig. 31c; it is substantially the same, but lacks a separate aperture for the charge of ore and fuel, which seems to have been fed direct into the reduction pit. Other examples have been recorded by Frobenius,[35] and Nadel.[36] Mediterranean connections of this furnace type are perhaps not to be associated with Greco-Roman antiquity: it does not seem to have entered West Africa as a result of Roman agency – it was unknown for instance in Roman Britain. We may more reasonably suppose it to have been introduced to North Africa by the Arabs at some date after their conquest of Spain in 711 – if indeed they were not themselves the agents of its introduction to the Iberian peninsula – but until more definite knowledge is forthcoming on the distribution of early Old World furnace types these must remain, as they are, suppositions.

From this picture of early iron in tropical Africa we can be certain of only one date, that for Meroitic smelting during the first century BC; we do not know how much earlier than this iron was being produced there, nor do we know when or by what means techniques diffused, if in fact they did, southward and westward to create industries in the forest regions. In the Ennedi hills of the Sahara, in the Wadi Basso, at a place called Gubba Tōb, Arkell excavated the remains of three iron smelting furnaces. Oral tradition associates these with Bedayat Tōla who once inhabited the area as far north as the red salt 'mines' of Dimi. Arkell considers it possible that these Bedayat Tōla may have been Christian Beja from the Bayuda desert who could have introduced iron working derived from Meroë. The Ennedi massif lies due west of Kabushiyya – the site of old Meroë – on about 17° N. The furnaces appear to be of the Meroitic type. The site at Gubba Tōb is associated with plain black-topped red bowls with thickened rims characteristic of Nubia, and these Arkell feels may also have been introduced by the Bedayat Tōla.[37]

For parts of West Africa and the Congo we can reasonably place the beginnings of the Iron Age at around AD 500, though the metal was probably known there for some time before this date. Until its destruction *c*. AD 324, Meroë seems to have continued the production of iron, for the

31a. Catalan furnace (*Dictionary of Greek and Roman Antiquities*)

31b. Catalan furnace, Nupe, Nigeria

31c. Catalan furnace, Afemai, Nigeria

conquering Ethiopians, a people in some respects of an apparently lower level of culture, boasted of having destroyed Meroitic buildings and of carrying off quantities of food, copper, and iron. These ravages remain evident to the present day at the palace of Amanishakete in the 'vast and trunkless legs of stone' which still lie where they fell among debris from the gutted roof.

At some stage before this end, perhaps a hundred years or so before the Axumite conquest, states to the north of Meroë and at one time apparently subject to its dominion were gradually acquiring autonomy. The founders of these states, the Blemmeyes and Nobatae, have left royal tombs indicating pagan cultures which lasted from *c.* AD 250 – *c.* 545. Here we are at last in the presence of an Iron Age justifying its name, in which the metal is skilfully employed in the manufacture of every conceivable object of daily use – folding chairs, tripods for cooking pots, and a wide range of tools and weapons including refinements such as tongs, shears, sawblades, etc. But though iron ingots excavated at Ballana and Qustul suggest an industry in surplus production it remains possible that a great deal of this iron may have been imported; certainly the predominant design influences in all the metal work, whether in bronze or in iron, is Roman and Near Eastern. In Equatorial Africa the term Iron Age however does not indicate much more than the mere presence of the metal – a state of affairs which in fact persisted long after the coming of Europeans in the fifteenth century. In such conditions the use of the term iron industry is barely justifiable: it is employed here only for want of a more suitable one.

At Nok in Northern Nigeria such an early industry is indicated by the excavation of iron tools, slag, and pottery tuyères of the type still used today throughout tropical Africa;[38] in addition we have from Nigeria the report of an iron hoe found eighteen inches below the bed of the River Delimi at the same horizon or even lower than that in which stone implements have been found, and iron bangles 35 cm deep in the tin bearing wash of the Forum River.[39] Excavation at the Rop rock shelter in northern Nigeria has recovered from a layer dated to the late Stone Age pieces of iron slag and two iron points, perhaps not indicating an extensive knowledge of iron-working but certainly suggesting that the people who lived there after the main microlithic phase at least knew about iron. The iron points might possibly however be intrusive, products of a more advanced culture of later date.[40] For Ghana, Ozanne is of the impression that at some period between 500 BC and AD 500 – the dates cannot be defined in the present state of knowledge – a series of cultural changes occurred in rapid succession, with the introduction of cultivation and stock-rearing, of pottery making and iron working, though little evidence of early practice in these activities has been recovered.[41] Mauny considers that by *c.* AD 500 all the peoples of the forest cultures were using iron, and a similar date has been proposed for the Congo.[42] For Southern Africa too the Iron Age may be said to have begun about AD 0–500; early Iron Age cultures are known from Katanga in the Congo and from a number of sites in the Limpopo valley.[43]

An expert mining people working Southern Rhodesian gold before AD 400 have left mines cut through rock to depths sometimes approaching a hundred feet despite the lack of hard steel tools.[44] This lack of steel is a general characteristic of traditional African industries: the technique of quench-hardening and laminating the metal to produce a uniformly toughened mass, long known around the Mediterranean, does not appear ever to have been understood in tropical Africa, though a hardened iron approaching steel was traditionally produced in most parts of the continent as a result of the accidental absorption of small quantities of carbon by the metal in the process of forging the impure bloom – a result not uncommon even among the Greeks.

Though Old Kingdom Egypt has furnished art history with a figurative woodcarving we have no evidence of the early practice of this art to the south, even though Nubians towards the end of the fourth millennium BC were already importing copper tools from Egypt,[45] a point worth considering in view of the importance woodcarving would later assume in tropical African art. Kushites – Napatan or Meroitic – have left no sculpture in this medium. Examples of Meroitic sculpture so far to hand are conceived for the earlier phases in terms of the Egyptian canon, and for later in terms of the Greco-Roman as exemplified in pieces at Musawwarat-es-Sufra, at Wad ban Naqa and at Begrawiyeh. The latter examples, dating from the period of Roman 'clientship' are, not unexpectedly, secular and classical in idiom, though African in subject matter. Here we encounter a near life-size figurative sculpture in plaster unique in African art. But various though the techniques of the Meroitic plastic are, nowhere do we find wood as a medium of expression. The present author has recovered fragments of what may have been wooden scaffolding embedded in the walls of an undated, unclassified Meroitic brick structure at Wad ban Naqa eighty or so miles from Khartoum. These remains are in a fair state of preservation; any contemporary woodcarving would hardly have vanished without trace in the dry conditions of the northern Sudan. A remarkable heroic figurative art in wood is produced by the Bongoba of the southern Sudan, but nothing is known of the age of its traditions. The Azande produce woodcarvings for the tourist trade which may not be particularly old. These traditions would in any case refer to the Iron Age; south of Meroë bronze-working has remained unknown throughout historic times to the present day.[46] For tropical Africa as a whole it is tempting to consider this medium of specifically Iron Age reference, bronze in West Africa being unquestionably an Iron Age phenomenon.

It is possible that in the forest regions where it now abundantly thrives woodcarving came to be developed as a symptom, or perhaps as a result, of those cultural changes suggested by Ozanne for Ghana, at some stage before *c.* AD 500. With the development of settled community life it may have achieved that numinous nature which so strongly distinguishes it from the earlier art of the Sahara with which it nevertheless retains certain

inconographic affinities. Though the Guinea forest was possibly inhabited at periods before the dessication of the Sahara archaeology has yet to unearth evidence of three-dimensional carving arts, either in wood or in stone, among these peoples. West African connections with the Sahara and the Mediterranean, more evident than elsewhere perhaps in brass casting technique, is indicated for iron-smelting and iron-working by the comparison of the Celto-Roman furnace design with identical types occurring in the great triangle bound by the course of the Niger and the Guinea littoral. But iron-working of the period, whatever its ultimate sources, does not appear to have occasioned that revolution in the material culture of these societies which we normally associate with the coming of an Iron Age. It appears on the contrary to be associated with an iron hunger in which the metal came in many areas to be ritualised, with direct effect on subsequent form in the plastic arts. At the same time those conditions were being created in which the slave trade came eventually to be organised on the basis of the European iron bar.

10 The Iron Age and the Iron Bar
c. 500—c. 1650

One consequence of the rounding of Cape Bojador in 1434 was the shedding of Portuguese blood on African soil by natives armed with spears. Thereafter wherever they went the Portuguese, confident in iron industries not a great deal older than those of the African, but incomparably more advanced, took cautious note of the native iron weapons, of barbed arrowheads whose potency was augmented by the smearing on of poison. Among the Jalof of Senegal the Venetian Ca de Mosta in 1455 describes murderous iron barbs the length of a span, and a Moorish weapon like a Turkish half-scimitar made of iron, not steel;[1] some years later the Portuguese Valentim Fernandes, a perhaps even more acute observer, speaks with horror of the viciously barbed spearheads of the Serer which were impossible to extract from human flesh once they had struck.[2] On the Upper Gambia Diego Gomes also observed spears, swords, and poisoned arrows reminiscent of similar weapons already mentioned in the twelfth-century *Tohfut al Alabi*, which within an hour of striking reportedly caused flesh to drop from the bone even of elephants and similar beasts.[3] Into Portuguese times the poisoned arrowhead of the western Sudan and Guinea is recorded as made either or iron or of wood, the latter not necessarily an earlier type, but probably more efficacious in holding a charge.[4]

These early voyagers also encountered the numerous lance-bearing cavalry of the empire of Mali whose traditions of armour went back to remote contact with Old Ghana and the Mediterranean world. Giant canoes were observed on the Senegal and Gambia rivers, each capable of bearing upwards of fifty men. It is possible that iron tools were used in their construction, since in Equatorial Africa we have no evidence so far that bronze was used for tools and implements as was the case in Egypt. The Arab traveller el Bekri (1067) watched such canoes plying a trade down the Niger between the Timbuctu area and Gao and three hundred years later this observation was repeated by Ibn Battuta. Similar canoes may have borne trade even farther down the Niger, though for great stretches along its course navigation would have been difficult: to the present day such canoes are common along its most southerly stretches. Early in the sixteenth century the Portuguese traveller Pacheco Periera observed that natives of the Ijo tribe 'use large canoes made from a single trunk, sometimes so large that they can carry eighty men. They come down the river for a hundred leagues or so bringing yams, slaves, goats, and sheep which they sell for salt to the Negroes

of the villages, and for copper bracelets which are more valued than brass ones.' These Ijo tribesmen carried 'daggers of a type common among the (white) Moors of Barbary'. Part of the trade linking forest villages with the western Sudan would have been carried overland; a north-south route was established which served an indigenous trade in the lower Niger basin before the coming of European commerce, and is known to have carried various items of European manufacture from North Africa and the Sahara to the coast. The age of this route has not been established,[5] though in western areas of Nigeria the capital of the Yoruba empire at Ọyọ seems to have been a trade entrepôt for the western Sudan from around the early fifteenth century.

A seventeenth-century author describes on the Ivory Coast a trade in which 'inland blacks sold vast quantities of (cloth) to a white people who live far in the interior, usually riding mules or asses, and carrying assegais or spears, which must needs be Arabs'.[6] So that with the opening of European trade in the fifteenth century Africans were in a position to dictate at least some of the terms, backed as they were by a wide range of tools and weapons and the skills to make and employ them developed over the previous thousand years or more. In fact so impressed was Fernandes with Sierra Leone as an armoury serving the greater part of Jalof country and with its resources of high-grade iron ore, that he concluded that Africans there needed only machinery in order to command an industry greater than he had seen anywhere in his own country. Fernandes's image was of course that of a Renaissance metallurgy in which the harnessing of water power had resulted in the development of the *Stückofen* and the blast furnace, whose vast yields at controlled high temperatures had made cast iron and steel available to European industry, with incalculable consequences for Africa. But in a thousand years of African 'metallurgy' not only had furnace design remained unchanged, so too had its products: cast iron and steel continued unknown and wrought iron remained insufficient to meet the needs of local populations. Iron weapons observed at this time around what is today known as Portuguese Guinea reportedly broke like glass, lacking any temper.[7]

By the beginning of the sixteenth century Sierra Leone was already one of the great iron-smelting centres of West Africa; we hear of a vast trade network in which iron purchased there by Mandingo middlemen was transported down the Gambia to the coast, whence it was distributed over the greater part of Jalof country.[8] Using the domed furnace described above, Sierra Leone remained an important centre of native smelting into modern times; as recently as 1919, in the northern chiefdoms of Sulima, Dean, and Makallia, iron-smelting still carried on there by Fullahs, Yalunkas, and Korankos was among the principal native industries of the country exactly as it had been in traditional times.[9] In spite of the intertribal scope of this industry certain evidence suggests that the metal, and the function of the smiths associated with it, was apprehended in the ritual systems observable elsewhere in tropical Africa.[10] Today of course the

people of Sierra Leone have machinery for extracting their high-grade
ore – one of the richest anywhere in the continent, or in the world for that
matter – around 70 per cent; at the Marampa mines about three and a half
thousand Africans produce an annual three million tons of this ore, which
brought if not wealth at least subsistence to their ancestors.

The distribution of the Sierra Leone type of domed furnace suggests
that similar smelting centres have existed in the forest regions of West
Africa from possibly remote periods, but the picture remains one of con-
trasts – of high availability of the metal in certain areas juxtaposed with
areas of virtual iron famine. Thus though the archaeological record suggests
a knowledge of iron in central Ghana relating to periods around AD 500,
for coastal areas the use of stone tools persisted into the fifteenth century.
As late as *c*. 1600 Accra iron was probably being imported from another
centre of the West African industry in the hills of southern Togo across the
Volta: a centre which retained its importance into the present century.[11]

In some cases where the traditional practice of iron industries is des-
cribed in European records, it has long been forgotten locally. In the early
decades of the present century observers could find no native memory of
iron-smelting in Ghana. The Lander brothers, travelling through Borgu
country in Nigeria in the early nineteenth century describe an industry
flourishing at Kiama; in recent fieldwork I was unable to find not only any
relics of this industry but also any informant who had even the faintest
recollection of its previous existence there. Modern villagers can rapidly
clear a site of centuries of accumulated iron slag by using these metallic
lumps in the foundations of their buildings. As remains the general pattern
in most rural communities in tropical Africa today, there was a time when
even the smallest hamlet could not be without its smith, iron tools being of
such importance in the subsistence farming universally practised. When iron
hunger during World War II obliged the Nigerian Colonial Government to
take steps to revive native production among the Kwaja of Bamenda in the
Cameroons, it was found that though the traditional Mbedji smelters had
long since gone out of business, a sufficient reserve of iron money used in
the payment of dowries was available for conversion to more practical
purposes.[12] In Togo, similarly, according to Thurstan Shaw, a wartime
production was reported in 1944 where in a single morning a hundred and
fifty headloads of smelted iron left the native furnaces.

Among forest peoples the importance of iron is to be understood not
only for its significance in farming and in war, but also for the intimate
relationship which has traditionally existed between these communities
and the life of the forest. Hunting provides the meat protein essential to
supplement an otherwise starch dominated diet. Unlike practice in more
northerly regions, cereals have never been staple food in the south; the
principal source of calories consists of starchy roots, high in water content
and low in protein, enormous quantities of which must be consumed to
ensure a minimum protein intake. The protein content of yam is, for
instance, 2 g, cassava 0.7 g; carbohydrates 24 g and 37 g respectively.

Eggs have never been significant in the traditional diet, and cattle are plagued by the tsetse fly. It has even been suggested that until the coming of the Portuguese in the fifteenth century and the introduction of new crops, most West Africans rarely had enough to eat, except when they lived near enough to the coast to procure smoked fish. But fish which could have been significant in supplementing this protein deficiency, appears never to have been important in communities far from water. The resulting reliance on the forest as the primary source of protein foods accounts for the ritualising of iron widely observable among forest peoples in tropical Africa. Gods and spirits of the forest under whose aegis the hunter, the herbalist, and all those whose business in the forest is extractive operate, need to be propitiated; in their propitiation a ritual symbolism is developed which as we shall see affects the entire concept of the function of the metal in these societies, the functions of the smith, and the forms of art. Iron comes to be obligatory in the cult-imagery of the forest deities as it is in the day-to-day material business of the forest.

The historic African iron industries, whether through the specialised techniques of smelting or through the more widely distributed practice of smithing, have opened cultural roads and byways through the tropical forests. Along these roads have travelled the slow but permanent agents of revolution in the lives of the iron-using communities, linking them with the Mediterranean and the Nile, and even possibly beyond the Nile with the far orient; for several medieval Arab writers tell us of an extractive industry exporting its products to India which affected some thousand miles or so of the East African coast stretching between Sofala and Malindi. This oriental view of Africa as a primary producer antedates popular European opinion by a good three hundred years.

Indian influence in Meroitic art and Axumite architecture has already been noted by Arkell.[13] Contemporary with Arab mineral exploitation of the East African littoral African iron industries, arising possibly from the ruins of Meroë, flourished in the tropical hinterland from a period following the destruction of the Meroitic capital in the fourth century AD. How long it took the influence of Meroitic techniques to penetrate the tribes of the southern Sudan, if in fact they did, and be transmitted from them to the tribes of northern Uganda we do not know. The Jur of Bahr el Ghazal in the southern Sudan used a shaft furnace reminiscent of the Meroitic type, fig. 24m, which is echoed in designs surviving from the industry in Uganda, fig. 24b, where, in the oral tradition, smelting is claimed to go back to *c.* AD 1000. From northwest Uganda the knowledge is considered to have penetrated southwards and eastwards and eventually to have reached the east African littoral at a point opposite Mafia Island, whence it permeated up and down the coast.[14]

A ritual involving the insertion of 'medicine' (charms) into a hole beneath the base of the furnace is practised among the Baganda and also among groups of tribes north of the Zambesi, and is associated with a Meroitic-type furnace design. The bearers of this design are considered to

have moved southward from East or Central Africa, perhaps down both sides of Lake Nyasa; one of their smelting sites, at Kalambo Falls, is dated to the eleventh century.[15] It has been suggested that in Rhodesia an Iron Age beginning around the twelfth century is to be distinguished from an earlier one, possibly going back to around 100 BC.[16] From Napatan times, perhaps as early as the fourth or third centuries BC, iron ornaments, tools, and implements were traded south to the settlement of Jebel Moya in the triangle of territory – the Gezira – between the White and the Blue Niles, a settlement of some importance even before the great days of the Meroitic period. By the tenth century Nubian Christian influence had extended far to the west, to the present limits of the modern Sudan, while Nubians were at the same time trading iron to Arabs on the Egyptian border against imports from the north; ancient Sudanese traditions of smelting were obviously still producing a surplus. Iron from Kordofan traded at the great entrepôt at Senaar, not far from Jebel Moya, was reaching Fazogli on the Blue Nile as late as the eighteenth century.

Thus, over the period which we know as the African Iron Age the metal, its artifacts and techniques achieved a wide distribution over most of tropical Africa in a trade in which areas of high availability, transmitting products or smelted blooms to areas of low productivity, were yet unable to satisfy the demands of the latter. Thus the iron hunger was perpetuated which would play an important role in the development of the slave trade and underpin its effects on tropical African cultures and their art.

This malignant iron hunger was by no means apparent to the early Europeans who ventured in wonder and curiosity along the African coast; changes resulting from their coming would take a long time to be felt in the hinterland. By 1642 the Portuguese had been ousted from the Gold Coast (Ghana) and though they continued to maintain some of their factories there, their place would subsequently be filled in the West African trade by the Dutch, British, French and Danes. The first nail was driven into the coffin of the traditional industry with the introduction of the European iron bar. During the first two hundred years of contact, from *c.* 1455 to *c.* 1655, European response to African requests was to include among trade cargoes 'small pieces of iron', 'wedges' and 'bits'; at this time European interest in the nature and possibilities of the African trade seems to have remained largely exploratory. More than a century after the Portuguese opening up of the coast, English newcomers to the trade, sailing for the Merchant Adventurers of Guinea, were being instructed by their principals to 'learn what commodities belong to the places touched at and what would be proper to carry there'.[17] Around this date (1561) we find the English trader Towerson reporting that among commodities most desired in Guinea were 'wedges of iron' and 'short pieces of iron', though in his previous voyage of 1555 he does not mention any demand for the metal. On the contrary he describes his admiration for native production of 'handsome darts and various instruments of iron'. At this date an organised trade in iron would

seem not to have been developed: 'People desire most to have basins and cloth; some would buy trifles as knives, horse tails, horns; some of the men going ashore sold a cap, a dagger, a hat, etc'.[18] A certain amount of independent evidence suggests that, among the Yoruba, iron came to be ritualised around this time, perhaps as a direct result of its increasing availability in certain communities.

Up to 1655 the Company of Merchant Adventurers was at least as interested in ivory, wax, hides, grain, etc., the combined yield of which was equal to that of gold, as it was in slaves: the traffic in slaves had not yet achieved that magnitude which was to be witnessed around the closing years of the century. Payment for commodities purchased along the coast was drawn from a list of trinketries and luxury goods, often of exotic nature and provenance in which, besides the manilla (the copper or brass bracelet of early Portuguese commerce) were included brass basins, pewter jugs, small bells, etc. – and odd bits and ends of iron. At the time of the English trader Jobson (1620) there is no evidence that iron was imported in any but these pieces and wedges. On the Upper Gambia he finds the natives, though boasting an iron industry and iron weapons, eager enough to purchase his 'small peeces of iron . . . whereof if we be furnished we can want none of their provision'.[19]

Iron hunger during the preceding centuries is also indicated in the widespread use of a native iron currency, recorded at Jenne on the Upper Niger by Leo Africanus. Later travellers record similar currencies from the headwaters of the Niger to Lake Chad, and along coastal areas from Sierra Leone to the Congo. Such currencies continue in use until modern times – examples could still be purchased in Liberia in 1965.[20] Poor yields from the traditional furnace resulting from faulty methods of reduction observable to the present day prolonged a craving for the metal into the early decades of the seventeenth century. But by 1668 the European iron bar was being traded along the West African coast from the Gambia to the Niger rivers. By 1678 it was described among the principal imports of the French factory at Goree on the Senegal, annual imports there being estimated at 10,000 bars or more; the bars were made in Brittany or Sweden.[21] The iron bar seems therefore to have been introduced along the coast at some time during the half century or so which elapsed between Jobson's time and Dapper's first mention of it, i.e. during the mid-stretches of the seventeenth century. Barbot notes that 'all the iron for Guinea is of the very same weight and size . . . and is called by the name of Voyage Iron, and is the only sort used all over the coasts of North and South Guinea'.[22]

In 1676 the Royal African Company's *Sarah Bonaventura* carried to the Gold Coast (Ghana) 5 tons of iron bars, valued at £18;[23] three years later the *Swallow* took to New Calabar 25 tons, valued at £381[24] and in the following year the *Mary* took to the Gold Coast 40 tons, valued at £580.[25] Henceforth we hear of the iron bar as the standard unit of exchange from the Senegal to the Niger Delta – an Iron Standard we may call it. It is described in the words of a contemporary:

A Barr is a denomination given to a Certaine Quantitie of Goods of any Kind, which Quantitie was of equal Value among the natives to a Barr of Iron when this river was first traded to. Thus a pound of Fringe is a Barr, two pounds of gunpowder is a Barr, and each species of Trading Goods has a Quantitie in it called a Barr; therefore their way of reckoning is by Barrs.[26]

Such a bar was flat, 3 m long, 50 cm wide, and 1 cm thick; it was divided into twelve lengths of 15 cm, each of these being then subdivided into three; the resulting portion was considered just enough for fashioning an African hoe.[27] In Dapper's time thirty-two or thirty-three of these bars weighed about 10 quintal, i.e. roughly 35 pounds each.

So our picture of iron in the Guinea forest during the Iron Age indicates that though the metal was smelted there from remote times its products were never adequate to meet local demands. Though the supply was supplemented from European sources from the mid sixteenth century onwards, and perhaps earlier, iron hunger continued chronic among the native populations until the condition was capitalised on by European industry with the introduction of the iron bar at some period during the mid seventeenth century. This was a direct result of the organisation of the slave trade in response to a sudden increased demand for labour on the West Indian plantations: the decade 1640–50 saw the introduction and development of the sugar industry in the Caribbean, which soon became insatiable in its demand for African labour. Within the first five years, in Barbados alone, the black population had risen from 'a few Negroes' to some 20,000. In the light of this new demand an Act of Parliament to settle the question of monopolies in British trade to Africa deprived the Royal African Company of its exclusive charter and threw the trade open to 'any of the subjects of His Majesty's Realm of England' for a provisional ten years. During this decade the volume of trade to the West Indies alone increased fourfold. As the time of the expiry of the Act approached, the Lords Commissioners of Trade, reviewing the position, found that of nearly 90,000 slaves imported into the islands of Barbados, Jamaica and Antigua during the period, the Royal African Company had been responsible for less than a fifth. At the height of the period private entrepreneurs had exported in a single year (1701–02) more slaves than the Company had managed in ten. The Company's performance in the teeth of competition was scarcely better than its achievements in the palmy days of the monopoly it had enjoyed since 1672. British industry had of course in the meantime expanded dramatically to meet the increased demand for voyage iron; gone were the days of the casual 'peeces', 'wedges' and 'ironwork of sundry sorts' traded by British seamen since the time of Elizabeth. As the Act came up for review in 1708 the founders and tradesmen of Birmingham, petitioning the House of Commons for the continuation of private enterprise, could point out that their products,

'through the great demand thereof for Africa gives employment to vast numbers of poor families who must unavoidably be ruined if the said manufactures should

be subject to one Buyer, or to any one Monopolising Society exclusive of all others'.

The said manufactures were the by now standardised hardware of the trade – the manacles, fetters, neck-collars, chains, branding-irons, thumb-screws and especially the newly produced iron bar, all of which today can still be observed rusting on the sites of old slave factories along the coast and major rivers of West Africa. The Birmingham industrialists naturally prayed that the trade to Africa might be 'continued open and free to all His Majesty's subjects of Great Britain'.[28] It was. Free enterprise in the Atlantic trade had done for British industry (and other European manu-facturers) what charter monopoly had not done since the first trading company had been authorised by Charles 1 in 1631. British iron and steel had now become the organised complement to the manhunts of West Africa, and the chronic iron hunger of the Africans would henceforth be sated to excess. Open trade would improve the quality of eighteenth-century iron reaching the Coast as Africans became increasingly more discriminating among European products as a whole. For certain ritual purposes however locally smelted iron continued obligatory into the twentieth century.

The increased availability of iron and its effects in the coastal societies is illustrated at Benin, whither in 1588, as traders were at the time doing all over the coast, James Welch took 'ironwork of sundry sorts;'[29] by the opening years of the eighteenth century the Bini were producing great quantities of their own ironwork *for market*: 'implements for fishing, ploughing and otherwise preparing the land'.[30] From Aṣante between 1674 and 1690 came the magnificent ceremonial iron cutlasses collected for the Danish Royal Cabinet and now in the Copenhagen National Museum. In the same collection are the two paintings shown in figs 32 and 33 which were executed in Brazil by Albert Eckhout in 1641 and presented to Frederik III of Denmark by Prince Johann Moritz, Governor of Pernambuco in 1654. Though European brass-mounted cutlasses were in some demand on the Windward coast early in the following century[31] the types represented here would have been made up by local smiths. They are of identical design to Aṣante examples in Copenhagen, and to other examples in London, decorated with gold leaf on pommel and guard. The type also occurs in Dahomey.

Though stone tools persisted in parts of Ghana (Gold Coast) into the fifteenth century, by the end of the seventeenth century we hear of sections of the people there 'forging all sorts of war arms that they want, guns only excepted, as well as whatever is required in their agriculture and house-keeping'.[32] Conditions more nearly approximating those of an iron age begin to appear in isolated centres, but even here these are not the result of the development of a true native metallurgy; throughout the continent the techniques of iron smelting and iron working, the associated tools and furnaces, and the knowledge of the properties and behaviour of ferrous ores and metals remained what they had been at the moment of the re-motest contact. The coming of iron had been apprehended and continued

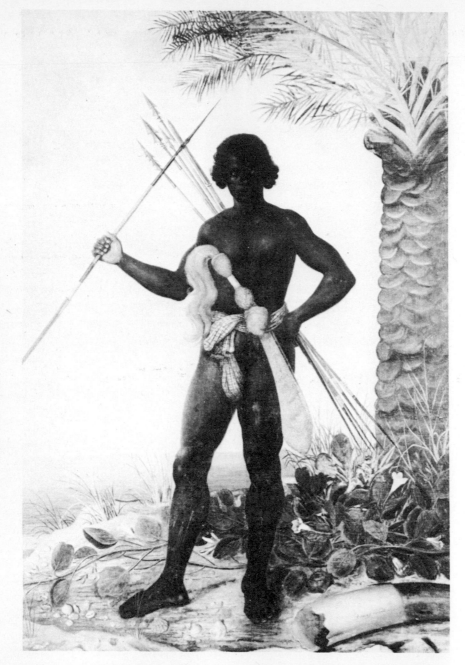

32. Aṣante ironwork,
seventeenth century

to be apprehended within ritual systems which explained all phenomena in terms of what have until recently been called 'animist' belief but which more accurately conceives of the nature of reality in spiritual qualities inherent in matter and which explain the phenomenon of matter itself. Such spiritual qualities are also apprehended as constituting the very nature of man. It is his relation with the alien and unpredictable natural world; his confrontation with force or power or being in this natural world, not in terms of inquiry or analysis or codification, but in terms of propitiation and

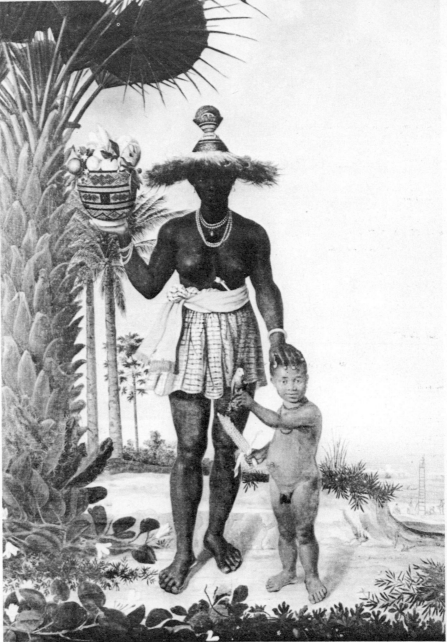

33. Aşante basketwork,
seventeenth century

the adherence to custom that explains the lack of inquiry and analysis which
has characterised the working of iron throughout all periods. It also explains
the genesis of form in African sacred art, and particularly those forms
developed in iron and bronze. In order to establish time-depth for our
appraisal of form in African iron sculpture let us now examine the process
of the ritualising of iron in an historical context, among the Yoruba, a
society in which the cult of iron is more elaborately developed than elsewhere
in tropical Africa.

11 The Ritualising of Iron:
c. 1530–1900

In considering the birth and growth of imagery in the sacred iron sculpture of West Africa, it will be necessary to propose a temporal framework for certain beliefs related to the *genre*. By the examination of type-motifs associated with the ritualising of iron in terms of these beliefs we shall attempt conclusions as to the emergence and style periods of the related stereotypes.

Among the Yoruba of Nigeria the ritualising of iron is centred in the cult of Ògún – *òrìṣà* of war, *òrìṣà* of iron. The double appellative possibly suggests the superseding of neolithic by iron age weapons: in many an Ògún shrine the *òrìṣà* is still worshipped in a block of stone or in a few stone celts – a vestigial memory perhaps of the meteoric associations of iron in its connections with the thunder-god Ṣàngó. To the present the black-smith's anvil remains a block of granite, in contrast to that of the brass-smith, which is of iron or steel;[1] sacrifices are made to the former and not to the latter.

The traditional club, one of the type-motifs of Ògún, is known by three names of which the *kumọ* represents a version made entirely of wood so carved that the knot serves as a head. The version known as *òrúkùmọ̀*, strengthened by the addition of iron spikes driven into the head continues to be represented in recent Yoruba bronzes in a shape somewhat reminiscent of the Meroitic type. On the *gàmán*, an iron chain is used to augment the weight; this club is possibly a development of the earliest known Yoruba weapon, the *kóńdó*, or throwing-stick, figs 34a–d. Of the Iron Age types, (b) and (c), the latter by virtue of its associated iron chain is most likely to be of post-European date, while the former might equally be pre- or post-European. From an era in which Ògún becomes the tutelary deity of farmers, hunters, smiths, and all those who use the metal, we have seven pieces of iron representing the seven categories of occupation under which he is worshipped (Appendix 1); this period is of indeterminate date. A pair of iron arrowheads employed in Ògún ritual might also refer equally to a pre- or post-European period, fig. 35; arrowheads of reed continued in use well into the twentieth century. The *gbàna*, an iron chain of twenty-one links kept in a leather sheath and ritually worn around the neck is another of the type-motifs of Ògún; again the iron chain indicates a post-European date.[2] The slave manacle of obvious European connections survives today in West Africa in miniature models used as amulets in Nigeria, the Ivory

34a–d. Yoruba war-clubs and throwing-stick. (*a*) *Kumọ*; (*b*) *Òrùkùmọ̀*; (*c*) *Gàmán*. These appear to have gone out of use only recently; examples are still to be found in private ownership. The *Kóńdó*, (*d*) is still in use for hunting. It is possibly the oldest of all Yoruba weapons

35. Pair of iron arrowheads sacred to Ògún – god of war, god of iron. About 25 cm high, these are stuck into the ground, one on each side of the head, in the mortuary rites of a hunter or farmer. They are normally connected by a chain

36. Miniatures of European slave manacles used as amulets in many parts of West Africa. Originals, upwards of 30 cm long, are still to be found in private ownership around the sites of old slave factories on the Guinea coast and along the Niger

37. Miniature of a bow (iron) used as a symbol of rank by a Yoruba war-chief. The original of such a bow from the collection of the Oni-Mayin, Mayin-Ogbó-mòṣò, western Nigeria, is in the African Studies Museum, University of Ifè. (About 40 cm long)

Coast, and Senegal, fig. 36. It is sold in Nigerian markets as a charm.[3] Of indeterminate date is the model of a bow in iron used by war-chiefs as an emblem of rank, fig. 37. From a period possibly before the iron bar came in to provide a convenient means of storage and a valued unit of currency in West Africa comes the pear-shaped lump of wrought-iron in the palace of the Oni at Ifè, today ritualised as the anvil of Ògún-Ládé, 'the mightiest blacksmith of Ifè', and regarded as a block of stone. That it was locally produced is evidenced in surface exfoliations marking the constituent lumps, as well as in the hammer-marks by means of which it was modelled into a mass some 90 cm high and 1.2 m in circumference. This lump of wrought iron held by a king might be expected to represent bullion stored against emergency in times of war, but as traditional methods of smithing provide no means of reducing such a mass to tools and weapons this seems unlikely to have been the case; it is more likely to have been fashioned as an object of ritual use and sacrificed to as it is at the present day. The iron bar was unknown in West Africa before c. 1650, so that at whatever stage this object was ritualised in its associations with Ògún it is most likely to have been at a date before this period while the metal yet remained rare and valuable.[4] At Ifè too, the Òrányán column, a five-metre high granite obelisk, claimed in the oral tradition to have been carved to this progenitor of a subgroup of the Yoruba, is studded with a hundred and thirty-three iron pegs, again suggesting ritual use of the metal possibly from a period before the advent of the iron bar; it has been associated by certain opinion with the cult of Ògún.

The hunter's amulet at fig. 38 is comprised of miniature models of the various types of iron hammer used by the smith, but for such hammers we are in no position to suggest a period. In an Ògún shrine at Igbeti in western Nigeria, similar models of iron hammers are kept in a calabash with the thunder-axe of the *òrìṣà* Ṣàngó and described as symbols of Ògún. The pair of *ẹdan* Ògún, fig. 39 (brass staffs used in the worship of the god Ògún) again comprises various miniature models of smiths' iron hammers but carries in addition a small model of the slave manacle, an unidentified crescent-shaped object, and a model of the African hoe. We have already associated the adoption of the slave manacle as a type-motif of Ògún with the European period so that its occurrence on this amulet has no further individual significance, but it tends to support a mid-seventeenth-century date for the pair of *ẹdan* Ògún in the same assemblage, whose style-cycle certainly refers to a period after c. 1650. From the same period comes a pendant for a war-chief at fig. 40. The spatulate blade might be a variation on or a development of the arrowhead motif of the spike at fig. 39. Later type-motifs appearing in the ritual symbolism of iron in the Ògún cult are the European firearm, which did not come into general use among the Yoruba until about the mid nineteenth century,[5] the padlock on a hunter's leather doublet, the model of pincers or tongs which remains one of the most characteristic type-motifs of this *òrìṣà*, and the European sabre.

All these type-motifs have been drawn from the symbolism of the Ògún

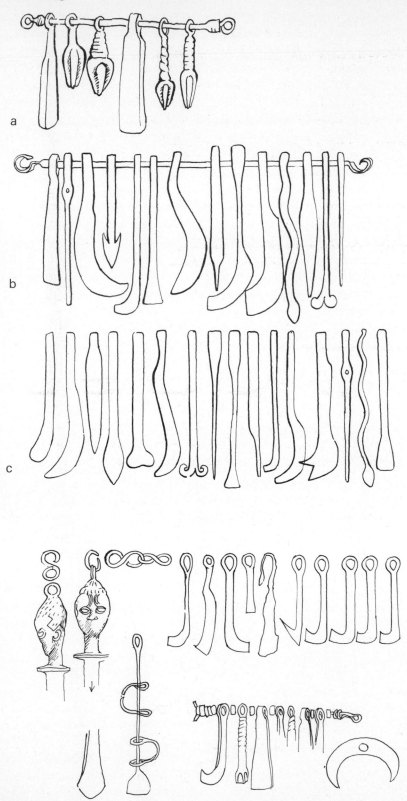

38 and 39. Amulets used by hunters and farmers, bearing some of the type-motifs of *Òrìsà* Ògún. Example (*a*) worn by a hunter at Igbeti, Nigeria, is of iron, the preferred metal; (*b*) and (*c*) from the Nigeria Museum collection, are of brass; fig. 39 includes the *ẹdan* Ògún

cult and provide evidence which permits us to view the double appellative of the òrìṣà – god of war, god of iron – as suggesting successive historical periods. If their collective evidence could suggest a definable period for the ritualising of iron among the Yoruba we would be clearer in our thinking on the nature of the social changes which occurred – if change did in fact occur – with the coming of iron, and on the effect of the ritualising process on the development of form in the associated sacred iron sculpture.

Tabulated, they do suggest a definable period for the ritualising of iron (table 1). Of the sixteen, only one is possibly of pre-European date; nine

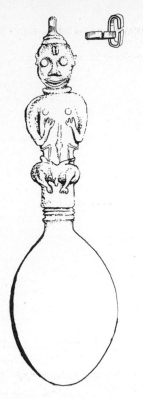

40. Brass-mounted iron pendant for a war-chief, with type-motifs of Òrìṣà Ògún

TABLE 1 *Type-motifs in the Ritualising of Iron among the Yoruba*

		DATE		
No.	Object	Pre-1500	Post-1500	Indeterminate
1 Kùmò				—
2 Òrúkùmò		0 (?)		
3 Gàmán			x	
4 Seven pieces of iron				— (?)
5 Pair iron arrowheads				—
6 Gbàna			x	
7 Iron bow (war chief's emblem)				—
8 Slave manacle			x	
9 Iron ingot (Ifè)				—
10 Hunter's amulet				— (?)
11 Hunter's amulet with ẹdan Ògùn			x	
12 Firearm[1]			x	
13 Padlock[2]			x	
14 Pendant for war chief			x	
15 Pincers or tongs[3]			x	
16 European sabre (Ògún Compound, Badagry)			x	

1. Dutch imports to the Gold Coast of the seventeenth century. Barbot, *A Description of the Coasts of North and South Guinea* [33] p. 291, but not common in Nigeria until the latter nineteenth century.
2. Described in the seventeenth century trade by Dapper, *Description de l'Afrique* [47], p. 300.
3. Described in the seventeenth century trade by Barbot, *op. cit.*, [33], p. 262.

suggest the European period, and six are of indeterminate date. Of the items of indeterminate date two suggest periods after that claimed in the oral tradition for the apotheosis of Ògún; these are nos. 4 and 10. Oral tradition indicates a 'date' for the apotheosis of Ògún as god of iron which is well within the European period, but without straining the implications of the evidence we seem to be in a position to regard the adoption of type-motifs in the Yoruba cult of iron as referring mainly to a period on the upper side of *c*. 1500, when, as we have seen, the malignant iron hunger

of West Africa came at first to be met by bits and pieces of the metal from European sources, and later by the universal availability of the iron bar.

Among the Yoruba the coming of iron is celebrated in various oral traditions, of which the following are three:

> This stone was the anvil of Ládé, the smith. Ládé was the mightiest smith of the past. When he died Ògún changed all his tools to stone. The stone in the Oni's palace is Ládé's anvil, and its name is Ògún-Ládé. It was washed out of the earth in a season of rains at the exact time when the Koran was brought to the land.[6]

> Like many other heathen nations the Yoruba have their traditions about the creation and the deluge. It is their belief that at the creation men fed on wood and water, that they had a long projecting mouth; that the bat was originally a creature in human form and was a blacksmith by trade, and that with his instrument he reduced men's mouths to their present shape, for which cause he was condemned to lose the human form and to assume that of a beast.[7]

> Sokoti Alágbèdè Orun was a spirit who dwelled in Heaven and was expelled for bad works and condemned to dwell thereafter among men. He became a blacksmith.[8]

The meteoric sources of early iron led the Egyptians to regard the metal as imbued with the blasting powers of the thunderbolt, expressed in their mortuary rite of the Opening of the Mouth.[9] Among the Yoruba a traditional relationship exists between Ṣàngó – the *òrìṣà* of thunder and lightning, and Ògún – the *òrìṣà* of war and of iron; the thunder-axe has been noted as a type-motif of Ògún as well as of Ṣàngó. When lightning strikes a village the dispossessed must seek refuge in a blacksmith's forge.[10] In the tradition recorded by Frobenius the Ògún-Ládé (or Ògún-Ládin), like those stone celts which the thunder god hurls during his visits among men, was 'washed out of the earth'. We have no evidence that meteoric iron was ever used by the Yoruba as it was in other parts of the continent. The association of Ògún with the thunder-axe might more plausibly be connected with the prior appellative of the *òrìṣà* – god of war, indicating perhaps a neolithic weaponry before the coming of iron, an idea seemingly borne out by the persistent worship of this *òrìṣà* in stone, by the conversion of iron into stone in Frobenius' myth from Ifè, by the propitiation of Ògún in Ọyọ kingship ritual,[11] and by the tradition in which at Ìrè village, his 'home', Ògún is remembered only as a warrior.

The second myth stresses the revolutionary role of iron in food production and the commonweal, and here we may recall its significance among forest peoples in meeting an endemial protein deficiency, while the third underlines the divine origin of the smith, a tradition which perhaps acknowledges the foreign origin of iron. These traditions, and particularly the association with the thunder god Ṣàngó, whose double-axe motif recalls a complex of lightning and thunder myths of Mediterranean antiquity, suggest for the apotheosis of Ògún as god of war a period well before the coming of iron when the Yoruba peoples saw him as the fiery *òrìṣà* of destruction and embodied in him such concepts of natural energy – impersonal

devastation and rending – as they had previously symbolised by the double-axe in their ancestor Ṣàngó, the terrible third Aláàfin of Ọyọ.

So the coming of iron was apparently apprehended among the Yoruba within a pre-existing *òrìṣà* system in which the potency of the unfamiliar metal was explained in terms of the blasting powers of the thunder-axe of the *òrìṣà* Ṣàngó, whose thunder mythology and its associated iconography in the janus-headed thunder-axe and in the sacred ram might well in turn be of nilotic and Mediterranean antiquity. The ram's head motif occurs widely in West African and Congolese art. In Meroitic architecture an Avenue of Rams replaces the Egyptian Avenue of Sphinxes. In the northern Yoruba village of Ìrè, where Ògún is claimed to have sunk into the earth, the Onírè (king), his 'lineal descendant' claims that Ògún is remembered in local tradition only as a warrior. There are no traditions of iron working or iron smelting there: iron was acquired in traditional times by silent barter. A recent author has described Ògún as 'the fierce *òrìṣà* of war most of whose praise-songs describe him as such; but Ògún is also a culture hero, the *òrìṣà* who introduced iron'.[12]

The Onírè relates a tradition according to which Ìrè, his village, was founded by Ogundahunsi, the son of Ògún; Ògún himself, the son of Oduduwa, the common ancestor of all Yoruba peoples, then departed on a long campaign. On his return, in keeping with his tempestuous nature, he killed his son for an act of arrogance; then in remorse and grief he 'sank into the earth' at the spot where today stands the shrine to his memory. From Ìrè the cult spread throughout Yorubaland. The tradition is remembered in a praise-song: 'Ògún kills Onírè and takes Ìrè.'[13] The villages of Ègòsì, Ìfàkì, Òrìn, Èpè, and Ìkirè all confirm the Onírè's claim that the cult of Ògún originated at Ìrè. At Èpè for instance, 'no *òrìṣà* is worshipped except Ògún-Ìrè; here too there are no traditions of iron working or iron smelting and no iron objects are associated with the worship of the *òrìṣà*. Òrìn village holds a small shrine to Ògún-Ìrè.

The present Onírè (1965) recites a list of twenty-nine kings in succession from Ògúndàhùnsi, which might suggest that for this part of Yorubaland where Ògún was apotheosised the metal was not in significant use *c*. 1530.[14] This state of affairs would accord with that apparently prevailing in parts of Ghana (Gold Coast) at the same time where, as Towerson's accounts suggest, the demand for European iron appears to have arisen only during his first and second voyages – between 1555 and 1561. We may remember too that for parts of Ghana the archaeological record indicates the continued use of stone implements into the fifteenth century. Though iron had been smelted in parts of the Guinea forest for probably upwards of a thousand years before this date its production was never adequate for local needs; for villages remote from smelting centres the metal remained rare and valuable and was obtained by barter, as was recently related for Ọbọ Aiyégúnlè (an important brass casting centre not far from Ìrè). It is possible that the second appellative of Ògún – god of iron – was ascribed at a date after *c*. 1530 as the revolutionary efficacy of the metal, evident elsewhere

in war, in wealth and conquest, no less than in its value in procuring forest victual, came to be fully appreciated in this remote Yoruba village. The nearest important smelting centre would then possibly have been the Igbira industries of the lower Niger; smiths at Ọbọ Aiyégúnlẹ̀, the village just mentioned, have in fact described trading caravans to obtain iron from Igbira country into quite recent times.

At Ìrè, despite the appellative god of iron, no objects in Ògún worship are fashioned in this metal; here in fact the worship retains a pristine austerity and objects found in shrines in the area are always described as 'decoration': no paraphernalia are necessary. The priest of the shrine guards the archetypal substances buried there, this spot being marked by a wood carving and a sword, as is also the case at Òmùò village some distance away where the sacred spot is identified by the placing on it of an old Bini bronze mask and a sword of Nupe design. In contrast anthropomorphic figurines in brass and in iron, and models of tools and weapons associated with Ògún in his dual role appear in some profusion in southern Yoruba-land, explained perhaps by the exuberance of brass casting schools at Ìjẹ̀bú-Òde and Abéòkúta in traditional times, and by virtuoso wrought-iron techniques following upon the increased availability of iron in the coastal areas with the coming of Europeans. Mention has already been made of iron amulets worn by Ògún worshippers representing the magical properties of the metal. There is also the ceremonial cutlass, the ritual brass figurines, and the ceremonial iron staff topped by a brass figure and used by senior cult-members. The style-cycle of these anthropomorphic figurines is generally to be associated with a period in Ogboni bronze imagery for which a date *c.* 1650 to *c.* 1830 has been proposed,[15] a period which witnessed the apogee of the Yoruba Ọyọ empire and its subsequent dissolution.

The illustration of the hunter's doublet at fig. 41 incorporates a tradition of iron in its purely magical function. This use of iron, along with the various 'medicines', oaths and incantations of traditional warfare, suggests its adoption in a metaphysical context which, though it might affect it, it could not destroy. Along with various 'medicines' efficacious in meeting the hazards of war and of the hunt are the double-pronged iron *àbà* stuck into a bit of wood. The warrior or hunter recites incantations over this before unclasping it and pointing the two sharp prongs in the direction of the adversary; its effect is to produce surrender or flight on the part of the latter. When not in use its power is neutralised by the points being struck into a tree. The large iron torque (*ìfúnpá*) functions in much the same way as the *àbà*. Worn on the upper arm it can be manipulated to produce choking in an enemy. In the small skin purse (*apẹ́tẹ́*) is contained a finger-ring of iron twisted into the shape of the *àbà*, which confers power to the warrior in hand-to-hand combat. The horn (*àṣẹ*) likewise contains three metal pins, one each of copper, brass, and iron, each of which the hunter might use as a pick for transferring 'medicines' to his tongue with curses meant to deliver the adversary into his hands. So it seems that though

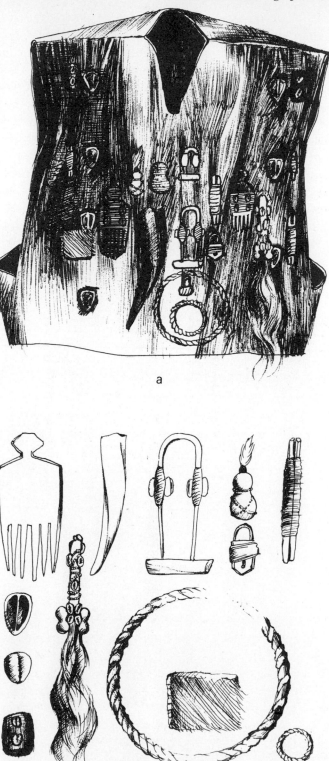

41. (*a*) Hunter's doublet with (*b*) 'medicines' and charms, Ibadan, Nigeria. (Coll. author)

known as the god of war in the *òrìṣà* system, the appellative god of iron was ascribed to Ògún only at a time when the metal and its effects became socially and militarily significant, a time which we regard as lying within the period *c.* 1530 to *c.* 1650. Around 1506–10 Fernandes describes a tribe in Sierra Leone who sacrificed to a god of war. Neither the idol nor any other objects associated with this worship indicate connections at the time with the ritual use of iron. From the mid seventeenth century the iron bar appears on the Guinea Coast to meet the demands of an iron hunger prevailing there apparently from the earliest times. At the end of the nineteenth century Ògún is being sacrificed to as god of iron at Benin.[16] It is therefore within a framework of *c.* 1530 to 1900 that we can place the life of those sacred forms in iron which reflect the ritualising of the various functions of the metal.

12 The Ritual Basis of Sacred Forms in African Iron Sculpture

The ritualising of iron is perhaps best explained within the structure of belief by means of which its strange techniques and processes were understood. For the Yoruba, iron was apprehended within an *òrìṣà* system which served to explain all phenomena, spiritual and natural, in terms of the operation of inherent power, the *Àṣẹ*. It does not seem improbable that in other parts of Africa similar causes were responsible for similar results – there exists much evidence to the present of the magical and ritual associations of iron in these parts; and such beliefs do not provide the conditions in which we should expect to find objective inquiry brought to bear on the problems of iron-smelting and iron-working. Power inherent in the unfamiliar and intractable metal is to be controlled not so much by means of analysing the process of its operation as by propitiation and prayer addressed to the *òrìṣà*, or god, who had been able to tame such power. The empirical development of iron metallurgy in Asia and in Europe was not therefore open to the African craftsman, trained from apprenticeship to suspect unfamiliar phenomena and to regard deviation from accepted practice as potentially harmful; the processes of his craft, strictly spirit-controlled, remained unavailable to inquiry. Along with rule of thumb practice passed down the generations in conformity with the peculiar African view of time – the 'eternal present' of the ancestors – went the body of ritual known to be equally efficacious in winning the metal and in placating the spirit of the *òrìṣà* dwelling therein. The effect of this ritual apprehension of the metal on the development of sacred form in African art may perhaps best be understood through the study of a triad of Yoruba cults – Ògún, Ọsányìn, Erinlè: their interrelatedness and the obligatory use of iron in their symbolism may enrich our view of the *genre* of sacred iron sculpture.

Of the triad we have already examined the cult-symbolism of the *òrìṣà* Ògún and the adoption of type-motifs in an historical context suggest that the double appellative of the god of war and iron, represents the superseding of neolithic by Iron Age tools and weapons. Bronze working arrived relatively late within the pre-existing Ògún cult-system: there has been no true Bronze Age in tropical Africa. The alloy and its working are associated with no independent *òrìṣà* or god, so that among the cult-objects of Ògún we also find bronze or brass castings, such as the brass figurines of

the *ẹdan* Ògún or those of ceremonial Ògún staffs and cutlasses. Other Ògún type-motifs are of course wrought in iron, any piece of iron being held actually to contain the *òrìṣà*; this accounts for its magical use, in amulets, by hunters and farmers. To the present day a person may take an oath by touching or kissing a bit of iron. The iron figurines, called spirits (*imọlẹ*) in an Ògún shrine in western Nigeria represent fertility among the other attributes of the god, figs 42–45. Such iron figurines, ranging in height from 15 to 22 cm, might be interpreted as functioning in the same way as the praise-songs of the *òrìṣà*. Of possibly late occurrence in the history of Yoruba plastics, the development of this *genre* is seemingly the result of an intimate association between Ògún, as god of iron, and the cults of Ọsányìn, Ògìnyán, and Erinlẹ – *òrìṣà* respectively of medicine, of the new yam, and of the forest. Though iron is also obligatory in the cult of *Òrìṣà Òkò*, god of agriculture, its ritual staff never bears images of any description.

With the cult of Ọsányìn, *òrìṣà* of medicine, is associated a stereotype of sixteen pigeons surrounding a bird (*ológèèsà*) which forms the finial of an iron staff of varying length and degree of elaboration known as the *oṣun Ọsányìn* (ritual staff of Ọsányìn), fig. 46. The pigeon is regarded as a symbol of vigilance, while the *ológèèsà* bird is seen as possessing spiritual attributes which are infused into medical concoctions; it is in fact known as

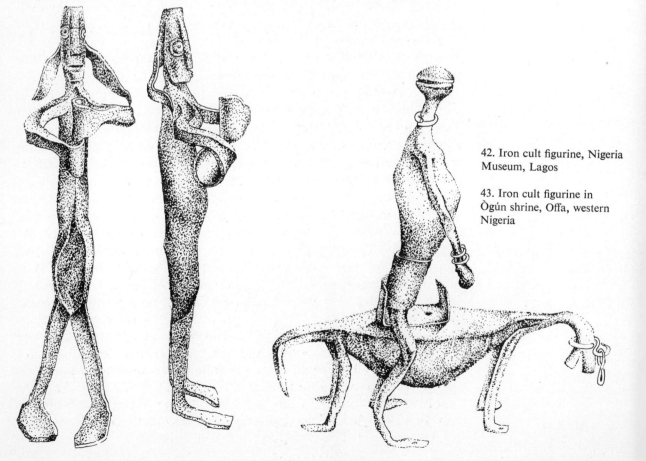

42. Iron cult figurine, Nigeria Museum, Lagos

43. Iron cult figurine in Ògún shrine, Offa, western Nigeria

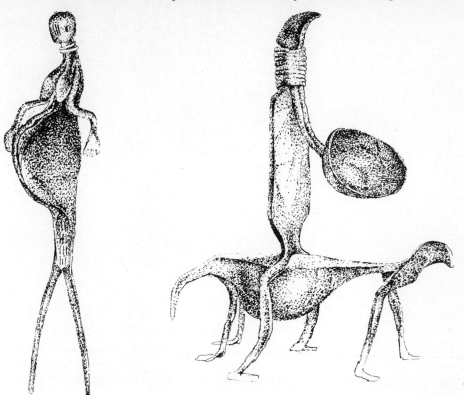

44. Iron cult figurine in
Ògún shrine, Offa, western
Nigeria

45. Iron cult figurine in
Ògún shrine, Offa, western
Nigeria

46. Ritual iron staff for
Òrìṣà Òsányìn

the physician bird and is regarded, perhaps with unconscious symbolic
import, as the most elusive of all birds – 'it lives far in the woods'. It is
never killed by the Yoruba for any purposes but medicine. The sixteen
pigeons surrounding it on the *oṣun* Òsányìn represent the sixteen principal
odus (utterances) of the Ifá oracle – an acknowledgment perhaps of the
divine element in healing, the Ifá system of divination combining as it does
the element of chance with the will of the gods. With each *odu* goes a
particular recitative and a distinctive dance pattern which carries its own
drum rhythm. A small platform, usually halfway up the staff but sometimes
placed elsewhere, stands in vertical relation to the head of the *ológéèsà*
bird; on this sacrifices are placed during propiatition of the *òrìṣà*: it is
considered 'the heart of the *òrìṣà*'. Stuck into the earth at the entrance to
the shrine the *oṣun* Òsányìn merely serves to localise and pin down the
òrìṣà in the manner already described for other African cults; it is in no way
a representation but only a collection of type-motifs constituting the
insignia of the cult, or names of the *òrìṣà*, and which functions as the locus
of worship. The configuration of the Òsányìn cult-stereotype thus exactly
reproduces imagery associated with the worship and propitiation of the
god; it is a materialisation of all those natural forces seen as operative in
the healing process. Herbs and specifics necessary in this process, gathered
in the forest, relate the cult to the *òrìṣà* whose power over iron dominates
the life of the forest – Ògún, in his second function – and this relationship
is expressed in the imperative use of iron in its imagery.

The Ọ̀gún priest or smith is also sometimes a 'medical' healer. Among the Yoruba Negroes of Brazil and Cuba Ọ̀ṣọ́ọ̀sì worship still persists in the cult of Ọdẹ-Ọ̀gún:[1] Ọdẹ, the hunter, in his association with Ọ̀gún, *òrìṣà* of iron. (In Brazil, Oxóssi has been identified with St Sebastian, as has Ọ̀gún with St George.) Johnson mentions at the court of the Aláàfin at Ọyọ – traditional capital of the Yoruba empire – the high-priestess Ọdẹ as head of all the worshippers of Ọ̀ṣọ́ọ̀sì, Ọ̀gún's wife; on state occasions she appears dressed as a hunter (hence her hame) wearing across her shoulders a bow strung with cowries.[2] Similarly at Ọyọ the traditional iron Sword of Justice of Ọ̀rányàn, the sanction of the king's power of life and death, is held by a priestess known as the mother of the shrine of Ọ̀sányìn (Ìyá Ilé Ọ̀sányìn); it is she who performs propitiatory rites to the god of medicine before the sword can be used.

The Ọ̀gún-Ọ̀sányìn relationship is further exemplified in the nature of objects used to mark that spot in the Ọ̀sányìn shrine where are buried the 'invoked substances' bearing the spirit of the *òrìṣà* – an *oṣun* (ritual staff), a 'gourd' made of iron, and the pair of pincers or tongs sacred to Ọ̀gún and which is one of the principal type-motifs in his worship;[3] the whole is girded about with the palm fronds used on iron smelting furnaces to ensure the surveillance of the god Ọ̀gún during a smelt.[4] During worship the new shoot from the heart of the palm, called *màrìwò*, is worn by Ọ̀gún cult-members; a strand of it is also tied around the Ọ̀gún cult-icon in the shrine or on any object used to mark the sacred spot. Such an icon is always fashioned with prominent male genitalia, said to signify the male exclusiveness of the cult, but more plausibly symbolising the generative importance of iron in agricultural communities, figs 47, 48.

Also necessarily made of iron and universally uniform in imagery and rendering is the *oṣun* Erinlẹ̀ (the ritual iron staff of the Erinlẹ̀ cult). Erinlẹ̀ is conceived by the Yoruba as the deity of the untamed jungle as distinct from

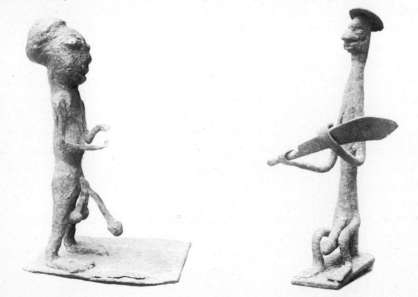

47 and 48. Iron figurines, Yoruba

òrìṣà Òkò, the deity of settled cultivation, whose connection with Ògún is similarly expressed in the obligatory use of an iron staff. The origin of the motif of the crested bird which forms the finial on the *oṣun* Erinlẹ̀, and the association of this cult with that of Ògún, is expressed in the following myth from Iwo.

All the hunters of the forest one day revolted against Erinlẹ̀, assailed him, and left him wandering helpless. When found by his wife he requested her to plait his hair into a coxcomb or crest. Then, changing himself into an elephant, he sank into the earth.

The elephant is trapped by hunters by means of covered pits; the name Erinlẹ̀ (*erin*: elephant, *ilè*: home) signifies the forest as the abode of this god, though the myth possibly implies the ascendancy of Ogún, god of iron, over Erinlẹ̀, god of the forest. In a description of the cult Johnson records that 'the representing image consists of black smooth stones from the river and an image of iron surmounted by the figure of a bird. The followers are distinguished by wearing a chain of iron or brass round their necks and bracelets of the same material.'[5] The smooth stones from the river in Erinlẹ̀ worship suggest a perhaps remote association with the thunder-axe known in Ògún worship. The elephant remains sacred to worshippers of Erinlẹ̀, as do two birds with crests reminiscent of the coxcomb of Erinlẹ̀'s translation: the *agbe* and the *àlùkò* birds – one green, the other purple. As the finial on the *oṣun* Erinlẹ̀ such a crested bird is surrounded by an apparently indeterminate number of motifs drawn from the life of the forest, representing tools and weapons as well as such creatures as the frog, the snake, the lizard, etc., reptile motifs probably associated, on other evidence, with the fecundity of earth as symbol of life itself, fig. 49. Like the *oṣun* Òsányìn some of these staffs carry a sacrificial platform along the shaft, others do not. In a role similar to that of the *oṣun* Òsányìn the iron staff of Erinlẹ̀ stands guard at the entrance to the shrine, marking the spot where the archetypal substances of the cult are buried. The spot is also marked by an

49. Type-motifs on ritual iron staffs for *Òrìṣà* Erinlẹ̀

image of the *agbe* or the *àlùkò* bird made to near likeness but of heroic size and covered with live feathers.

Thus the forest, as the source of all herbs and of the abode of the hunter, forms the link between the three Yoruba cults Ògún, Òsányìn, Erinlẹ̀.[6] In the cult of Ògìnyán – the festival of the new yam – occurs the little known staff at fig. 50 with associated type-motifs of digging-stick, axe, mattock,

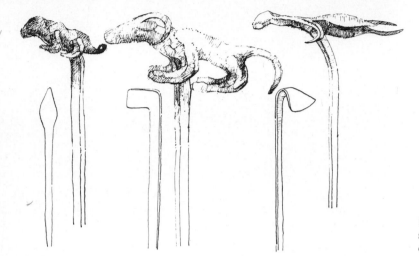

50. Type-motifs on the iron staff for *Òrìṣà* Ògìnyán, *òrìṣà* of the new yam

etc. The significance of the deer which forms its finial is obscure, as is indeed much to do with the cult itself. Also intimately related with Ògún is the cult of *òrìṣà* Òkò, the god of agriculture, whose massive Norman-looking iron staff, around two metres high, is invariably beautifully wrought, chased and studded. This impressive object is built around a wooden armature; it was conceivably at some remote period made entirely of wood, and associated with the digging-stick. Its construction is explained at fig. 51. The several standardised divisions seem to have only a technical, not a ritual, significance; in any case any correlation between belief and form in these staffs is today quite forgotten. Though still linked with agriculture and the life of the farm the staff also functions, not surprisingly, in an associated fertility cult.

Developed in the far west of Nigeria in the tiny rock-bound village of Ìràwọ̀ the cult has today spread throughout Yoruba country, its priests everywhere so rigidly controlling the production of the stereotype that, allowing for slight regional interpretation in proportion and embellishment, this staff of the *òrìṣà* Òkò remains the uniform product of the cult across various subgroups. Excellent examples survive in ritual use at the settlement of the kings of Old Ọyọ at Igboho – the town in which four Yoruba Aláàfin were exiled, probably *c.* 1555 to *c.* 1610.[7]

Periodically washed with sand and lime to preserve their metallic lustre these staffs are a fine testament to the traditional skills of the African smith – skills which have also been impressively exercised in the fashioning of

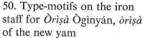

51. Construction of the iron staff for *Òrìṣà* Òkò. (*a*) and (*b*) are of wood, (*a*) being bound with an iron strip and crowned with a solid spiked iron head

elaborate standard lamps such as we find at Benin and among the northern Yoruba, in which as well as various objects of daily and functional use are incorporated figurines on human and animal themes, figs 52, 53.

52. Standard lamp, Afemai

53. Detail of fig. 52

Skills developed over the years in the fashioning of these various objects placed at the disposal of the artist a range of forms in wrought iron and a freedom in their use which come to maturity in the virtuoso pieces from Nigeria and Dahomey. Behind these pieces, both among the Fon and the Yoruba, stands the tradition of decorated iron staffs in which wrought iron is worked into the complex repertory of forms demanded in the representation of implements of war, of the farm, and of bird and animal motifs, by bending, twisting and hammering into sheets out of which are structured the convex and ovoidal forms characteristic of the *genre*. The famous Dahomey example representing the god of iron, Gu, represents cult-imagery associated with this god among the Fon; the assembled type-motifs which constitute the theme of the head-dress are cutlass, hoe, digging-stick, fish-hook, etc. Other staffs on which figurative motifs appear are wrought exclusively to the royal ancestors – a tradition which seemingly goes back to the calabash of offerings used in mortuary rites; their various elements name specific attributes of the ancestor (*noms forts*) and partake of his being.[8]

We may distinguish in this *genre* between primary and derived forms. The former are solid and occur in figurines which make no attempt at naturalism: they remain close to the original rods and bars of circular or rectangular section, of the forge, fig. 54. The latter on the other hand widen the range of the geometrical elements of structure employed by the artist in the creation of hollow volumes of single and double-curved surfaces – cylinders, truncated cones, paraboloids, etc. – resulting in shapes more to be expected in cast rather than in beaten metal, figs 42–45. This conscious

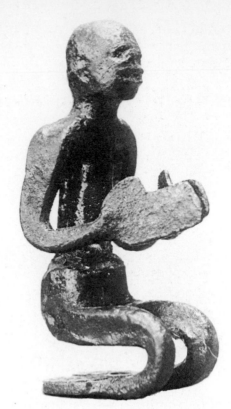

54. Iron figurine, Dahomey (Yoruba)

approximation of derived form to the forms of nature might perhaps represent a chronological relationship in which the primary forms resulting from twisting, bending, splitting, etc., are earlier; they are certainly technically inferior. In the absence of welding and riveting, the structure of the characteristic iron figurines produced by the Bushongo, fig. 55, the Daho-

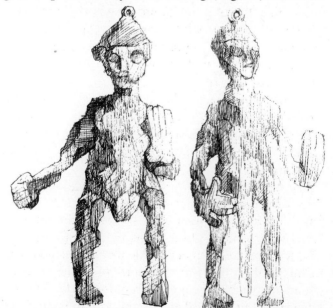

55. Iron figurines, Bushongo, Congo (after Torday)

mey, and the Yoruba is determined by the need to use as few constituent pieces as possible – a technique demonstrated in the facture of the ritual staffs, fig. 56. The overriding aesthetic appeal of these pieces rests therefore

56. Ritual iron staffs, Yoruba

in the logic of the construction method in its realisation of forms that are inevitable and true to the material: forms which in many cases are as unitary as the carver's block of wood. The realisation of a diversity of shapes from a given bar of iron of circular or rectangular section expresses the same formal resourcefulness for which African wood-carving is already noted.

Limitations imposed by the nature of the material severely confine the

representational content of the work to a few generalised statements so that to the European eye the validity of the work rests in the formal solutions achieved in its manufacture. It is in this that we may most satisfactorily relate the aesthetic of these African iron figurines to forms outside African art; for an appraisal of this structuralist aesthetic is most readily suggested by the Suprematist and Constructivist theories of the Russians, Malevich and Tatlin, who between 1913 and 1917 formulated those concepts of non-objective art which have had such a profound effect on European plastics to the present day. For Malevich, the Suprematist theorist, reality in painting is inherent in the sensational effect of colour itself – an idea pursued with varying degrees of rigour by Delaunay, Mondrian, and various contemporary practitioners of Optical Art. In three-dimensional plastics the Constructivist view that matter carries its own primary visual appeal, which is vitiated when bent to representational ends, opened new possibilities of expression in twentieth-century art, in which the most unlikely materials came to be employed to aesthetic ends, the process of facture being seen as itself an aesthetic element, and as invoking spatio-temporal expression through the resolution of the concept. One imagines that the successors to the constructivist aesthetic – Gabo, Pevsner, Gonzales and all those sculptors of the present moment to whom the nature and behaviour of matter is of supreme importance in the process of making – would have found small difficulty in accepting the aesthetic of these cult-figurines, for by the inescapable suppression of representational fidelity the human figure in African iron remains confined to structural issues raised in the reduction of bars of the metal to purely conceptual form. It is the solution to such issues which imparts to these works a formal integrity which today we appreciate only as a result of the non-objective experience in European art of the past half-century.

Before *c.* 1500 come the various forms of the African iron gong today covering a distribution area from the Bahr el Ghazal in the Sudan to the ruins of Zimbabwe in Southern Rhodesia, and on the West Coast to Nigeria and Ghana, fig. 57. It has been suggested that the Yoruba design, the so-called sistrum, also depicted on the Benin bronze plaques, was used in Egypt during the Twenty-fifth (Ethiopian) Dynasty[9] – the period of those Kushite kings who after nearly a hundred years on pharaonic thrones were to introduce the Egyptian plastic to the Napatan and Meroitic kingdoms of the Sudan. For what it is worth the suggestion is there that this gong design, like a few other ethnographic traits occurring today in West Africa (such as the African comb, the cosmetic *kohl*, etc.) followed probably the same route – across the Sahara corridor – as that taken by a possible Meroitic stream of influence in the iron industry, though why the 'sistrum' should disappear along the southerly route into Uganda, where techniques in the iron industry apparently did not, remains a puzzle. But it is interesting to note that the folded design from Zimbabwe is echoed in brass types still sold in the markets of Uganda, and which also occurs in wooden forms

57. African iron gongs. (*a*, *b*, *c*) Zimbabwe; (*d*) Katanga; (*e*) Ghana; (*f*) Uganda; (*g*) Nigeria; (*h*) Ghana; (*i*) Barotse; (*j*) Urangi. (Except (*e*) and (*h*) all types are after Walton. cf. folded types, (*b*), (*d*) and (*f*) with West African folded types, fig. 213, (*l*) (*p*) the latter dated at *c.* AD 1000; (*e*) and (*h*) are seventeenth century types still common today (after Barbot))

among the tribesmen of Somaliland as a camel bell, in pottery in Ruanda Urundi, and in decorated wood in the Congo (see fig. 213m). As though there is not enough confusion, this folded type also occurs in the lakes region of the Upper Niger, excavated in a context which suggests a date *c.* AD 1000, and is still in use today among the Dogon, fig. 213p. A tubular type of iron bell also occurs among the Kiga, north of Ruanda, near Lake Edward.

Tribal movements from possibly remote periods have thus established a cultural context of considerable extent for the iron industries and their products. Moreover, a certain amount of religious interrelationship in imagery has occurred, for instance between the Fon and the Yoruba. The cultural environment for the study of the development of iron sculpture has traditionally transcended presentday political boundaries – a fact which has permitted us to isolate this *genre* as an independent artistic phenomenon within our object of study, subject to the history of the medium, the reaches of technique embraced within this history, its cult orientation and the implications of its spatial distribution. These factors were conditioned too in a more general sense by African attitudes regarding the nature of matter, of time, and the nature of man himself – attitudes which relate the life of forms in African iron sculpture to sculpture produced in other media despite the disparity of forms in which they are expressed. It is these attitudes, and not the nature of the resulting forms, which provide a view-

point for appraisal, and comparative data for relating African iron sculpture
to the general phenomenon of art as human beholding in other cultures.

Iron in African art has taken us across two thousand years to obscure
contacts across the Sahara with the Mediterranean, and perhaps with the
Nile, and we have noted the winning of the metal by African smiths in the
forests of Guinea and the Congo from perhaps as early as *c*. AD 500.
For want of a more suitable term we have named these activities industries,
but in their lack of capitalisation of raw material and process, in their
method of organisation in the family and the clan and above all in their
characteristic lack of understanding of and control over the metallurgy of
the craft, traditional African iron working amounted to anything but an
industry. It was indeed so inefficient that despite the almost universal availa-
bility of high-grade ores in these communities iron-hunger had from the
earliest times plagued the African breadwinner, with a corollary protein-
hunger which would contribute to the ritualising of the metal in certain
important areas. These conditions had a decisive effect on the organisation
of the slave trade during the mid-stretches of the seventeenth century on
the basis of the European iron bar. This trade would in its turn itself for-
ever destroy any possibility of the development of a true iron industry.
These conclusions directly affect our study of the emergence of iron forms
in African art, for it is precisely in the operation of those modes of meta-
physical rather than of physical apprehending, which we have already
examined, that the iron art of tropical Africa developed.

Techniques, wrested from nature over two thousand years of the history
of the metal in its westward journey from early beginnings among the
Hittites, were absorbed on the African continent not into a physical but
into a metaphysical world order in which spirit or force or energy was
conceived to be instinct in every natural substance. This vital force, also
dwelling within man himself, could potentially operate on the world and
on man with beneficent or harmful effect, depending always on the rela-
tionship at any given moment between man and the gods who in their
functions severally represent these forces of nature – a relationship princi-
pally characterised by propitiation and worship. The transmutation of
base rock or earth into enduring metal of such vast potential for the com-
monweal and for the exercise of power would be the most patent expression
possible of inherent vital force in natural substances, a force to be controlled
by subjection and prayer at each stage in the handling of spirit-bound
matter. In the silence of the forest the miner raises his prayer to the god of
iron before his descent into the mine; on the day of the smelt he observes
a blood sacrifice to the block of granite containing the spirit of the god; he
dresses before his unlit furnace, in the obligatory white of purity, having
had no contact with a woman, and ties around its waist the girdle of palm
branches sacred to the god whose fertile power might be graphically expressed
in a pair of female breasts modelled on the furnace wall; his bellows might
carry prominent male and female genitalia, as do the pair of Congolese

iron figurines. Even when beaten into a hoe, the farmer must further placate this wild and potent metal and not consider it 'tamed' until it has worn white with use.

Thus the metaphysical controlled the techniques of iron-smelting and iron-working. Nevertheless rule of thumb observances everywhere underlay successful practice. Shortly after lighting his furnace and girding it with the protective palm the smelter tests with a flaming brand the combustion gases escaping from the furnace flue for the change from carbon dioxide to carbon monoxide which signals the moment for insertion of his charge of ore; throughout the process of reduction he takes precaution against inducing a liquid metal through overheating the furnace. As we have seen too, he is aware of the vital function of his flux and the method of producing it as a byproduct of smelting, though he could hardly explain its action on his ore. The smith in his turn is fully aware of the hardening effect of repeated heating and hammering of the bloom which he has received from the smelter, but could not dilate on the accidental absorption into the metal of the small quantities of carbon responsible for such hardening. The empirical development of metallurgy in Asia and Europe was not therefore open to the African craftsman trained from apprenticeship to suspect unfamiliar phenomena and to regard deviation in practice as potentially harmful; processes in his craft, strictly spirit-controlled, were not open to inquiry, to extemporising, to invention or the formulation of that body of theory which characterises a true metallurgy.

The products of his craft impregnated the earth and secured the iron worker's home; its highest efforts consequently flowered in the forms of worship, in the exigencies of ritual. The practice which lay behind the working of sacred figurines and the diverse forms of cult-insignia produced an iron sculpture of such rigour as to be readily translatable into the austere requirements of the European plastic of the twentieth century. The vision of artists who profitably continued in wrought iron forms that echo African architectonic concepts, grounded in the instinct and autonomous energy of the art-object, has contributed to change in the course of European plastic art from the time of Cézanne and the Post-Impressionists. The utterance of these iron forms in African art, now ritually silent but still embodied in masterpieces from Dahomey, and in the sacred and ceremonial figurines of the Yoruba, the Bambara, and the Bushongo, has not therefore passed unacknowledged in the wider culture of man.

Into the coming of iron we read significance for the development of all the arts of tropical Africa. Though the Guinea forest had possibly been inhabited for the previous two or three thousand years or more we might expect the coming of iron to have brought about changes revolutionising the arts by creating those conditions which give birth to the gods; how otherwise explain the numinous nature of so much of tropical African art when contrasted with the art of the Sahara, with which nevertheless it bears affinities? By virtue of their small size African wood-carvings suggest the possession of iron, forms developed in an iron age in response to

systems for symbolising experience among settled peoples, settled cultures. Into such systems bronze entered, and the fact that in tropical Africa bronze is an Iron Age phenomenon explains the processes of its flowering in sacred and secular forms.

Part Three

COPPER, BRONZE, GOLD

13　African Bronze Workers and the Western Sudan: *c.* AD 950–1484

The division of the past into historical ages characterised by mastery of the material most widely employed in man's daily life – Stone, Bronze, Iron Age, etc. – will not take us far in understanding the nature of metal art in African societies where these terms, as we have seen for the Iron Age, would need to be so qualified as to become virtually meaningless. There was a time when iron came; there was a time when bronze came. And that in tropical Africa they occur in this order is itself indicative of the relative uselessness of the terms in any but the most general sense. The Iron Age merely denotes a period during which along with slings, throwing-sticks, wooden clubs, etc., warriors also used arrows tipped with iron (but still carrying those tipped with reed), swords, spears, etc., while on the farm their wives employed cutlass and hoe along with the digging-stick – conditions which persisted in some communities well into the present century. The sickle, used in Bronze Age Egypt, remains unknown, as does the range of tools necessary in the arts of carpentry and joinery. The use of iron makes no difference to problems of lifting and shifting, to the harnessing of power, to the centralisation of capital and the development of industry, nor to improvement of the processes of primary production; so that there is small evidence of that widespread transforming of the environment in tropical Africa which we associate with the coming of an Iron Age. These are the conditions in which form was apprehended in African art in all its media of expression. Apart from the metaphysical implications of man's subjection to the environment already discussed, function and process in the practice of the arts were also affected: wood-carving remained without the jointing, by nail, mortice-and-tenon and similar devices, which would have been possible within the experience of carpentry; figures therefore remained small and rarely achieved the dimensions known for instance in Old Kingdom Egypt; cast iron work, mastered in India since the fourth century, as exemplified in the Delhi column, remains unknown throughout all periods. Though iron is everywhere employed for the most primary utilitarian ends, the Iron Age in Africa did little to augment the range of man's ten fingers.

In the westward spread of metallurgical ideas from Asia Minor, effective contact was established with these areas only after the European Bronze

Age had been succeeded by the Iron Age: the first material contact of tropical Africa with the outside world was therefore of the Iron and not of the Bronze Age. We have seen the truth of this for African iron-working, or at any rate for one influence affecting it, in the introduction of the Celto-Roman domed furnace to the western Sudan at some period, apparently, around the opening years of the Christian era or the closing years of the first millennium BC. It is significant that the great schools of African bronze-casting should all be located within the area which we have defined for the distribution of the domed furnace – an area bounded on the north by the course of the Niger and on the south by the Gulf of Guinea, and that contacts affecting the emergence of these schools are separated from the Bronze Age of Europe and the Mediterranean by a good thousand years or more. As we have said, African bronze working is an Iron Age phenomenon. The cultural stages implied in the use of the terms Iron and Bronze Age run concurrently: iron and bronze work are products of a common social and metaphysical environment. But whereas iron was ritualised in its vital role in the survival of the common man – as his cults demonstrate in agriculture, the harvest, the hunt, in medicine, in war, etc. – bronze is significant in African societies principally in the appurtenances of priest and king, of ritual and ceremony; on the one hand subject to the metaphysical ordering of the universe, on the other to institutions of divine kingship. To the present day in most societies it retains semi-precious associations referring to a period upwards of a thousand years ago when it was bartered for human flesh and gold; for as long ago as the fifth century BC we hear of a gold trade conducted by silent barter on the Atlantic coasts of the continent in which Carthaginians acquired the metal from the circumspect natives of the western Sudan.[1] And though from Arab times, during the eighth century, African gold had started caravans moving south, laden presumably with Mediterranean wares, it is not until the tenth century that we first hear of copper in this trade.[2] Henceforth and throughout medieval times, quantities of copper and its alloys would be fed by this trade into regions south of the Sahara, and in this way contribute to the rise there of the bronze industries which have since so astonished the world.

It is difficult to imagine that these medieval Moors, braving the hazards of the Sahara, were any more conscious of playing a civilising role in Black Africa than the seafaring Portuguese pioneers who in the fifteenth century began to seize the initiative in the trade. Yet consciously or no these foreign agents would profoundly affect the social and cultural life of Africa and consequently the nature, if not the expression, of its art. In the Lower Congo a sacred imagery in bronze follows hard on the heels of the exploring Portuguese – a mission-inspired art which also affected Bini work of the same period both in bronze and in ivory. Some years earlier, perhaps before the close of the fifteenth century, a tourist trade in carved ivory had sprung up among coastal natives of Sierra Leone to meet the demands of Portuguese seamen.[3] The Aṣante *kuduo* (bronze reliquary) is predominantly characterised by Muslim decoration, and copies of Bini artifacts made in Portugal,

and of Kalabari brasses made in Manchester are still to be seen in African collections.

Nor was the African caster slow in copying the objects of exotic appeal that came his way: the history of the medium is pleasantly punctuated by his interpretations of early Christian bronze lamps, Renaissance vases, Portuguese and Indian heads, Indian elephants and a wealth of decorative motifs originating in Europe and the Mediterranean. But it is as sources of raw material that the early contacts were most important in determining the cultural environment of the tropical African bronze, for with raw material eventually came technique, and technique in the African bronze offers something of a picture of its past.

But though the written sources cover a longer period in the history of bronze than they do for iron, we are in some respects in a less sure position for studying it in depth, bronze having never been independently ritualised. There are no separate gods explaining its adoption in African societies and the means by which it came to be generally used; it appears everywhere to have been adopted within ritual systems previously associated with the working of iron, notwithstanding the separate identity and function of the bronze caster and his generally more elevated status. The patron of bronze has typically been a member of a prestige class associated with court or with cult, the alloy being the luxury article *par excellence* in traditional times. Despite its ubiquity its confinement to a largely exclusive patronage makes it rather more elusive an object of study than iron. Even though materially the African bronze has been as linked with European sources as was iron, and though its masterpieces are today among the best known examples of African art in Europe, it has nevertheless remained of less significance in the history of modern European art than have been for instance African wood, or even iron, sculpture; the medium has been entirely ignored by European artists of the modern movement. The reason seems to be that European appreciation of the African bronze was based on those examples closest to the European aesthetic – those of the Ifẹ and Benin schools; but African bronzes exist, and remain unknown, which by their conceptual originality are of greater significance in the study of aesthetics than the products of Ifẹ and Benin.[4]

Bronze objects are known from Senegal to the Cameroons and into the Congo but the alignment of such objects with known schools of casting remains a difficult task for the art historian, for the African bronze has traditionally been subject to extreme mobility. There is evidence of the institution of the travelling smith, known in Bronze Age Europe, whose activities would have distributed idiom and technique over large areas. The lifetime of one such itinerant craftsman in a given area would produce problems sufficient to bedevil inquiry for months in the field, even supposing that a converse and much more confusing activity had not been occurring simultaneously: certain spatially closed and stable schools appear as manufacturers of export wares which, apart from finding their way great distances afield, are frequently not in the idiom of the school concerned but

in that of the client who has submitted an object, in any medium, to be copied. Benin, Ijẹbú-Òde, and perhaps Ifẹ̀ all seem to have functioned in this way.

It will be necessary to distinguish between the schools responsible for this diversity and intermixture of idioms. As we did for iron we should therefore try to frame the existence of the African bronze within temporal limits which may reveal something of its growth in relation with cult and court. Finally, applied to African art, the term bronze is an approximate one. Though it is generally true to say that most African 'bronzes' are in reality brasses – those of the Ifẹ̀ corpus for example – sufficiently extensive analysis has not so far been carried out for confident determination on the vast number of examples to hand, many of which are still held in shrines and continue in use. So avoiding the pedantic and in keeping with the accepted loose manner in which the term is employed in the literature we shall continue to speak of bronzes in a general way (Ifẹ̀ bronzes rather than Ifẹ̀ brasses) except where a distinction between the terms furthers discussion.

Who were the pioneers whose interest in the southern Sahara was to initiate the cultural changes in the western Sudan and Guinea, which in turn stimulated the growth of the medieval empires of Ghana, Mali, Songhai? Who were the first traders to western Africa and with whom did they trade? Bettering an early Greek voyage that may have reached the Senegal River the Carthaginians seem to have taken the first good look at the mysteries of the dark continent, its volcanoes belching to the skies, its strange animals and stranger people – and its gold. But their part in the gold trade up to Roman times does not have the significance for us which it might, for whatever the merchandise they traded – perfume, Egyptian stone, Greek pottery – it is unlikely to have been the brass which was to distinguish the cargoes of the caravan trade of a later day, the alloy being then virtually unknown. Copper and bronze the Carthaginians would have known, and perhaps even supplied to their colonists left scattered along the Atlantic coasts of Africa as far south, perhaps, as Arguin Island, but these would hardly have been the principal materials in a trade to which the natives of the western Sudan seem to have been even then no strangers. According to Palmer these were perhaps the Sanhaja (so called by the Arabs) and the Lamtuna, the earliest stocks of the western Sahara. The latter in medieval times roamed from the salt fields of Taghaza to Timbuctu in the Niger valley and may have played their part in the awakening of empires to the south. Perhaps it was they who bore the Roman furnace to the headwaters of the Niger, though it is sometimes claimed, with more likelihood, that the Jewish dispersal from North Africa early in the second century could materially have affected this region of the western Sudan and the blood of its populations.[5]

Following their bloody revolt against the Greeks in Cyrenaica and Egypt AD 115–*c*. 117, groups of these dispossessed Jews, migrating south-ward, are thought to have settled among the pastoral Fulani of Senegal and Futa by whom they were absorbed: just the evidence we would seek

as explaining the incidence of the domed furnace in the area and nowhere else in tropical Africa. But the tradition, though conceivably embodying a degree of truth, unfortunately remains without supporting evidence, unless the distribution of this furnace type now makes it seem more plausible. These Jews certainly appear to have been in the right place at the right time to lend credibility to the hypothesis which might lead to yet further speculations as to their possible role in the gold trade to the Mediterranean initiated by the Carthaginians, which appears to have died out during Roman times.[6] In 734, shortly after their arrival in North Africa, the Arabs mounted their first expedition southwards in their search for the city of gold; descendants of their troops led against Ghana between 734–750 had become pagan Ghanaians by the mid eleventh century.[7] But not for another half century, in 780, would written records relate a definite connection between the Mediterranean trade entrepôt of Tahert (Tiaret) and the central and western Sudan, whither trade routes now led direct to Gao on the Niger, and to Ghana; and half a century later still Ghana first appears on Arab maps.

From the earliest times the pull of the Saharan salt mines would have drawn Ghanaians northwards: their chronic need of salt would be the complement of the gold upon which their empire eventually came into being – an empire which in the later eighth century appears to have spread from the hinterland of Senegal to the basin of Lake Chad. El Bekri (1067) mentions salt imports at Gao on the Niger from Tadmekka (Es Souk) and even further afield.[8] By medieval times Taghaza had become a great salt depôt meeting southern needs against an exchange of millet – a city of salt such as Camus (and Herodotus before him) describes, its houses and mosques built of salt-blocks roofed with camel skins. In the words of a contemporary, 'The Negroes come up from their country and take away the salt from there.'[9] The caravan trade did not therefore go in one direction only; Negroes from the forest may have been acquainted with the exotic wares of North African bazaars from the earliest periods, at first bringing back such luxury items as caught individual fancy and stimulated the acquisitiveness of those at home. In this way we might perhaps explain the presence of copper objects south of the Sahara – trinketry and miscellaneous trivia which first appear there, apparently, only towards the close of the first millennium AD.[10] This date seems entirely plausible when we consider the deadening Vandal influence of the fifth and sixth centuries, and that at the time of the emergence of the colony at Carthage in Augustan times brass was still a new product of Roman metallurgy which would hardly have been available in the quantities required in a transcontinental trade.

Within the buckle of the Niger occur a number of sites in which neolithic remains and iron objects have been found in association; the same area yields fine filigree copper jewellery and bronze objects – all suggesting that these sites represent two historical stages, the latter perhaps associated with Old Ghana at its apogee, between the tenth and early eleventh centuries. Here we have tumuli burials in which ornaments and belongings in

precious copper and bronze are ritually buried with the dead. In this culture brass and iron appear on the breastplates of horses, in horse-bits, sabres, lances, arrows, hatchets, and various other sophisticated weapons and implements; these latter have been credited to invaders who had introduced techniques of metal working and building in brick and stone. However, the great burial tumuli occurring everywhere in the area establish the existence of a civilisation already expert in weaving and in making pottery of a perfection not achieved by later conquerors of the western Sudan – Susu, Malinke, and Bambara – all of southern origin.[11]

Now excavation at Kumbi Saleh, the capital of Old Ghana, has confirmed the splendour and sophistication of the city. It was divided into two sections, one inhabited by proud and wealthy Arab traders from the Maghreb occupying the Mediterranean type stone house not then common in the western Sudan, the other by the black kings of Ghana bound to their traditional religion and beliefs. Until its destruction by the Almoravids in 1076 the population of Ghana had remained predominantly pagan, dependent for material amenities, even for badly needed salt, weapons and tools, on the only source of these things open to them – the lands to the north. Uneasy must have lain the heads of the Ghana kings when the sanctions of power so patently lay in alien hands; uncomfortable too must have been daily relations between contemptuous Arab and proud pagan, neighbours in spite of themselves, thrown together at the gateway to the gold mines of Guinea – a situation generating its inevitable conclusion in the *jihad* which would bring pagan Ghana to dust and affect the subsequent history of the entire area. In the daily life of the two sections, the two cities, it requires no effort of the imagination to envisage the role played by the African townsman or peasant. In the metal arts he would certainly have served an apprenticeship by means of which technique and its benefits would slowly have been acquired by his own people, in fashioning the delicate filigree work, for instance, which these Arab merchant-princes would have had made for them by jewellers up and down the Mediterranean, skilled in the business since antique times. These craftsmen moving south with their patrons, would transmit the knowledge in many an unpretentious workshop, glad of the black labour to hand. For filigree work with its techniques of fine wire-drawing or hammering, its gold and silver solder, its fluxes and delicate blowlamps could have been acquired by the African only through apprenticeship, and such an apprenticeship would also teach him the many and complicated processes of casting metals by the technique of *cire-perdue* – a technique which he can be assumed to have employed at first in the goldsmith's workshop before applying it to brass and bronze, fig. 58.

From an early period in the history of the western Sudan may conceivably have come the treasure of cast gold figurines found in Tripoli in 1929, of importance perhaps in revealing the nature of forms which would subsequently characterise bronze art. As yet, surprisingly, a confident Arab culture in the western Sudan, that of Ghana for instance, has yielded to the

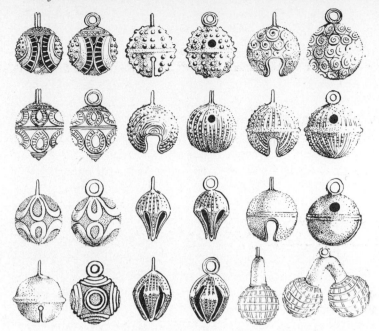

58. Filigree gold work, Aṣante

spade few objects of the bronze caster's art which can unequivocally be regarded as of local manufacture; copper trinkets of the period from sites all over the region are mostly crude representations hammered into the shapes of birds and lizards, etc., with ornamental items such as crotals, bracelets, and rings. It would seem that though hammered copper and brass were used for small ornaments in a local industry the more ambitious type of object in cast brass or bronze continued to be imported from the Maghreb. Very likely the cupreous alloys remained too valuable right to the end of the period to be used other than as jewellery or currency. Copper pins from Kumbi Saleh, flattened at head and tail, strongly suggest this use. Throughout medieval times copper bracelets are used as currency in the gold trade of the western Sudan and continue to be so used as this trade turns southwards with the coming of Europeans in the fifteenth century; in Nigeria the standardised currency bracelet, the manilla as it came to be called by the Portuguese, was withdrawn as currency only in 1946. A small copper bar was perhaps used as currency at Takedda to the north of Nigeria in medieval times[12] where Ibn Battuta (1354) describes a more important copper currency cast

into bars a span and a half in length, some thin and others thick – the thick bars sold at the rate of four hundred to the *mithqal* of gold, and the thin at the rate of six or seven hundred to the *mithqal;* with the thin bars they buy meat and firewood, with the thick slaves, male and female, millet, butter and wheat.[13]

Ibn Battuta's observation is probably the earliest written reference to the local casting of the metal; but though the process employed is a far cry from the technique of *cire-perdue* casting, the mining, smelting, and casting of copper into ingots for a local trade cannot pass unnoticed, for it implies

the use of much the same range of tools and equipment necessary in brass or bronze smithing – furnace, bellows, crucibles, moulds, and iron tools for handling the liquid metal.[14] Such mines and their accompanying workshops were scattered at various sites throughout the western Sahara; their products however, apparently at no time great, were always secondary to imports crossing the desert from the Mediterranean and Europe. A Genoese trader stationed at Tuat in 1447 observed that the alloy was brought from Romania – which we know to have been exporting bronze since the second millennium BC – to Alexandria, whence it was sent south along the caravan routes of the western Sudan. Eight years later the Venetian navigator Ca da Mosta observed Arabs in the hinterland of Cape Blanco with a large train of camels carrying brass, silver and other merchandise 'from Barbary to Tombutu and the country of the Negroes from whence they bring gold', which gold 'is sent in divisions first to Toet (Tuat) and from thence to Tunisia'.[15] It is sometimes claimed that one of the motives prompting Mohamed Ali's invasion of the old Anglo-Egyptian Sudan in 1821 was the fame of the copper workings at Bahr el-Ghazal from whence the metal reached the markets of Kano and the western Sudan to the Hoggar Mountains, traded there by Baggara Arabs.[16] This industry may well have been stimulated by the eastward movement of those peoples from the Chad basin towards the end of the fifteenth century and the beginning of the sixteenth who eventually founded the Funj kingdom of Sennar.[17]

Copper ingots excavated in 1952 at Maranda near Takedda in present-day Niger, are of the type noted by Ibn Battuta six hundred years earlier – 'a span and a half in length', fig. 59. We can deduce from their shapes that these ingots were cast in the open stone or clay moulds still to be found in the workshops of the West African smith, which, apart from causing the characteristic semicircular section, also sometimes produce flanges by an overflow of the liquid metal. That these flanges do not run the entire length of the bar in the examples recovered merely indicates that the moulds in which they were cast were not seated horizontally during the pour: they were never meant as makeweight as suggested by their excavator.[18] Crucibles from this site are smaller than those used in bronze-casting today, but size here is very much determined by the volume of the desired pour and the limitations of the bellows employed. Similar copper-smelting crucibles have been recovered at a site which their excavator considers to have been in twelfth-century Gao.

Maranda, an old caravan halt, was known to the earliest Arab travellers. In the mid tenth century its black inhabitants were thought to be connected with the peoples of Gao and Ghana. Its copper trade, like that of nearby Takedda, reached Nigeria through Gobir and perhaps continued into the fifteenth century; Maranda was still inhabited in the late eighteenth century, though by then its workings had disappeared.[19] The open mould of fig. 60, photographed in northern Nigeria, could equally have been recorded at any bronze-casting site in the forest region: Iwo, Ọyọ, Ekiti, Ifẹ̀, Ibadan, at all of which places it is still used – another bit of material evidence for

59. Copper ingot from Maranda, near Takedda, cast from an open mould similar to that described by Ibn Battuta in the local industry, in 1354. Such ingots are still produced in Nigeria (after Mauny)

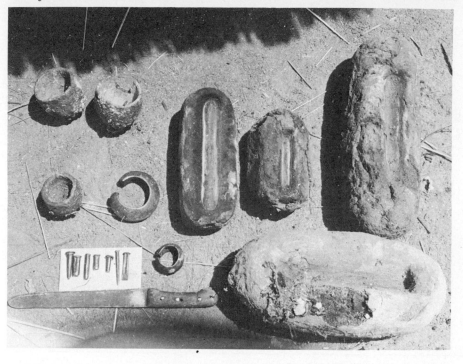

60. Open mould for casting brass or copper ingots, cf fig. 59

linking at least some of the bronze industries of West Africa with those of the western Sudan and the Mediterranean; its use at Takedda establishes a *terminus a quo* for copper-working in the Nigeria area, for the ingots purchased would be worked in one form or another by their buyers. Though copper is known to have been traded to Old Ghana from at least as early as the tenth century, for material evidence of its working in Nigeria we must rely only on the distribution of this open stone of clay mould, which produced the ingots still cast in the same method today by smiths in that country. How the metal was worked – whether by cold-hammering into ornaments and implements, by alloying with zinc to make brass, or with tin to make bronze – we do not know. The two latter processes would imply a knowledge of techniques for casting the alloy produced – which would be made for no other purpose.

A sequence seems to have occurred in the founding of the Sao culture of Lake Chad in which, according to local tradition, two separate groups of immigrants brought respectively copper jewellery, and the metallurgy of iron and bronze. The Sao culture is considered to have lasted between the eleventh and the fourteenth centuries.[20] In Old Ghana too we have noticed primitive copper-working, by hammering, from the earliest periods, but indigenous bronze-casting by the *cire-perdue* process does not seem to have attained the mastery there which we observed in the Sao examples; not that this latter carries particular aesthetic significance – its interest lies chiefly in the mastery of technique and on the light which this technique might throw on bronze-casting elsewhere. Certainly at some stage after the tenth century, possibly quite some time afterwards, the primary working

of copper by hammering into images and perhaps into implements was succeeded by the casting of cupreous alloys: the evidence provides no reason for looking farther back than this to account for the rise of the bronze industries of West Africa.

In seeking a temporal framework for bronze-casting industries south of the Sahara we may consider a few bare facts: that beginning with Al Hussein (950) we have written evidence of trade copper entering Old Ghana, and that copper ingots reaching Nigeria from a mine at Takedda in the Sahara in 1354 were cast there in moulds such as are still used by the African smith. That in these four hundred years the art of *cire-perdue* casting was possibly learnt in the area is suggested by the gold hoard of cast figurines of African imagery found in Tripoli, though they may well have been cast later: the casting of gold figurines was observed among the Dinkira of the Gold Coast (Ghana) hinterland in the early eighteenth century,[21] in a counterfeit trade already noted by English travellers towards the end of the previous century.[22] We can only say that they are more likely than not to have been made during or before the virtual end of the Saharan trade in the fifteenth century. For how long the open mould of Ibn Battuta's day has been employed in the south we cannot say; its presence there is cited merely as material evidence for the connection of these industries with those of the western Sudan and the Mediterranean, a point on which considerable speculation still exists. By 1485 brass is used in Bini kingship ritual, but the relevant objects, described in the sixteenth century, still carry a Mediterranean association and do not necessarily imply brass casting in the forest regions:

King John (of Portugal) was informed by the Benin ambassadors who came to desire the priests for their instruction, that 250 leagues beyond them was the most powerful Prince of all that country, called Ogane; by whom the kings of Benin, for the security of their title, were confirmed, receiving from him a staff with a head, and a cross like that of Malta, all of brass curiously wrought. An ambassador was always sent with presents to solicit these ensigns of royalty for the Benin kings: but he never sees Ogane, because he speaks from behind a curtain. Only at their departure from the audience does he show a foot in token that he grants their request.[23]

During this period bronze bracelets, pendentives, animal figurines, etc., are being cast among the Sao of southern Lake Chad by methods which appear similar to those of certain industries farther south. A dispersal of smiths following on the Muslim interdiction against graven images after their conquest of Bornu in the sixteenth century is thought to have spread Sao techniques among the Hausa and Kanuri where to the present the itinerant smith is a tradition.[24] Farther south it is generally claimed that bronze was being cast at Ifẹ early in the period, for it is from Ifẹ that the technique is believed to have been learnt at Benin at dates variously placed by recent writers at *c.* 1280 and *c.* 1380; but plausible as these dates may seem within the period we must observe that they are based entirely on oral

tradition and tendered in every case with very uncertain supporting evidence. An Ifè-Benin succession in bronze-casting is at least open to doubt.[25]

So for the period which marks the coming of brass to the western Sudan and Guinea, which we have chosen to close with the date of the era opened by the arrival of the Portuguese, we shall content ourselves with accepting that copper and its alloys were known and worked, that the casting of bronze by the *cire-perdue* process was practised around Lake Chad and probably elsewhere, that a ritual imagery was perhaps already developed, and that brass had already acquired a sacred function in the institution of kingship at Benin.[26] But for the existence of local schools of figurative bronze-casting anywhere in the Guinea forest with its implications of tradition and canon we have no evidence at all.

14 The Bronze Schools and their Techniques: Introduction

To define the limits of idiom and style as a school is a useful if necessarily alien conceit in the study of African art. Conforming to a particular controlling canon by virtue of those stereotypes which serve to perpetuate its forms, schools in African art, and particularly in bronze casting, can be as distinct and mutually independent within a given tribe as between tribe and tribe separated over great distances. Its cult or ancestor orientation is the peculiar mark and patent of each school, no one conforming to the sense of rectitude or beauty of another, though within a given school there may paradoxically exist several idioms resulting from instances where an established and gifted group serves as a factory in an export market affecting distant or conquered peoples. The present Ọba of Benin, Akenzua II, claims that in olden times his brass casters sometimes made replicas of objects sent them for this purpose by neighbouring peoples.[1] Thus cult objects controlling ritual sanctions in one area could be manufactured in another area at the dictates of an alien idiom. Copying of this nature might take place as far afield as in Europe: a documented example of objects so copied is provided by two brass monitor lizards in the Pitt-Rivers Museum, Oxford, made by an English firm to the specifications of the people of Bonny, in Nigeria. According to Horton the monitor lizard is one of the manifestations of Ikuba, the god for whose shrine the pieces were offered. From the same area comes a churrigueresque bronze figurine of a European apparently cast in Europe. In such cases the bronze copy soon acquires the ritual determination of the model from which it was made (lizard, animal skull, etc.) and is then believed to have been 'brought out of the river', or 'left behind by the water spirits', etc., so that its original identification with a given school, in the absence of the determinants of such a school, is later difficult to establish.[2] But this is a phenomenon restricted to relatively few schools in African bronze-casting; in most cases, though the distribution area of a given school might be very large as a result of the activities of the itinerant smith, technical and iconographic determination remains a possible means of isolating and defining such schools. It is their techniques, their distribution, their style influences or style isolation, and the cultural environment affecting them as a whole which we shall now examine.

Major influences affecting the rise of bronze industries south of the Sahara have been exercised, as in the case of iron-smelting, from the north.

These industries have emerged in much the same area as that of the domed furnace of Mediterranean connections. By far the most important of bronze-casting schools have flourished and continue to flourish in what is today known as Nigeria. Bronze-casting has also arisen in the Cameroons, Dahomey, Ghana, the Ivory Coast, Liberia, Sierra Leone and Senegal, but nowhere in any of these centres do we find the rationale of a school: the aesthetic canon, the clearly defined local tradition which isolates and controls the activity and produces a corpus which is an intelligible object of study. In the present state of our knowledge the concept of the school is to be encountered only in Nigerian local practice. In the Lower Congo bronze was introduced by the Portuguese after the fifteenth century by techniques which are not characteristic of tropical Africa; smiths there have employed an open mould process virtually unknown elsewhere. It is in the *cire-perdue* technique that the masterpieces of the African bronze have been created, and this technique gives a unity to practice throughout the region.[3] It was possibly already in use in Ghana around 1555, for at this date the English sea captain John Lok observed weights and measures in the gold trade which may even then have been, as they were at a later date, the miniatures on geometrical and animal motifs cast in brass now characteristic of the *genre*, fig. 61. Recent research has

61. Gold weights, Ghana

suggested that these were preceded by certain seeds, but we have no relative dates.

In Nigeria five great bronze-casting schools, and possibly a sixth, each of autonomous idiom, occur within an area bounded to the east and to the north by the course of the Niger and to the south by the Guinea coast – an area marking the easterly limit of distribution of the domed furnace. Each of these schools has produced masterpieces of bronze unrivalled by the products of any other in tropical Africa: the study of the African bronze could in fact be legitimately narrowed to a compass embracing the operation of these half a dozen or so schools, for among them are posed all the problems attendant on an understanding of the growth of the industry. No schools of bronze are known for eastern Nigeria. Though bronze objects in a variety of idioms occur there in some profusion we have no evidence for aligning objects from this area with any local industry – the hypo-

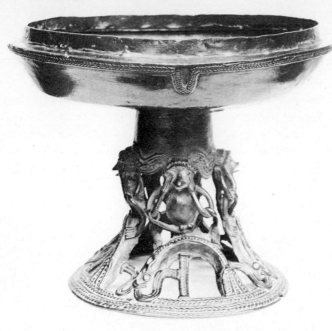

62. Bronze dish, provenance unknown (southern Nigeria)

thetical Lower Niger industry, for instance, remains without its workshops, figs 62, 63. The well-known 'Ibo' or 'Ibibio' brass bells were possibly cast in the Cameroons if we accept the evidence of an observer who in 1923 recorded a typical 'Ibo' bell which he describes as cast by the Eyāp tribe who manufactured them for export only, having themselves no use for

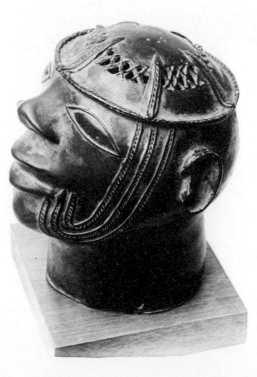

63. Bronze head, provenance unknown (southern Nigeria)

64. Brass bell from the Cameroons. This 'Ibo' or 'Ibibio' brass bell frequently found in eastern Nigeria, was recorded in 1923 as being cast in the Cameroons (after Thomas)

such objects,[4] fig. 64. West of the Niger are traditional schools at Ifè, Benin, Ijèbú-Òde, Abéòkúta, and Ọbọ Aiyégúnlè in northern Yoruba. Some slight evidence suggests that a bronze school once flourished at the seat of the old Yoruba empire at Ọyọ-Ilé about a hundred miles to the north of present-day Ọyọ.

From Dahomey comes a characteristic bronze idiom of no great plastic quality, as well as more accomplished work in wrought iron, and in beaten copper or silver. Ghana, farther west, has produced superb masks in bronze and gold, figs 65, 66, as well as the bronze *kuduo* already noted, of Islamic

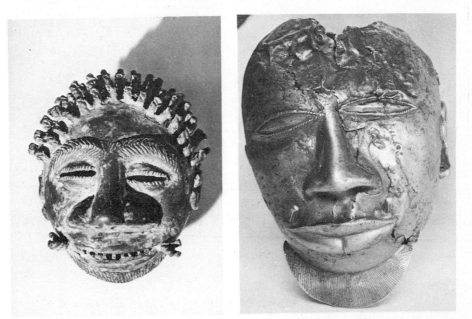

65. Bronze mask, Ghana

66. Gold mask, Ghana

design but of African facture, said to have served traditionally as reliquaries on the graves of important persons, fig. 67; small gold ornaments worn by Aṣante priests secure the Moslem association. The Aṣante and the Baule have produced miniature castings in *cire-perdue* so similar in execution and imagery as to suggest a common source of influence. Sixty years ago Desplagnes cited the resemblance of this work to certain Habe castings of gold weights: 'Les Habbés . . . sont surtout connus en Europe par une série de figurines du même genre rapportées de la Côte d'Ivoire, et servant de poids à peser l'or. Ces figurines représentent les animaux totems et les emblèmes des diverses familles . . .'[5] This is certainly not the only time that the iconography of the Guinea bronze has been enriched from a northern source. Filigree-working, which has very remote traditions in the eastern Mediterranean basin, was introduced to Italy by the Venetians and into Spain by the Moors, both events indicating dates for its appearance south of the Sahara within the bronze period which we have delimited at around the tenth century.

Bronzes of no particular aesthetic merit come from the Senufo, from the Sao peoples of Lake Chad, from the Cameroons, and from the Mende

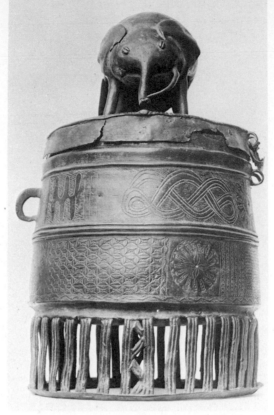

67. Bronze reliquary, Ghana

of Sierra Leone – among the latter small *cire-perdue* castings reminiscent of the gold weights just mentioned. There is an extremely accomplished group of bronzes, so far of unknown authorship, held in shrines at the villages of Jebba and Tada on the Niger which, though insufficiently homogeneous to be regarded as constituting anything like a corpus, are nevertheless of importance not only in their evident connections with the work of established schools to the south, but also in their unique aesthetic in the African bronze, figs 161, 162. Awaiting methodical study are a variety of pieces from the Tiv of the lower Benue – work minor in intention and achievement though here and there not lacking in charm; on the basis of extant examples we are not however so far in a position to think of them as constituting a school in the sense of other great centres in Nigeria, figs 68, 69.

A group from Igbo Ukwu in eastern Nigeria is remarkable, and justly famous, for a fragile jewel-like aesthetic of a delicacy to be compared in Africa only with Roman pieces imported at the Nobataean capital at Faras: nowhere again shall we encounter the diaphanous lightness of these calabash shapes, crescentic drinking-bowls, mammoth shells, reptiles and animals, though approaches to the sculptural human figure are insignificant or non-existent – only a small human face so far appears among this group. Here again we lack the wherewithal to speak of a school, of the

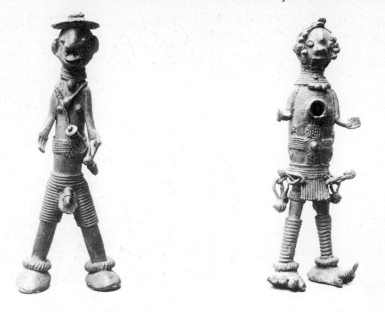

68, 69. Bronze figurines, Tiv tribe, Nigeria

skills of generations of craftsmen moved by a controlling impulse consistently developed and resolved. Like much else in the African bronze these pieces all seem the work of a moment, an exquisite explosion without antecedent or issue, but the filling out of the corpus by recent archaeology may place future scholars in a better position for art-historical and style appraisal, figs 70, 71.

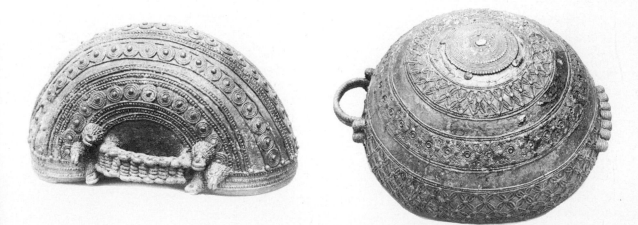

70. Bronze crescentic vessel Igbo-Ukwu, Nigeria

71. Bronze bowl, Igbo-Ukwu, Nigeria

Unique, but as yet also of unknown authorship are the castings of animal skulls recovered in various areas of the Niger delta. Like the bronzes of Igbo Ukwu, no local traditions of casting are associated with these pieces, fig. 72. In the case of many African bronzes we may think of isolated workshops of no long life, of itinerant craftsmen perhaps producing work to local demand but whose forms are bound by the inevitability of no strong tradition: the evidence of today's tourist industries in the African bronze

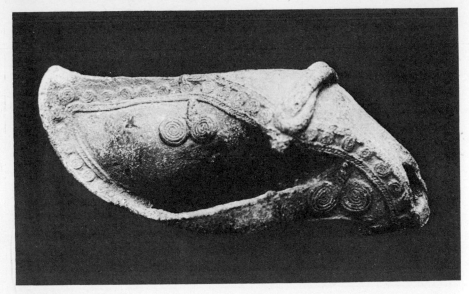

72. Bronze animal skull,
Niger delta

are at least suggestive. From remote times too bronze objects, by virtue
of the semi-precious value universally placed on the alloy, and in their
association with cults that flourish and decay over wide areas, have been of
great mobility.

The study of the African bronze is to be meaningfully illumined only in
the operation of the great schools of casting so far known to us. Far the most
important of these from an historical or aesthetic viewpoint are those
confined within the western areas of present-day Nigeria – those from Ifẹ̀,
from Benin, Ijẹ̀bú-Òde, Ọyọ-Ilé, and Ọbọ Aiyégúnlẹ̀; and in subjecting
these schools to study in our appraisal of form sacred or secular in the African
bronze, it is as well to remember that we are dealing not with the unified
political relationships of the present day but with the role of bronze in his-
torically autonomous and independent states distinct in traditions and polity,
in the control of wealth and power, and related only in the effects of sub-
jugation or conquest. In this context the notion of the individual school
takes on the significance normal to it in the study of any art, African or
other.

15 Ifẹ-Benin

The central mystery of the art of Ifẹ is that oral tradition cannot account for it; no bronze industry exists there today which could materially contribute to an understanding of this school in its historical connections, nor are the objects the centre of any cult which might shed even an oblique light on their former significance. There is in fact a hint of evidence that the people of modern Ifẹ, today so divorced from its art, ritually 'kill' or otherwise render innocuous historic terracotta pieces which they happen upon from time to time in the occupations of the farm.[1] Yet it appears both from the bronzes and the terracotta that this art once performed a ritual function. The lack of Ifẹ traditions concerning bronze and terracotta is in frustrating contrast to the situation at Benin where tradition remains in relatively sharp focus, where bronze-casting is practised to the present day by strictly traditional methods, and where idiom continues conservative and venerated by the contemporary people. Despite historical associations with Ifẹ there are at Benin no traditions which throw any light whatever on Ifẹ bronze-casting. This historically anonymous situation of bronze at Ifẹ is remarkable when the city is considered as the sacred cradle of the Yoruba peoples, as the school from which Benin is alleged to have learnt the art, and when we remember the sanctity in which its kingship is held among all Yoruba peoples to the present day. The coronation of a Yoruba Ọba is sanctioned by the Oni of Ifẹ – a tradition which has inclined certain opinion to identify the Ogane of the fifteenth century Portuguese account, already mentioned, with the Oni of Ifẹ, though we have no grounds at all for assuming the connection.[2]

The site of the holy city has changed more than once in traditional times, its present location being the last of several previous settlements. This may account for the vagueness of local tradition and for the absence of *in situ* schools of bronze-casting in the tradition of the classical heads.[3] Several towns and villages in present-day Nigeria are known as Ifẹ, and Ifẹ-type manufactures, such as stone carving and the famous pottery pavements, occur at sites today distant from the holy city.[4] Here we have a culture which in the light of recent archaeology wove, manufactured glass beads, constructed houses in clay, and created a classicising art in terracotta and in bronze the like of which in its singularity of idiom continues unknown elsewhere in Tropical Africa. But in spite of its primacy in Yoruba culture and persistent traditions which claim it as the mother of all traditions, its supposed antiquity and associations with Benin in its glory, its material remains so far known are surprisingly few; the bronze corpus at present

comprises less than thirty pieces, and the terracotta are not remarkably many, all well within the productive life of a single artist – even a Giorgione, or a Vermeer. We may assume, though, that much yet awaits the spade: the terracotta continue to be unearthed by farmer and by builder. By contrast, sculpture at Benin runs into thousands of known pieces, all extant at the time of the destruction of the city in 1897; it is doubtful whether any great new hoards of Bini art will be revealed by archeaology. Unlike those at Ifẹ̀ too the Bini bronze heads and bronze plaques are supported by a welter of objects from the industry of utilitarian or ceremonial use – bowls, boxes, stools, personal ornament and insignia which, all together, promote a three-dimensional reality and credibility completely lacking in the Ifẹ̀ corpus.

Confronted only with the surviving objects it is difficult to sense the quality of the Ifẹ̀ ethos, unsupported as it is by evidence from the related arts – architecture, and wood- and ivory-carving mainly – though the thematic rigour of some Yoruba sacred drumming heard in Ogboni houses might suggest the sense of number implicit in these bronzes. The coldness of this art results not only from its classicising idealism but also from this quality of immobility in the social context; its forms lack those attributes which necessarily express the contingencies of time, the elements of discovery and adaptation, the energy implied in failure – and consequently, despite its 'portraiture', human appeal. Intentionally or not it is an art of number, the expression of a mensurational idealism which would have been perfectly comprehensible in the age of humanism, in the ordered interpretation of visual experience of a Piero della Francesca, a Brunelleschi, an Alberti: the harmonic structure of the universe reflected in the deliberate constructs of man, fig. 73 – a comparison worth making in face of the facile alignments from time to time proposed between the Ifẹ̀ and the Bini schools. What would a Bini bronze – any Bini bronze – have meant to the architect of the façade of S. Maria Novella! But the fact that the Òbàlúfòn mask from Ifẹ̀ would not have seemed out of place in this Florentine church points merely to the conceptual originality and greatness of the Bini bronze – quite the peer of Ifẹ̀, and infinitely more African. An art of particular connotation, even of comment, the Bini stereotype always leads back to human existence in space and time. It is an art of kings but here too are the beasts and creatures of forest and field, 'merchants, soldiers, and wild beast hunters', girls and boys, the passage of custom down the years; it is an art of stereotypes whose resistance to decay is reflected in its conservatism of idiom and whose forms are perhaps the most eloquent celebration of purely secular existence anywhere to be found in Africa.

But Bini art has fared badly in the literature. One reason for this might be its unfounded association with that of Ifẹ̀. First apprehended in Europe as the righteous loot of a 'city of blood', it remains part of the ethnographica of the world's museums to the present moment. Yet its sobriety, its integrity, its explosive restraint, its *intellect*, should be grist to the mill of many a modern theorist. For at all periods it remains an earthbound and secular

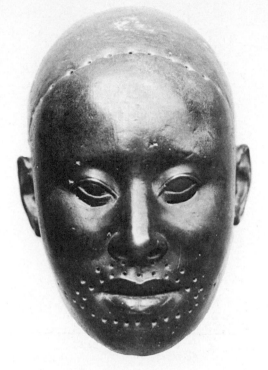

73. The Obàlùfoǹ bronze
mask, Ifè

art realised on that borderline where classical clarity and instinct energy
meet, a border country not perhaps inhabited by European art since the
cubist researches of Braque and Picasso in the two or three years before the
beginning of the First World War. If the Ifè bronze provokes memories of
Palladian geometry, that of the Bini most readily expresses the aesthetic of
the Musée de l'Art Moderne and the seriousness of European art in the
first two decades of the present century, fig. 74.

Yet traditions of origin continue to relate the two schools – Benin learnt
bronze from Ifè, early Benin therefore looks like classical Ifè. Chronologies
have been constructed on this precarious assumption. But demonstrably
Bini art can be claimed on much material and iconographic evidence to
represent an entirely independent and original flowering of the African
genius. Because of the importance which this supposed Ifè-Benin succession
in bronze-casting has assumed in recent scholarship it may be fruitful to
consider the relative claims and confusions which have arisen in the past
few years.

Two accounts of the origin of figurative bronze casting at Benin are pro-
vided by Bini court historians, and both are in print:

When the white men came, in the time when Esigie was king, a man named
Ahammangiwa came with them. He made brasswork and plaques for the king,
he stayed a very long time, he had many wives, but no children – the king gave
him plenty of boys to teach. We can make brasswork now, but not as he made it,

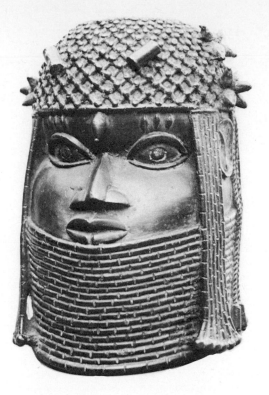

74. Bini bronze head with high collar

because he and his boys are dead. Before King Esigie died he sent one man named Inoyen to the white man's country with some white men. He stayed long, and when he returned he brought back with him that plain stool and a message of salutation from the king of the white men.

When Erisonye was king he had one made like it so that men might see it and say: 'Look, Erisonye made this.' When Osogboa was king he sent messengers to the King of Igbon, a country near the Niger – but the people of Igbon were bad, and killed the messengers – then Osogboa was vexed, and he sent war against Igbon and caught the king and plenty of his people. When they brought them Osogboa called Ahammangiwa and his boys, and asked them if they could put them in brass. They said: 'We can try.' So they did, and those are they. The king nailed them on the wall of his house. The other plaques are pictures of white men, friends of the kings and Ahammangiwa, but who they are or their names we do not know.[5]

The second account is more recent:

Ọba Oguola wished to introduce brass casting into Benin so as to produce works of art similar to those sent him from Ifè. He therefore sent to the Oni of Ifè for a brass smith and Iguegha was sent him. Iguegha was very clever and left many designs to his successors, and was in consequence deified, and is worshipped to this day by brass smiths. The practice of making brass castings for the preservation of the records of events was originated during the reign of Oguola. He lived to a very old age.[6]

The most that can be said for these two accounts is that they each acknow-

ledge an outside agency for the introduction of bronze. In regard to the first, it may be argued that the name Ahammangiwa is as likely to refer to an Arab visitor to the Benin court as to a European, supposing it not to be a corruption; there is some evidence that Arabs were traditionally regarded as 'white'. But, as will be shown in Ch. 18, bronze-casting method at Benin is wholly different from that traditionally practised in the north and is more readily associated with European sixteenth-century practice. It remains difficult, however, to regard Ahammangiwa as a Portuguese name. According to this account, in any case, Ahammangiwa and his assistants were the first to cast bronze plaques at Benin. As regards the second account, there is at Ifè no corroborating tradition, nor is the craft there remembered to have been introduced from a foreign source even though the origin of this art, in its classicising idealism, would seem in greater need of explanation than that of Benin with its typically African aesthetic. The first account, obviously the official one at the close of the nineteenth century when this historic art was brought to an abrupt end by the British punitive expedition, seems to have been replaced after the conquest by the second, more traditional-sounding one, involving an Ifè-Benin succession already recorded by Talbot in 1926 and by von Sydov some years later.[7] The first tradition is specific in the bronze objects cited: those plaques commemorating Orhogbua's victory over the 'Igbon' of which, from their subject matter, several versions may be attributable to the period, and the royal stool of Eresonye's time, *c.* 1735–1740, fig. 199. The relative dates are the first half of the sixteenth century, and the middle of the eighteenth century though it would be obvious, and the account does not claim this, that the tutor, Ahammangiwa, could no longer have been alive at the time the stool was cast. The objects cited in the second account are of a more general nature, referring only indirectly to the founding of the plaque tradition as a whole. It is at present thought that, as with most of the Yoruba kingdoms, the second dynasty at Benin, to which this second account refers, was founded around the beginning of the fourteenth century,[8] though so far no evidence exists of the role of bronze there at this time. The point has been made by a historian of Nigeria that through four hundred years of contact between Benin and various nations of Europe no hint of this relationship with Ifè emerges in any record until after the British occupation of the kingdom, and he quotes a tradition recorded in 1823 which describes the founder of Benin as 'a white man who came from the great water'; to this undated ruler was attributed the introduction of the working of brass, iron, and ivory, and the establishment of laws, a tradition which, like the first, places the inception of bronze-working at Benin within the European period, i.e., after the completion of the navigation of the Guinea coast in 1485.[9]

It will be recalled in the light of this tradition that the iron-smelting furnace type, as noted in the previous chapter, is different in this region from that known among the Yoruba. The Bini moreover have no independent god of iron (they have accepted the Yoruba deity), and tools used in the industry appear to have been different in traditional times from those

known to the west – the smith's hammer, for instance, pictured in the bronzes.

The second account, according to which the knowledge of bronze casting was brought from Ifẹ̀ *c.* 1280 or *c.* 1380, invites examination in the light of the Portuguese account of brass insignia conferred by an inland monarch on Bini kings in the middle of the sixteenth century.[10] If these early dates for the introduction of bronze are accepted, then a good two or three hundred years' experience in casting would have lain behind the Bini Ọba at the time that the tradition of an Ogane was first recorded. In 1540, in their own words, this was a 'very ancient custom' among the Bini. The precious insignia of kingship could therefore reasonably be expected to occur in the bronze record expressly instituted 'for the preservation of the record of events' concerning the Bini monarchs. Though representations of these occur on bronze plaques attributable to the seventeenth century, no extant Bini bronze can at present be dated in the thirteenth or fourteenth centuries. The bronze record seems more readily to support the Ogane relationship than the Ifẹ̀ one, for none of the bronze heads claimed to have been cast at Ifẹ̀ up to the fourteenth century and sent to Bini Ọba in confirmation of succession have been recovered in intensive excavation of the Benin palace area,[11] though the Ifẹ̀ archaeologist Willett has recently announced carbon-14 dates of the sixth and tenth centuries for the burial place of the heads of deceased Ọba sent to Ifẹ̀, according to tradition, in exchange for bronze ones. Nor has archaeology recovered any of the 'many designs' claimed to have been left to his successors by the supposed Ifẹ̀ tutor, Iguegha.[12] If both accounts are acceptable, then the spiritual overlordship of the Bini would seem to have been held successively by the Oni of Ifẹ̀ and the Ogane of so far unidentified location, the first up to at least the fourteenth century and the second later. It may be relevant to mention here that at Benin a change in the manner of succession is believed to have taken place around 1700 – from brother-to-brother to primogeniture.[13] In the seventeenth century the Ogane's insignia occur on an important Tada bronze, on several Bini bronzes and on a small bronze figure (the ascription is only tentative) conceivably of the Ifẹ̀ school, figs 75, 76 (i and j), 87. The dominion of the Ogane seems therefore to have been felt at Benin at this time. It may also have been felt at Ifẹ̀.

The second account indicates, and independent evidence supports it, that bronze came earlier to Ifẹ̀ than to Benin. Technique in the two schools differs, however, that at Ifẹ̀, in common with the Jebba-Tada group, apparently deriving from an early northern source perhaps with Mediterranean associations. As will be seen, technique at Benin is conceptually independent of northern influence and appears to have coastal and European associations. On internal evidence, as indeed seems to be claimed in the one tradition, the journalistic and narrative bronze plaques, meant to serve as a kind of pictorial archive of the Bini court, appear to represent the earliest efforts of the Bini bronze caster. The making of bronze plaques, on the other hand, was apparently unknown at Ifẹ̀.

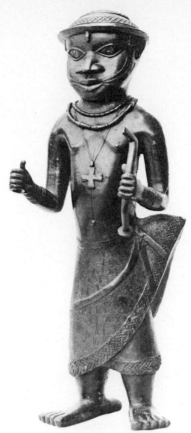

75. Benin, bronze figure with Maltese cross

The ceremonial of the Ogane, also that of the Mais (kings) of Bornu, appears to have been typical of Tuareg nobility. One of these, with his hornblowers and courtiers, is represented in a much-cited drawing of 1825 by the explorer Denham, sitting in a sort of kiosk from which he granted audience. Palmer has pointed to a connection of old Bini traditions (and those of a number of societies of the lower Niger) with Kanem-Bornu: the staff of royalty, the cross, and the disc, to which may be added the so-called high-collar of Bini nobility, which recalls the mouth-veil of Bornu tradition. At Ijèbú among the Yoruba royal crowns exist which carry the face veil, and the convention is widespread in various other Yoruba ọbaships and chieftaincies, though unknown at Benin. Resulting from the Beni-Hilal conquest of the Fezzan around AD 1050 the Chad basin appears to have received an influx of Teda peoples fleeing south and mingling with the older populations, particularly the Jukun. Palmer gives the following note on the modern Kanuri version of the succession of races who have inhabited or ruled the country to the west of Lake Chad, which is now Bornu: 'the tribe called M'bum, and then the tribe called Kwona [Jukun], then the tribes called Tuareg Kindin Kel-Bura, then the tribes called Sau [meaning according to him merely indigenous Negroes or Negroids]: then the Maghumi descended from Saif: then the tribe called

Kai Bulala.' According to the Sao records they have been in their present Dikwa habitat since about AD 1000, which would place the period of Kwona (Jukun) domination at a period anterior to that.[14]

It has been observed that principally among the Jukun the cruciform emblem is used as a symbol of office and that throughout all the regions in Nigeria affected by Jukun influence – from the area of Dikwa to the coast near Calabar – nearly all the symbols of office, such as staffs, are based on the principle of a shaft, two arms, and sometimes a central projection. In some cases the result is a trident, in others a cross.[15] The trident spear carried by Kanuri nobles was the badge of the god of water; a similar trident was used by the Durbi at Katsina for the purpose of divining who should be the new king; at the sanctuaries of Bugudima in Tibesti is said to be a trilith, about ten feet high, which is a trident.[16] At Ifẹ̀ the famous five-metre high obelisk to the Yoruba culture hero Ọ̀rányàn bears a trident design of iron nails driven into the granite, while, as has been noted, the 'staff with a head' – a long segmented staff ending in a disc – appears on several Benin bronze plaques carried by the king. In these plaques a great

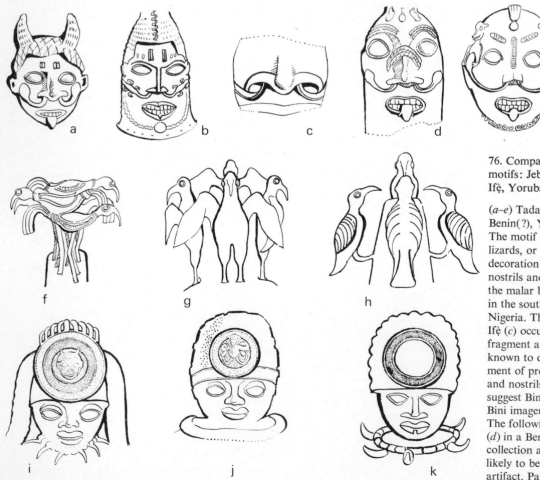

76. Comparative iconographic motifs: Jebba, Tada, Benin, Ifẹ̀, Yoruba

(*a–e*) Tada, Benin, Ifẹ̀, Benin(?), Yoruba.
The motif of everted snakes, lizards, or simply a linear decoration issuing from the nostrils and running across the malar bones is widespread in the southern bronze of Nigeria. The example from Ifẹ̀ (*c*) occurs on a terracotta fragment and is the only one known to date, but the treatment of proportions in lip and nostrils more readily suggest Bini authorship and Bini imagery, cf. fig. 77. The following example (*d*) in a Benin private collection appears more likely to be an Ijẹ̀bú (Yoruba) artifact. Particularly striking

in this series is the motif on all but the Ifẹ̀ example (the relevant part is missing) in which a spatulate object is clenched between bared teeth. In the example at (*d*) it is figured as a leaping frog. Note the disc beneath the lips of the Benin bronze at (*b*) possibly to be associated with insignia of royalty conferred by a foreign spiritual overlord. It occurs elsewhere in the Bini bronze, worn as an armlet or mounted on a staff, as also at Tada, fig. 87, and *i–k* below

(*f–h*) Tada, Benin, Yoruba. The Tada motif of four birds forming a finial to a head-dress frequently occurs at Benin, and also occasionally among the Yoruba. Among the Yoruba, birds, usually pigeons, occur fairly commonly on brass staffs to the Ogboni and sometimes to Ògún; four birds as a finial here occur on a large Yoruba Ogboni bronze (Ibadan) in a style datable to the period 1640–*c*.1835; cf. figs 217–19

(*i–k*) Tada, Jebba, Benin. The occurrence of the head-disc on these three 'warriors' is amongst the strongest evidence we might hope for of a connection between Benin and some powerful northern kingdom responsible for the authorship of these Jebba-Tada bronzes. Since we may not consider the lip mark at (*k*) an anatomical peculiarity of the Bini, it does not seem unreasonable to read it as an abridgement of the frog-motif at a–e. See figs 161–63. Note the collar of teeth and bell pectorals in these examples.

disc is also worn on the royal left arm. This motif is common to Jebba, Tada and Benin, fig. 76 (i – k), at all of which places it is employed in the same manner: as a head disc, or a finial on a royal staff. The Maltese cross appears as a prominent motif on an important Tada bronze. Very striking in the consideration of northern influence on southern iconography is the face on the Tada head-disc in which a spatulate object is clenched between bared teeth. This motif occurs also on bronzes of undoubted southern provenance, for example on a bronze bell from Benin (but probably made at Ijẹ̀bú), and on a bronze mask in the Nigeria Museum of Yoruba facture, fig. 76 a–e.

At Benin too, as at Ifẹ̀, appears an earth taboo also observed among the Jukun, in which the feet of a king may never come into contact with the ground; this perhaps accounts for the curious motif in Bini art in which the legs of the king are represented as looping outwards from the body in two opposed semicircles ending in what appear to be fish heads – a sign, like many another used by the Bini smith, in keeping with the conventions of drawing available to him, lacking, as we shall see, recourse to the methods of linear perspective,[17] fig. 77. On King Ovonramwen's entry into Benin City in 1897 as recorded by a local historian, he was 'supported in the usual way by chosen men holding him up by each arm'; for the Bini artist it is difficult to imagine a convention, other than that employed in the plaques, for rendering this effect. It would be interesting to find among the Jukun, should the evidence ever come to light, a graphic device illustrating their version of the tradition in which the Aku, their divine king, was so heavily charged with life force that his feet must not touch the ground for fear of causing damage to the crops.[18] The characteristic vertical stria-

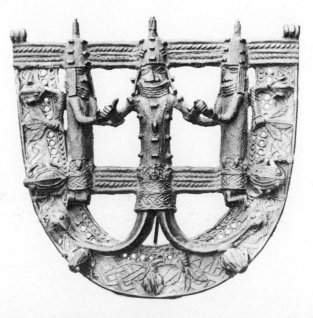

77. Benin, bronze plaque of an Ọba with everted legs

tion of the Ifẹ heads is still to be observed on the faces of Kanuri tribesmen from Maiduguri in northern Nigeria, fig. 112e, f.[19]

So the evidence for a connection of both Benin and Ifẹ with some northern centre of bronze seems strong, and while we are far from locating such a centre the evidence at least suggests that a wider cultural context than is at present accepted needs to be sought to explain much in the nature of Bini art, its relations with Ifẹ, and the art of Ifẹ itself.[20] In this connection it might not be amiss to speculate upon the existence in the history of Nigerian, or even perhaps West African, bronze-casting, of the influence of now extinct schools of northern orientation, just as there are extinct peoples, whose successors in the south have continued traditions the origins of which are now lost.

The Sao culture provides one example of such an extinct school, and the dispersal of smiths therefrom with implications of their influence has already been noted. According to Palmer the Jukun, the Hausa, the Nupe and the Songhai all owe their smithcraft to old traditions from Kanem-Bornu. A competent centre of bronze certainly seems to have existed at the now vanished capital of the Jukun at Kwororafa; from the area has come the example at figs 78, 79, which in the evidence of the crotals employed

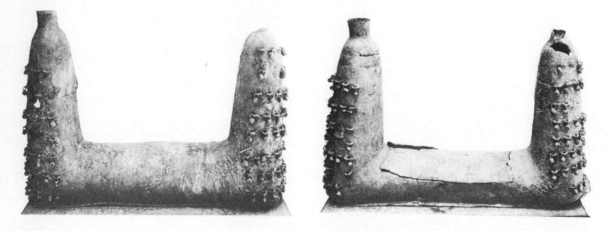

78–79. Bronze head-rest, Jukun

suggests a date after 1590, a time when the power of the Kwororafa is at its height. According to the Kano Chronicle, Bauchi and Gombe were by 1600 tributary to the Kwororafa; it is now fairly certain that during the sixteenth century their power extended over most of the area enclosed by the Benue and the Niger. During the seventeenth century Kano and Katsina both fell to them and Bornu was saved only by Tuareg intervention. When we recall that some of the bronzes at Jebba and Tada – the group representing warriors – were certainly contemporaneous with the height of Jukun power, it does not seem absurd to seek connections which link these bronzes with the north-east, if not in authorship at least to some extent in the sources of their unique iconography. Benin was in its glory, though there the close of the sixteenth century did not, as we shall see, witness a bronze art of the mastery of the Jebba-Tada pieces. Apart from the evidence

of a shared iconography between Benin and Jebba-Tada we have the picture of a realised and accomplished bronze industry in the north at a time when the Bini were yet fumbling for the terms of their bronze canon, figs 80, 81.

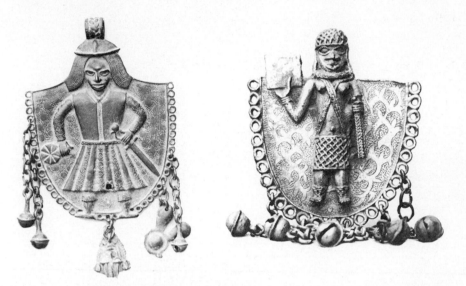

80. Shield plaque with Bini-type crotals

81. Shield plaque with European-made crotals

At whatever centre these Jebba-Tada bronzes were actually cast their maturity certainly preceded that of the Bini bronze, and though a similarity of iconographic motifs does not necessarily imply a technical connection we cannot ignore in the case of the Bini bronze the direction in which iconographic influences point. Among the welter of shared motifs we may regard as striking the incidence of the collar of teeth at Tada, at Benin and elsewhere on the lower Niger, figs 82, 83, 84 h, j. Traditions are likely to travel in any

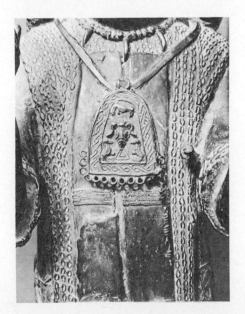

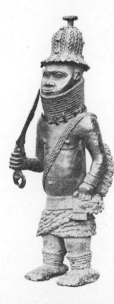

82. Tada, collar of teeth

83. Benin, collar of teeth

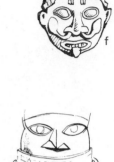

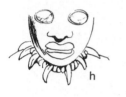

84. Comparative iconographic motifs, Jebba, Tada, Benin, Ijẹbú-Òde, Igbo-Ukwu (*a–e*) Taɗa, Benin, Jebba, Ijẹbú-Ode, Igbo-Ukwu. In the two interpretations of the so-called ram's head motif at *b* and *c*, the legs might have developed from a reading of the negative areas outside the pedestal triangle at *a*, and thus suggest a chronological sequence; the pedestal triangle occurs in the Nubian motif at fig. 169(*a*) of the third to sixth centuries. The motif of the 'ram's head' on the head-disc of the Jebba *Warrior* and on the surcoat of the Tada *Warrior*, figs 161–62, might already have been of some age at the time that these bronzes were cast (in Meroitic architecture an avenue of rams replaces the Egyptian avenue of sphinxes): they might therefore already have separated into two independent designs from which the smith was free to choose, in which case a chronological relationship could not on these grounds be read between these two pieces, though it seems more likely that, as at *e*, the smith was merely copying a motif which he did not understand. It is specifically the later design which is copied at Benin

(*f–g*) This horned head-dress is sometimes called a winged cap in the literature. Commencing on the Nile the horn has been associated with royalty or nobility in several African cultures, notably along a route in which it is observed among the Funj of Senaar and on the Benue. The brow marking was recorded for the Bini early in the sixteenth century by an observer who claimed that it was employed by no other African tribe. If correct this would establish the occurrence of the motif

direction and this collar might equally have gone north, but very much of our evidence points to the movement of metallurgical ideas southwards, connecting the Guinea forest with the lower Sahara, the Mediterranean, and as we shall note in the occurrence of certain motifs in bronze art, even perhaps with the Nile.

Evidence of an iconographic association between the Bini bronze and those of the school which created the Jebba-Tada masterpieces is summarised in the comparative designs of figs 76, 84. Though no doubt can be cast on the association of Benin and Ifẹ̀ bronze art, such slight evidence as we so far possess refers only to mature periods – the seventeenth century or later. We have no evidence at all for that Ifẹ̀-Benin transference of bronze-casting technique assumed as a base point in the structuring of recent

at Ijẹ̀bú as of later date, under influence from Benin

(*h–j*) Tada, Benin, Lower Niger. The collar of teeth rarely occurs on southern bronzes outside the Benin school, but is prominently figured at Jebba-Tada. The degenerate version at *j* (after Fagg), suggests Bini influence in the lower Niger

(*k, l*) Tada, Benin. The bell-pectoral as an emblem of rank is of wide occurrence in the Bini bronze. Though bells are used in other ceremonial ways by many other southern peoples they do not often occur in bronze work

Benin chronologies, and the question assumes importance not only in the matter of dating the Benin corpus but also in crediting hypothetical early dates attributed to the Ifẹ̀ bronze and so far not supported by any substantial evidence.

Finally in the sixteenth- and seventeenth-century bronze scene we cannot ignore the effects of that interpenetration of peoples and ideas occasioned by the widespread raids of the Atlantic slave trade; the depredations of the Kwororafa, the Bini, the Ọyọ and the Aṣante have all doubtless played their part in West African bronze history.

The first of the Bini local traditions is interesting in recalling the making of plaques, as the second also seems to do, among the earliest essays in Bini bronze craftsmanship, though in this case, as in that of 1823, the source is claimed to have been European. According to modern king-lists, the kings cited, Ẹsigie and Osogboa (Ọrhọgbua), reigned consecutively during the first half of the sixteenth century, a period of marked Portuguese influence at Benin[21] when for the first time we hear of the European mercenary soldier in an African war (for Portuguese troops are locally remembered to have helped Ẹsigie subdue the Idah in 1515). It is not therefore surprising that Portuguese personages appear on the bronze plaques whose sole function was the commemoration of the glory of the Bini monarchy. A number of these plaques can therefore be ascribed to the period, though the 'Portuguese' motif in various abridged forms continues for some time, doubtless, like many another motif in Bini art, as a symbol of that power which is an attribute of the divine king. Whether plaques were being cast before Portuguese times or whether the *genre* took its rise roughly contemporaneously with their coming, or even as a result of their coming, as two of these accounts seem to imply, we cannot say. An even more provocative issue is whether the plaques, as suggested in the first and second traditions, represent the earliest bronzes made at Benin.

In his study of the Ifẹ̀-Benin relationship Ryder points to the occurrence of some of the shared iconographic motifs already mentioned as perhaps arguing for a distinct polity in southern Nupe possessing a common bronze imagery with Benin. However, if we credit a tradition recorded by English in which the Nupe people worshipped in the Yoruba tongue the Ifẹ̀-type seated bronze figure in their collection, fig. 86, it is difficult to regard them as the authors of these fine bronzes; in any case they lay no claim to authorship but associate the bronzes instead with the external sanctions of kingship in the Igala. Ryder's view that both the Nupe and the Bini may once have been linked to the same spiritual overlord – as yet unknown – is more easily credible, as is his proposition that a possible locus of influence on Benin, and even of the Ogane of the Portuguese record, may be the Beni of the early Arabs whom he places north and south of the Niger in present-day Nupe country, and who with their culture and traditions appear to have been wiped out in the Fulani conquests of the nineteenth century.[22] Apparent confusion is increased when we take into account the Yoruba

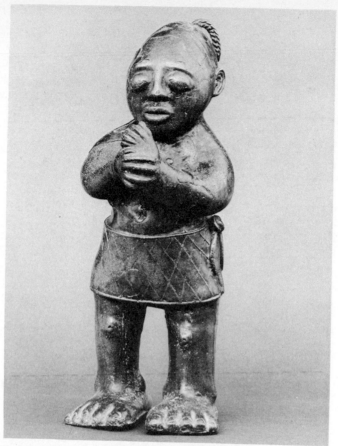

85. Tada, standing male
figure, bronze

domination of the Nupe during the eighteenth century. One of the Tada
bronzes tantalisingly suggests, in the sacred sign of the left fist over the right,
that most primary of Yoruba cults, the earth-worship of the Ogboni, deeply

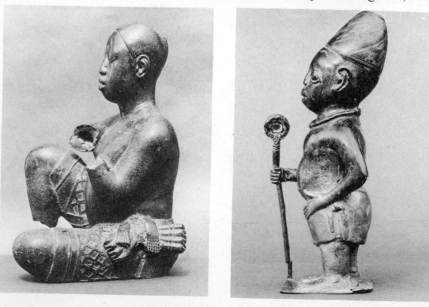

86. Tada, Ifè-type seated
figure

87. Tada, bronze figurine of
a staff bearer

entrenched at Ọyọ, fig. 85; for the time being we are in no position to draw inferences. It may be, however, that a future scholarship seeking the beginnings of Ifẹ̀ classicism could profitably have a closer look at these humble pieces in the Tada collection, as is suggested by a comparison between the famous seated 'Ifẹ̀' bronze from Tada and the *Staff Bearer* in the same collection, figs 86, 87.

Influences certainly exercised on the Bini bronze during the sixteenth and seventeenth centuries by some as yet unidentified northern industry seem to provide reason enough for a rethinking of the Ifẹ̀-Benin relationship in bronze casting. Equally certain evidence, as we shall see, connects Ifẹ̀ technical traditions with those responsible for the Jebba-Tada bronzes – traditions not shared by the craftsmen of the Bini bronze.

16 The Benin Bronze Chronologies

Recent chronologies of the Benin bronze have been published by Fagg and Dark,[1] both the result of first-hand acquaintance with the material from fieldwork in Nigeria, and from the great collections of Europe and America. They therefore represent an advance on earlier chronologies which understandably suffered from the state of the study at their time of publication.[2] With the early authors, as with the early geographers of Africa, fancy filled a good many of the gaps created by a paucity of facts, and an enviably detailed landscape emerged across which later scholars have tended to beat all too clearcut paths. An increased precision in Benin studies might assist not merely in clearing the dense growths of fancy in this historical landscape but also in demolishing a few of those landmarks which have hitherto seemed most reliable. Benin art may well never be the subject of a respectable chronology.

To what degree would this matter in the context of African art? Chronologies are of course a European passion and do not in themselves express inherent necessity in the life of forms in African art where style lacks its principal determinant – the ever-changing vision of the individual artist: where the cult itself, rather than the inspiration of the artist, determines the nature of plastic expression. But in any culture chronologies, whether seen as the sum of individual impulse or as an expression of the all-embracing undifferentiated cultural ethos, serve as a gauge of style, of the life of forms in temporal expression; as the framework within which the phenomenon of style has its being, they are the ribs and vertebrae of a conceptual organism of which a morphology seeks to lay bare the soul. African art is never biographical in the European sense; in its study we have to do with the constants of type, stereotype, and archetype which are subject to only limited formal variation in the expression-language of a given society. In such a society diachronic interpretation is necessarily alien, since the African artist does not conceive of his forms in terms of the evolution of his personal vision in the manner of his European counterpart; for him it is of no consequence that the stereotypes number two, or twenty, or ten thousand and that their occurrence covers several lifetimes of artists before and after him; he can conceive of the life of forms in no other terms. We learn little by seeking to understand this art by chronologies expressed in days and months and years, for the basis of African art, even so concrete an art as that of Benin, does not rest in the individual: the individual does not dictate its terms of change. But African art does change (though not perhaps necessarily develop) and it is the manner of

this change which a chronology might help us to glimpse. Further, it cannot be sufficient to state that such an idiom succeeded to such and such at this or that period; we should want to know why this was so, what fundamentally accounts for growth or decay in given forms, whether a rationale could be observed as governing the life of forms in time, and what was its nature if so. In short we should expect a morphology.

It is no criticism of the Benin chronologies so far attempted that they have shied away from this desirable end in the study of African art: the data are simply lacking. But if we cannot as yet attempt conclusions, might we not nevertheless aim at rigour in diagnosing the material to hand? Because of the importance of these two chronologies in their contribution to the study of the art of Benin we shall examine them in some detail. They are similar in their isolation of the plaques and in their treatment of these to a greater or lesser degree as an art-historical diagnostic, but they differ in the starting points assumed. That assumed in Fagg's earlier chronology is the Ifè-Benin succession of the second account quoted above, dated *c.* 1280, with the reservation that a 'crude and unimportant' local industry may have predated the importation of technique from Ifè. In the first chronology the Benin corpus is seen as exhibiting a type of head of generally naturalistic form which, supposedly deriving from the Ifè tradition, is on this account considered to be the earliest and to have been produced during the first two centuries of Bini casting which terminated with the period of first European contact in the late fifteenth century. The late sixteenth century ushers in a new tradition characterised by more massive castings resulting from an increase of brass made available by the Portuguese, and by the making of the plaques; the Ifè tradition has run down, and the pieces of this 'middle period' are of a stereotype uniformity. The plaque period comes to an end in the early eighteenth century, after which follows the late period, a period of flamboyant decay. Individual works exhibiting the characteristics of each period are thus dated. Five years later Fagg elaborates on this chronological structure from a new point of departure – that of the bronze plaques – which he now places within the 'well defined temporal limits' of the mid sixteenth century to the late seventeenth. All pieces which appear stylistically posterior constitute the late period. Without explanation the beginning of the early period is advanced to *c.* 1400.[3] Summarised, these two chronologies are given below:

TABLE 2. *Chronologies of Benin bronze art: 1958, 1963*

	Early	Middle	Late
1958	*Late 13th c. to late 15th c. Ifè Period*	Late 16th c. to early 18th c.	Early 18th c. to end 19th c.
1963	15th c. to mid 16th c.	*Mid 16th c. to late 17th c. Plaque Period*	Early 18th c. to end 19th c.

The 1958 chronology leaves out of account a good century between the end of the early and the opening of the middle periods, a time in which works presumably continued to be executed in the earlier idiom. It is for this reason perhaps that the 1963 chronology advances the terminal date of the early period by fifty years – there are obviously not sufficient extant examples of this hypothetical early period to cover a span of three hundred years, the opening date of which rests on only one of four oral traditions. For his dating of the plaque period which constitutes the axis of the second chronology two early European sources are cited; their importance justifies rather full quotation:

The king's palace . . . contains several apartments for his ministers, and fine galleries which for the most part are as large as the bourse at Amsterdam. These are supported by wooden pillars encased in copper on which are engraved their victories and customs. The majority of these apartments are thatched, each corner embellished by a small pyramidal tower crowned by a bird with out-stretched wings in copper. (Dapper)[4]

The second source I have re-paragraphed for emphasis:

[*1st gallery*] The first place we come into is a very large gallery, if it must have that name, which is sustained by fifty-eight strong planks, about twelve feet high, instead of pillars, these are neither sawed nor planed, but only hacked out. As soon as we are past this gallery we come to the mud or earthen wall which hath three gates, at each corner one and another in the middle, the last of which is adorned at the top with a wooden turret like a chimney, about sixty to seventy feet high, on which is fixed a large copper snake whose head hangs downwards, very well cast or carved, and the finest I have seen in Benin.

[*2nd gallery*] Entering one of the gates we come to a plain about a quarter of a mile, almost square and enclosed with a low wall. At the end of this plain is another such gallery as the first, except that it hath no turret. Some time since this gallery was half thrown down by thunder, since which no hand hath been laid to rebuild it. This gallery hath a gate at each end,

[*3rd gallery*] and passing through one of them a third gallery offers itself to view, differing from the former only in that the planks upon which it rests are human figures but so wretchedly carved that it is hardly possible to distinguish whether they are most like men or beasts, notwithstanding which my guides were able to distinguish them into merchants, soldiers, wild beast hunters, etc. Behind a white carpet we are also shown eleven men's heads cast in copper, by much as good an artist as the former carver, and upon each of these is an elephant's tooth, these being some of the king's gods.

[*4th gallery*] Going through a gate of this gallery we enter another great plain and a fourth gallery, beyond which is the king's dwelling house. Here is another snake as upon the first wall. In the first apartment at the entrance of the plain is the king's audience chamber where, in the presence of his three great lords, I saw and spoke with him. He was sitting on an ivory couch under a canopy of Indian silk. (Van Nyendael, trs. Bosman)[5]

Even allowing for the vagaries of translation van Nyendael must obviously be considered an acute observer, though his terms of expression

are maddeningly approximate on crucial points. He is vague on the distinction between carvings and castings, being apparently more interested in number than in sensation; he takes in fact a generally dim view of the works of art before his eyes whether made of wood or of bronze, not perhaps surprising in one from a culture not noted for sculptural expression and which had just produced in painting the aesthetic of Frans Hals and Rembrandt. Dapper's account is appropriately brief, befitting one who wrote from hearsay and had never visited Africa. But though Dapper never cast eyes on these bronzes Fagg tells us that he recorded their magnificence with admiration! – and contrasts this 'admiration' with van Nyendael's failure to mention the plaques at all thirty-odd years later in what he reads as 'a most thorough description of what was probably a recently rebuilt palace. This *argumentum ex silentio* is proposed as evidence that the plaques had already been pulled down and stored in an outhouse where they were found in 1897.[6] But it is far from certain that the plaques had been torn down after the time of Dapper's informant; in fact there is a hint of evidence in van Nyendael's account (1702) that he did see and describe them. This lies in his descriptions in the first and third galleries. In the former are noted the twelve foot high planks 'neither sawn nor planed, but only hacked out', i.e. rough-hewn posts with no figurative carving. But a few minutes later van Nyendael is unclear about whether the 'copper' snake on the turret before him was cast or carved, a point which would present no real difficulty to one with an eye for such things. In the third gallery he compares the bronze heads of the Oba with the 'wretched carvings' on the veranda posts not far off – 'by much as good an artist as the former carver'. But these wretched 'carvings' may well have been the same bronze plaques earlier seen by Dapper's informant, and which had not been removed in the purely hypothetical rebuilding of the palace proposed in the second Fagg chronology.

A picture of dereliction is in fact clearly painted by van Nyendael for Benin as a whole and for the palace, a part of which just before the entrance to the third gallery had fallen down in the storms without a hand having been subsequently lifted to rebuild it. Anyone who has spent a dry season in Benin City will be familiar with the ochrish-red deposit of dust which forms a concealing skin on exposed objects, together with the spiders' webs and wasps' nests that rapidly accumulate on such surfaces in the tropics. Van Nyendael's inability to distinguish the subject matter of these plaques may have been as much due to his lack of interest in the art, and his supercilious attitude towards it, as to their partial obfuscation through neglect; for the subject matter of the plaques is nothing if not crisp and clear – so long as they can be seen! The subject matter too, described for him by his apparently patient and tolerant guides, reveals the exact content with which we are today so familiar in the bronze plaques – 'merchants, soldiers, wild beast hunters, etc,'; this evidence at least casts doubt on their removal. In such a crucial matter we can hardly lay absolute store by the word of an observer to whom the distinction between carving and casting was of so little importance. Yet van Nyendael's evidence is pivotal to establishing

the Middle Period of the second Fagg chronology – mid sixteenth century to late seventeenth century – a period negatively used in defining putative early and late bronze styles.

Though it appears from the oral tradition that around 1890 the bronze plaques, or at any rate some of them, were kept in storage in the palace compound,[7] we have no means of knowing the actual date at which they had been put away. Such storage may in any case have represented a current surplus of objects, like the bronze stools found lying around in the palace compound in 1897, for which there may have been no more room in the palace but which nevertheless continued to be valued. As van Nyendael's record leaves in some doubt the matter of their existence on the pillars of his day it would seem at least hazardous to regard his account as conclusively determining the end of the plaque period. And even could this evidence be proved unassailable, even were it established beyond all doubt that the plaques had been removed from their pillars during the latter years of the seventeenth century we should still want evidence of a firm date after which they had ceased to be *cast*. For their description by Dapper's informant around the mid seventeenth century is no more proof that they were being cast at that date than the fact that they were not described by van Nyendael in 1702 is proof that they had ceased to be made. That they perhaps continued in use at Benin right up to the sack of the city in 1897 is indicated in the following, albeit equivocal, report of the surgeon of the punitive expedition. He found inside the palace 'all the rafters of wood carved with rough figures; some of the rafters have been covered with brass sheeting on which figures have been punched',[8] i.e., repoussé figures worked into the cladding over the rafters in keeping with a tradition apparently current in the early nineteenth century.[9] They are mentioned by a visitor to the palace between 1816 and 1821.[10] The observation which follows may or may not refer to cast bronze plaques in their traditional function, first recorded in the mid seventeenth century: 'The roof is supported by over a hundred *pillars made of bronze sheets riveted together*, giving a very good effect.'[11] Far from conclusive, though our informant's distinction between these bronze sheets and the repoussé brass cladding on the rafters may reasonably narrow our area of doubt. Repoussé work was not uncommon at Benin and in villages around the Delta; it was recorded at Old Calabar during the eighteenth century. That our observer at the end of the nineteenth century should be independently struck by 'riveted' bronze sheets covering the palace pillars at least suggests their difference from the repoussé work he had just described on the rafters. It is only to be regretted that he did not specifically describe these things as plaques; the Benin plaques remaining in museums today carry the holes of this 'riveting' around their edges (they were more likely attached to the pillars by nails of a type recently excavated at the palace site). For any other than the purposes of scholarship, 'bronze sheets riveted together' would have seemed a not inaccurate description from one who was after all no more than a tourist.

These chronicles of kingship were available to the Bini monarchy from the very earliest production of bronze; it seems doubtful whether monarchs at any period, in a non-literate culture, would have discontinued the tradition. Quite certainly this historic *genre* remained available to Bini monarchy in 1936, when a plaque, every detail in the traditional idiom, was cast to commemorate the accession of the present (1965) Ǫba, Akenzua 11. Nor does it seem likely that a tradition fallen into desuetude for a good two hundred years should have been so effortlessly and competently resurrected. It would appear fastidious in the extreme to doubt, on the evidence, that the casting of plaques was maintained throughout all periods to the sack of the city, and even beyond. So the record raises a doubt as to the reliability of the temporal limits ascribed by Fagg to the 'plaque period' which forms the sheet anchor of his second chronology. While such doubt remains this chronological structure seems far from secure enough for 'dating' the Benin corpus.

Based on form-sequences drawn from the study of many types of Benin bronze heads, Dark's chronology follows Fagg's first of 1958. Striking an independent path across the landscape of Benin chronology, and guided only by established landmarks and empirical knowledge of the terrain, it is carefully plotted from the known to the unknown. Established landmarks are those of an Ifè-Benin succession in bronze-casting, found plausible and accepted, and the dating of the plaque period from the mid sixteenth century to the time when they were 'taken down and stacked away' in an outhouse before van Nyendael's visit in 1702. We have examined the reliability of these two landmarks on the map of Benin art history, but even so Dark's method is instructive.[12]

The point of departure chosen is the early nineteenth century, at which time a certain motif associated with the reign of the Ǫba Ǫsẹmwẹdẹ (*c.* 1816) appears on some of the bronze heads. This is the bead cap with two 'wings', one on each side. It is argued that any heads carrying this motif could not have been cast before this time. This type is preceded by those bearing a high collar, 'traditionally assigned to the time of Ǫba Eresonye (*c.* 1740)', with which is associated a vocabulary of motifs and qualities diagnostic of the art of the time. But among these it is noted that of heads so distinguished some bear flanges round the base while others do not; these are therefore assigned to different periods: those with flanged bases to the time of Eresonye, and those without flanged bases to an immediately preceding period. Working backwards, a category distinguished in the tradition as 'heads of the old days' is suggested as having preceded the pre-Eresonye heads and is assigned to the sixteenth century. An early example of the period – the Queen Mother type – is placed at the first half of the sixteenth century and this period, on style evidence alone, is felt to have been preceded by an even earlier one referring possibly to a pre-sixteenth century era. In summary the chronology for heads runs:

TABLE 3. *A Chronology of Benin bronze heads: 1960*

Category	Reign	Date
1 Beaded cap with two wings	Ọba Ọsẹmwẹdẹ	*c.* 1816
2 High-collar heads with flanged bases	Ọba Eresonye	*c.* 1740*
3 High-collar heads without flanged bases	pre-Eresonye	pre-1740
4 Heads of the Old Days	—	16th century
5 Early Heads	—	pre-16th century

* 1735 in some chronologies

Though the hypothesis of an Ifẹ̀-Benin succession is accepted as plausible the chronology is not pinned to this tradition; it is merely acknowledged that the examples which survive may have been made after the Bini learned the art from Ifẹ̀, in which case 'it is necessary to assume that they represent a point in a style sequence which changed little at Ifẹ̀ from the time at which the Bini acquired the technique'. Thus though the chronology does not hinge on the succession, this succession is subsumed as a base point in the development of Bini bronze-casting. It is at the same time allowed that a hypothetical early Ifẹ̀ style was 'more stylised than those examples which survive to us, and thus approximated even more than the surviving examples do to what are assumed to be the earliest Bini examples, which do, in fact, show a recognisable measure of stylisation'. These speculations do not materially affect chronological interpretation; the method employed is based on the alignment of given motifs with the oral tradition. The resulting grouping is identified where possible with traits characteristic of a given period: inquiry proceeds backwards from the known to the unknown.

It is the nature of that which is considered known that creates difficulties. In every case the knowledge derives from unsupported oral tradition. A representation of the 'beaded cap with two wings', credited in this chronology on the basis of oral tradition to Ọsẹmwẹdẹ's reign in the early nineteenth century, appears on a Tada bronze datable to the seventeenth century or later. It is unlikely, for instance, that in the ten years of Eresonye's reign (fifteen in some chronologies) the very wide range of traits and qualities attributed to works of this period should all have been developed, and that none of these appear earlier (though apparently they continue after him). Moreover the high collar motif assigned to this reign is based on the coral collar already described as early as 1668 as obligatory wear for certain nobles on pain of death. Why the theme should be treated as a diagnostic in the bronze heads from 1740 only is difficult to understand. It is also difficult to undertand why heads with flanges and those without should be read as indicating a temporal sequence, or why the lightness of weight in a piece should contribute to defining it as 'of the old days'. As for

the transition of styles, no more evidence is proffered than that type B 'appears to be intermediary' between types A and C! But even were this form-sequence established on the most rigorous basis possible it is an extremely hazardous undertaking in the absence of independent criteria to align a form-sequence with a time-sequence, if only in the matter of establishing a direction for the series.

In this connection far the greatest difficulty to be encountered in the study of African art is that the motifs which supply the content of any such series, by virtue of their nature as signs, are of very long life and by no means spatially stable; so that unless the life-span of a motif could be independently determined its usefulness as a diagnostic of style remains negligible. For instance the Maltese cross of sixteenth-century tradition (or earlier) appears on the eighteenth-century stool at fig. 199. In addition we can rarely be certain whether two or more motifs stand in a spatial or a temporal relationship: they might be separated by several generations or by the width of street between two workshops. But a connection between a form-sequence and a time-sequence is suggested, though not established, for all bronze plaques in the Dark chronology. These are grouped on the basis of the degree of their relief: (1) those which are conceptually two-dimensional, (2) a type conceptually halfway between (1) and (3) in which third category low-relief forms are imposed on a flat surface as opposed to forms arising or growing out of the flat.

Purely in terms of degree of relief it is difficult to appreciate the difference suggested between the second and third categories. To this criterion of depth of relief, however, are applied certain motifs individually felt to refer to each group. Thus the high-collar motif attributed in oral tradition to Ọba Eresonye's time (1740) in the study of the heads, is ascribed to the supposed end of the plaque period at 1700. The two-dimensional low-relief examples commence the plaque sequence at the mid sixteenth century by virtue of their incorporation of Portuguese motifs. No date is proposed for the type considered 'conceptually halfway' between these two.

A chronology based only on style is certain to be arbitrary in any culture, but far more so in African cultures where the determinants of style are not individual and dynamic in the European sense. On the basis of style alone, Dali's mid-twentieth century *Crucifixion* should be attributable to the Renaissance! Where such a chronology is supported only by oral tradition, or by quasitechnical data such as the degree of relief practised in bronze-casting, its arbitrary and subjective nature is hardly modified. In the temporal limits proposed, Dark's chronology seems as unacceptable as Fagg's. The case for a progression from low to not so low relief demonstrates nothing at all, since any degree of relief is open to any plaque artist at any period, subject only to individual whim, no inherent historical process being involved. Because an Ifẹ̀-Benin relationship is subsumed for the growth of style in the heads, and because heads are implicitly believed to have been the earliest products of Bini casting, the earliest bronze period is placed at a pre sixteenth-century date, examples of which 'by reason of

their less stylised qualities' and on no other authority, are proposed as the base-point of this Benin chronology.

Our examination of these three chronologies (Fagg 1958, 1963, and Dark 1960) suggests the need for a reappraisal of the approach to the history of Benin art, or to the history of all African art for that matter. For because of the nature of the material, and of the time view within which African works of art have their being, attempts at strict chronologies, or even at relative chronologies are full of pitfalls: an unfortunate situation, for the subject of art histories is the life of forms in time – a history of forms. We need to understand style, for style exists in a continuum, and it is the goal of the historian of art to place a given example within the style-system of which it is a function. Evidence is required of that intention in the particular work which is objectivised in style. But a morphology cannot be based in style – it must be based in that from which style results, i.e., in idiom – idiom in motion so to speak expressed in those forms by means of which a given culture symbolises experience – in a metaphysical sense as well as in number. The art of a culture is its *logos* as well as its *mathesis*. Apart from the spirit to which it seeks to give a habitation and a name, every work of art by existing implies a geometry of proportion, a canon by means of which it secures public reference, and which is inherent in its characteristic idiom – the system of forms developed in a given society for symbolising such reference. In African art, as we have seen for the cult-object, this symbolising of reference is achieved by visual formularies which bear the characteristics of verbal language. In the Lower Congo the configuration of certain pot-lids amounts to sentences by means of which mute communication might take place between man and wife in times of marital stress.[13] On a different level we have already examined the type-motif in its association with the attributes of a given god and its role in producing standard and universal responses in the suppliant, responses which bear witness to the unspeakable – in fact the Word.

In Bini art the Word is of small significance: it is a secular art, an art of knowing through measure, of emblem, of obedience perhaps, for an emblem functions in one direction only: it requires no response. Here visual formularies do not function for the apprehension of spirit; they are not signs through the control of which communion may be established with the god; they call upon no purely individual posture or condition. And if in any sense Bini art can be associated with the art of Ifè it would be in an observance of canon, a secularity, a conscious idealism rare in African art.

The most generous temporal framework which we can at present ascribe to the Benin bronze corpus is the period 1485 to 1897 – the earlier date merely marking the arrival of the Portuguese and not necessarily indicating the existence of a local bronze art. A Portuguese description of 1558 does not mention the very accomplished bronze castings observed on the roof of the palace a hundred years or so later, nor were they mentioned by the first British trade missions to Benin in 1588 and 1590; this of course does not signify that they were not there for those who had eyes to see. Of the

several European visitors to Benin during the two hundred years in which these things probably dominated the city landscape, those who mentioned them, or the bronzes adorning the palace, can be enumerated on the fingers of a hand; but it can be claimed in defence of these mute visitors – soldiers, sailors, traders and missionaries mostly – that they were no strangers to the sight of public bronze decoration at home, and that such embellishment at the court of a king would have seemed rather to be expected than to warrant especial mention. It seems likely that bronze plaques, in keeping with age-old tradition, were in fact being cast at Benin during the two hundred odd years 1668–1897, and the internal evidence of the plaques themselves indicates that they were being cast there perhaps as far back as the mid sixteenth century. From the example, just mentioned, in the Benin Museum, we know that such plaques were being cast at Benin as late as 1936.[14] We have no certain evidence for believing that plaques were not being cast continuously throughout this period of roughly four hundred years: at least one nineteenth-century document seems in fact to suggest that their life cycle might be coterminous with that of the bronze figurative art as a whole. If this is indeed the case their interpretative-formal content would make of them a valuable subject of a Benin morphology.

For the period before the coming of the Portuguese in 1485 the most that can be claimed is that bronze-casting was possibly known in the Guinea forest, as can be assumed from the attested copper trade to Borgu in what is today northern Nigeria. But the incidence of the open copper-casting mould in the forest regions to the present day, apart from establishing a connection between these industries and those of the Sahara, does not in itself provide evidence for the medieval working of bronze in the south. For Benin we have no examples of bronze art which could unequivocally be attributed to a period before 1485, though it is not unlikely that an industry already producing items of personal ornament by the *cire-perdue* process might also have been attempting more ambitious work; but we are yet to support this speculation with evidence. It can reasonably be assumed that the stone mould of Ibn Battuta's time (1354) would have been used in the forest regions for casting ingots which were then bent into bracelets in the same way as they are made today in the south. Such ingots twisted into torques yield the interesting designs at fig. 88. But the neck collar at fig. 89, weighing eleven pounds and apparently of an old tradition, was cast by the *cire-perdue* method. This mould was certainly used at the Yoruba seat of empire at Ọyọ-Ilẹ̀, believed to have been founded not long after Ibn Battuta's time; the evidence indicates that its bronze technique was of northern connections. What remains an open question is whether, anywhere in West Africa, *cire-perdue* bronze-casting was introduced by the Portuguese; the only industry known to have been influenced or to have been created by them is that of the tribes of the Lower Congo,[15] and this was not based on *cire-perdue* casting. Whatever the nature of hypothetical early industries at Benin, their products in the figurative arts do not appear to have attained any degree of aesthetic or formal mastery, for in the earliest

88. Brass bracelets, northern Yoruba. (*a*) bracelet produced by twisting a bar of brass; (*b*) cast design suggested by (*a*)

Diameter 27cm

2cm
4cm
2cm
6cm

89. Cast brass neck-collar, Yoruba. Though of great weight this is worn by women in festival dances, associated with a dancing cutlass, fig. 209, and bracelets as at fig. 88

known bronze art – that of the plaques portraying Portuguese, which by virtue of this fact could not have been cast earlier than 1485 – we find all the formal ignorance of an art apparently for the first time struggling with the problem of creating, without supporting precedent and all alone, the conventions of a plastic language for rendering the many-sided and conflicting data of the objective visual world.

It would be logical stylistically to isolate this 'Portuguese' period and to consider it a base point from which to trace the development of style in the corpus as a whole. That this has not hitherto been attempted can be explained only by several oral accounts, describing the beginnings of the Benin bronze at Ifè a century or two before the coming of the Portuguese which would define the earliest works of Benin craftsmanship in terms of an Ifè aesthetic. But even had a Portuguese period been used as a foundation for the study of style, in the absence of supporting data we should need to rely only on subjective judgment in determining succession. This is obviously unsatisfactory, since the phenomenon of style needs to be framed by other factors and supported by independent evidence before it can convincingly be subject to temporal interpretation.

In the history of European art even if we lacked independent evidence it would be no difficult matter to arrive at notions about the language of forms peculiar to a given school or period, and which generates style. In the hypothetical art of the Folk of the Cross we should discern spatially distinct methods of approaching the treatment of the iconic theme – differences which would suggest contingencies of a social-historical nature which had been responsible for the emergence of the particular idiom in any given case. The society which produced the Isenheim crucifixion knew the art of oil painting and employed the science of perspective in its depiction of space, while the Florence of Giotto's time did not yet know either; so that despite the common iconic theme a Giotto crucifixion is formally a very

different thing from one by Grünewald. Whereas the forms of Giotto result from his reaction against the Italo-Byzantine tradition, those of Grünewald grow out of his opposition to the Italian Renaissance; each painter within the limits of his skill, and even more within the limits of his cultural ethos, by objectifying the deepest needs of his society in highly selected forms at the same time creates the plastic idiom of the art peculiar to that society. This comes about in spite of employing technical processes which may have been developed elsewhere, for the borrowing of a technique does not necessarily imply the transferring of an imagery; an imagery cannot in fact be transferred and retain its meaning or value. Grünewald's oil painting was developed in Germany, and Giotto's fresco technique was as old as European art when he created his private revolution by the use of it.

It is idiom which explains style; style being a result and not a cause cannot be employed to explain itself. So even if we could stylistically isolate a 'Portuguese' period in the Bini bronze and append to this the styles of successive periods, we should still be in no position to attempt a morphology; classification of this type, even where not based on subjective judgment, could be supported only by an uncertain oral tradition. And even going beyond style into the idiom of which it is a result we find Bini art bewilderingly unsupported by the usual diagnostic aids – by biographies, a social history, or even iconographic self-sufficiency; important decorative or symbolic motifs in this art also occur in examples from Ifẹ̀, Ijẹ̀bú, the Niger Delta, and even so far north as Jebba and Tada. And to add to our difficulties we find that beneath the welter of examples and 'periods' Bini art has changed little or not at all in any fundamental way during the entire course of its existence. The stereotypes of this art occur with little or no variation through all its media of expression, in ivory, in bronze, and in wood and with no adaptation to the several techniques involved. It is as though the Bini craftsman, whatever his material of execution, consulted a standard repertory, not only of forms but also of emblems, which he produced wholesale to the taste of a single patron of inflexible requirements – the reigning sovereign – in the manner of a salesman choosing from a well-thumbed catalogue. This standardising of elements is observed to the last detail even in the decorative motifs employed, so that given the time and the inclination it would be possible to compile a sourcebook of types and stereotypes recurring in all media and throughout all periods.

We hear of traditional Bini cloths, now vanished, of considerable value at the time of the traders – needlework tapestry with life-size figures worked into openweave cotton material; but need we wonder what these figures looked like? – they would have been those of the bronze plaques, the ivory tusks and the wood-carvings. For much more so than in any other African school the product of the Bini artist consistently conformed to the traditional stereotype; it would be no surprise to learn, could this ever be established, that a common production, or even a mass production, was known and practised in traditional times. It would require the labours of one more than normally dedicated to run his thread of interpretation through this laby-

rinth of type-motifs, for in such a study all aspects of Bini art – each smallest emblem in each medium of expression with its significance as sign – would be involved. In this deliberate standardisation, this conscious eradication of the vagaries of individual impulse, Bini art recalls that of Egypt; a resemblance also borne out by the principle which secures the stereotype and controls the forms of the craftsman – the Benin canon.

17 The Benin Canon and the Basis of a Benin Bronze Chronology

The revolution in 'seeing' initiated by Giotto in the fourteenth century would bring in its train a quasi-mathematical system of perspective as providing the terms of a schematic space on a two-dimensional surface equivalent to the three-dimensional space of objective visual experience. But the researches of the Quattrocento would await full plastic expression in the achievements of the High Renaissance, the early vision inhering in the later. Berenson has noted the preoccupation of the early Venetian painters – the Bellinis, Carpaccio, Cima da Conegliano – with problems of volume, of space and of aerial perspective; at the beginning of the sixteenth century we find the greatest of the Venetians achieving solutions to these purely painterly problems. The illusionist experiments with the principles of perspective and foreshortening which we observe throughout the Quattrocento are echoed in the self-conscious 'space-time' essays of certain artists of the present day. Just as we may appraise one vision in terms of the other, so the formal achievements of the Bini bronze may be read in terms of its earliest intentions. The Bini vision is that of the pre-Renaissance or even pre-classical world of the Assyrian reliefs or of the Egyptian frescoes, not that of the ethos which produced the mariner's compass and promoted the discovery of the world and of man. Yet in one important respect we may regard the attitude of the Bini artist as not altogether unrelated to that of the artists of the Quattrocento: in that secularisation of vision which in African art we notice elsewhere only in the Ifẹ̀ school.[1]

Here is an objective attitude to nature, a dethronement of the gods and a celebration of man which would not have been incomprehensible to a Uccello or a Mantegna, based as it is in the intellectual adoption of schemata in a vision opposed to nature and grounded in law. A knowing has arisen, for the first time in African art, of an order different from the traditional metaphysical expression of experience and the manifestation of such experience in the gestures and postures of the gods and the spirits; different from the apprehension of the Word in obligatory sacred forms in wood and in stone. It is a vision which liberates the artist from his role as passive functionary of the iconic theme into a conscious and deliberating creator subject only to laws of his own discovering: for the first time the artist is actor and not agent. Where previously his forms had been dictated by conventions for the interpretation of the Word, he now assumes an attitude of inquiry into the operation of phenomena in the material world and is

compelled in this new stance to seek equivalents within the limits of his art for his visual experience of nature. We may describe this new relationship with nature as mathetic: a knowing through measure rather than a knowing through faith. It is tempting to align this relationship with the material imperatives of bronze-casting technique, with the apprehension of metallurgical laws distinct from those which had determined the nature of form in a traditional sacred art. But not very distant from Benin, among the Yoruba for instance, we find this not to have been the case at all – the coming of bronze there is integrated into a pre-established *òrìṣà* system, and the ancient utterances of the gods continue to be made through the new material.

At Benin and at Ifẹ we associate this revolutionary expression in the arts with the operation of temporal rather than of spiritual power, with the finite aspirations of the divine king rather than with the eternal imperatives of the gods. Why these needs arose when they did we do not know, but their emergence resulted in this new art of secular forms whose orientation was henceforth to lie no longer in belief but in empirical laws formulated in an attitude in which the intellect alone comes to confront the visual phenomena of nature. The Bini bronze smith was confronted with entirely new problems – problems inherently of discovering plastic equivalents for objective visual experience (formulae for 'seeing' in Gombrich's meaning of the term). An examination of his responses to these problems might reveal processes in the development of the Benin canon and perhaps even suggest, as a corollary, the basis of an approach to a Benin 'chronology'.

As Gombrich has observed, we need schemata of one sort or another for coming to terms with the formal intentions of the artist in any culture. His forms, nevermind how wilful, how seemingly arbitrary, cannot exist in a void; they need to be proposed within some kind of schema in order to be apprehended at all. Such a schema, as the conceptualisation of shared experience, serves as the bridge to the community across which the artist secures public utterance; where it is not understood his forms too will be incomprehensible.[2] That employed in the realisation of form by the Bini bronze craftsman has been subject to little change throughout four hundred years; the history of this art can be interpreted as a history not so much of forms as of resolutions; so indeed can the history of European art since the Renaissance, expressing as it does changing viewpoints in this problem of seeing, exemplified in the researches into anatomy of the early Renaissance, in the perspective studies of the Quattrocento, the chiaroscuro of Caravaggio and Rembrandt, in the Impressionist study of light, Cézanne's post-Impressionist thesis on optics, and in present-day Constructivist and kinetic experiments in space in its relation to matter. But whereas the European artist has adopted these changing viewpoints in the evolution of a plastic vision, or rather has approached the problem of finding plastic equivalents for visual experience from several fundamentally related points of view, the Bini artist has confined himself to a single interpretation which, once resolved, he has felt under no compulsion to change. His art far from reflecting the spirit of restless research of his Renaissance contemporaries

is concerned above all with stasis, with the securing of tradition through his forms. As in Egyptian art, the stereotype once determined becomes a symbol of stability reflecting the permanence of kingship; here as elsewhere the forms of art are determined by the nature of patronage, idiom thus conforming to function. Which is not to say that, as also in Egyptian art, we may not here and there find a variant idiom spontaneously adopted by an individual bronze caster 'in his own time', while free of the imperatives of a rigid patronage. This might explain the naturalistic idiom of those heads and figures of dwarfs to be encountered in the Benin corpus, occasionally conjectured, by virtue of their apparent non-Bini naturalism, to be of a residual Ifẹ aesthetic and hence 'early' – an unnecessary conjecture when the ease of acquiring a naturalistic idiom is taken into account: naturalism has been practised since mesolithic times. But from the time of the coming of the first Portuguese until the sack of the city in 1897, Bini art maintained a consistent and uniform indifference to naturalism in its preference for a system of forms dictated by the observation of an inflexible canon. A study of the history of this vision in its adoption of principles for rendering the human figure might contribute to our understanding of the Bini aesthetic by placing its plastic forms, its idiomatic expression, in time.

There are no styles in this art: problems resolved in the earliest period are those practised by rote in the latest; the early vision inheres in the very last works. The bronze plaques cover a period of perhaps four hundred years and vary little in content from beginning to end – human figures in repose with occasionally an animal or a bird. Violent action is avoided; any action at all is in fact implied rather than represented, for though the human figure is at times acknowledged as a source of physical action, it is an action observed *from the outside* in terms of constant formulae rather than seen as motivated from within with potentially arbitrary and incalculable effect in the resulting form. The muscular dislocation, the continuity of movement, the temporal anticipation which we feel in the *Discobolus*, with its destruction of what is known, its surprises, its implications of transformation, are abjured. Deliberately so, for from an early stage the Bini artist, having found a suitable formula for the rendering of the upright static human figure, saw no necessity to do more than imply that the stance of this static figure, within an explicit context, had changed in accordance with his own external observation of it, and not through a wilful and arbitrary need of its own. Volition is indeed accorded to the human image in the external visual world, but it is a volition which disregards spatial implications and which is always rendered in terms of the artist's point of view, subject to formulae which he had developed for rendering the immobile human model; not a volition seen as originating within the organism with unpredictable anatomical consequences. Movement in the sculpted figure is subject always to the intentions of the artist: he *causes* it to move in the same way as an instructor of drawing might cause a lay-figure to move.

The contemporary English painter, Francis Bacon, has based his interpretation of the human theme on Muybridge's compendium of photographs

of human and animal locomotion; the often incongruous shapes assumed by these figures in motion would have been incomprehensible to the Bini artist. In the manner in which formal problems, once resolved in the earliest period of Bini art, continue to dominate idiom in all subsequent periods we are reminded of the incidence throughout Egyptian art of the stereotype repetition of an idiom resolved once and for all in the Old Kingdom and never abandoned.

Apart from their formal content the descriptive content of the plaques is also limited – Portuguese soldiers and traders, Bini warriors and noblemen, hunters, and, greatest of all realities, the Bini court with its life centred around the Ọba. From details of the dress and accoutrement of the Portuguese represented we are able to isolate the earliest group of these plaques and to study, over a period of the first hundred years or so, 1485–1590, the solution to those formal problems which will determine idiom in all later periods. The year 1590 represents a datum-line between the 'medieval' and the modern periods in the study of this art; its significance for all West African bronze chronologies we shall discuss in a later chapter. It is interesting in this connection to recall Berenson's demarcation between the modern and the antique in European art as lying in an attitude on the part of the artist in which his forms come to address more and more the actual needs of men rather than to serve some more than human purpose. The admonitory and edifying function of art in the service of the Church gave way, particularly among the Venetians, to the need to reflect a direct and conscious delight in living, free of metaphysical reference. In the secular and intellectual attitude consciously adopted in response to the complexities of external nature, we may regard the achieved solutions of the Bini artist as inherently modern and of profound importance in the history of African art.

The Portuguese group of bronze plaques, characterised from its descriptive content by the dress and armour of the mid sixteenth century, appears to represent the earliest essays of the Bini smith in a system of plastic cognition: the first attempts made by him in discovering two-dimensional equivalents for three-dimensional experience. The subject treated is the oldest and most primary of all – the image of a standing man, fig. 90. However wanting in aesthetic achievement, the objects embodying his solutions to the problem represent a revolution in African art comparable to that achieved by Giotto in his break with the vision of the Byzantine tradition. For whereas in the traditional sacred art of Africa the human figure is conceived merely as the material substrate of the spirit, as inferential and possessing no independent definition or capacity for locomotion, it now comes to be seen as spiritually autonomous, guided by will and thus subject to incalculable changes of stance, mobile, variable in shape and contour. The Bini artist is faced with the problem of reducing the undifferentiated nature of this new experience to terms which he can control and which can be repeated and adapted to a number of ends: from the welter of conflicting visual experience he is obliged to abstract constants which

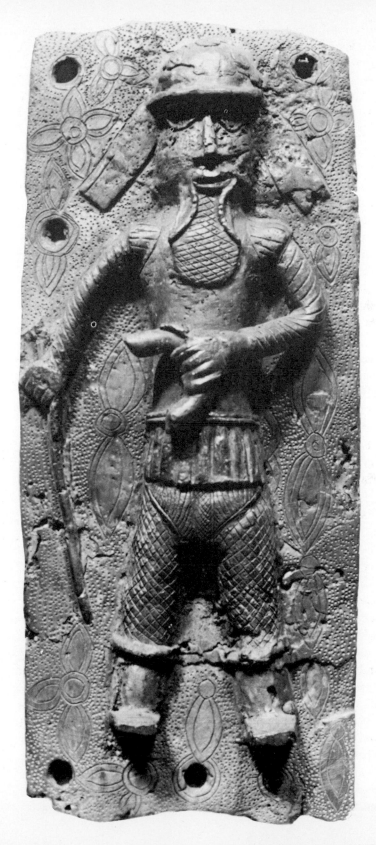

90. Benin, plaque figure of a
standing man

will be universally intelligible and which in a non-literate culture can be read as easily as a poster. He invents visual slogans. This done, he has no further need for the conventions of naturalism. He is like a man who, having discovered a glittering treasure after great labour, contents himself with an ingot or two for the conduct of a spartan but self-determined, if self-denying, life.

We may interpret the Bini image of the human figure in characteristically spartan terms: his concept of symmetry is a static one of bilateral equipoise – he avoids the *eurhythmy* of the Periclean Greek with its inherent physical imbalance. His masses are simple and bounded by gravity; their axes seem to meet at the centre of the earth. Surfaces are not broken and transformed by the folds of garments to yield an excitement which might in any way imply the temporal. There is no dionysiac presence; it is an ascetic but non-spiritual art, stranger alike to anguish and to ecstasy.

The Law of Frontality enunciated by Lange as explaining the structural principle of primitive sculpture provides a useful basis for the interpretation of Bini plastic form. It is that 'whatever position the figure assumes the rule applies that the central plane which can be supposed to lie lengthways through the human body . . . and which cuts it in two symmetrical halves, must retain its position in one plane, and cannot be turned or bent one way or the other'.[3] The *central plane* is envisaged by Lange as frontally bisecting a hypothetical rectangular block encasing the upright full-face human figure which it bisects in the manner described, fig. 91. In our examination of the plaques this *central plane* retains its position in relation to the plaque as a whole and determines the viewpoint of the spectator. Each plaque is a frontal section through Lange's hypothetical encasing block, made at varying depths, each determining the degree of relief of the figure, or figures. But as we are concerned principally with two dimensional expression (the plaques) and with sculpture which though materially three-dimensional is yet conceived in two dimensions (the bronzes in the round), we might add the concept of a *median plane* operating for *individual* figures in the manner described by Lange. In the case of the plaques it is necessary to discriminate individually between the orientation of figures, and to relate them all to the controlling concept, the *base plane* – the plane of the plaque itself – which serves as a support for the figures and in terms of which they are conceived.

91. The Law of Frontality (after Lange)

Thus in our interpretation of the Benin canon as revealed in the plaques we need these three concepts: (1) a *base plane* defined by the surface of the two-dimensional plaque, (2) a *central plane* bisecting the base plane at right angles and which defines the path of vision *of the spectator*; and (3) a *median plane* individual to each figure, of the same definition and function as the central plane of Lange, but which, as we shall see, is related to the path of vision *of the sculptor*. This distinction between a *central plane* determining the viewpoint of the spectator and a *median plane* controlling the posture of each separate figure will be appreciated when we observe the

path of vision at times adopted by the sculptor as distinct from that of his spectator. The relationship between the two is illustrated in fig. 92, where it will be observed that while the median plane, *pqrs*, rotates through 45° in accordance with the frontal viewpoint obligatory to the Bini sculptor, the central plane, *ps*, continues to determine the path of vision of the spectator

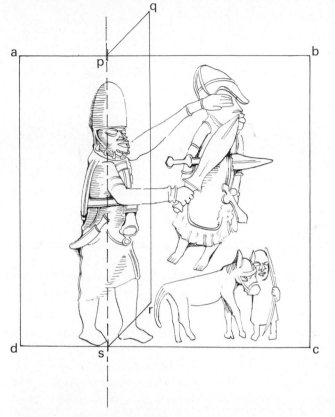

92. The Triumph of Ọrhọgbua (?), illustrating central, median and base planes. Here foreshortening is achieved by an actual turning of the mass of the Ọba's figure so that its median plane determining the point of view of the sculptor, stands at 45° **to the central plane,** which determines the locus of observation of the spectator. In the figure of the captive chief the body is rendered to the base plane, to which the median plane remains at right angles; here sculptor and spectator share a common locus of observation on the central plane; even though the intention is to illustrate the profile effect of the transfixing of the trunk of the captive, the sword is rendered in planar profile on a full-face torso. The head of the horse is physically turned at 45° from the base plane in order to accommodate the figure of the groom, thus avoiding the need for linear foreshortening. Source PR 2(5) (source references in prelims)

at right angles to the plaque. Both are controlled by the base plane, *abcd*, which determines the spatial context of all figures represented.

Schemata worked out by the Bini artist for the human figure were based on the representation of a human being standing full-face, with its implications of bilateral symmetry. With this is tied up the frontal viewpoint of the sculptor anchored in the median plane of the figure. Any deviation of the figure from the full-face posture raised problems in foreshortening which, being purely linear, would need to be resolved *by drawing*. This is to say that, with the destruction of a strict bilateral symmetry, forms begun to overlap or to disappear altogether and require linear reinterpretation. So long as the path of vision of the sculptor remains coterminous with the median plane of the figure this new relationship of forms with its arbitrary contours would make it unnecessary for him to reconceive the forms of the figure with each new movement it makes. But with each inflexion of the torso or limbs to left or right or up or down he would need to invent a new set of plastic equivalents for his objective visual experience. These would

involve formal reinterpretation of the members of the human figure which would lie outside his normal experience or the normal experience of his spectators. The foreshortening of arms for instance on a two-dimensional surface would result in the unfamiliar shapes at *a* and *b* of fig. 93, which are

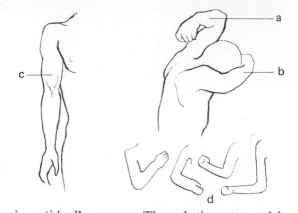

93. Interpretations of arms in the human figure. (*a*) (*b*) conventions of foreshortening in modern European drawing; (*c*) Ideal, or everyday, conception of an arm; (*d*) examples of arms from early Benin bronze plaques, conceived without benefit of the conventions of foreshortening or perspective

very different from the platonic or 'ideal' arm at *c*. The solution at *a* and *b* resolves the problem of foreshortening on a two-dimensional surface: it is a problem *in drawing*, in visualising linear equivalents for shapes that depart from the norms of daily experience. But, unlike the Greek or the Renaissance sculptor, the Bini sculptor enjoyed no tradition of the resolution of visual problems by means of drawing; behind him were no conventions for rendering nature on the two-dimensional surfaces of the vase-painting or the fresco; he was confined to the rendering of 'ideal' and static views of the human figure, or its members, for want of the means to adapt these to the arbitrary and conflicting expressions of forms in motion. The repertory of forms implied in the use of foreshortening and perspective, the symbolising of spatial experience which these represent, lay outside his technical framework and the conceptual experience of his people. Moreover the realising of forms that depart from the 'ideal' in accordance with the norms of daily experience would involve the destruction of the median plane on which rests his path of vision.

Solutions of the Greek sculptor to such problems can be observed in the variety of forms in the low-reliefs of the Parthenon frieze by means of which he realised visual equivalents for the movement of men and animals in the Panathenaic procession; the various examples of the foreshortening of the members of the human figure are achieved through that visualising *by drawing* which by the fifth century BC had become a normal mode of seeing for both the Greek artist and the Greek layman, fig. 94. But faced with similar problems the Bini artist does not reconceive the shapes of the elements of the human figure with each movement: he does not depart from the path of vision imposed by his observation of an inflexible median plane; his solution is *to turn the relative mass through actual space* into the desired position, and thus rotate the median plane intact. He follows the figure round, so to speak, leaving his spectator rooted in the central plane. Fig. 95a illustrates the spectator's viewpoint on the central plane, while 95b illustrates the rotation

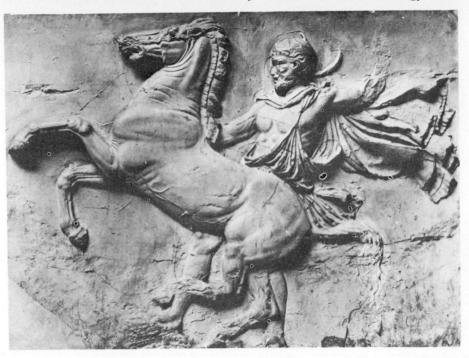

94. Foreshortening by drawing: horsemen preparing for the Panathenaic procession, Greek

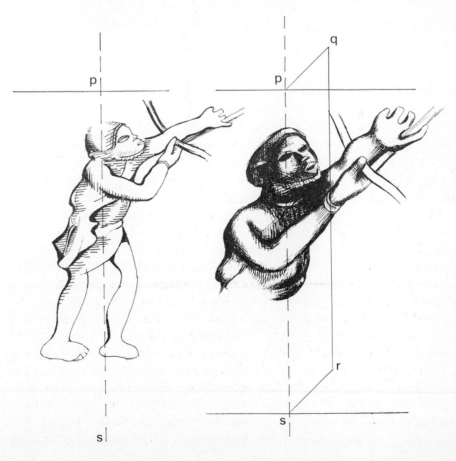

95. Rotation of the median plane. Source: VLP. 29

of the median plane in the sculptor's obligatory frontal view. The sculptor has realised for his spectator the three-quarter view while refusing to relinquish his own conceptual path of vision. He has not departed from the schema of the full-face rendering, he has avoided the need to reinterpret each separate element of the figure as it assumes a new contour in space, he has avoided the hazards of foreshortening, through drawing, with its shapes that might or might not 'look right' depending on his conceptual skill, and which in any case would be unfamiliar, and perhaps even unreadable, to his spectator; most important of all he has secured his median plane from that warping which results from its independent movement natural in the articulation of the human torso.

Far to the west of Benin, in the Yoruba Ijèbú school, an attempt at resolving this problem provides an interesting contrast. Here the smith boldly departs from the Law of Frontality governing the Bini artist and, for the courtiers supporting the king at fig. 96, attempts a three-quarter render-

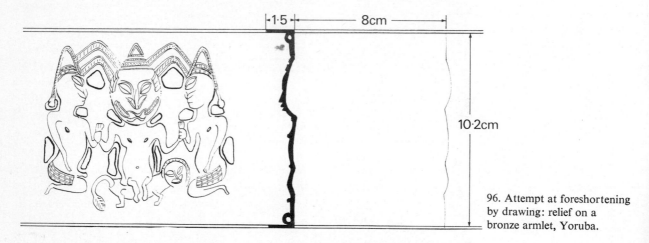

96. Attempt at foreshortening by drawing: relief on a bronze armlet, Yoruba.

ing *by drawing* and not by means of a material rotation of his forms through actual space. But he lacks the technical apparatus for realising such a view – the repertory of forms necessary in creating equivalents for his visual experience such as lie in the hands of the European masters of foreshortening. That the turning head and torso call for the creation of forms entirely different from those familiar in the frontal view he understands well enough. He does not need to be told that in this new posture an eye, a shoulder, a pectoral would disappear. By what means then are these effects to be secured? Had the Ijèbú smith recourse to a tradition of drawing, the visual conventions for rendering the overlapping of planes, the recession of volumes with their consequent re-inflexion of contours, the articulation of a unified space, would have aided him in reconstituting his forms in the three-quarter view. But he had recourse to no such conventions. His figures, despite their linear nature, achieve no extension in depth: they are conceived in terms of the base plane, by which they remain bound. His attempts therefore come nowhere near solutions. However clearly the new

forms might present themselves to his mind's eye, he lacks as yet the vocabulary of the plastic language by means of which they may be realised. But it is an attempt at a solution, *by drawing*, in the hands of an artist for the first time coming to understand the articulation of volumes in terms of line. We should not doubt that the posing of such a problem would have suggested its own eventual solutions, though creative impulse in the African bronze remained destined to realisations of quite a different order.

The significance of the realisation of the three-quarter view in the Bini plastic vision will be more fully appreciated when we examine the stages by means of which it was achieved. The controlling plastic concept in these plaques is of the human unit treated in exclusion to all accompanying units; it is this unit which in itself dominates the creative approach of the artist. Where he has to deal with several such units in a single composition he never treats them thematically, that is, as parts related to the whole in a composite construct; they are rendered as simply standing side by side in an arithmetic rather than a harmonic approach to composition, conceived in spatial relation only in terms of the base plane on which he works. Which is to say that these figures do not interpenetrate or overlap to define a common space; their spatial expression is a function of the base plane and does not refer to the unifying space of living experience.

The Bini artist avoided having to invent formulae for rendering living space, i.e. perspective, foreshortening, etc.; his problem was the articulation of the elementary or primary area of the plane on which he worked in representing on it equivalents for his objective visual experience. He therefore could not employ those visual conventions, acceptable to the European eye, in rendering for instance the posture of his Ọba whose feet do not touch the ground as he is borne along by his courtiers, an image that recurs in several of the bronze plaques. Formally the earliest of his attempts at translation from the world of nature into the world of art appears in the group of plaques representing Portuguese personages in mid sixteenth century costume and accoutrement. The problem is that of representing a standing man full-face. In fig. 97 a–d we observe some of his solutions.

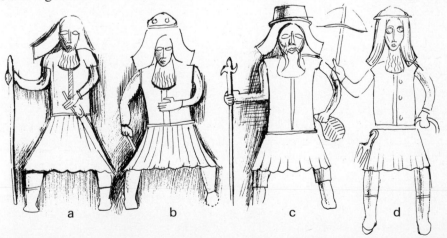

97. Conventions for rendering the standing figure full-face, Benin. Sources: (*a*) VLP 3(4); (*b*) VLP 4(*d*); (*c*) VLP 4(*a*); (*d*) VLP 15

a b c d

In all of them he finds difficulty in treating the legs as an integral part of the figure; they are mere pillars supporting descriptions of clothes, head-gear, etc., the things which obviously most excited his curiosity and wonder at the time. A realisation of the full structural integrity and unity of the human figure seems beyond the power of the artist at this stage. Every item of subject matter in these plaques strictly adheres to the dictates of the base plane: each statement is planar. Spatially the forms suggest the tentativeness of a person unwilling to venture too deep into unknown waters. The limbs are articulated radially on the base plane, and at right angles to the median plane, rather like hands on the face of a clock, fig. 93d; there is no form which does not submit to the dominance of the base-plane, itself static, and this imparts a rigidity and symmetry to these figures which will persist in all later work, fig. 98. In accordance with this dominance of the base plane the

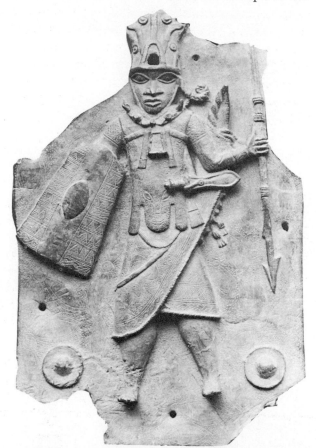

98. Dominance of the base plane: plaque figure of a warrior, Benin

figure carries few accessories which might challenge the planar concept; where such an object – a sword, a cutlass, a musket – is represented, it is laid out on the base plane and parallel to it instead of assuming an independent angle as in real life. The mind of the spectator in these instances fills in the lacunae. The problems involved are partly constructional; they are the problems which face the child making mud figures on the doorstep. Each form refers to the plane on which he works and no difficulty arises so long as

he does not envisage forms which cannot be so related. But in these plaques the reason is also technical; for forms significantly projecting from the base plane might require the support of a number of struts to buttress the wax model against the weight of the mould. In certain plaques of the period, as technical confidence is attained, we do in fact notice the appearance of such struts as individual items – a cutlass, a staff, a spear – are rendered free-standing though still parallel to the base plane. But conceptually the problem of foreshortening, involving the *warping* of the median plane, is avoided; the initial form is planar, and accessories – even those known to stand at an angle to this initial form – remain planar. The base plane, both in a conceptual and in a technical sense, offers the security of a river-bank to the swimmer not willing to venture too far into unknown waters – a perfectly acceptable situation so long as the artist remained content within the limitations imposed by forms in unforeshortened low relief, and so long as he did not attempt to find equivalents for visual experiences of a more complicated nature.

But even in the Portuguese period there were those who did not remain so content; obviously a whole range of natural expression strained against the bonds imposed by the frontal concept. From the shallows of the river-bank he becomes aware of cooler and more refreshing waters in the depths ahead. While refusing to abandon his refuge in the base plane with its median viewpoint he now attempts, as in the equestrian piece at fig. 99, to render not the full-face but the profile view of a man. It is interesting to note that this example was cast rather late in the period, at a date after 1590, perhaps some time early in the seventeenth century, as attested in the associated crotal type (cf. figs 80, 81). Here the horse and the head of its rider are represented as ideal forms which the artist would have no difficulty in visualising, though asymmetrical. But he could only deal with this asymmetry in his accustomed frontal-planar manner with its median view; this results in a composite of ideal forms constituting an equivalent for objective visual experience which he knows to operate in quite other terms, but which accords with his technical and conceptual equipment.

The problem is again encountered at fig. 100, in profile and three-quarter

99. The median plane in an equestrian profile, Benin: cf. fig. 111. The associated crotal indicates a date of the late 16th or early 17th century. Sources: PR 19 (112); PR 22(129)

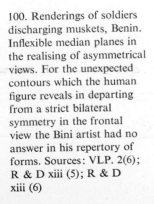

100. Renderings of soldiers discharging muskets, Benin. Inflexible median planes in the realising of asymmetrical views. For the unexpected contours which the human figure reveals in departing from a strict bilateral symmetry in the frontal view the Bini artist had no answer in his repertory of forms. Sources: VLP. 2(6); R & D xiii (5); R & D xiii (6)

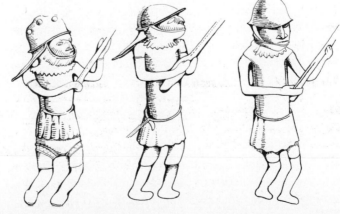

101. Foreshortening by drawing: St Christopher from a Westminster Abbey psalter, English, late twelfth century

views of soldiers discharging muskets. Could the Bini artist have brought himself to acknowledge the conceptual warping of the median plane involved, his rendering might have appeared as in the twelfth-century English drawing at fig. 101, which illustrates not only the asymmetry resulting from the movement of the figure about its axis, but also the warping of the median plane which expresses a new relationship between what, in the frontal view, had been symmetrical elements: hip-bones, knee-caps, elbow- and shoulder-joints, ankles, feet, wrists and the head in its relation to the rest of the body. Attempts of the Bini artist to find formal equivalents for this new experience appear at figs 102–4. In these the median plane is not abandoned, even though the asymmetry of the pose is acknowledged in the placing of the legs, in the profile and three-quarter heads. Muskets and swords remain fixed to the base plane, on which the limbs are allowed to move radially. One of the earliest students of these plaques has remarked on the curious

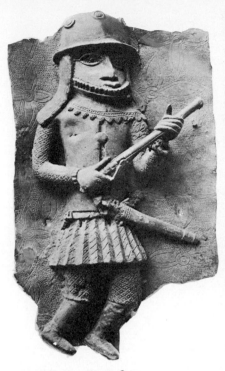
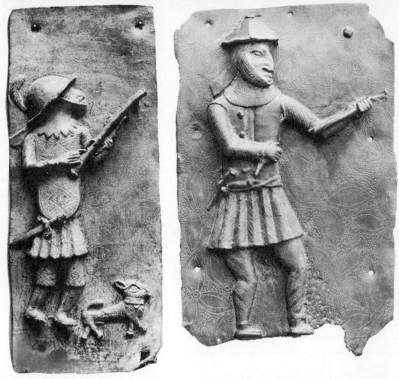

102–4. Benin, plaque figures of soldiers discharging muskets

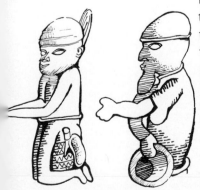

105. Foreshortening by transposition, Benin. Sources: R & D xxix (1); VLP 6(c)

convention of the Bini artist whereby the legs of Europeans are sometimes rendered crooked in this way while it is never employed for Africans. It is the answer of the Bini artist, in planar terms, to the actual crooking of the legs in the shooting position (observable only among European owners of muskets in the mid sixteenth century), for which he had no ideal or ready-made answer in his repertory of forms. It is of interest in these renderings that the three-quarter view is not achieved as a foreshortened drawing on a two-dimensional surface, as in the Greek relief, but by a material transposition of the mass of the head through 45° from the median plane of the torso. The sculptor has in fact conceived an independent median plane for the head and this, as at fig. 95b, necessitates his shifting his locus of observation. It is possibly through some exercise such as this that he achieved the unitary shifting of the entire median plane to suggest the three-quarter view at fig. 105 in which the problem is not resolved *in drawing* (by foreshortening) but by the transposition of the actual mass of the figures. There thus result two loci of observation: that of the spectator based on the central plane, and that of the artist based on a rotating median plane. Plaques with several figures are therefore not rendered in a common conceptual space accounting, as in the Greek example, for the disposition of all units, but in a multi-visional space in which each separate figure is conceived on its own rotating median plane, all independent of the central plane which determines the path of vision of the spectator.

A curious combination of two- and three-dimensional rendering in a single figure occurs on a bronze jug in the Nigeria Museum, fig. 106. While

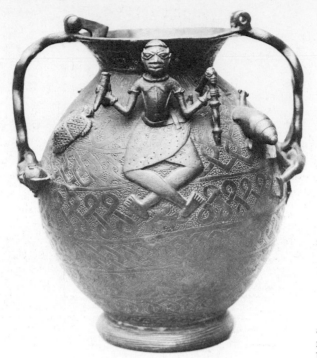

106. Combination of two- and three-dimensional rendering: bronze goblet, Benin; see fig. 200

the three-dimensional treatment of head and torso presents no interpretive problems the Bini artist is at a loss to find an adequate linear formula for rendering the cross-legged posture in two dimensions. His solution, as in the bronze plaques, is a sum of ideal views – a profile leg outlined in the base plane to which is appended, albeit in reverse, a plan of the foot. This latter need not be thought as naïve or perverse as it may at first appear, if we regard it as a sign for the divinity of the Qba, of which the everted legs of the bronze plaques is only one of several indicating that, for an excess of life-force, the feet of the sovereign could not come into contact with the earth. This sign of the everted foot is sometimes employed on the forehead of an Qba where only the head is being cast, fig 200. For want of the resources of linear foreshortening, of the means to resolve certain conceptual problems purely by drawing, the Bini artist resorts to a variety of such signs, all no less eloquent than those employed by deaf-mutes or by road traffic authorities. They serve the Bini artist and his public in place of the abstractions of perspective and the incongruities of foreshortening, as the example at fig. 107 illustrates, in which the positioning of the Qba's feet, and those of the horse of the vanquished chieftain, are sufficient to indicate that everyone is in motion – that we are observing a triumphal procession enlivened by clapping, the sound of horns, the beating of drums, all vigorously on the move.

In the formulation of the Benin canon the inflexibility of the median plane on a static base plane is the principal determinant in two-dimensional expression. Nowhere does the Bini artist attempt that fragmentation of the

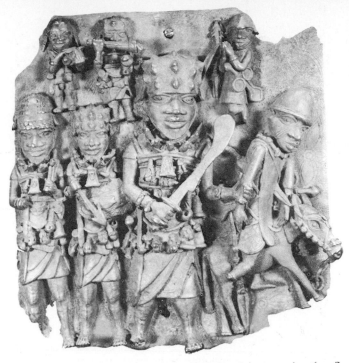

107. Benin, the Triumph of
Ọrhọgbua (?), bronze plaque

median plane which we observe for instance in the figures of Greek and
Amazon at fig. 108, nor the foreshortening *by drawing* of the late antique
dish from Mildenhall, fig. 109 – conventions which the Bini artist lacked in
the whole course of the development of his vision. The multivisional

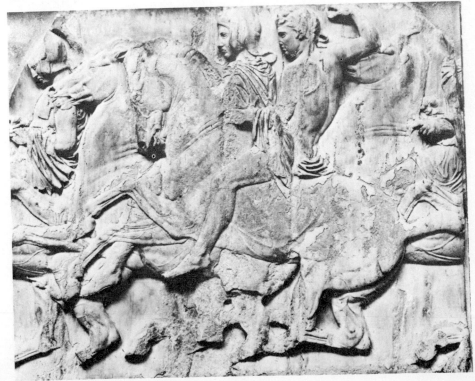

108. Fragmentation of the
median plane: the Parthenon
frieze, Greek

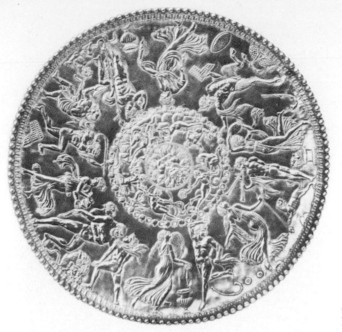

109. Foreshortening by drawing: the Mildenhall dish, British

juxtaposition of ideal forms secured the Bini artist from the need to treat his figures in pictorial space as for instance in the contemporary Italian low-relief at fig. 110, a purely linear resolution of three-dimensional form

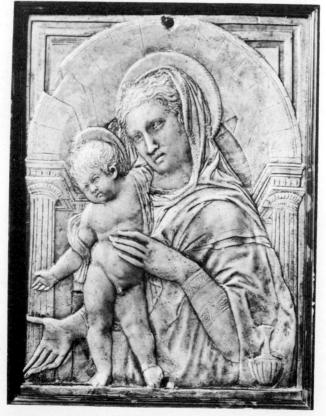

110. Foreshortening by drawing, Madonna and Child, Italian

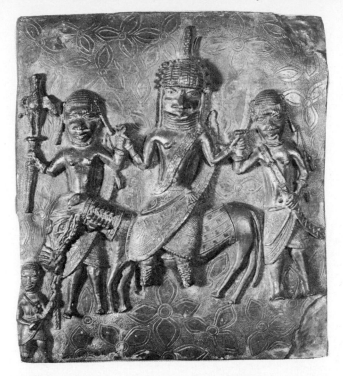

111. Benin, a royal procession, bronze plaque

in face and torso and in the foreshortening of the fingers. In the Bini procession at fig. 111 groom, king and courtiers are swung into full-face in accordance with the operation of the median plane of each figure in relation to the viewpoint of the sculptor, while only the horse in profile suggests the course of the procession from right to left. But in the Panathenaic procession the profile movement is qualified by a corresponding foreshortening of riders in depth achieved by means of drawing in stone, never deeper than two or three centimetres. These are comparative, and not value, judgments, proposed only to define the nature of idiom in the Benin canon, since for a significant response to these bronzes we need to see them in terms of their own conceptual intention and of no other.

Out of the variegated and often contradictory data provided by objective visual experience the Bini artist stage by stage worked out such formulae as would serve as constants in rendering objective visual experience, and which in his community would be as unequivocal as is the written word in others. His various formal solutions cover a period from the earliest casting of plaques, possibly around the end of the fifteenth or the beginning of the sixteenth century, to well into the modern period, which may be defined as opening with the seventeenth. After their expulsion from the Gold Coast (Ghana) by the Dutch in 1642 the Portuguese lost interest in West Africa and turned to the development of their Brazilian plantations. The date therefore provides a rough *terminus ante quem* for the representation of Portuguese personages in the Bini bronze, and taken with the

evidence for the introduction of the crotal at Benin in 1590, a Benin chronology is now in a position at least to isolate certain characteristics of this 'Portuguese' period.

A number of 'Triumphs' of the modern period, all on the theme of a foreign tribal chief led in victory procession by a Bini Ọba, show a confident interpretation of the canon at this stage. They were possibly executed over a period of time, perhaps by several hands, we have as yet no means of knowing. The theme and elements in their descriptive content recall the tradition of Ọrhọgbua's victory over the King of Igbon quoted by the court historian to members of the punitive expedition of 1897. Could the series be unequivocally associated with Ọrhọgbua, the earliest of them would have been cast during the latter sixteenth century, assuming them to have been roughly contemporaneous with the events described. But who were the Igbon? No tribe can today be identified in Nigeria by that name, though it is tempting to think of some group of the Ibo people living in 'a country near the Niger', whose facial markings at the period appear to have been not unlike those represented on the 'Igbon' captives in the plaques, fig. 112a. But the comparison cannot be pressed for rather similar face-markings appear on the Igbo-Ukwu bronze face at fig. 112b, on the warrior now held at Jebba Island in the Niger and claimed in the oral tradition to have come from Idah lower down the river, fig. 112c, and on a stone carving from Esie, near Ilorin in northern Nigeria, fig. 112d. Their common similarity to the Ifẹ face-marking 112e, itself remarkably similar to markings still used in Maiduguri, in northern Nigeria, 112f, need no longer go unrecorded. Since the only purpose of such face-markings would be to distinguish between tribe and tribe as clearly as possible they would hardly have been duplicated

a

b

c

d

e

f

112. Comparative tribal markings, Nigeria. (*a*) 'Igbon'; (*b*) Igbo; (*c*) Jebba (?); (*d*) Esie (?) – drawn from a reproduction in Fagg, W. and Plass, M: *African Sculpture*; (e) Ifẹ; (*f*) Maiduguri (modern)

across tribal boundaries. So it seems reasonable to consider the possibility of a contemporary connection of some sort between the peoples represented in these heads if, from their present-day location, we regard them as always having been separate peoples. They may, alternatively, have been emblems conferred on the various tribal rulers from some common source – yet another strand in the web of mysteries of the Nigerian past, but a not wholly irrelevant speculation when other iconographic affinities between the Bini and other southern bronzes, and those of the Jebba-Tada group are taken into account, figs 76, 84. Also, if the Ahammangiwa of Bini tradition is celebrated as having cast these 'Igbon' plaques they were, as indeed the tradition relates, certainly not the earliest made at Benin, for whether or not they are connected with King Orhogbua (Osogboa of the tradition) they are morphologically not representative of the earliest castings (which, according to this tradition were made under his predecessor, Esigie), and at least one of them is in any case to be associated with a date after 1590. According to the Bini historian, Egharevba, Oba Orhogbua was around this time conducting the campaign which extended Bini authority over Lagos; the event is sometimes also considered to have occurred around the turn of the seventeenth century.

In these Triumphs we note the avoidance of a unifying pictorial space with its implications of recession, and the verticality of structurally independent and autonomous units exactly as they occur in the earliest castings. A formula expressing an immobile bilateral symmetry has emerged for rendering the Bini face, subject to no emotions, and this will never be departed from, fig. 113. Artistic curiosity, early reflected in experiment and change, has frozen into formulae which most suitably suggest the stability and impregnability of the Bini monarchy – the sole patron of these bronzes from beginning to end. In these purely secular forms we observe a control of the vagaries of individual impulse, of individual curiosity or inspiration, as absolute as that produced by the imperatives of belief in the sacred African bronze. The secularisation of vision expressed in Bini art would stimulate no triumphs of the individual intellect, no Piero della Francesca, no Leonardo: such propensities remain in the service of organised power and the imperial will, whose uniform utterances, like those of Achebe's Ibo gods, issue from throats of metal.

This art is characterised by an inherent and impassive power, all the more impressive when its modest dimensions are remembered. Henceforth the formal principles of the Bini bronze would be subject only to refinement at the hands of artists now confident in a tradition of their own making. Style would flower in those masterpieces, perhaps the finest in all Bini art, which may be designated as of a Hieratic Period, figs 114–18, works conceived in the utmost rigour and formal restraint and characterised by an inhuman idealism of absolute bilateral symmetry. Here the merely temporal is abjured, the human theme depersonalised; movement is rendered neutral in terms of the dominant base plane, as is the treatment of anatomical detail or surface excitement of any sort; lateral rhythms set up

113. The Bini bronze stereotype. Like the prose which Shakespeare reserved for the utterances of crowds and of ordinary persons a less formal, more 'prosaic' image served the Bini artist in his rendering of strangers, as might be read in the faces of vanquished kings in those triumphs over the 'Igbon', of which several versions exist (see figs 92 and 107)

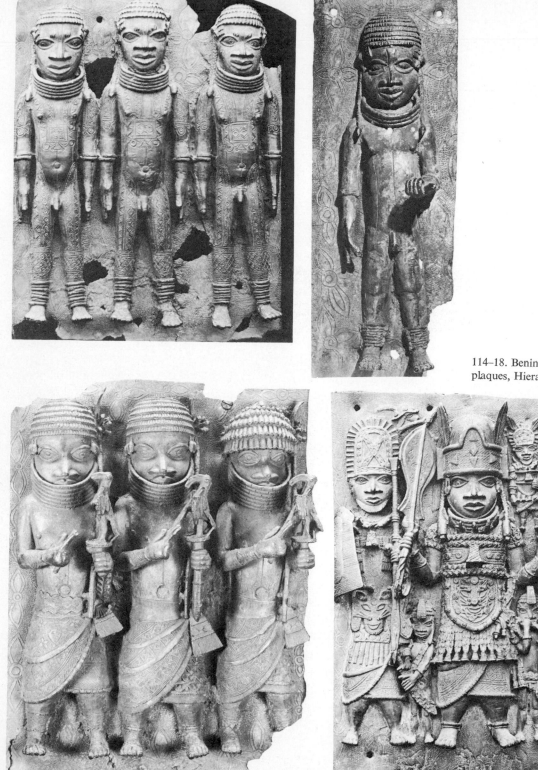

114–18. Benin, bronze
plaques, Hieratic Period

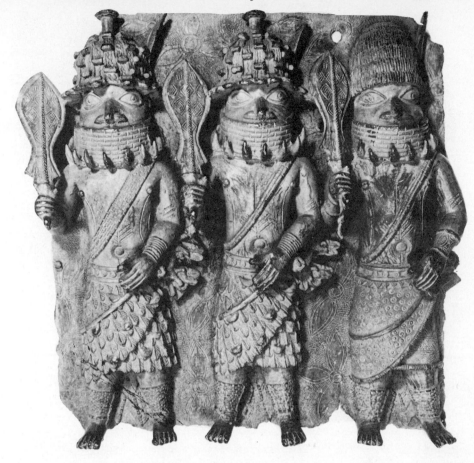

between two or more identical figures enhance their transhuman idealism. These figures have no inscape, the eye may delight in no seductive detailing; all is mass frontally rendered, fibreless strength contained. They are bronzes to a superlative degree – the polar opposite of the dematerialised drawings in wax that are the sacred Yoruba pieces. In these plaques the limbs are the most beautifully conceived in all Bini art – arms imperceptibly modulated stand as rigidly as ceremonial staffs beside a rigid body, palms unflexed and set at a uniform ninety degrees to the base plane with thumbs foremost. Bini art will henceforth know no higher reaches in the expression of its canon. Here an absolute technical mastery reveals all the certainty of a tradition in which early labours now yield rich and confident rewards.

This morphology of the plaques is not proposed in isolation as though representing the products of an independent school; it is meant as a diagnostic of style in the Benin bronze as a whole. Its stages apply also, if less clearly, to the three-dimensional sculpture conceived by the same artists. In the Benin City Museum are those three very rude castings of Portuguese soldiers whose uncouth vision and technique have provoked notions of a Bini 'rustic' style, fig. 119 a–c. These are reputed in oral tradition to be of

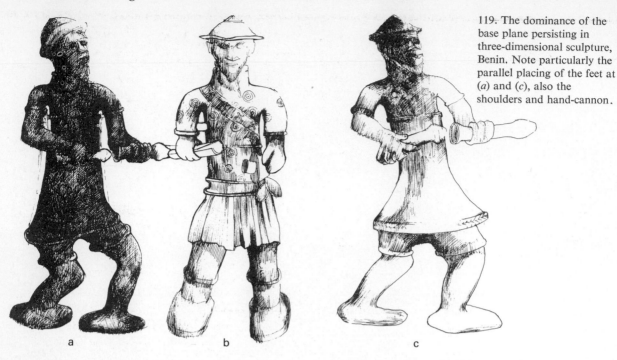

a　　　　　　　b　　　　　　　c

119. The dominance of the base plane persisting in three-dimensional sculpture, Benin. Note particularly the parallel placing of the feet at (*a*) and (*c*), also the shoulders and hand-cannon.

officers who accompanied the Ọba Ẹsigie in his campaign against Idah on the Niger in 1515, a not unlikely claim in view of the subject matter. The idiom is that of the plaques of the period; so much so that a common hand may even be assumed for the group and for certain plaques of similar subject matter: their conceptual identity with the morphologically early plaques is illustrated in the treatment of full-face and three-quarter forms based in the type of model analysed at fig. 100. These sculptures are simply plaques made solid, so to speak. An implicit median plane determines the viewpoint of sculptor and spectator alike, while, despite the possibilities of the third dimension, an invisible base plane is still acknowledged. Their makers have inherited no visual tradition – no effort of a previous hand seems to stand behind them; in their naive occupation of space, in their planar articulation they are threshold forms whose rigidity in face of the complexities of the three-dimensional human figure will leave their mark on Bini bronze sculpture forever. Conceptually they bear comparison with the Late Meroitic relief at fig. 120, realised two thousand years earlier within the terms of the Egyptian canon. Here all forms are dominated by the base plane; but where the Egyptian artist would have acknowledged a profile contour for the lower torso (at times too even for the shoulders) the Meroitic artist has left the median planes of his figures intact, appending to them the profile feet in exactly the manner observed by the Bini sculptor in conceiving these figures in the round, *a, c*. In this connection the *Discobolus* might provide a purely sculptural contrast since Myron similarly stood on the threshold of classical form. This figure is also rendered in a single plane rather like a relief. But, unlike at Benin, the artist does not shrink from that

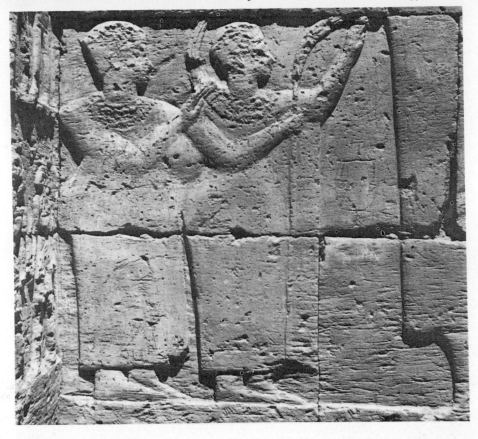

120. Planar articulation of the human figure: relief from a pyramid chapel, Meroë

warping of the median plane which in this case results in a right-angle relationship between the axes of hips and shoulders in a conception of physical movement which would remain unchallenged in European art to the time of the Futurist propositions of the twentieth century. In the earlier Greek bronze at fig. 121 (probably Spartan) an interesting contrast is provided in the separate median planes adopted for full-face and profile views in the same figure.

In these Bini 'Portuguese' pieces, as in the plaques at fig. 97 a–d, the stubby arms and trunklike legs are mere carriers of the details of dress and accoutrement; they are not expressions of an integral conception of the human figure. Like all later Bini art they essentially deny physical movement. The feet though fully three-dimensional *still lie parallel to an invisible base plane* exactly in the manner of the plaques (cf. figs 102–4). Despite the resources of the third dimension the vision of the sculptor remains conceptually rooted in the base plane and bound to that inflexible median plane in terms of which the figure is conceived. Such evidence strongly suggests that these must be amongst the very earliest of three-dimensional bronzes attempted by the Bini smith, and though it may be objected that these three pieces provide only a limited diagnostic, the conceptual limitations of the period are further echoed in examples figuring Bini Ọba and, presumably, their queens. On the evidence, then, we may confidently regard the equestrian

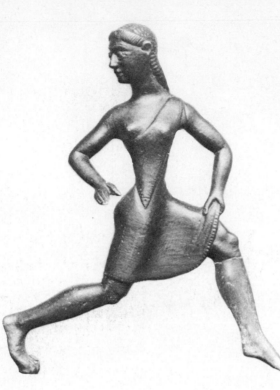

121. Bronze figurine of a girl running, probably Spartan

piece at fig. 99, cast during the fifty-odd years 1590–1642, as the type-example of this stage in the evolution of the Bini bronze, whether in the plaques or in the round. If local tradition is correct in associating the pieces at fig. 119 with Portuguese officers present at Esigie's campaign in 1515, then seventy-five years would need to be added to this phase of the style-cycle, assuming the pieces to have been roughly contemporaneous with the event they supposedly record, i.e. 1515–1642.

A morphology of sculpture after this period would be difficult to follow, if indeed there can be considered to be such a thing, for the technical problems raised in finding plastic equivalents for objective visual experience in the case of the plaques were never so thoroughly faced in three-dimensional work. In these figures, as in the heads, the fragmentation of the median plane is avoided to the end; they remain conceptually two-dimensional in their adherence to an inflexible and static median plane and in their implicit acknowledgment of an invisible base plane. There is no evolution of vision such as we observe in the plaques, no essentially three-dimensional resolution of problems – the heads do not pivot on the axis of the neck, do not look upwards or down; figures do not swing or bend: there is only the vision of the plaques produced in the round. Lacking other evidence we may precariously seek a temporal succession in apparent progressive technical sureness, in the difference for instance between the officer of fig.

122–3. Benin, soldiers
discharging muskets, bronze

122 and that of fig. 123, comparisons such as may also be made between
various equestrian pieces, hornblowers, and plaques of like subject matter.
But in the absence of independent data we should only in this way be reading
time-sequences into form-sequences which, as we have seen, may be ex-
pressive of nothing more than the relative skills of contemporary craftsmen.

Characteristics of the hieratic category of the plaques may be observed
in iconographic elements of certain heads in the round, for example in the
wiglike convention for rendering the close-fitting cap built up of helical
coils set side by side, often in association with the vertical brow marking
first recorded in the early sixteenth century, figs 124, 125, a combination
which also occurs at Ìjèbú Òde, fig. 193. On the morphological evidence

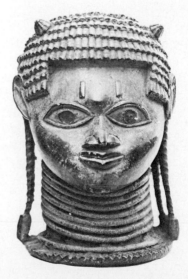

124–5. The Bini 'wig' and
brow marking of the
sixteenth century

work of this type must be considered advanced – a conclusion independently supported by the occurrence of an identical type of cap combined with similar brow marking on a Tada bronze of undoubted seventeenth-century date. We must bear in mind that even after 1590 the Bini artist is still struggling with interpretive-formal problems in his response to objective visual experience, figs 80, 81, and that as late as the early seventeenth century his solutions to such problems, far from having been resolved, were still in their infancy, fig. 99.

In the use of the original European-made crotal, which seems to have been introduced by the English to Benin in 1590, the plaque in fig. 81 is possibly closely to be associated with this date – later on specifically African types of crotal will be developed. The characteristic Islamic repoussé decoration of the baseplate once again suggests northern associations for the Bini bronze of the period.

The Benin canon represents in African art an important change in the role of the artist; from being the passive agent of god or spirit he becomes an independent creator responding to the stimulus of his visual environment. In the process of finding plastic equivalents for objective visual experience he discovers schemata regulated by the operation of a median and a base plane to his forms and these planes, always unarticulated, continue to govern expression even where his forms are three-dimensional. His sculpture in the round is therefore essentially conceived in two dimensions, being projections of concepts proper to execution in the plaques and apparently first resolved in the plaques. In assessing the resulting idiom and its expression in style we must remember that the researches of the Bini artist were never directed to achieving the naturalism of his European contemporaries of the Renaissance; like the Egyptian artist he developed plastic conventions intended to be as explicit in statement as that of verbal language. Such conventions could not change from generation to generation without defeating their central purpose: they constituted a language meant to be read down the centuries. In such circumstances it is not surprising that, having in the first place achieved a revolution of vision in African art comparable to that of Giotto's in the European tradition, the Bini artist did not realise the logical consequences of his new stance in relation to nature – the conquest of the visual world in naturalist forms. But it must be remembered that though naturalism in art is comparatively easy to achieve and is amongst the oldest of idioms developed by man in the rendering of nature, it has been eschewed by most cultures in their preference for an idealism of one sort or another. Form in Benin is ultimately rooted in such an idealism. That in four centuries the corpus numbers a mere seven thousand works[4] or so is to be explained by a probable high rate of casting failure coupled with the known custom, also practised by Aṣante and Greek, of melting old or unacceptable pieces in the production of new.

Secular patronage, besides determining the nature of form, also accounts for a wider range of manufactured objects than we find elsewhere in the

African bronze. Organised into the craft guild under the shadow of the palace, Bini craftsmen would more frequently be called on to widen the compass of their resourcefulness than would for instance the Yoruba masters of the sacred bronze whose client, constrained within the narrow imperatives of cult, demands no mask, no plaque or memorial head, no animal cast or cosmetic box nor the sundry trivia of courtly pomp and fancy. In such a range of effort realised by the Bini a trajectory of intention is discernible in the craft from beginning to end. The Bini bronze represents a singular intellectual adventure in the African plastic. It has been called cold, passionless, pedestrian, stereotyped; it has been read as a prosaic blurring of the Attic vision of Ifè; it has suffered comparison so distorting that today one can hardly look on it without wishing it other than it is, regretting old skills bent to an end apparently so wanting. To believe with Underwood that Bini art is an early example of the failure of the intellect to restrict the expression of rational emotion is not only to read into it an intention other than its own, but also utterly to misunderstand the nature of its formal achievement.[5]

As in the art of Ifè, but more patently so, this corpus does indeed represent the triumph of the intellect over rational emotion, though hardly in terms of Ifè classicism. It is the most obviously reasonable of the African bronze corpora. In its own way it re-enacts all the adventure of the Renaissance from Giotto to the Mannerists, all the more staggering when the want of fertilising influence, the patrimony of tested ideal, is taken into account. For this art is unaffected by any other. Here despite a symbolism of sometimes distant implication we may not speak of influence. Within the city wall a canon is developed in response to imperial will alone, a response vested in intellectual form of the utmost rigour, an apprehension of form as distinct in the African plastic as is the aesthetic of Ifè. In its spartan restraint, in the paucity of the elements of form engendered, in their rendering as proportion, it is much like any other African art; but in its apprehension of form as visual experience adapted in an independent universe of thought, as a universe of forms born of empirical law and subject to an unchanging life in time, it is unique. In the Ifè corpus we would need to seek far for the trajectory of such an intention, for if here we may perhaps find its Giotto the stages of his progress are far less certain. In the Benin school we envisage the artist of cumulative generations poised on the verge of untravelled voids reviewing with discontented eye the efforts of an earlier hand.

Is this entirely to deny the faculty of intention to the Ifè artist? Were his forms born perfect from some divine mould lacking the error of primitive effort? Not even for the Athenian Greek might such certainty be claimed; so it is best left to a future scholarship and a fuller corpus to uncover process and authorship in this art. In the present state of our knowledge we cannot even be certain, as we are for Benin, that these pieces were made at Ifè. And if this seems to drag old skeletons from discredited cupboards we must remember that the past decade of intensive archaeology at present-day Ifè has not succeeded in scotching notions of a distant authorship, though

small doubt can any longer exist that these pieces were factured on Nigerian soil, demonstrably *with* Nigerian soil, by African smiths most likely.

Bini art by contrast is rooted in definable impulse and purpose within the city walls. In its eschewing of the sensuous, the temporal, the accidental it continues spartan throughout its long history. Its restraint is violated not even in the chirrugueresque exuberance of those heads of later kings crowned with birds, writhing with reptiles, scored with the passage of native or foreign symbol and sign which we may regard as suggesting the high and decadent, the apical and ultimate, figs 126, 127. In its dominant principles

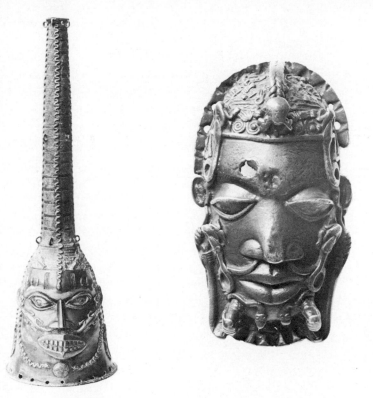

126–7. The mastery of convention: bronze heads, Benin

Bini art is far from expressionist: it is measured and sober and conservative. Content with acknowledged limitations and bolstered by a technical mastery unknown even at Ifẹ, it could be claimed that its most noble expression was achieved in those works of the Hieratic Period where, as at Ifẹ and also in the Yoruba sacred bronze, the stereotype achieves a peak of idealism unrivalled elsewhere in the African bronze. By virtue of their number and in the explicit formulation of a canon realised in the secular attitude and refined over centuries these bronzes must be considered the most remarkable and impressive of all schools of African casting.

18 Technique and the Ifẹ̀-Benin Relationship

In the matter of technique serious doubts may be raised against the claim of an Ifẹ̀-Benin succession in bronze-casting. If it can never be established one way or another that a craftsman, named and revered in Bini tradition, was sent by the Oni of Ifẹ̀ to teach the art to Bini smiths – *c.* 1280 according to some accounts, *c.* 1380 according to others – it can at any rate be shown that the techniques he is claimed to have imparted were not those traditionally practised by the makers of the Ifẹ̀ bronzes. But while an idea of Bini casting is easy enough to come by from the number of smiths still in practice, how are we to arrive at notions of technique at classical Ifẹ̀ in a society where today there are no traditional smiths, no relevant oral traditions, and the extant works of art are relatively so few and so limited in range and subject matter? Once again we must consider the idea of vanished schools of bronze at centres to the north of Ifẹ̀; for it is in the seemingly residual practice of an isolated school in the savannah belt of Nigeria apparently with no technical affinity with casting as it is today known in the south, that we may seek parallels with Ifẹ̀ bronze casting. And so far as possible influences exercised upon Ifẹ̀ go, we need not be too surprised to find these coming from the north along a lifeline disrupted by the chances of time and the interdicts of Islam, a lifeline which we have seen to connect the earliest knowledge of bronze in the forest region with sources in the Sahara and the Mediterranean.

Today smiths at the village of Ọbọ Aiyégúnlẹ̀ in northern Nigeria acknowledge that their technique came from farther afield – from their ancestral home at Ọbọ-Ilé. Their split with Ọbọ-Ilé in fact occurred within living memory 'about sixty years ago' (1965) when the villagers deserted their original hill settlement for access to the motor road which would revolutionise their traditional life and contribute to the disruption of their immemorial crafts. They claim that it is they who, first knowing bronze, apprenticed it round the land – a tradition which we need treat with no more seriousness that we do that of the smiths of Benin. Though their claim may contain rather more substance, the fact remains that *cire-perdue* casting could hardly have developed spontaneously at Ọbọ, and if we can no longer trace the lifeline which once connected this school with possible centres to the north, technique at Ọbọ today at least suggests that such a lifeline may in its time have existed, feeding industries as separate as those of the Baule-Aṣante and the Sao of Lake Chad. These schools,

distinguished in their treatment of the African bronze by the manner in which the investment is laid, as well as in the treatment and composition of cores and moulds, can be contrasted with schools which have historically followed the *cinquecento* method.

Despite Cellini's maddening casualness in discussing technique, we do here and there among his numerous episodes of love and passion find allusions to cores, moulds, armatures, furnaces, wax, clay, etc., which suggest a fairly complete picture of *cire-perdue* (lost-wax) casting in Renaissance France and Italy. At just about the time, between 1540 and 1545, when he was abusing his Parisian mentors for bungling the casting of his *Jupiter* by employing the method incompletely, Bini smiths were casting their earliest bronzes in much the same way. Had they been present at the casting of Cellini's work they would certainly have been no strangers to the process before their eyes – they would have understood the cracking of the mould and the consequent escape of the alloy which brought disaster to the operation; they would even conceivably have sympathised with Cellini's objections to casting a largish piece without the risers which would lead off gases otherwise trapped inside the mould, for the use of such risers is known to their descendants to the present day.

The lost-wax process requires first the making of a clay core roughly the shape of the figure (or other object) to be cast, fig. 128. For stability this usually needs to be supported by an iron armature inside its principal masses – Cellini talks of his cores 'well strengthened with iron'. Depending on the thinness of the casting desired – and some African bronzes are paper-thin – the modelling of this core progressively approaches that of

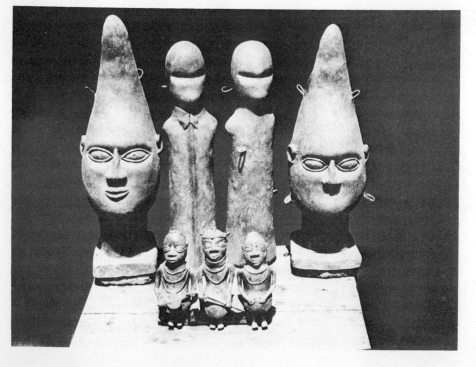

128. Benin, bronze casting cores with investment and metal pins in place

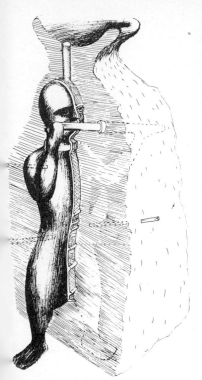

the finished object, except in its surface detail. While still wet a number of iron pins are stuck into it of such length that they protrude in various directions to form supports later on for the wax investment and for the mould, so that core and mould remain stable with the wax layer sandwiched between them, figs 128, 129. It is then allowed a few days in the sun to dry thoroughly. Detail is incorporated on the outside face of the skin of beeswax (the investment) with which the core is next covered. In the *cinquecento* method this skin of wax is rolled out on a smooth flat surface under a cylindrical object very much as a housewife might roll pastry; at the required thinness it is cut into convenient portions, each of which is then used to cover the core as one would with strips of cloth, fig. 130. A wet chisel-shaped tool, usually of wood, is used to press the wax firmly on to the clay core in such a way that it exactly assumes the shape of the latter, leaving no cavities or air pockets. On to this wax coating are modelled details of the required degree of finish, care being exercised to achieve just the clarity of surface and precision of decoration required in the bronze cast, for on to this surface will be applied the first sensitive layer of the clay mould. A plug of wax is appended at this stage to the top end of the object (or to the bottom if the object is to be cast upside down), and this will form the duct along which will later flow the molten alloy. The clay mould is then built up over the wax investment in two or three layers, each layer being dried before the application of the next. The layers are built up by pressing stiff pellets of clay on to the object in the same manner as modelling is taught in today's art schools, and these soon produce a satisfactory thickness around the core and its wax covering. For most objects two layers are sufficient, three or four for the very largest. The operation ends with the building of a clay cup around the plug of wax appended to the head or to the

129. Section through *cire-perdue* mould showing position of the core, and wax investment finished with casting detail. Iron stays hold the figure in place. After the wax has been melted out the plug attached to the headdress will leave a pouring duct for the liquid metal

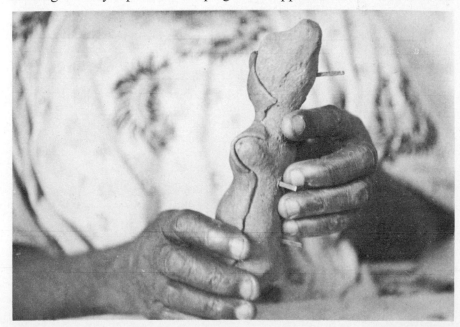

130. Yoruba, laying the wax investment

tail of the object, and this cup when the whole is dry will receive the charge of molten bronze. The object might now be described as a clay sandwich with a wax filling, the layers held in place by the iron pins first introduced into the core. The sun-drying of the mould is followed by a firing in which the wax is melted out; this is continued upwards of an hour until the entire mass is glowing in the embers. Now finally free of wax and moisture, the object might be described as a pottery sandwich with an air filling – the air filling in the cavity left behind by the *lost* wax. As the inside surface of the mould has picked up the last detail of the wax image on which it had been formed, it is now a sort of finely engraved pottery die whose fidelity of impression could be so great as to have recorded the impression of a careless finger-print. Stuck into the ground with its pouring cup upwards it is now ready to receive its charge of molten bronze.[1]

This *cinquecento* method has been practised along the same lines in Egypt since the Second Dynasty, and for some centuries before that – perhaps as early as 3500 BC – in Mesopotamia. In Europe the technique seems to have fallen out of use during the Middle Ages and to have been neglected until an Italian revival during the early fifteenth century ushered in a tradition which would result in the sixteenth-century popularity suggested by its name. It is hardly surprising that its occurrence in the earliest Benin bronze-casting should coincide with the revival of the craft in southern Europe: or, put another way, we should be surprised to find the method employed at Benin, or anywhere in the Guinea forest for that matter, much before the sixteenth century – an important consideration in view of the unestablished early dates usually ascribed to this and other schools. It is true that copper and perhaps brass and bronze were known in the cultures of the Guinea forest before this date, but for their working by the *cire-perdue* method in a figurative art at these early dates we have no evidence at all.

Could the technique have been introduced from the Nile? Again we have no evidence. Egyptian workshops of the fifth and sixth centuries were certainly engaged in an export trade in bronze objects of late antique and Early Christian design to the Nubian peoples, but though tombs at Ballana and Qustul have yielded rich stores of such objects, similar objects are not known for West Africa, though from Ghana we have a very crude copy of what seems an Egyptian hanging lamp of the period, possibly, like the bronze ewer of Richard II, or the prototype of the Ghana gold chalice of a later date in the British Museum, imported in the caravan trade of the Sahara long after it was made. It is unlikely that anthropomorphic bronze-casting affecting West Africa would have originated in Egypt after the Moslem conquest of the seventh century, and anthropomorphism is the principal characteristic of the West African bronze: it is rarely purely utilitarian. From a statuette of, presumably, a Kushite personage, found at Jebel Barkal, gold appears to have been cast quite early in Nubia in a competent figurative art. This example however, whether from Napata or from Meroë, is solid and therefore probably not cast *cire-perdue*. A miniature

bronze relief excavated at Wad ban Naqa suggests a Meroitic industry, but as Meroë fell to the Axumites early in the fourth century AD, we may not reasonably look to it for bronze influences directly affecting West Africa. Although we cannot be sure how the *cinquecento* method arrived in the Guinea forest it does not seem to have got there much before the sixteenth century.

But brass was being cast by the Sao peoples around Lake Chad at a much earlier time, possibly as early as the eleventh century. How the technique arrived there we are unable to say but the process employed, as evidenced in recent practice, was not without influence on brass-casting practice farther to the south. We shall therefore examine it, particularly in its difference from the *cinquecento* method of the Renaissance. It is substantially the lost-wax technique as described, but with important differences in the treatment of armature, core and mould, and in the manner in which the investment is laid. In some instances, as in the school at Ọbọ Aiyégúnlẹ̀ in northern Nigeria, latex is substituted for beeswax. Milk bled from *Euphorbia kamerunica*, fig. 131, is boiled until reduced to a tough rubbery gum which is stored by the smith in rings the diameter of a saucer. By its nature this gum is not responsive to the same treatment as beeswax in building the investment over the core: it is not rolled into sheets but reduced

131. *Euphorbia kamerunica*, the latex plant used in bronze casting

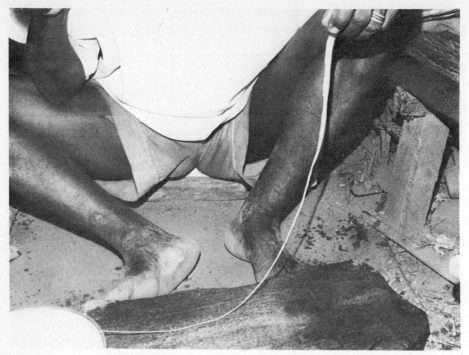

132. Latex thread for a
bronze object.

to threads. The investment is built up by winding these threads around the
core as a length of cotton is wound around its reel. As the threads can be
rolled to a hairsbreadth very fine work may result, fig. 132. It is a lengthy
and painstaking process, producing extreme detail of decoration and work-
manship, the latex being modelled not by a wooden tool dipped in cold
water as in the *cinquecento* method, but by a steel tool heated in the fire.
Sections of the investment are thus cemented hot; they could not adhere
cold as is the case with beeswax. The characteristic shapes into which
the thread may be wound constitute the design motifs of this method –
plaiting, winding into spirals, loops, bosses, coils, or rolled into clusters of
pellets, each the size of a pinhead, etc., fig. 133. Work executed by the use of
latex is therefore readily distinguishable from that executed in beeswax; the
latter cannot be reduced to threads of such delicacy as is possible with the
former: in its leathery resiliency latex thread can be rolled almost to invisi-
bility without breaking and the finest decoration built up by this means.
The resulting bronze is jewel-like rather than plastic in quality, and is in
fact very reminiscent of the filigree work which we have associated with the
coming of bronze in the western Sahara.

This is the technique of the Baule and the Aṣante; on the evidence of
contemporary practice it was apparently also used in the Sao bronze. It is
possibly also the technique of some Igbo castings from eastern Nigeria,
figs 70, 71, though often in these examples the tell-tale 'spiral' surface has
been smoothed to a finish. In the Igbo pieces, however, the clusters of micro-
scopic pellets covering the surface of certain pieces, the helical coils formed
from smaller helical coils of hairlike thinness and regularity and the realism

133. Latex model for a
bronze object

of the minute insects represented could hardly be explained by the use of
the wax method. It is well-nigh impossible to work wax thread to such fine
tolerances without its adhering to the fingers, hence the cold wet tool
employed by the smith. But beeswax is sometimes used in this 'spiral' way
in building the *cinquecento* investment, as recently recorded among the
Aşante; in these cases however the thread is so thick – as much as 0.2 cm
diameter – as to serve no purpose which could not have been better served
by using it in its more natural way, by rolling into sheets, figs 128, 130. This
use of beeswax in coarse threads, entirely non-functional, is clearly an
adaptation of the (northern) latex method to southern needs; the type of
euphorbia used, though found in the forest regions, does not grow there
to the luxurious heights known in the north; the milk of southern trees is
considered by northern craftsmen useless for reducing to gum.

This 'spiral' technique, as we have called it, if often further distinguished
from the *cinquecento* in that the bronze is not melted separately and then

poured into the pouring cup; crucible and pouring cup form part of the mould, all sealed in one piece. When the whole is heated the liquid bronze runs into the lost-wax cavity without the intervention of the craftsman, fig. 134. The method is described for British Museum examples from Aṣante. Far the most important distinction between the two methods – spiral and *cinquecento* – is in the nature and treatment of the core and the mould.

In the lost-wax process the composition of the mould and of the core encased in it is of the profoundest importance to the success of the casting. Whatever their relative composition mould and core must remain stable under extreme changes of temperature: they must stand up to the temperature of the molten brass (800° – 1000°C) without cracking, yet must be sufficiently porous to allow gases trapped inside the lost-wax cavity to escape with the introduction of the liquid alloy. Smiths employing the *cinquecento* method achieve porosity in core and mould by the admixture to their clay of varying proportions of organic matter – fibre, animal dung, etc. – the mould receiving rather more of this admixture than the core, and this ratio determines the direction of escape of the gases upon entry of liquid alloy into the lost-wax cavity. In large figures where the porosity of the mould might not in itself be considered sufficient for the purpose, tubes (or risers) are added to its base along which the liquid alloy drives off excess gases. We have seen that in this method the mould is built up from pellets of mixed clay to three or four layers. In contact with the molten bronze both core and mould are burnt through and through, so that on being cracked open after the casting the mould tends to disintegrate in a blackened dust. The pouring temperature of the bronze is inevitably conducted to the inside of the core mass by the metal armature and by the metal stays transfixing it, thereby causing burning of the core outwards and inwards simultaneously. These are the conditions which we find at Benin and in modern Yoruba practice; but they do not obtain in the spiral method employed for instance at Ọbọ, where an entirely different approach is used in the composition of core and mould.

In the Ọbọ core and mould, no admixture of organic matter is employed; instead, a very finely pulverised charcoal is added to the clay to increase its porosity; this approaches 50 per cent for the core while for the mould the ratio of charcoal to clay rises to around 55 : 45 per cent, ensuring an outward direction of escape for the trapped gases. As a result of the charcoal-admixture, and the virtual absence of organic matter in their composition, core and mould are here of extreme stability. This hard and stable charcoal-clay mixture is employed as a drain-plug in the domed iron smelting furnace of the western Sudan, a detail which possibly associates the two industries. On account of its hardness the Ọbọ core needs no armature – at the end of its preparation by drying and heating to red-hot temperature in an open fire it has in fact become a bit of pottery. It is true that it is usually built around a slight metal rod, but this serves more as a handle by means of which the core can be manipulated during the building of the investment

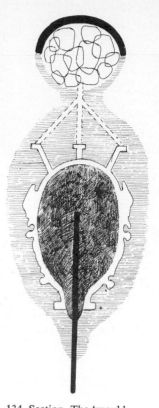

134. Section. The 'mould-cum-crucible' method in *cire-perdue* casting. In this inverted casting of a medicine pot an iron rod holds mould and core in place. Plugs of wax attached to the legs of the pot meet in a common duct at the base of the crucible. The wax (or latex) is melted out and the crucible filled with tablets of brass each about the size of a large coin. Over the whole a cap is fitted (black) and secured with a clay luting. In the firing the metal runs slowly *at an even temperature* into every nook and cranny of the mould thus obviating the hasty pour of the *cinquecento* method and the consequent anxieties to which even Cellini was no stranger

than as an armature, fig. 133. Furthermore its use obviates the need for the metal stays employed in the *cinquecento* method to connect the separate layers – core and mould – since it provides a common base to which these are attached. As the metal rod of Ọbọ practice does not run right through the core and is never in contact with the molten bronze it conducts no heat inwards to the heart of the core mass. Such a core examined after a cast therefore shows no trace of burning from its centre, which retains its original terracotta colour.

The Ọbọ mould is built up in several layers, as many as six or seven, all of fine liquid clay applied with a feather, each successive layer being thoroughly dried in the sun before the next is added. The first layer is merely a transparent slip over the delicately convoluted surface produced by the spiral technique; other layers are laid successively thicker. The entire mould is not so substantial as that of the *cinquecento* method, but even so in contact with the molten alloy it does not break down; burning of the fabric in fact takes place on its inner surface only, to a depth of a centimetre or two, the remainder being a firm red pottery. On the outer surface of the core much the same thing has taken place – a burning to a depth of a centimetre or so, fig. 135a.

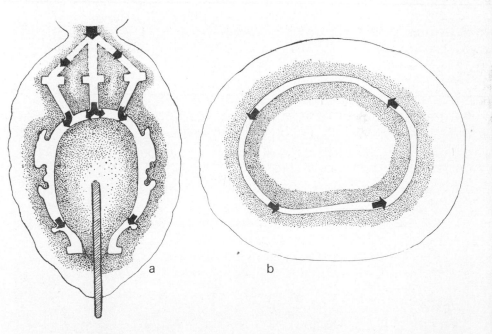

135. Section. (*a*) The Ọbọ core and mould showing burning of the core and mould masses during casting; (*b*) Reconstruction. Core and mould of the Ifẹ̀ *Lafogido* bronze bust showing burning of the core and mould masses during casting. In both cases burning is from the contact surface only; there is no burning from the core centre outwards; cf. fig. 143

Since the metal rod on which the whole has been supported is used after casting as a gouge for removing the core-filling from the completed bronze, detailed examination of such a core is not possible where (as in the medicine pot of the illustration) the object is rather small; but examination of the pottery-like fragments left lying around after the breaking open of the mould is revealing. Each such fragment is a shell 1.5 to 2 cm thick, a third to a half of whose thickness, though thoroughly burnt, is still stable, as is the

remainder of the shell (the outside of the mould) which is a firm red terra-cotta. Examination of this burnt inner area of the mould reveals the fine impressions of the contact surface which had reproduced the configuration of the wax model and imparted it to the molten bronze. But more important than this, further scrutiny discloses interfaces running between the several layers with which the mould had been built up. Having been applied almost liquid with a fine feather, layer upon dried layer, these separate layers have not fused: the dousing with cold water to cool the mould after casting has produced exfoliations so marked that fragments of a single layer have fractured off complete. This evidence of the behaviour of the Ọbọ mould casts a ray of light on casting techniques possibly employed in the Ifẹ̀ bronze.

The Ifẹ̀ bronze technique

Only in a very few of the bronzes of the extant Ifẹ̀ corpus have the cores been left in place; our examination of the Ifẹ̀ casting technique is based on two of these, the 35 cm high *Lafogido* bust, fig. 136, and the famous *Seated*

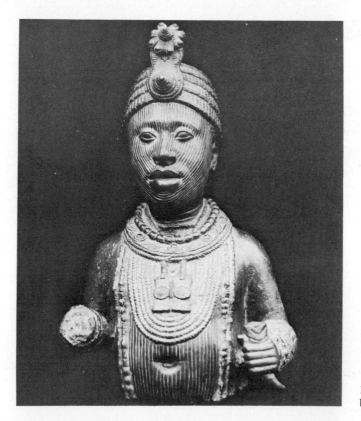

136. The Ifẹ̀ *Lafogido* bronze bust

Figure from Tada, fig. 86, universally acknowledged to be from this corpus. Though only limited conclusions may be drawn from the study of two Ifẹ̀ cores as against hundreds of examples remaining in the Benin corpus, relative differences nevertheless suggest contrasts. In some of the Ifẹ̀ cores

a metal rod serves a purpose similar to that in the Ọbọ core, but in none of them do we find evidence of the use of the integral armature of the Bini craftsman, the members of which ramify the core mass with almost the thoroughness of a skeleton. It is in his treatment of his core and in its behaviour during casting that we might most clearly point to differences in practice between the Bini and the Ifẹ̀ craftsman and, almost gratuitously, realise similarities between methods employed at Ifẹ̀ and at some northern centre, or centres, responsible for the Jebba-Tada group of bronzes.

Mention has already been made of the careful ratios observed by the Ọbọ smith in the admixture of pulverised charcoal with his clays, between the core mass and the mould, necessary in determining the direction of escape of gases trapped in the lost-wax cavity. The mould always contains upwards of 5 per cent more charcoal than the core. Chemical analysis of core stuff from the Ifẹ̀ *Lafogido* bust reveals a low percentage of carbon remaining in the burnt contact area, 2.11 per cent, consistent with the burning of a clay originally containing relatively small quantities of organic matter. By contrast the admixture of large quantities of organic matter – animal dung, fibre, etc. – is a characteristic in the preparation of clays for moulds and cores in the *cinquecento* method as today observed among the Yoruba and at Benin. Carbon present in a sample of the Ọbọ mould amounts to 7.20 per cent.[2] The small amounts of this residual carbon in the Ọbọ and Ifẹ̀ samples indicate that the sculptors' clays were similar in being admixed with charcoal, and not with organic matter. Here it must be borne in mind that the comparison is between the behaviour of the Ọbọ *mould* and the Ifẹ̀ *core*, and that the observed higher admixture of charcoal in the former would give a reading for residual carbon slightly higher than that for its core; so that for the Ifẹ̀ mould we can assume a slightly higher reading than for its core. The disparity between the Ọbọ mould reading and the Ifẹ̀ core reading does not therefore represent such a wide actual difference as might appear from the relative figures. The contour made by the carbonised area of the Ifẹ̀ core with its unburnt centre was slightly sharper than those obtaining in the Ọbọ moulds. Mould fragments at an observed casting in Ọbọ were compared with ones from previous castings in the same workshop as well as with the cores of the Ifẹ̀ *Lafogido* bust and the *Seated Figure*.

At Benin and among the Yoruba, organic matter is always added to the native clay in contemporary practice. Except for an isolated workshop in Abéòkúta practising a tradition of acknowledged northern origin, the charcoal-clay mixture appears unknown anywhere in southern Nigeria. In this detail at least practice is distinguished at Ifẹ̀ from that at Benin and among the other Yoruba. The method seems specifically northern, inherent in a conception of the core mass which is rendered stable *vis-à-vis* its mould by a device other than the integral armature of the south, and recalling von Luschan's observation that one of the greatest difficulties of the *cire-perdue* process is this positioning of the core inside its mould, we may now consider ways in which the difficulty has traditionally been met by craftsmen north and south.

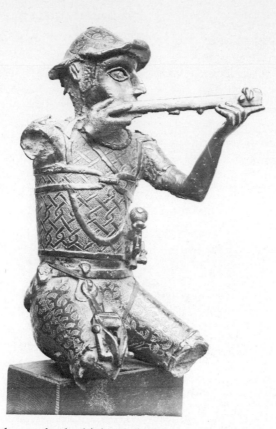

137. Benin. Portuguese soldier, bronze

In its difference from the method which produced the Ifè *Lafodigo* core, that employed for the Bini *Portuguese Soldier* at fig. 137 is striking. Barely 30 cm high in its present condition this piece yet reveals all the thoroughness of the Bini craftsman in structuring the interior architecture of his core. The members of the armature run through the core mass with the utmost detail in distribution and even anticipate its role in the life of the bronze shell; it runs through the musket to its nozzle, appearing even in the mere centimetre of the soldier's wrist, fig. 138b. This thorough ramification of the armature has needless to say produced that uniform burning of the

138. The Benin bronze armature. (*a*) Section. The molten bronze in contact with iron members in the Bini mould and core; (*b*) detailing of the Bini armature

core mass to be observed in all Bini pieces where the evidence remains. An arrangement here seems to have been made before casting whereby at the juncture of the right arm with the shoulder a wax disc was set into the core member transverse to the direction of its armature, which, after casting, would be converted into an internal bronze plate of a piece with the bronze skin, but embedded at right angles to it in the core of the arm. We also find this device employed by the craftsman of the Ifẹ̀-type *Seated Figure*, fig. 86, at Tada, with even greater elaboration, as well as on the Jebba *Warrior* where it provides a formidable buttress at both elbows, figs. 139a, b, and

139. Reinforcing bronze members. (*a*) Benin, *Portuguese Soldier*. Bronze disc in right arm transfixed by iron armature. (*b*) Ifẹ̀ (Tada group) *Seated Figure*. Bronze disc A, B, in broken off right leg, pierced by an iron rod, C. This rod is employed to hold together the relative sections of core after the wax disc has been 'lost'.

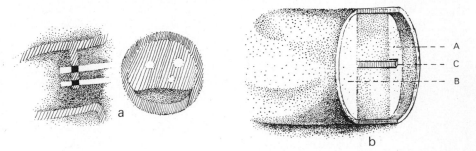

161. The resulting altered tension of the bronze surface, combined with the effect of expansion of the disc inside the shell, perhaps accounts for the uniform fracturing of three of the limbs in the Bini piece, and the relative limbs in the famous Ifẹ̀ and Jebba pieces. In the *Portuguese Soldier* slight evidence (visible even in the reproduction) suggests that a similar disc might have broken off at the right knee-joint. The disc remaining in the right shoulder reveals the three broken off ends of the iron armature which had pierced it. Here at a mere 2 cm diameter of the limb we observe the concern of the Bini craftsman for the interior architecture of his bronze; the armature scaffolding of many a Bini bronze in fact yields an intellectual pleasure in its own right: it discloses in this craftsman something of the faculties of the engineer.

In view of important differences in bronze-casting method between northern and southern schools, the occurrence of this internal disc-buttress at Benin, Tada and Jebba suggests a connection of some sort between these craftsmen at some time during the first half of the seventeenth century. In this case a 'date' may be indicated for the Ifẹ̀ piece, for judging from its uniform result in fracturing the relative member in the examples remaining to us, this disc-buttress can hardly be regarded as a device tested by time in the experience of its authors; it seems little more than an incautious bright idea – employed, it is true, on the Tada and Jebba pieces with fine ingenuity – which spread rapidly over a great distance before its dire effects were realised, if ever they were. If this were indeed the case, and if authorship of the disc is attributable to the craftsmen of the Jebba-Tada bronze, or *their* tutors, then well over a hundred years' experience of the splitting effect exercised on the bronze shell by oxidised iron armatures expanding inside the cores of small bronzes should have placed the Bini caster on his guard

against the possible results of expansion from these internal members for which, in fact, with his comprehensive armaturing, he had no need. The device seems specifically appropriate to the massive armature-free pieces of the north, and to have been copied, or taught, at Benin. If so, it was in other respects very brilliantly adapted by the Bini craftsman.

We are astonished in a magnificent bronze *Cockerel* in the Nigeria Museum to find the device maintained of slipping tongues of wax into the still plastic core mass which in the cast will become one with the bronze shell. It is here employed to hold wax investment to core, in this way supplementing or perhaps even replacing, those iron stays which normally transfix mould, wax and core to keep them in stable relationship, fig. 140a, b. The

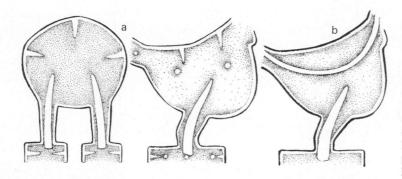

140. Benin: securing the bronze casting core. The interior engineering of two Bini bronze cockerels, Nigeria Museum. (*a*) Two sections showing bronze claws cast of a piece with the bronze shell and the pedestal, and armaturing of legs. (*b*) Iron armature connecting head and tail becomes a permanent element in the life of the bronze shell after removal of the core. Similarly the armaturing of the legs

wax investment in this instance buries roots into the core mass with the tenacity of a creeper on a stone wall. It is possible that similar wax tentacles once penetrated the plastic mould stuff in the opposite direction, but which in the bronze state would have been filed to a finish. In this way the bronze surface would not be disfigured by the filed-off heads of the iron stays which would leave their mark in a later corrosion such as are seen on some of these old bronzes. Elsewhere, in the pedestal for instance, brass stays are employed in this casting to the same end, but these, holding a different temperature inside the lost-wax cavity, do not fuse with the bronze skin in the cast. Such a device for marrying the wax investment to its core, and possibly simultaneously to its mould, would be most obviously effective in a simple shape such as the body of this *Cockerel*, though no reason exists why it should not have been employed in more complicated pieces. In another Bini *Cockerel* the massiveness of the iron rods employed as armature are envisaged by the craftsman as not only effective in bearing his core but also as a permanent element in the life of the bronze shell once the core has been removed. In this piece an inverted arch a centimetre thick runs from neck to tail of the bird, while the legs each encase a sturdy iron rod 1.5 cm thick, giving to the stance of the bird a built-in and enduring strength, fig. 140b.

We note a similar engineering of his wax model to meet ends which will operate only in the life of the finished bronze, in an *Equestrian Piece* also in the Nigeria Museum. Here the hooves of the horse meeting the pedestal are each buttressed from below by solid bosses upwards of 0.6 cm to 0.8 cm

corestuff

bronze shell

141. Benin: buttressing an equestrian piece

beneath the base plate. A flattened boss of wax would in each case have been inserted into the still plastic core mass of the pedestal as the smith laid the investment, and this in the cast would fuse with the bronze plate and the hooves of the animal. The result is a virtually indestructible welding of the animal to its pedestal, fig. 141. To such preliminary labours, which lie beyond the concern of a later eye, the Bini smith applies all the meticulousness of a high craft. Could we accept Boas's dictum that the object of art achieves aesthetic significance in virtue only of the evidence of a perfectly controlled technique, it would be difficult to deny to the Bini bronze a place in the very finest collection of art ever created by the hand of man; for from the invisible engineering of the core outwards through the treatment of the investment and mould these pieces are nothing if not expressions of perfectly mastered and controlled technique.

A core stands four-square around its metal armature. While still wet it is further pierced in several directions by those iron pins which will connect it to its mould and hold the two in stable relationship. In the final stage before the pour the two have been baked to pottery to rid the cavity of its wax. What happens next will radically change the nature of mould and core, and the smith is prepared for this; all his prior labours have in fact been directed to this moment in which the fire-bright alloy will burn the clay masses of mould and core to cinder while they must yet stand up without cracking, even so little as a hairsbreadth, as the die-like incandescent mould surface is picked up by the liquid bronze. A matter of seconds: the flaming orange colour of the alloy changes to cherry, to crimson and then to the silver-grey of newly cast bronze. Under rapid cooling induced by sprinkled water the mould breaks down; its fragments lie ignored around the base of the new piece while runners, risers, iron stays and casting excrescences are filed away. Should a piece cast by this method be then cut through from side to side the saw would sever the armature and perhaps some of its members and maybe an iron stay or two. The core mass inside the resulting section would then be found to have burnt evenly through from one end to the next.

This is the characteristic of the Bini *cinquecento* core, engendered in the behaviour during the casting of its interior iron elements, which in some pieces continuously connect the bronze shell with the backbone of the armature. In its passage the liquid alloy must traverse the iron stays holding core and mould together across the width of the lost-wax cavity, and these will conduct heat inwards to the centre of the core mass as simultaneously the members of the armature also bear heat inwards from the contact surfaces of the core. The main member of the armature will carry this burning along the centre of the core, after which no particle of clay therein is left unburnt. We may not section a Bini bronze in order to demonstrate this comprehensive burning of the core by its armature, and though plenty of cores exist in these bronzes it is unlikely that we shall ever encounter an example which provides such a section. But at fig. 142 is reproduced the section of a Yoruba bronze produced under observation by exactly the

142. Section through a Yoruba bronze

methods employed by today's Bini smiths – a clay-dung core composition supported by an armature of greater or lesser detail and pinned to its mould by those iron stays which, in contact with the molten alloy in the lost-wax cavity, conduct heat into the core mass to be vertically distributed by the main member of the armature. This core mass has been thoroughly burnt. The *Portuguese Soldier*, like many another Bini bronze, retains such a thoroughly burnt core.

Not so the *Lafogido* bust or the *Seated Figure* from Ifẹ̀. Here the core masses are only partially burnt – on the contact surfaces, to a depth of a centimetre or two. For holding his core upright and in stable relationship with its mould the Ifẹ̀ craftsman has employed another method than that of the carefully structured armature of the Bini smith. In the Ifẹ̀ bust, and in other pieces in which the cores remain, there is no evidence of the integral armature of Bini practice, no trace of that burning of the core centre which would be occasioned by the presence of an integral armature. Instead, as shown at figs 135b and 143, the core section reveals a thoroughly carbonised contact surface enclosing an unburnt mass of light brown clay. Like the Ọbọ smith, the smith at classical Ifẹ̀ seems not to have given the least consideration to the virtues of the integral armature, but to have harkened instead to a tradition in which the problem of holding his core mass upright

and maintaining it stable within its mould was differently resolved. What-ever the arrangement it was one which, apart from having no need for the comprehensive armature, had no need either for the iron stays securing mould and core, or for the bronze claws cast of a piece with the shell, of Bini practice. The passage of the molten alloy through the lost-wax cavity would not in Ifẹ̀ hands be obstructed by the iron stays which, along with the members of the Bini *cinquecento* armature, we have seen to account for the burning of the core mass through and through; as there was no agency beside actual contact of the core surface with the molten bronze to conduct heat inwards, the Ifẹ̀ core is burnt regularly and evenly *to a limited depth only*. In the medicine pot from Ọbọ Aiyégúnlẹ̀ we observe this even and regular burning in mould fragments recovered after the cast; but here the diameter of the core was so small – about 3 cm – that burning of the relative contact surfaces met at the centre of the core; this burning however was not occasioned by the presence of the iron staff since, as is evident in the diagram at fig. 135a, the staff was at no time in contact with the molten bronze. From the Ifẹ̀ *Lafogido* bust a similar iron staff may have been removed; but whether so or not the central core mass remains unburnt. A clay very much like china appears in the core of the Ifẹ̀ *King and Queen*; it is as hard and smooth as porcelain, and just as resistant to picking with a metal point, possibly (as at Ọbọ Aiyégúnlẹ̀) the result of firing the core before investing it, or, less likely, a hardening occasioned by contact with the molten bronze. In either case it illustrates the resources of the Ifẹ̀ craftsman in the matter of supporting his cores without the metal armatures of the Bini smith. This type of core stuff is unique in the present Ifẹ̀ corpus.

Examination of the Ọbọ mould at fig. 135a, after casting, revealed that the several layers of which it had been built up tended to separate along their relative interfaces. This may have been caused by contraction as the mass was rapidly cooled by dousing with cold water, when air between the several layers would promote exfoliation, or perhaps by water-vapour travelling along these air-seams under pressure from the red-hot bronze in the lost-wax cavity. The cores of the *Lafogido* bust and the *Seated Figure* reveal a similar flaking of the carbonised matter of the contact area from that at the unburnt centre of the core mass, again possibly to be explained by the effect of cooling combined with the action of water-vapour in the form of gases driven inwards under pressure during the pour of bronze: resistance would build up along a contour later observable as an interface between carbonised and uncarbonised matter. This water-vapour, condensing, would tend to solidify the unburnt clay mass and thus accentuate its physical difference from the carbonised matter of the contact area, figs 143 and 144.

The characteristics of the Ifẹ̀ *Lafogido* core resulting from the absence of an integral armature are therefore observable in the core of the Ifẹ̀-type *Seated Figure* a great distance away in the Tada group, fig. 86, evidence which seems to underpin guess-work as to the identity of its authorship. In the reproduction can be seen the ring of carbonised matter still adhering to the bronze shell of the arm. The core of the smaller *Staff-Bearer*, fig. 87,

143. The core of the Ifè *Lafogido* bronze bust. The black strip at the lower left is the carbonised contact surface; the white area is the unburnt core mass and the dark portion (upper right) is the interior of the bronze shell; cf. fig. 135b

also at Tada, shows the same burnt and unburnt areas, the same flaking between the burnt contact area and the unburnt core centre, and this perhaps adds some substance to the comparison of idioms already suggested. A study of this humble group might one day shed some light on the beginnings of the Ifè bronze. We are in any case able to read important aspects of Ifè practice from evidence provided by all the pieces in the Jebba-Tada group, evidence which explains the crucial matter of the device employed by the Ifè craftsman in positioning the core inside his mould.

144. During casting, water vapour driven in the form of gases into the core centre of an Ifè bronze builds up resistance under pressure along a contour later observable as a more or less clear interface with the carbonised matter of the contact area. Condensing, this water vapour solidifies the core centre (white) and thus promotes flaking along the interface. In section such a core is therefore a ring of heavily burnt matter surrounding a mass of unburnt, from which it is fairly easily flaked

For in common with Ifè practice none of these bronzes rely on the integral armature of the Bini *cinquecento* method – all their cores are 'Ifè' cores in their independence of the integral armature, in their consequent peripheral burning, and in the manner in which without the use of iron stays, or of bronze claws cast of a piece with the shell these cores are secured from movement, fig. 140.

Several of the Tada pieces stand, or have stood, on baseplates, as also do the two at Jebba. Here the baseplate is not only a structural device enabling the finished piece to stand unsupported, it is more importantly a function of the casting method employed. In the northern Yoruba village of Ìfàkì, not far from Ọbọ Aiyégúnlẹ̀ from which it claims its bronze tradition (a claim significantly supported by the incidence there of the Catalan-type iron smelting furnace known to the Nupe still farther north) an old smith pointed out to me in a description of his method that he built his core on a clay platform, which also bore the mould structure. Sharing a common base in this way neither mould nor core could move independently of the other: no metal stays were therefore necessary to secure them. In the Jebba *Warrior*, and in other pieces of the Jebba-Tada group, such a platform is echoed in the plate cast of a piece with the feet, fig. 145. Where in others

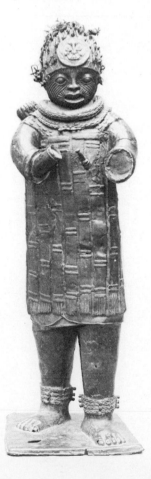

145. The Jebba *Warrior*, the platform pedestal, with lozenge-shaped aperture (base) for unifying core and mould

such a plate does not exist the method has been employed just the same – the clay platform on which this bronze plate was cast, and not the bronze plate itself, being the crucial element in casting: it serves precisely the purpose of the iron staff in the Ọbọ core at fig. 135a, that is, it holds core

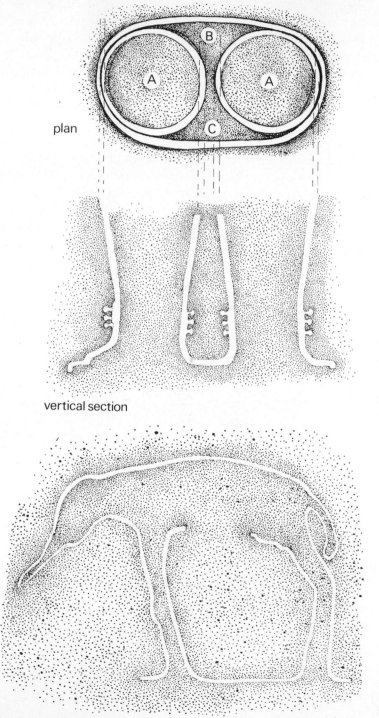

plan

vertical section

146 (*a*). Unification of core and mould: the Jebba *Warrior*. Section across base of surcoat (upper diagram) illustrates union of core and mould through cylinders of legs, A, and bottom of garment, BC. Union similarly occurs through soles of feet, lower diagram; vertical section

146 (*b*). Vertical section. Unification of core and mould: Tada *Elephant*

and mould in stable relationship and is thus effectively an alternative to the iron stays employed to the same end in the *cinquecento* method. As we have seen, this absence of iron stays, iron claws, or a central iron armature causes only a peripheral burning of the core mass such as we observe in these bronzes, in the *Lafogido* bust from Ifẹ̀, in the *Seated Figure* at Tada, and in Ọbọ practice, there being no agent which might convey heat dissipated from the cooling bronze to the centre of the core.

The diagrams at fig. 146a, reveal that through the cylinders of the legs, A, as also through the large gap at the base of the surcoat, BC, the core of the Jebba *Warrior* formed part of the continuous mass of its mould, both secured to the baseplate of the figure. At these major points, i.e. at the base of the trunk and the soles of the feet, the core mass is unified with its mould, holding the figure rigidly in place and securing the lost-wax cavity clear. As in all other standing figures in the group, the base of the garment could not therefore have been closed to provide complete attachment for the legs – in them all the cylinders of the legs are only partially attached, to the outer hems of the garments, causing rather a tin-soldier effect when viewed from below. For the ostriches and elephant in the group a large rectangular aperture (15 cm by 10 cm in the elephant) has been left in the abdominal area for the same purpose – to unify core and mould at a major point in the body mass of the creature and thus maintain the core in its mould as stable as an egg in its shell, fig. 146b.

The method explains a most important difference between Ifẹ̀ and Bini practice. With only a single exception, all the Ifẹ̀ heads bear a cranial cavity – in each case as large as the sculptor dared go without interfering with the natural proportions of the face – necessary in unifying his core and mould in a continuous mass around his wax investment, fig. 147a. Secured at its top end through this cranial cavity and at its bottom through the neck, the core mass would be prevented from shifting, even by a hairsbreadth, inside its mould – a certainty not perhaps enjoyed by the Bini smith of *cinquecento*

147 (*a*). Vertical section. Unification of core and mould: Ifẹ̀ bronze head. All but one head in the extant Ifẹ̀ bronze corpus employ the device of unifying core and mould through a large cranial cavity opposite the aperture of the neck. The device occurs also in the *Seated Figure*, fig. 86

147 (*b*). Unification of core and mould: the Jukun *Head-rest*. Vertical section

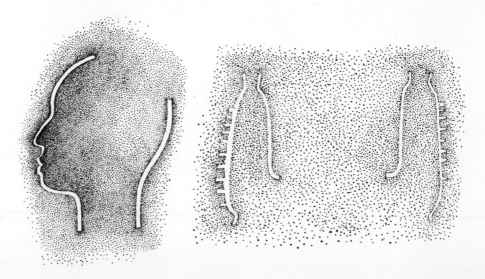

practice whose cores at Jebba-Tada dimensions would have placed a formidable weight on their iron stays, with possible consequent sagging inside their moulds. This might explain the uniform small size of Bini and Yoruba bronzes when contrasted with these mammoth shells from the north, and also the Bini device in the *Cockerel* illustrated at fig. 140, of employing bronze claws for a rather bulky core in place of the usual iron stays. Similar unification of mould and core occurs in the Ifẹ *Seated Figure* in the Tada group, evident in the great cranial cavity opposite an otherwise inexplicably open base, and the consequent absence of the integral armature of the Bini smith. The realising of so complicated a posture on this scale without the use of a more or less detailed armature must be regarded as somewhat of a *tour de force* in African *cire-perdue* casting. The Jukun *Head-rest* too, figs 78–79, in its hollow chimney-shapes and open base, indicates the same casting method, and here we note an additional 'window' in the main member which, as in the Ifẹ heads, would have made of mould and core a unified block securing the lost-wax cavity inside, figs 79 and 147b. Gaps left in the crowns of some Bini ancestor heads are sockets for carrying the relative ivory tusks, and not technical devices as at Ifẹ. At the rear end of the Ifẹ *King and Queen*, fig. 148, three largish lozenge-shaped apertures have been cut into the wax investment in the same manner as on the baseplate of the Jebba *Warrior*, fig. 145, and for the same purpose – to unify core and

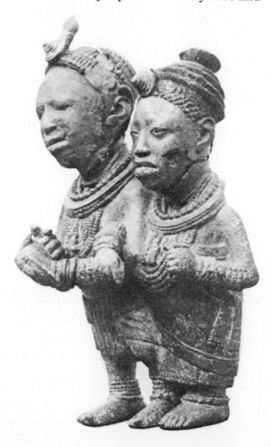

148. Ifẹ, *King and Queen*, bronze. Three largish lozenge-shaped apertures are employed to unify core and mould in these figures; similarly on base-plate of the Jebba *Warrior*

mould at these points. This casting detail again suggests contemporaneity for an Ifẹ̀ bronze with two important Jebba-Tada pieces during the first half of the seventeenth century.

All these cores are self-supporting. In the absence of the integral armature of Bini practice the authors of these bronzes fashioned the investment on a sun-dried or lightly-fired terracotta model. For supporting such a model, bits of iron were locally employed where a particular member, an arm, a neck, needed strengthening as the work proceeded. In some cases, as in the Tada *Elephant*, no supports of any kind appear to have been used – the body shell is now hollow, but the single leg which still carries undisturbed core stuff bears no iron member, an observation which also holds good for all the human figures. In the Ifẹ̀ *Seated Figure* a local strengthening is effected in one limb by the use of the integral bronze disc, already noted, pierced by an iron rod some 10 cm long. In the core of an *Ostrich* is embedded a spiderlike tangle of bronze at the base of the neck, cast of a piece with the bronze shell – a local strengthening effected by the positioning of a bed of wax into the still plastic core mass – from which would sprout the neck. A further local strengthening with bits of iron occurs in the neck column proper. This local use of iron is however a far cry from an armature: it does not account for the support of the considerable mass of the body nor the very long legs. Owing no doubt to the oxidisation of the iron member which, by expanding the core causes the bronze skin to split, the necks of both ostriches have since broken: in the smaller of the two a powdery trace of rust remains where once the stem of iron, seemingly not much more substantial than the rib of an umbrella, would have held it. Most astonishing in this piece is the presence of the stalk of a woody shrub, now of course thoroughly carbonised, running through the entire neck column and obviously used as a support for the plastic clay *before* bits of iron were added, for where this stalk is continuously central to the core mass, the iron is peripheral. Botanists have been unable to identify this shrub or pin it down to any particular area but in any case its presence as an important structural element in the modelling of the bird points to the self-sufficiency of these cores even at impressive dimensions: any strengthening with iron served mere local contingency.

Here clearly we are dealing with a tradition in which enormous mud figures are fashioned (in the manner of the heroic-size *Mbari* mud sculpture of the Ibo peoples) on mud pedestals; their body masses or members, each perhaps built independently and at different times, were held here and there by twigs or bits of iron as needs be. The assembled whole would then be slowly dried or lightly fired before being invested with the wax (or latex) coating and secured through apertures, cranial cavities, or 'windows' to the mould. In such a piecemeal method whereby individual elements – cylinders of legs or torso, the ovoidal body masses of ostrich or of elephant – are separately modelled, dried and assembled, we might more easily understand the building up of the giant unsupported cores at Jebba-Tada and of the Jukun *Head-rest* with their unitary strengthening of members as the work

progressed, in place of a comprehensive iron armature which in a single concept accounts for the whole mass. The casting of bronze on terracotta cores has been recorded around Lake Chad in connection with the spiral technique in a tradition apparently of some age there, fig. 149. From our

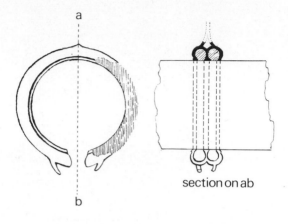

section on ab

149. Casting a bronze bracelet on a terracotta core (Chad, after Hamelin)

study of these Jebba-Tada pieces, the Ifẹ̀ *Seated Figure*, the Jukun *Head-rest* and the *Lafogido* bust this is the tradition which we infer for the Ifẹ̀ bronze. Nowhere in these bronzes is there any trace of the calculated and comprehensive armaturing of the Bini smith, in which respect at least they are not unique in the African bronze.

The securing of the core inside the mould is the most crucial element in the *cire-perdue* bronze technique, for in the stability of the lost-wax cavity lies the eventual success of the cast. Our evidence shows that two distinct methods of meeting this problem have been practised by the traditional smith, roughly to be aligned with practice between northern and southern schools in their conception of the structure and support of the core. The method today practised at Ọbọ Aiyégúnlẹ̀, and reported at one village in northern Yoruba, accounts for a peculiarity in these cores in which burning of the core mass is contiguous with the contact surface only, there being no agent to conduct heat to the core centre. Such a method permits the casting of large bronzes of a relative thinness and fragility. It has been employed in all the northern schools examined, at which places alone in all tropical Africa, *cire-perdue* casting achieves dimensions more properly to be associated with the piece-mould method. The use of iron stays for securing mould and core is nowhere in evidence in any of these schools, but is the central characteristic of all southern practice, notably at Benin.

The tradition that Ifẹ̀ taught bronze at Benin is likely to die hard. In its short life it has become deeply rooted in scholarly opinion and in local belief. On it have been structured serious chronologies of the Bini bronze with near-antique dates consequently assumed for Ifẹ̀. We have seen however that the material evidence points in quite other directions. Far from its

having been the case that Ifẹ̀ taught bronze at Benin the question to be resolved is – who taught bronze at Ifẹ̀?

Ifẹ̀ bronze metallurgy and Ifẹ̀ bronze dating

As to the metals used in the Ifẹ̀ bronze a clear picture now emerges from recent analyses carried out in the laboratories of the British Museum. In the following table the sample numbers are those of Underwood's *Bronzes of West Africa:*[3]

TABLE 4 *Metallurgical Analysis of Ifẹ̀ Bronze Heads*

Sample no.	Tin	Lead	Copper	Iron	Zinc	Total
1	0.9	15.9	68.8	0.9	11.6	98.1
2	0.6	13.8	71.2	0.7	13.3	99.6
3	0.2	1.2	96.8	0.2	nd	98.4
4	0.2	nd	99.7	0.1	nd	100.0
5	0.1	0.1	99.2	0.1	nd	99.4
6	0.05	0.3	99.2	0.2	nd	99.7
7	2.1	5.6	74.0	0.2	15.3	99.6[1]
8	0.7	11.1	71.8	0.6	15.0	99.2
9	1.3	13.6	74.2	0.5	9.6	99.2
10	0.05	nd	99.1	0.1	nd	99.2
11	1.3	11.3	74.1	0.8	11.9	99.4
12	1.1	9.9	77.5	0.6	9.3	99.4
13	nd	14.5	73.4	0.9	9.7	98.5
14	1.7	6.4	76.2	0.4	13.9	98.6
15	0.9	4.4	79.8	0.6	11.8	97.5
16	1.0	11.0	74.2	0.6	12.3	99.1
17	0.05	0.0	99.4	0.1	nd	99.5
18	0.8	11.4	73.4	0.6	13.1	99.3

1. Including gold 2.4 per cent. nd: not detected.

The heads examined then are either pure copper or brasses with a high proportion of lead; they are not bronzes at all, in that bronze is an alloy of copper and tin. The British Museum analysis reveals that they fall into two groups: (i) nos 4, 5, 6, 10 and 17 can be described as copper; (ii) the remainder, with the exception of no. 3, can best be described as heavily leaded brasses.

Lead–zinc ratios in this second group (group ii) are interesting: they occur roughly in the order of 1 : 1, 1 : 2 and 1 : 3, as the following table shows:

TABLE 5. *Lead-zinc Ratios in Ifẹ̀ Bronze Heads*
Lead-zinc ratio 1 : 1

Sample no.	Tin	Lead	Copper	Iron	Zinc
1		15.9	68.8		11.6
2		13.8	71.2		13.3
8		11.1	71.8		15.0
9		13.6	74.2		9.6
11		11.3	74.1		11.9
12		9.9	77.5		9.3
13		14.5	73.4		9.7
16		11.0	74.2		12.3
18		11.4	73.4		13.1

Lead–zinc ratio 1 : 2

Sample no.	Tin	Lead	Copper	Iron	Zinc
14		6.4	76.2		13.9

Lead–zinc ratio 1 : 3

Sample no.	Tin	Lead	Copper	Iron	Zinc
7		5.6	74.0		15.3
15		4.4	79.8		11.8

The closeness of the lead–zinc ratios within each group, and the range of these groups from 1 : 1 to 1 : 3 makes it seem doubtful that the metal was smelted from a mixed ore such as orichalcum, as has been suggested;[4] the evidence seems more reasonably to indicate a controlled alloying: we cannot ignore the suggestion of experiment in the alloy at no. 7. Here a significant gold content (2.4 per cent) is combined with a quantity of tin (2.1 per cent) relatively high to the other heads (0.01 to 1.7).

Two of three Nigerian smiths questioned on the composition of brass were aware of its constituents and the difficulties encountered in alloying them resulting from their differing melting points. An Ibadan smith demonstrated such alloying in my presence by adding his zinc to the molten copper only at the very last moment before the pour, in an attempt to counter the effects of its vaporisation;[5] an Abéòkúta smith described the process of alloying and produced samples of the constituent metals in evidence.[6] Neither of these, like the Ọbọ smith later interviewed, knew anything about bronze nor had any word for it in his language. The Bini, however, distinguish between bronze (*ẹrọnmwẹn*), and brass (*oze*). The Ọbọ smith did not know how to make brass. All these smiths knew that the addition of lead promotes the easier flowing of the alloy into the mould. It is not un-

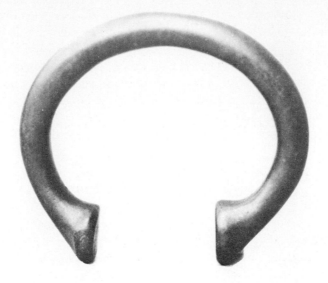

150. The trade manilla

likely that alloying was practised traditionally, though the activity would have been secondary to direct casting from the trade manilla and other piece-goods common in West Africa since the early Renaissance, fig. 150. The knowledge of alloying copper and zinc would however be of relatively recent reference in West Africa, for though brass was made by reducing calamine since Roman times, zinc was not isolated and identified as a metal in Europe until the latter part of the sixteenth century. As the process of reducing calamine with charcoal in the presence of molten copper can be presumed to have been unknown to the African smith (for whom a cupreous metallurgy does not appear to have existed traditionally), the alloying of copper with metallic zinc evident in recent practice could hardly refer to periods earlier than the sixteenth century. This conclusion admittedly does not take us far, for we know that the Portuguese were already trading brass up the Gambia as early as 1458,[7] and that the alloy had probably been crossing the Sahara centuries before this date. At the opening of the sixteenth century, Nigerians at the great brass-casting centre at Ijẹbú-Òde, not far from Lagos, were busy selling slaves for brass bracelets; so too, a hundred and forty miles to the east, were the Bini, who however preferred copper ones. Copper bracelets were likewise preferred by the Ijo of the Real and Forcados rivers, who never appear to have been brass casters, their preference for copper having apparently the ornamental rather than the metallurgical significance which it retained among these peoples into recent times: 'These Negroes go quite naked, wearing copper collars the thickness of a finger around their necks.'[8] The copper bracelet was traded as far as Fernando Po.

So the evidence indicates that while on the Guinea coast brass was probably known and used from quite remote times it was always an import

and unlikely to have been produced anywhere in West Africa by local alloying. This is of a certain significance when it is remembered that most West African 'bronzes' are in reality brasses. Since the Arabic language does not distinguish between copper, bronze and brass (*naḥas*) we have no definite means of being certain how much of the latter alloy, if any, entered the Guinea forest before European times. Neither archaeology nor art history can unequivocally point to the existence of figurative bronze-casting in the Guinea forest for periods before this importation of European brass, though a bronze practice is known for the Chad region from a much earlier period.

As we have seen from the morphological evidence, it is unlikely that bronze-casting was seriously practised at Benin much before the early years of the sixteenth century when the first plaques were being made. It is possible that local industries may have existed here and there in the Guinea forest casting the 'small and unimportant' objects – trinkets perhaps – already suggested by Fagg, but it is doubtful whether the great figurative brass-casting of the Bini had yet been developed. It is a curious fact that though no certain evidence so far exists that brass-casting was taught to the Bini by the Portuguese their coming seems nevertheless to have acted as a powerful stimulant in the rise of a local industry. This may perhaps have been encouraged by an increase in royal wealth brought about by the Bini monarchy's exclusive control of trade with a consequent consolidation of power and enrichment of the social order.

Analysis of a typical specimen of sculpture from Benin made in the British Museum in 1899 discloses much the same copper–lead–zinc ratios as we find at table 5 for an Ifẹ head, the lead–zinc ratio being 1 : 3.[9]

TABLE 6 *Lead–zinc ratio in an example of Benin bronze sculpture*

Tin	Lead	Copper	Iron	Zinc
0.5	5.85	78.5		14.34

Apart from this instance of apparently similar alloys employed at Ifẹ and Benin, material evidence suggests close and perhaps amicable relations between the two peoples around the seventeenth century. The typical vertical striation in the treatment of the Ifẹ royal face appears also on certain Bini plaques. In one of these, fig. 151, the motif is associated with the crotal as a decorative element, and this indicates a date in West African bronze chronology later than 1590. The piece may have been commissioned in honour of a contemporary Oni by a Bini monarch; for its Bini facture is indicated in the fidelity of the craftsman's modelling of the crotals on its hip-mask, the hip-mask itself being a distinctive Bini badge of honour, occurring frequently elsewhere in the plaques. The crotals represented here are minute, but even so the exact type is described – a version of the Bini crotal with banded waist and three-part division of the sounding chamber. Similar ex-

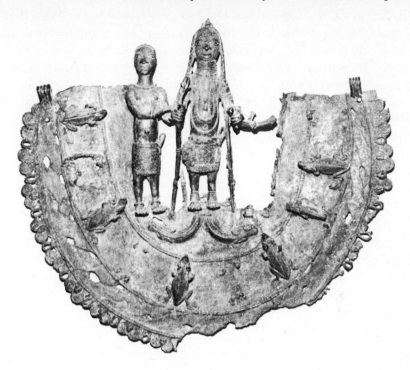

151. Bronze plaque, Benin

amples occur, for instance, on the *Ram-headed Breastplate* of the Apapa hoard, and frequently as independent articles. None but a smith accustomed to the manufacture of so insignificant an item could have rendered it with such exactness in a mere few millimetres of wax. The crotal nowhere occurs on any Ifẹ̀ bronze, nor does any reference to it occur in published reports on Ifẹ̀ archaeology; this article in fact, as we shall see, enjoys a distribution in the coastal and riverain areas of Nigeria, and does not appear ever to have been known inland, at the Ifẹ̀ and Ọbọ schools. Smiths at Ọbọ today cast small tubular brass bells, about 5 cm high, which are fairly common in southern Nigeria, but no jingling bells of any description are known for classical Ifẹ̀. Was Benin then dispatching bronze insignia to Ifẹ̀ at a date in the seventeenth century? The University of Ifẹ̀ archaeologist, the late Oliver Myers, has furnished the following note on an even more recent Ifẹ̀ 'date':

During excavations of Igbo Obamere at Ile Ifẹ̀ charcoal was obtained from the heart of two collapse walls, and this was examined by Dr Griffith of the Museum of Anthropology of the University of Michigan and found to date to AD 1380 ± 100 years. The archaeological horizon of the sample cannot be fixed with certainty except in so far as it makes it clear that the wall was built subsequently to that date. But I was already convinced that the shrine was constructed, like others in Ifẹ̀, after the reoccupation of the town in the nineteenth century. The shrine was made in an extensive area of previous occupation, found also not far away by Frank Willett. It is very probable that the charcoal came from this horizon, and the date falls within the period considered likely to be that of a large extension of Ifẹ̀.

This excavation (1964–65) like a subsequent one of 1966 at another Ifẹ̀ site, produced terracotta heads of the classical type, a small brass-casting crucible, and a stone fragment of an open brass-casting mould of the type described at Takedda in the western Sudan by Ibn Battuta in 1354 and used to the present time by smiths in southern Nigeria. None of these objects independently provides a date for classical Ifẹ̀. A preliminary report on Oliver Myers's excavation has since been published with an editorial footnote which informs us that when the same laboratory processed the sample a second time the result came out at 1730 ± 100. Five other radio-carbon dates recently announced for Ifẹ̀ appear to confirm the antiquity frequently claimed for the art, in this case the terracotta. They range from the sixth to the twelfth century, with a date at the eleventh century for a layer in which terracotta were excavated, though their excavator claims no more than that terracotta sculptures associated with Ifẹ̀ were being made before Europeans first visited Benin.[10]

Carbon-14 dates ranging from the sixth to the twelfth centuries, with terracotta dated in the eleventh century, appear to support the antiquity sometimes claimed for Ifẹ̀ and its art. If this early date for terracotta is acceptable, it might suggest that, as seems likely elsewhere in Nigeria, the idiom was transposed wholesale into bronze with the coming of tech-nique. It seems at any rate that the Ifẹ̀ bronze represents part of a general flowering in West Africa whose masterpieces all appear not much earlier than the seventeenth century. Around this date, a social era began to develop in these societies, resulting from the plentiful supply of iron as the slave trade was organised among the European nations; the effect of this should be taken into account on the general flowering of the arts, and particularly the metal arts. It is a period in which the Ọyọ empire, for instance, reached its zenith as a large-scale exporter of slaves in return for iron and iron artifacts, and which saw its expansion to the south and south-west into Dahomey. Ọyọ thus at this time commanded a trade route linking the Atlantic coast to the Niger bend and beyond, into the western Sudan and the Sahara. The end of the century witnessed the rise of Dahomey and the westward expansion of Benin to bring Lagos, and perhaps Ijẹ̀bú, under tribute, as well as the dominion of the Kwororafa over vast areas of the north between the Niger and the Benue. A hundred years earlier Ijẹ̀bú had already been known to the Portuguese as an exporter of fine cloths and of slaves, in return for which they demanded brass bracelets. All these king-doms created masterpieces in bronze, copper or iron. It certainly does not seem unlikely that the Ifẹ̀ bronze figured in this general picture, and that, in the case of certain southern schools, this bronze efflorescence was connec-ted with the European presence.

What is the position in regard to dating the Ifẹ̀ bronze? Ifẹ̀ and Benin employed entirely different methods of the *cire-perdue* process. Technique at Ifẹ̀ is demonstrably that of the makers of the Jebba-Tada bronzes, and though the fact does not in itself imply contemporaneity for the two schools, the possibility ought to be considered of a common source, in European

trade, for the alloys employed. Should these bronzes ever prove to have been linked to this trade source the *terminus a quo* for the two schools, as also for the Jukun *Head-rest* would be the close of the fifteenth century.

On internal evidence the type-group of the Jebba-Tada bronze is datable to the seventeenth century. This group shares a technical device with the Ifè bronze in the lozenge-shaped aperture cut into the wax investment for securing the unity of core and mould in casting. The device was employed on the baseplate of the Jebba *Warrior*, on all but one of the Ifè bronze heads and on the Ifè *King and Queen*. Should analysis ever establish a *terminus a quo* at *c*.1500 for the alloys employed in all these bronzes, then this shared device would tend to suggest for the bulk of the Ifè corpus a date around the seventeenth century.

Though the relative casting methods are dissimilar, another technical detail suggests contemporaneity for the Ifè, Benin and Jebba-Tada bronzes around the seventeenth century. This is the device for buttressing the bronze shell with a disc prepared along with the wax investment noted at fig. 141a, b. It can hardly be suggested that three distinct schools made this discovery independently. There is also the suggestion of a common source for the alloys used at Ifè and Benin, at tables 5 and 6. The disc-buttress from Benin is of the Portuguese period 1485–1642, the latter date marking their expulsion from the West African trade, though here and there they continued to maintain factories along the coast.

Technical evidence apart, iconographic motifs common to these bronzes from Ifè, Benin and Jebba-Tada suggest a relationship of some sort among them at around this date, figs 76, 84. Prominent among these are the insignia of the Ogane – 'the staff with a head' and the 'cross like that of Malta'. The staff occurs on a piece from Tada, fig. 87, and renderings of the cross on another. Two pieces in this group are more readily aligned with the Ifè school than with any other known at present. Should they ever be demonstrated as of Ifè authorship, a link with the Ogane, evidenced in the royal staff, would be established. The relative tradition possibly belongs to the fifteenth century, at which date there is as yet no evidence that either Ifè or Benin controlled a figurative bronze industry. For Benin at any rate the inception of a figurative bronze art seems associated with the quantities of alloys brought in by the Portuguese as well as with their military and cultural influence at court in the latter fifteenth and early sixteenth centuries. What the position was at Ifè at this date is not yet known, but the paucity of bronzes there and their restriction to predominantly royal themes is provocative. What connection, if any, may be held to have existed between the casting of these royal heads and the Ogane with whom the bronze tradition seems to suggest an association? What is the origin of the Ifè terracotta, a medium by no means well known in other Yoruba schools, but of old and superlative achievement in the north? What indeed is the origin of the Ifè kingdom itself and the Oni's spiritual supremacy to the present day? With regard to the bronze tradition the Jukun seem to have been in the right place at the right time to lend some

substance to speculations as to the identity of the Ogane, though just now the evidence supports no more than speculation. The *Head-rest* recovered at their royal burial place is in the technique and aesthetic of some of the Jebba-Tada bronzes and, like them, is datable in the seventeenth century. The Jukun earth taboo appears at Benin and at Ifẹ. There are also the characteristic facial striations of the Ifẹ bronze, still found in northeast Nigeria. On technical and iconographic grounds a connection between Ifẹ and Benin in the seventeenth century, and between them both and the makers of the Jebba-Tada bronzes at this date seems very strongly indicated.

19 The Ọbọ School

The technique of the Ọbọ school, as we have seen, has a possible connection with bronze at classical Ifẹ̀. But these smiths had a technique of perhaps even greater age than at Ifẹ̀, for in aesthetic and idiom alike the Ọbọ school is unique in African bronze. It may well be the last pale avatar of an ancient line whose patrimony once linked the riches of the western Sudan with those of the Mediterranean bazaars of a remoter era. The possibilities of speculation are infinite, but we can hardly doubt that the Yoruba smiths who today remain the sole exponents of the craft have inherited their practice intact from a source originally of wider reference. Their spiral method may have been employed by the older Sao of Lake Chad; traces of it certainly persist in Asante. In this fossil jewellery can be detected a delight in the beauty of matter enjoyed for its own sake, a playfulness in which matter itself comes to be broken down to yield the secrets of those elements which strain against its inertia. One might visualise them as little monuments beyond the reference of nature, defying gravity and dimension, since in them time itself seems atomised and light endless.

The Ọbọ smith is the impressionist of the African bronze. But his is not the Impressionism of the European nineteenth century (which could never be interpreted in the forms of sculpture); in its denial of mass and in its celebration of surface it is more nearly the Impressionism of Islamic ornament. In its control of the expressive – we might even say the musical – possibilities of light, in its elaboration of surface to the limits that a given form can bear, in its negation of gravity and its defiance of inertia this is not the aesthetic of the forest. The forms of the forest are earthbound, concrete, expressed by bare masses in geometrical relationships: the bronzes of Benin, for instance, which could equally have been realised (and in fact were) in ivory or in wood; or those of Ifẹ̀, indistinguishable from its terracotta, or the Yoruba sacred figurines in their finely realised finish. In the Igbo corpus alone among southern bronzes do we find a cognate identity of surface, a similar glory in light as agent and end. One would need to envisage these objects as they first left the hand of the smith glittering in minuscule whorls, in coiled coils, in microscopic pellets and clusters, every surface breathing light, creating rather than inhabiting space, immaterial yet massive with energy; one would need to have witnessed such sunbursts broken fresh from the mould and free of the patina which now clouds their beauty in our museums, to grasp their particular intention and ancestry, figs 152 and 153. For the Igbo and the Ọbọ bronzes it would not be rash to conceive a common ancestry, though of the former not a single meaningful word can be uttered at present.[1]

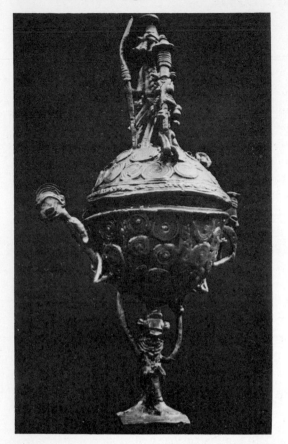

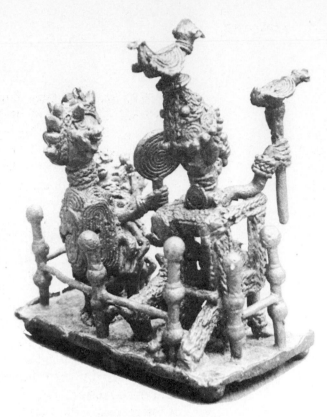

152. Ọbọ Aiyégúnlẹ̀, bronze kola-nut bowl

153. Ọbọ Aiyégúnlẹ̀, *King and Queen*

How are we to understand these bronzes? In technique limiting and creating form, or in a vision, the vision perhaps of filigree smith or jeweller, purposefully selecting a means to an end in the landscape to hand? From the latex of a local cactus such a smith might perhaps come to spin the first filigree thread as bright and slender as a strand of gold with which he winds his dream in loops and bosses and spirals around a core fired to the nature of stone. The minute miracles of the Igbo bronze cannot be understood in any other method, and this determines imagery in all the products of the Ọbọ school, for only latex thread can yield the hairsbreadth and uniform diameters which give these bronzes their singular character.[2]

Ọbọ Aiyégúnlẹ̀ is a small village just within the border of northern Nigeria. Here people live in much the same way as their ancestors, though most are now Christian. There is a school, a church, a palace, grouped as in the pages of some nostalgic African novel around the market square. No main road, no shops. A bus once a day, no cars. People weave, farm, and in the old days supported a bronze industry which has fathered practice deep into Ekiti country and whose influence might be felt as far to the south as Ogbomosọ. Here perhaps the smith lives even closer to tradition than at Benin, though now he must supplement insufficient returns with a bit of ironworking. One of the most gifted of these, one Adirotutu, is the

most famous in modern practice.[3] A student of his, Bamidele, is still alive, working and living to a strictly traditional pattern. His compound, which in better days might have swarmed with apprentices and slaves, is now managed only by his wives and children and perhaps a member or two of his father's destitute family. Women and girls, beside running the household, are needed to keep the smithy in water, to reduce charcoal to powder on the grinding stone, while young boys turn their hands to the bellows, the anvil or the care of tools and equipment. Commodities not produced in the village can be purchased from neighbouring markets on the appropriate day. Particularly in quest of salt, iron, or brass the trader might travel to distant centres in caravans and under the safe-conduct, in traditional and dangerous times, of chief or king. Such tradition claims brass 'from the Portuguese', 'from Tapa' (Nupe), or 'from Benin' in trade rods exchanged against slaves. From Afemai came iron unworked.

154. Gourd 'crockery' from an Ọbọ household

From locally grown cotton women spin thread on corn-cob spindles which they then dye the various blues of Yoruba fancy tied in *adire* patterns, or printed by simple discharge methods using local starch. Rich in geometrical inventiveness, these dyestuffs are sometimes also as figuratively topical as a Caribbean calypso. Africans traditionally produced such cloths, as well as richly woven material for export, before being outstripped by the European machine.

The smith sleeps on a straw mat about eight foot square, with no sheet or pillow, but in a winding cloth that serves as both. As he makes his way along the bush path in the morning to inspect his traps for small animals caught overnight, he cleans his teeth with a sprig of sage. In this savannah country his usual capture would comprise various rodents; rabbit, hare, rat, etc. The traditional traps are of great variety and ingenuity and are a useful supplement to the throwing club and arrow.

So he lives with his place and people. His mud-built workshop is also the centre of his family compound: he works in their midst, and amongst

155. Equipment of a smithy, Ọbọ. (*a*) *hammers*; (*b*) *anvil*; (*c*) *open mould*; (*d*) *crucible*

the other villagers. The secrets of Ògún (god of war, god of iron) give him power. In addition he is healer, tower of strength and general comforter, known to all, and respected even by his king.

156. The tools of the smith, Ọbọ

The knives and minute trowels used in creating the elements of his forms are unknown to the southern smith. Here we may not speak of modelling, all is plaiting, spinning, weaving with the passionless concentration of a spider and the industry of a termite. Here is no purely plastic intention; these forms are born of the sensibility of the jeweller – their intention is to adorn, not to express metaphysical experience. Paradoxically therefore they are the most non-physical and immaterial of all African bronzes.

Clusters of *Euphorbia kamerunica* (ọrọ), fig. 131, attaining heights in the rocky outcrops of northern Nigeria of ten to twelve feet, account for these forms. From the trunk milk is bled into flat calabash dishes, then transferred into a largish gourd. It soon congeals from a freely running fluid into a turgid slow-moving mass which needs to be scraped along to assist its flow. At the end of two hours or so a pint is tapped which in the smithy is immediately transferred to an open pottery vessel for boiling. Stirred continually over a slow fire it congeals further into a toffee-like mass which is finally plunged into a pan of cold water to harden into the rubbery ochre-coloured lump familiar to the smith. Through the next half hour or so he alternatively kneads and stretches it until it is firm enough to be bent into a thick ring for storage. From this store of prepared latex, carefully kept free of dust and grit, he will draw the gossamer threads used to invest his core. An open wall of his workshop faces a window in the opposite wall.

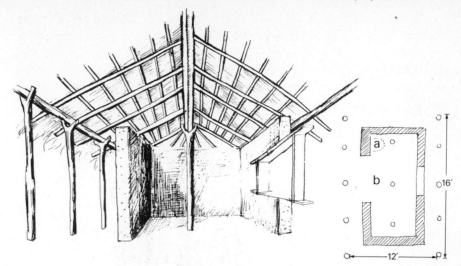

157. The architecture of a smithy, Ọbọ

Despite the free-standing thatch roof heavy blue clouds of smoke make work inside the smithy uncomfortable for long stretches. In the cross-draught induced through the two long walls hearth and bellows are positioned in the concentration of light under the archway. Around the other walls hang the smith's tools and implements, shelves, boxes of scrap brass, completed casts, made-up cores, etc. A store of firewood stands at the ready outside the workshop. In the working area near the hearth is the pot of palm-kernel fuel which keeps his fire going throughout the day, a fuel probably chosen for its high calorific heat. The whole is functional and on an efficient scale.

158. Section of a forge, Ọbọ, (*a*) bellows; (*b*) tuyère; (*c*) seat for bellows worker; (*d*) heat shield; (*e*) palm-kernel fire

The smith's product – a medicine pot, a group of figurines, always secular, free of the imperatives of the gods – may take days and weeks in the making, careful though he sometimes is to make up batches of cores beforehand against the likely demand. Like all other African smiths his repertory of forms is small – always he copies from an actual or a conceptual model; his client, no matter from how far afield, is unlikely to demand the unfamiliar, and often provides the model. There is small room for

extemporising or for the vagaries of a personal vision, but on a given theme surprising variations may be achieved. The work of the great Adirotutu is for instance easily identifiable in the Ọbọ corpus for the personal mannerisms which he developed within the prevailing idiom, yet in every detail he remains a perfect exemplar of the school. Consider too the baroque exuberance achieved on the Ọbọ theme in the Iddo casting at fig. 159.

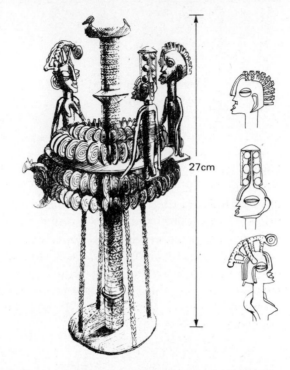

159. Bronze kola-nut pedestal bowl, Yoruba (African Studies Museum, University of Ifẹ̀)

Here the forms of an over-refined tradition are inflected with the harsher cadences of a purely Yoruba vision, but do not lose themselves in the traditions of Yoruba casting. In their atomisation of light and matter they remain inpregnated with the sensibility of the jeweller rather than with the rigidity of the sculptor inherent in the Yoruba aesthetic. It is not until we come to the degeneration of form at fig. 160, that all memory of the sculpturing of light is lost, though even here the camel's-head finial underlines the northern association.

From this study of the Ọbọ school we can see that it is erroneous to consider the latex method as an alternative to wax in bronze casting, as has sometimes been claimed. In technique, in imagery, and in aesthetic the work of the half dozen or so smiths who still practise today this no doubt ancient craft stands alone in the African bronze. Affinities and influences take inquiry beyond the borders of present-day Nigeria to the spiral method known among the Aṣante and the Sao. Though a possible connection between this technique and the early gold trade of the Sahara provides a direction for speculation we have no facts with which to support conjecture. The two distinct approaches to bronze noted by Petrie and by von Luschan

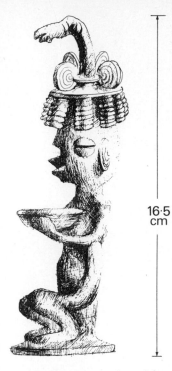

16·5
cm

160. The degeneration of the
Ọbọ idiom

and examined by the author in the workshops of living smiths very possibly indicate separate influences on West African casting, and this seems supported by the independent aesthetic associated with the spiral method. Smiths today practising one method have in every case been found ignorant of the other; in Aṣante a wax method is confounded with a spiral method which might represent a vestigial memory of an earlier northern practice. A similarity in the preparation of moulds and cores indicates common practice at Ọbọ and at classical Ifẹ̀, though their aesthetic is of course poles apart. In modern times the *cire-perdue* method has been reported from as far east as the Shilluk (of the Nile) and from as far south as the Ba Ngala of the Upper Congo. Both these centres make the model of vegetable materials rather than of wax; the Shilluk of the resin of *Ficus sycamora*, and the Ba Ngala of the plantain root.[4] Neither method has been recorded for West Africa where all the great historical schools have worked in latex or in wax, the former in its possible association with the Sao culture and in its orientalising imagery being perhaps of an older reference. It might not perhaps be too rash to interpret the methods of the Shilluk and the Ba Ngala as adaptations of the latex technique of the western Sudan and northern Guinea. In any case the isolation of the Ọbọ school once more suggests the idea of now vanished centres to which the student might have looked for explanations of much that remains puzzling in the history of the African bronze. Here however we ought to bear in mind the possible role of Ọyọ state, tentatively dated to the fourteenth century, as a link in the movement of ideas from the Sudan into the forest regions.

20 The Jebba-Tada Bronze

Though clearly not the products of a single school certain bronzes are claimed in the oral tradition to have shared a common history since the early sixteenth century, when they were deposited in the Nupe villages of Jebba and Tada twenty-five miles or so from each other some distance beyond the Niger-Benue confluence.[1] The tradition relates to a culture hero, Tsoëde, who fleeing Idah on the Lower Niger stretch brought with him these objects, along with a bronze canoe, now vanished, as sanctions of chieftainship among the Nupe. But to the present we have no reason to regard the details of this tradition with any more seriousness than we may do several other such; in a small Ògún shrine at Òmùò village for instance, just inside the Ilorin border, a finely cast though seriously flawed bronze mask from Benin is seriously claimed in the local tradition to have been made by Ajàká, the first Ọba of the town.

From a hill dominating a poetic green sweep of the Niger a monument to Mungo Park faces the ochre-dry mud-thatch village of Jebba, where a precarious railway bridge spans the river. The contents of its principal shrine may now be famous but Jebba hardly notices; the visitor will wait

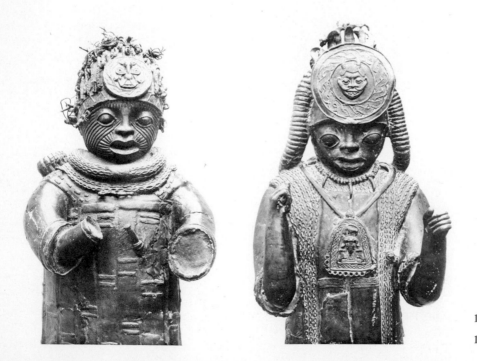

161. The Jebba *Warrior*

162. The Tada *Warrior*

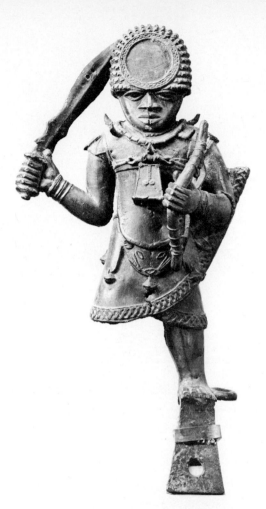

163. Benin *Warrior*

while the watchman finds the key, and be embarrassed by the latter's uncomprehending stay in the small dark shrine as he confronts what are obviously two masterpieces of the African bronze. He might leave impressed – as bronzes their sheer size is impressive – but would hardly know why: in the way one might perhaps be impressed by a single work from an unknown and long dead hand. Once seen the brooding power of the Jebba *Warrior* is not easily forgotten, nor is the compelling spirituality of the female who shares the darkness of this remote shrine with him.

Together the nine pieces in this group raise several problems in the history of the African bronze. They are all in the casting tradition which we have examined in the *Lafogido* bust of the Ifẹ school, though of them only three might reasonably be attributed to Ifẹ authorship, figs 85–87. Three more, among the most important of bronzes ever cast in tropical Africa and all unquestionably from the school, or hand, of the same master, share a number of iconographic motifs with Benin; but they appear to represent a slightly older tradition, figs 145, 161, 162. Yet three others, an elephant and two ostriches, seem the products of an individual hand,

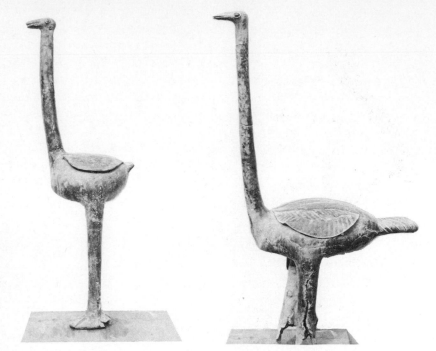

164–65. Tada ostriches

figs 164–66. The group therefore comprises what is fairly certainly the work of two masters each represented by three pieces, and what we may regard as an 'Ifè' group of three, two at least of which again appear to be from the same hand – the 'Ogboni' piece and the *Staff-Bearer*, figs 85, 87. It is far from unlikely that these three pieces are again the work of a single artist,

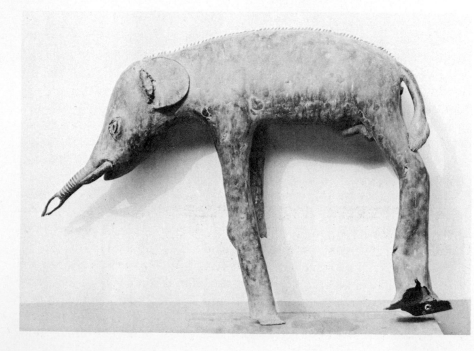

166. Tada *Elephant*

the magnificent *Seated Figure*, fig. 86, being perhaps a mature vision of the eye which had earlier conceived the *Staff-Bearer*, a range of development readily acceptable in the *oeuvre* of a given European artist – one might contrast those rather saccharine early El Grecos in Athens, *The Adoration of the Magi* or *St Luke the Evangelist*, with the acid ecstasy of his later vision – in which case we might very well be dealing here with the author of at least some of the bronze heads at Ifẹ̀. Should this ever be proven, and the means to do so conceivably exist,[2] we would be faced with that most unique figure in the traditional African scene – the artist developing from work to work at the behest of a private and individual vision expressed in a purely mathetic, and therefore objective relationship to nature. It would be an astonishing revelation.

The group comprises:

Jebba
(*a*) A standing female nude, 1 m 10 cm (44 in)
(*b*) A standing male warrior, 92.5 cm (37 in)
Tada
(*c*) Elephant, 55 cm (22 in)
(*d*) Ostrich, 1 m 28 cm (51 in)
(*e*) Ostrich, 1 m. 8 cm (43 in)
(*f*) Male figure in tasselled coat of mail, 1 m 18 cm (47 in)
(*g*) Seated male nude, 53 cm (21 in)
(*h*) Male figure with disced staff, 43 cm (17 in)
(*i*) Standing male, 55 cm (22 in)
(*j*) A broken-off human left foot.

In the first decade of the sixteenth century the Portuguese navigator Pereira described the people of Benin and its districts as having 'a mark above the eyebrows which other Negroes do not'. This brow marking, not surprisingly, occurs on several Bini bronzes as also on the head-disc of the large bronze *Warrior* from Tada. This latter, along with two others in the group, we know to have been cast a good hundred years after Pereira's observation, and by a single artist. At the opening of the sixteenth century Benin was no humble African village but a kingdom extending 'some eighty leagues by forty' or in today's terms, some 700 by 350 kilometres (though the sixteenth-century Portuguese measure may have been different). To supply the demands of the still young slave trade the Bini waged continual war on their neighbours. It was a time when the power of the Jukun was about to be felt, or was indeed already being felt, in vast areas to the north of the Niger. It was a time too in which paradoxically the Bini still relied on sanctions of kingship vested in a foreign sovereign whose identity remains a vexing issue in our studies, but who we know to have comported himself with the graces of Tuareg nobility. He apparently also controlled an at least efficient bronze industry.

Not enough is so far known about the Jukun to credit them with a Tuareg ceremonial in the early sixteenth century, but a hundred years or

so later they were certainly in possession of a mature bronze industry. At this time was produced the mammoth hollow cast *Head-rest* at figs 78, 79, recovered from the traditional burial place of their kings together with a number of small bronze vessels of undetermined use. The feat of casting this enormous shell (about 1 m by 60 cm), very typical of the contemporary picture, reminds us of the legend of a bronze canoe used by the culture hero Tsoëde and suggests the craft which produced the great hollow-cast animals at figs 164–66. These castings are so far of unknown authorship but their idiom would not have seemed amiss among the bronze objects of the Jukun burial.

In all these Jebba-Tada objects the casting technique is the same as that employed for the Jukun *Head-rest* – the 'platform' method already examined. If not secure, the case seems at least strong for associating these animal casts from Tada with the Jukun industry. And should future scholarship on methods that are perhaps less assailable eventually identify the Jukun *Head-rest* with the authorship of these Tada pieces, what then might we come to think of all others in the group, all demonstrably following the same 'platform' method of casting, with the consequent similar evidence locked in their core masses? We acknowledge the fact that the recording of these pieces at the burial place of the Jukun kings is no more proof of their having been cast there than the recovering of Ifẹ̀ bronzes at Ifẹ̀ proves a local industry; but indubitably northern is the subject matter of these bronzes – the ostriches, the coats of mail, even the mythical or legendary vision of the elephant. According to its discoverer, the Jukun *Head-rest* is a copy of a leather original native in the area. The model of the cap worn by the Ifẹ̀-type *Staff Bearer* in the Tada group has also come to light – a finely woven straw cone recently acquired by the Nigeria Museum among the Igbira. Like the Jukun bronze these Tada pieces seem certainly northern.

In the evidence of the crotals profusely cast on its type-example the Jukun bronze also seems modern: no earlier than the seventeenth century, and therefore contemporaneous with the warriors at Jebba and Tada. If their contemporaneity and a shared technique are sufficient to associate Jukun authorship with the Jebba-Tada pieces, the conclusions arising from such an association would profoundly revolutionise our thinking on the history of Ifẹ̀ and of the Ifẹ̀ bronze. One wonders why the apparently most insignificant of the group at Tada – a mere 43 cm high and the smallest by a good deal of all the pieces in this shrine – should command a local worship, a continuing sacrifice where the others do not? This worship seems to have been uninterrupted from the day of its earliest use, for the rags which shroud it in its shrine, and which one is gravely forbidden to remove, conceal the golden colour of fresh bronze where the rest of the piece has grown the patina of centuries. This is the figure, the only one of all these bronzes, that bears the 'staff with a head' of the Ogane tradition. It is decidedly not of Bini tradition or facture, and very much more possibly of the craft which produced its companion piece, the famous Ifẹ̀ *Seated Figure*. Our search for the Ogane may well come to rest on some as yet

unexcavated archaeological horizon, as claimed in the Portuguese account
– to the east!

In this group we find the image of the ancestor stereotype. Here explicitly
is ancestral form: the ancestor posture, the physiognomy of the ancestor
– elements clearly to be read in the three large bronzes of a common hand,
figs 161, 162. (The largest of these three, the Jebba female *Nude*, about
1 m 10 cm high, is not reproduced.) In each of them arms rise across the
torso in that gesture which implies an action that is no action at all and there-
fore non-temporal, a gesture that is in fact an utterance, a sacred sign, as the
Yoruba Ogboni gesture or the gesture of the Òbàlùfòn cult-icon are sacred
signs, figs 167, 168. Their female *Nude* shares with these warriors such a

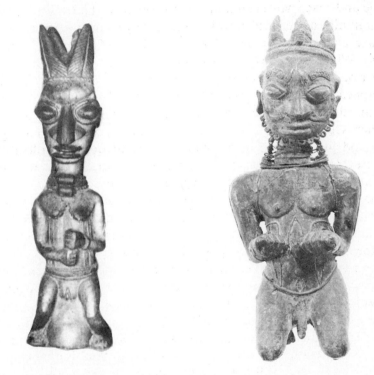

167. Yoruba bronze, the
Ogboni sacred sign

168. Yoruba bronze, the
Òbàlùfòn sacred sign

sacred sign, a sign whose meaning we therefore see to be non-particular,
non-personal, non-temporal, *representing* nothing. These faces too are
made to the same conceptual image; their features do not appertain to the
contingencies of a human time; they are as depersonalised, as dynastic, as
certain Old Kingdom statuary, and as transcendantly spiritual. So we have
here an ancestor ideal, the ancestor form-stereotype to which, in work after
work, the particular artist will conform. In this ancestor ideal we can
perhaps read parallels with Ifè classicism in the ideal of an aesthetic canon
towards which the artist constantly seeks to conform. For these bronzes
also breathe the classical air, if not in harmonic number at any rate in the

deliberate measure of their emotive elements. These extinct eyes do not radiate but merely reflect a human light, in their moonlike chill that holds the regard of those who survive; eyes set so low in the face that they almost form a line with that of the nostrils and thereby dominate the face as much in their lunar chilliness as in their size and form. These emotive elements are echoed in lips which although turned inward, inverted in the assurance of some sphinx-like secret, nevertheless, like the ascending arms, are eloquent in an utterance which, too, is sacred.

Yet here also are the realistic minutiae of daily life – the dagger, the plumed and crowned helmets, the coats of mail, bells, tassels, all the ornament of a particular day, the vestments of splendid occasions, the specific, the personal. Here in the face-markings are tribe and identity, identity and status in the regalia, in the emblems – the ancestor spirit located as it were in time and space while continuing in the other world. In these specifics, in such minutiae as he is laden with in the earthly context we read his relation to place and event; he dwells in the spirit world clothed in his earthly history. What therefore are we to make of such an ancestral figure – figure of warrior, or chieftain, or king – in which the naturalistic habit of a Bini face appears among his regalia? For on Pereira's word this disc-image is none other than a Bini face, with its brow markings employed among no other Negroes of the early sixteenth century. We are observing a northern artist modelling the wax detail of an ancestor figure. Such a hand has left us two other masterpieces in whose common characteristics we have read the elements of the ancestor stereotype. His warrior, or chieftain, or king he crowns with an emblem whose visual force in the total image is that of a modern poster in a cathedral. In the frontal regard determined by the dominant eyes this emblem requires a plane surface. In this figure, unlike his other and possibly earlier warrior at Jebba, he renders the disc of tradition larger than the entire frontal area of the face which it qualifies and crowns. In the centre of such a strident disc he models the image of a foreign royalty – a Bini royalty in the symbolism of the horns, the brow marking and the bead cap, all similarly meaningful to the Bini smith: for to the artist of this Tada bronze no equivoque would be permissible in such a commission. The brow marking of the general Bini populace must be rendered specific in the symbolic horns of their sovereign. What is the meaning of this? We can hardly believe that the connection implied is one of physical dominion, since contemporary records attest Benin's martial conquests at the time so far afield as Lagos. It is a connection more easily to be understood perhaps in a tradition such as the contemporary account relating to an Ogane, a distant spiritual overlord whom internal political expediency may have justified the Bini monarchy in maintaining as holder of their sanctions of kingship, if only in the interests of succession. We do after all know that among the Aláàfin of the Yoruba Ọyọ empire, greater in its time than Benin at its greatest, traditionally and to the present day the sanctions of kingship have rested with such a distant spiritual overlord, with the Oni at Ifẹ̀, whose kingship is still consecrated by the

brass-mounted iron Sword of Òrányàn. The idea of a distant spiritual overlordship might spell assurance in an insecure temporal order; in any case the Bini royal insignia rendered with care and precision on this indubitably northern ancestor piece must imply something more than mere artistic fancy.

In the iconography of these bronzes provocative associations spring to mind with nilotic themes involving dates at which a figurative bronze is certainly unknown in West Africa. But it is unnecessary to imply the diffusion of technique merely from the mobility of motifs, as we have already noted in the long history of the double-axe in nilotic and mediterranean mythology before it came to be adopted in many a West African cult. Palmer has noted the representation of the Blemmye vulture-goddess on Karanog pottery in its possible association with the design of the Tuareg shield,[3] but whether or not Tuareg agency may legitimately be invoked to explain the symbolism of the vulture-goddess on the Niger it is at least difficult to question the similarity of the motifs from Benin, Tada and Jebba with the victory-motif as it appears on this Nubian pot, figs 84 a–e and 169 a–c.

169. Comparative design motifs: Nubia, Benin, Jebba-Tada. (*a*) Symbol of the vulture-goddess on Blemmye pottery (after Palmer); (*b*) motif from a Bini ivory carving (*c*) medallion on a Jebba bronze, see fig. 161

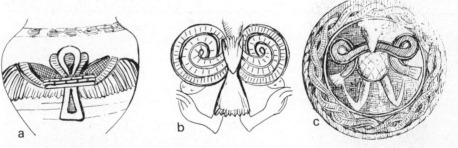

The horned head-dress of the Nubian eparch at fig. 170a might similarly have resumed a Blemmye tradition of horned deities or rulers,[4] and from either source may conceivably have derived the horned head-dress of Bini tradition.[5] The horned head-dress is certainly, on other evidence, to be associated with the Bini royalty. The Funj of Sennar, according to Arkell,

170. Comparative design motifs: Nubia, Benin, Jebba-Tada. (*a*) Horned head-dress of a Nubian eparch (after Shinnie); (*b*) horned head-dress in the Bini bronze (see also fig. 84 *f, g*); (*c*) medallion on a Tada bronze, see fig. 217

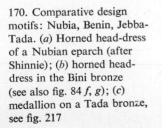

171. Horned caps. (*a*) Funj (after Arkell); (*b*) Yoruba; (*c*) Benue (after Baumann); (*d*) Blemmye (after Palmer)

inherited their horned cap from Nubian Christianity.[6] Among the Yoruba a horned cap is worn as a symbol of chieftaincy or seniority at the present day, and Bauman reports a similar cap from the Benue,[7] fig. 171; but most striking is its occurrence in the Bini bronze – on the plaques, in masks, and in sculpture. And should we wonder at the feasibility of Bini connections with the Nile the mask shown in fig. 172 with a horned cap might make such

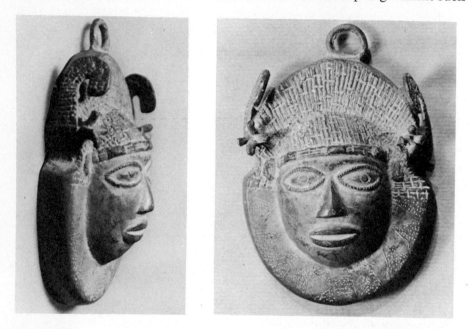

172. Benin, bronze mask, the horned head-dress

a connection seem at least possible, for it was dug up in 1960 on the Red Sea while the foundations of a new building were being laid. Oral tradition claims this horned cap to have been introduced at Benin by the Ọba Ọsẹmwẹdẹ (1816–48),[8] a tradition patently contradicted by the evidence on the Tada medallion. We have examined a Benin chronology partly based on this tradition. On a pendant mask the motif is rare; I have encountered no other examples in museum collections or in the literature. The graphic convention for rendering this head-dress – a wiglike arrangement of curls framing the face in a severe rectangle – recalls certain Old Kingdom wood-carvings. It also appears in a small bronze head of a Negress from the Alexandrian school, in the British Museum, and also very widely in relief and three dimensional sculpture at Meroë.

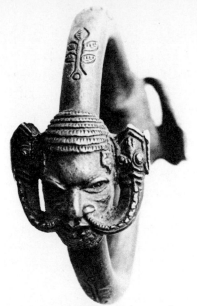

173. Benin, bronze bracelet, the motif of everted reptiles issuing from the nostrils; cf. fig. 76 a–e, fig. 77

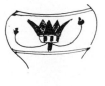

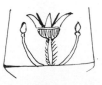

174. Designs on Blemmye pottery, AD 250–545, from Karanog (after Palmer). A veiled horned deity with triple crown. The figure becomes a symbolic lotus in other designs

The horned head-dress is not otherwise a familiar motif in the African bronze, though the theme of everted fish, snakes or lizards running up each cheek is. This latter might represent an abridgement of that symbol employed at Benin and perhaps at Ifẹ for indicating the divinity of a king in which tradition requires that his legs may not come into contact with the earth, fig. 173. It occurs too on bronzes among the Ijẹbú and Abéòkúta Yoruba. Fig. 174 provides an interesting example of the transformation of a similar theme associated with a Nubian horned deity.

In size alone these Jebba-Tada bronzes suggest vanished industries: they are the largest south of Egypt. Except for a few heads in the Ifẹ and Benin corpora the life size is nowhere else nearly approached in the African bronze. That the massive operations of Greek and Egyptian have never been attempted in the African bronze is perhaps to be attributed to the limitations of the *cire-perdue* when contrasted with the piece-mould process. Considering these limitations the Jebba-Tada pieces must be seen as works of a staggering technical ambition. Moulds of monstrous size would once have clothed these images whose facture and handling, with wax investment and core in place, would have demanded the brawn of many an apprentice as well as the skill and ingenuity of the master-smith. Such a mass as the Jebba female *Nude* would once have nestled in a mould near 2 m high, runners, risers and mould-cup in place, needing to be heated bit by bit in an open fire to free the wax which would be tipped out liquid, as from some giant terracotta flask, at angles increasingly approaching the vertical as the last traces were drained free. One imagines no less than an inferno for the necessary baking of the mould red hot to free the last traces of wax before the pour of molten bronze, an undertaking as incredible in the handling as the raising of the fifty ton monoliths on Easter Island; for at this stage every hairsbreadth crevice of the impression inside the mould must be drained free of wax and remain as dry and flawless as a die.

A labour of perhaps months involving many craftsmen culminates in this moment in the life of the mould when it is buried in the ground, mouth upwards, for the pour. How many steaming crucibles might we imagine on how many hearths glowing under the nozzles of how many bellows, every detail and calculation tuned to this moment of feeding the alloy into the mould-cup. In the union of technical and aesthetic mastery revealed in these pieces we can distinguish an artist of a very high order. As the capacity of the African bellows dictates a limited size of crucible we should imagine dozens of these at the ready, the boiling liquid in motion, the tense figure of the master-caster bent over the mouth of the mould. A second's delay between one pour and another would cause that ineradicable gap in the bronze which would run like a great crack around the entire figure, such as we see in one of the finest of the Ifè heads, and in the smaller figures of a king and queen. No such crack exists on any of the Jebba-Tada figures: the pour of fire-bright alloy into the mould-cup has been smoothly continuous, crucible following crucible through the hands of the master-caster without pause until as in a tropical dawn the glowing disc of bronze rises from the darkness of the feed channel.

Cellini possibly knew no greater anguish than the waiting that follows this moment, wondering whether the mould had received its charge in every nook and cranny, whether every trace of gas had been expelled up the risers or through the mould mass, whether core and mould had stood up to the temperature of boiling bronze or had cracked, even so little as a hairsbreadth, and had freed the alloy into wilful and disfiguring adventures beyond calculation and beyond sight. In that silence of the waiting which follows on the last pour of the last crucible and the snuffing of the last bellows and the cooling of the embers the voice of the god no longer guides the intuitions of the smith; only human ingenuity may now counter possible disaster. And the smith has his ways, his resources, his will. The English sculptor Michael Ayrton sees all creation as reasoned response to the will of one deity or another, whether for the European or for the African artist, whether conceptualised in abstract theory or personalised in the gestures of the gods; errors are seen as divine rejections to which empirical knowledge proposes answers. To the eye of the master-smith the collapsed mould discloses the inevitable error, the miscalculation, the passage scamped or hurried, in some gaping hole or fissure where bronze has failed to catch bronze in the surface tension which should unify all his forms. Experience fills the astonished silence not with awe at this divine rejection but with the responses of a sure tradition. A subsequent operation will renew the draught of the bellows driving fresh blue smoke shot with flame, will see crucibles refilled, wax kneaded, mould-stuff reground and applied like a poultice over a new skin of wax, a pouring-cup structured over the whole – a 'burning-in' operation mounted with the passionless skill of a surgeon. These Jebba-Tada pieces are all pocked on their insides with the evidence of such burning-in. On the outer surfaces the patches, like the effect of the plastic surgery of our day, are marked by fine contours which the patina of centuries beyond

any vision of the smith has merged with the mass. In our museums the sweat of these remote craftsmen, their anxieties, their errors and responses are fused into the forms of these very African masterpieces.

And to what degree are they African and nothing else? On the quality of their peculiar form – that which distinguishes them in the African bronze – we may note that their facial imagery is subtle, of a mature and tested vision. And if in every case the modelling of the limbs seems no more than cursory we should remember that these sculptures are not intended to be merely representational; if they were, the sensibility which conceived the facial modelling would have given us finer limbs. These forms do not represent the ancestor – they are the vehicle through which communion may be established with the ancestor in the spirit world. By virtue of that spirit known universally to inhabit all matter, the assemblage of his accoutrements, those objects characteristic of him which had conferred or confirmed his power, are rendered as part of the man, the essentials of that being in which he lived among men.

In the shrine at Jebba is held also the giant iron chain associated with the culture hero Tsoëde, every bit as sacred as the bronze figure itself; it is charged with that same spirit which had in life been manifest in the man and which survives him; it is an attribute of his being and no mere object of function and utility. It is therefore not held *to his memory* in the European sense; it is itself that spirit in which after death he lives, that in him which may eternally act among men, which as a result comes to possess a significance far beyond the particular. In just the sense in which this Jebba chain is the ancestor, so also is the assemblage of tools and weapons which today we still find in many an ancestor shrine up and down the country, objects which continue to retain that which a man gives up in death and which therefore effectively replace his mere image and memory in a realism more stark than in the forms of any art, fig. 175. In such a realism the concept of an image is enriched. So in the elaborate assemblage of the Tada ancestral configuration the elements of this concept of ancestral form achieve explicit expression in the detail and minutiae of the bronze technique. Among the Yoruba in the forms of wood – the forms of the second-burial figures or of the Egungun mask – a similar realism invades the hieratic nature of the ancestor concept. To the schematic forms of the Egungun mask are wedded the realistic postures of the ancestor in his earthly context – those postures of the hunter, the warrior, the farmer through which in the lives of his issue he will live eternally in heroic dimensions. Hence therefore the rationale of the ancestor piece. It is spirit-sculpture in just the sense of the sculpture of the gods though its sanctions are different – the ancestor, unlike the gods, has no say in the facture of his image; since the image is in fact a product of his total earthly life, he does not preside over it.

By means of such an image, by means of that spirit known to be clenched in the forms of matter, the ancestor may be reached in the spirit world. His life in the spirit world is therefore secured in the devotions of his issue. Has

175. Ancestor shrine, Badagry, Nigeria. The attributes of the ancestor survive him in the tools and implements which gave him power as a blacksmith

Griaule not found the vital force fixed for all time in the ancestor sculpture worshipped by the living, while Horton has pointed to the equivalence between the ancestor piece and a moribund man – to the pointing of the face of the sacrifice towards the head of the sculpture, sculpture seen as the *head of the spirit* and exercising control over the spirit? Such sculpture conveys the spirit of the ancestor to his descendants still on earth: the dead preside over the affairs of the living who in turn seek that increase, that wealth of progeny through whose devotions they too shall acquire eternal life. Worshipped and nourished by the spirits of the living, the dead will return among them: the newborn child bearing all the characteristics of the ancestor will certainly appear and to him will be given such a name as spells an endless cycle – Babatunde ('Papa comes again') etc. The forms of the ancestor piece are therefore those of a union of the eternal with the transient and the particular.

In this way we understand hieratic expression pervaded with the realism of the apparently particular – the forms of the sacred in union with the forms of the secular. We are not disturbed in the Jebba-Tada bronze by the realistic minutiae, the elaborately rendered surcoats, the brass bells, the tassels, the armour, which to the Western eye seem to penetrate the other-wordly serenity of the figuration; they are all in a sense forms of the other world, the forms of the 'eternal present' in which the shell of the present is continually fused with the reality of the eternal. And such a concept of form distinguishes these pieces in the African bronze; a concept which surely is a unique interpretation of the classical impulse. At Benin this union of sacred and secular forms will be transformed in the realm of the symbolic; nowhere else do we encounter this synthesis of sacred and

secular elements; it is the peculiar contribution of the Jebba-Tada vision to the African bronze.

Assuming a starting point of 1590 for the incorporation on these bronzes of the European-type crotal – evidence which we shall examine in detail in Chapter 25 – we have a situation in which a mature bronze art is being practised by the makers of this Jebba-Tada group at a time when the Bini craftsman is still struggling for the terms of his bronze canon. On the Jebba *Warrior* the crotal appears in an already advanced form, i.e. with a three-part division of the sounding chamber, while on the large Tada figure is incorporated European wire associated with a mid seventeenth century date. On the former the crotals are cast of a piece with the figure while on them both special eyes have been cast to receive the chain-links of wire, so that in neither case should we regard these items as later additions; on the head-dress of the Jebba *Warrior* is a tangle of European wire with here and there slivers of sheet brass presumably from the same source and incorporating a type of chain-link known in Egyptian workshops of the fifth and sixth centuries, figs 1, 161, 176. On the evidence the earliest date that can

176. Egyptian chain-link (after Petrie)

reasonably be attributed to these two bronzes must be some time well into the seventeenth century, and later rather than earlier. Slight iconographic evidence suggests too that the large Tada figure was cast later than its companion piece the Jebba *Warrior*, but since with the female *Nude* these pieces all seem to have been made by the same hand or in the same workshop, the time-gap would not be significant. Attributions of these bronzes to the fifteenth or sixteenth century on the basis of the Tsoëde tradition are no more reliable than the early dates which, on similar evidence, continue to be ascribed to the Ifẹ̀ bronze.

Where these Jebba-Tada pieces have uniformly been left out of account in the historical treatment of the African bronze we have tried to bring them into the general framework. If their idiom and facture are at present to be explained only with reference to other schools of casting this is at least no more than is claimed for them by their present owners. Local tradition that they came from Idah on the Niger confluence may well be based on fact, in which case we would need to think of uncomfortably later dates than are

usually accepted for the Tsoëde migration. We would need to think too of workshops far beyond Idah. In discussing a bronze head found on a Bini shrine – virtually identical with that illustrated at fig. 200, William Fagg notes that the related cult might have had original connections with the north-east and even beyond. There is the Bini conquest of Idah (where also occurs the bead cap and brow-marking in bronze masks), and there is Jukun domination of Idah to explain such a connection. That Jukun workshops might have been responsible for the group of elephant and ostriches seems indicated in their technical and idiomatic similarities to the known Jukun piece at figs 78 and 79, which being of a seventeenth-century date or later might roughly date these others. As to the authorship of the warriors and their companion piece the female *Nude* from Jebba, all very likely from the same workshop, these also are seventeenth-century pieces of a provenance north of the Niger. Iconographic motifs shared with the Bini bronze seem to indicate some kind of relationship other than one of conquest and sub-jugation, and this recalls the tradition of Bini kingship sanctions held by a distant sovereign. Whether this group is to be associated in authorship with the group of elephant and ostriches cannot so far be established with any certainty, but on purely technical grounds the likelihood seems strong.

The third group raises questions of the most farreaching implications of all, for in them seems to lie the whole question of the history of Ifè and of the Ifè bronze. It would be as difficult to deny that two of these three pieces are from the same workshop as it would be to deny that the third piece, the famous *Seated Figure*, is of the school which produced the Ifè bronze corpus. It by no means strains the implications of the evidence to regard these two small figures as of an Ifè craft, rude as they may seem in a relative sense. But if we remember that we are dealing here with the classical impulse, with an impulse towards the harmony of pure number, the range of effort realised between these pieces and their possible flowering in the *Lafogido* bust or the *Òbàlùfon* mask does not seem too great for aesthetic credibility: the distance travelled for instance by Cézanne between the turgid romanti-cism of his early years and the high classicism of his later would seem much greater. These comparisons between the two small Tada bronzes – as between themselves on the one hand and between the pair and the Ifè corpus on the other – are subjective, idiom-based: they are 'hunches'; the comparison needs to be based on more objective evidence.

Such objective evidence as is available at present is provocative in the extreme, and far from conclusive. It rests in the demonstrably similar techniques employed by the craftsmen of *all* these Jebba-Tada bronzes with those at Ifè, as we have seen in our study of the relative core-stuffs, their approach to the iron armature, their similarity in the unification of mould and core as a solution to keeping the two in stable relationship attested in the cranial cavities of the Ifè heads, the body cavities of the Ifè royal couple and those of all the Jebba-Tada pieces. The evidence is provo-cative because in the Nigerian bronze these similarities are particular to the Jebba-Tada group, to Ifè and to Ọbọ Aiyégúnlè. Obviously we cannot on

this ground alone claim a common parenthood for all these schools – for Ọbọ Aiyégúnlẹ̀ at any rate the relationship would seem merely collateral. But what are we to think of the others? Of the two small Tada bronzes which we define as of an Ifẹ̀ aesthetic one carries the staff with a disc which links it to the Ogane of tradition. The Ifẹ̀ heads bear a striated facial marking today worn by natives in northeastern Nigeria, at Maiduguri. Should the Bini connection with the second group of Tada bronzes (those bearing insignia known at Benin), lead to the location of the Ogane among the Jukun we would have a situation in which we should need also to associate these two small Tada bronzes with a Jukun industry, if only in virtue of their common method of facture. As for the relationship of the Ifẹ̀ bronze to that of the Jukun, the missing link would then prove to be the connection of these two small bronzes with the Ifẹ̀ *Seated Figure* – a connection which purely subjectively one feels to be strong indeed, and which may in the future be established on unassailable physical grounds. It seems at any rate that if Ifẹ̀ fathered the Bini bronze, it was itself the child of some remote and knowing father.

21 The Yoruba Sacred Bronze

What of the genesis of form at the hands of the Yoruba masters of the sacred bronze? Our study once more comes to embrace that union of craft with the utterances of the god in which most absolutely the act of art is negated. If in the forms of Bini art we legitimately seek the processes of intellect, of the secular attitude rooted in a response to visual perception, or see in the bas-reliefs of the Ìjèbú craftsman perceptual problems proposed to which time will allow no answer, the sacred Yoruba bronze is the negation of all such processes and attitudes. Here is a metaphysical interpretation of form unique in African art, the forms of will-less mediation, of abnegation, in which through human agency the god itself secures its manifestation. Where in the iconography of Christian art the euhemerist tradition might explain the birth of the god in the life of a mortal of more than human attributes, the gods of the Yoruba are to be understood more as the groping of mortals for the godly essence. If 'animist' belief explains the workings of spirit in universal matter, *that which works* would need to be differentiated within the total of natural phenomena. The Yoruba pantheon emerges as the conceptual referent of all cosmic experience. Each *òrìṣà* or god becomes the concretisation of a complex of attitudes through whose total agency man may reach out to man and confront an often inimical universe, in response to the manifestations of an ever changing reality.

First among these apprehensions of the world is that of man in his imponderable relation to the life of the earth – the mother from whom all issue and to whom all return. The concept of the ownership of the land central to Ogboni belief might have spread from some aboriginal locality by means of colonisation or otherwise, but it is now mobile and not vested in a particular people and is found throughout Yorubaland in the worship of the Earth-Principle, Ilè. Whether the beginnings of this aboriginal earth-cult can be correlated with an art idiom which survived the introduction of the typical art of *òrìṣà* worship, and developed in a parallel though distinct line from *òrìṣà* art, will perhaps never be established, but idiom in Ogboni art surely refers to very ancient beginnings. Except for certain metal forms in *òrìṣà* art which it demonstrably influenced, Ogboni art in its iconic orientation, as well as in its forms, is not easy to reconcile with the Yoruba plastic as exemplified in traditional wood carving, either sacred or secular.

Form in this art cannot be appraised without a glance, however cursory, at some religious aspects of the cult organisation.[1] The society is headed by a chief priest (the Olúwo) whose office, like that of the speaker (the Apèèna)

is hereditary, being vested in the lineage of the man who first introduced the cult in a given area. In both offices succession falls to the eldest son of the senior wife, though this person holds the power to nominate in his stead his next younger brother, or even the son of another of his father's wives whom he might consider a more suitable candidate than himself. Election of the new Apèèna, or new Olúwo on the death of the old is carried out by all eligible members of the lineage. So that though the cult of the ownership of the land is mobile, or at some stage became so, tutelary rights within each organisation are hereditary.

The personification of the Earth-Principle in the cult is Onílè – the Owner of the Earth, at once Earth itself and Infinite Mother. Beier cites an Ogboni myth in which we sense something of the awe attending on her propitiation. Earth and Heaven once hunted together. They killed only a small rat over which they began to fight. As a result Earth refused to bring forth any more crops, and there was famine. Then all the *òrìsà* went to Heaven and persuaded him to submit.[2] Onílè is symbolised in the cult by the left. The Ogboni sacred sign is of the left fist clenched over the right with thumbs concealed. Members always dance to the left in the Ogboni temple;[3] a bead bracelet on the left wrist is part of the cult insignia. On the death of a member marks are made on the left wrist in the ritual recall to the Ogboni of powers imparted to that member during his life. Many other African peoples distinguish between the left and the right sides of the body, the right being symbol and seat of strength and virility, the left of weakness and femininity.[4] We may perhaps read into this among the Yoruba the primacy of the spiritual and ineffable over the concrete and the material, expressed in its central symbol of the left clenched fist planted over the right.

Anthropomorphic renderings today claimed to be Onílè are not many and not easy to authenticate, but as they do not in any way significantly depart from idiom in Ogboni imagery they need not be considered separately. A large bronze claimed by the Olúwo in an Ibadan cult house to be Onílè and worshipped there as such, fig. 167, is identical with one in the Nigeria Museum identified by Morton-Williams as Ajàgbó,[5] a terrible spirit standing in close relationship to the Earth Goddess, whose image is used by the Ogboni to detect a member who has revealed a secret or otherwise acted treacherously. Ajàgbó-Ekun is similarly claimed in an Iwo account to have been a terrible Alàáfin of Oyo, a warrior, later apotheosised as a vengeful spirit whose image is used in Ogboni punishment. In the temple the great *agba* drums summon all members. The offender is declared, executed, and his blood poured over the image of Ajàgbó. The image is usually rendered with eyes fore and aft and of terrible countenance; the piece at fig. 177 might therefore seem more suitably to be of Ajàgbó than of Onílè. Only half a dozen or so of these remarkable bronzes are known of which three are now in the Nigeria Museum, Lagos, while three remain in ritual use. A fine example in a private collection is plausibly claimed to have been made before the destruction of the town of Owu in or about 1835. But in many shrines Onílè is merely a concept symbolised in a certain object rather

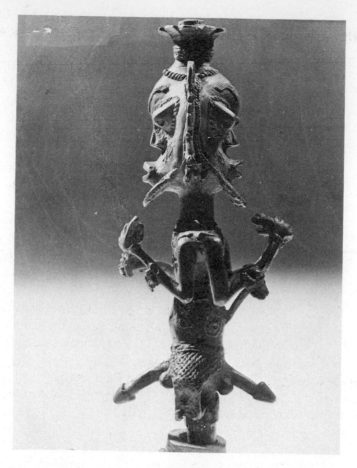

177. Yoruba, Ogboni bronze
of Ajàgbó (?)

than an anthropomorphic rendering, and it is possible that like the High
God in Yoruba cosmology Onílè is never anthropomorphised but regarded
simply as a focus in the temple in which the spirit of the Earth-Principle is
localised.

In the sanctification of the shrine, Ilè, the Earth-Principle itself, is buried
in the floor of the shrine and the Onílè, which could be any object at all,
is placed on it as a focus marking its existence: it may be a pebble, a cowrie
shell, a figurative bronze-casting. The pattern is constant through many
Yoruba cults and has led European observers from the earliest contacts
erroneously to believe that worship is attached to such objects in themselves.
In the ritual sanctification of the shrine sacrifices are made of the tortoise,
cockerel, sheep, pig, snail, pigeon and duck. Ilè is then localised in the shrine
by burying the heads of these sacrifices in the earth floor. Associated
with this burial are certain natural substances symbolising the four elements
of the Ogboni system: Olórun (the Sky God), Ilè (the Earth-Principle),
blood (judgment), and human being, represented respectively by powdered
chalk, pure black mud from the river, powdered camwood, and powdered
charcoal collected from the fires in which food has been cooked for mem-

bers during the ritual. These substances are gathered into four calabashes previously used in the ritual and buried in circumferential relationship to the sacrifice. The site is then an Ilè, the sacred centre of the shrine and marks the spot in which the initiate may confront the spirit of Earth,[6] fig. 178.

4

178. Location of Ilè in the Ilédì. (1) Olórun, the sky god; (2) Ilè, the earth-principle; (3) blood (judgment); (4) human being, and (5) heads of various sacrifices

1 5 2

3

Important in Ogboni imagery is the image of the spirit Eluku-Oro, the spirit that rises from the earth. According to an Iwo account, it is the genius of the earth embodying the principle of justice and used to enforce secrecy among members. To the layman the dominant feature of the Ogboni is this forbidding secrecy which imparts that hieratic and inscrutable character observable not only in the personality of its members but also in all its sacred bronzes. This spirit is figured in a bigeminate form which seems to represent a stage in the morphology of Ogboni imagery whose starting point took place in the mid seventeenth century. But the day-to-day operation of the cult revolves round the use of the pair of *edan*, the pair of figura-

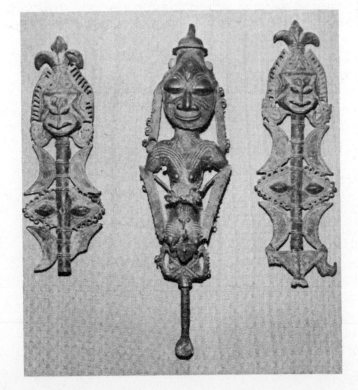

179. Yoruba, bronze, the Ogboni pair with *edan* Ògún (centre)

tive brass staffs which each member has cast on initiation and which remains in his possession for the remainder of his life, fig. 179. Symbolising the union of Heaven and Earth on which all human existence is based, this pair of figurines, male and female connected at their heads by a chain, is usually no more than 30 cm or so high, and often much smaller. Each of these might bear one or more of the type-motifs of the cult, for example the characteristic sacred sign of left fist clenched over the right, the executioner's club (*òrúkùmọ̀*), the anthropomorphic staff of office, also known as an *ẹdan*, a ceremonial fan usually cast in brass, a dish, a wooden ladle used in initiation rites, etc.

In spite of the asceticism and solemnity of Ogboni imagery there is frequently also an erotic symbolism generally absent in other forms of Yoruba art. Renderings of Ajàgbó (the bifacial image cast in a single piece back to back) are aggressively ithyphallic, fig. 177, while the large female figure usually identified as Onílẹ̀ is correspondingly ithyclitoric, fig. 167. Most consistently in the *ẹdan* pair, male and female genitalia are exaggeratedly stressed. In examples where the *ẹdan* is no more than a head on a spike identifying genital members are nevertheless appended to the staff; in other cases the body is conceived as the mere carrier of genital detail. A pair in the photographic records of the Nigeria Museum, Lagos represents the human generative act. One regional style still practised in the small Yoruba village of Ìlobú figures the female *ẹdan* with full breasts suckling an infant and surrounded by several smaller figures, fig. 180. This preoccupation with the sexual theme in an overwhelmingly impersonal and spiritual art would seem to stress the fecundity of Earth in rituals propitiating her fertility, the human generative act expressing the higher union of Earth and Heaven of which Human Being is the dependent issue. Sexual taboos do however operate in the use of the *ẹdan*; a husband may not bring it into contact with a menstruating wife or with a barren woman.

This spiritual identification of imagery in Ogboni sacred form may now be illuminated by the study of the Ogboni artist in his relation with the Earth Spirit, Ilẹ̀, and of the functioning of creative subjectivity in the genesis of artistic form, sacred or secular. Only a man past fathering children may become an Ogboni smith (*akẹdanwáiyé*), since spells invoked during the manufacture of the image might impair the potency of a younger man: the continual invocation of the *òrìṣà* attendant on casting the *ẹdan* is held to have a cumulative effect for better or for worse on human personality. A man grows to have superior powers; people tend to fear him. Young men avoid the occupation since the continued concourse with the *òrìṣà* if not resulting in actual impotence is at least associated with the loss of children. This tradition explains the Ogboni organisation as an old man's institution and has a direct bearing on Ogboni art and imagery. The young smith is precluded from casting the image, which must above all retain its character as icon. The title *akẹdanwáiyé* in fact suggests a chosen one: 'he who brings the *ẹdan* to earth'. There is a spiritual connotation. There is the implication

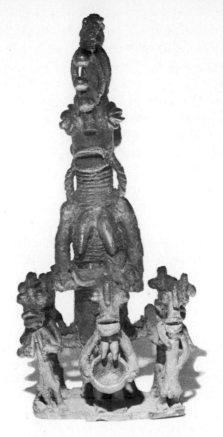

180. Yoruba, bronze, *ẹdan*
Ogboni

too of the revelations of insight which in the Western world are subsumed in the definition of the artist: in this sense we may perhaps regard the word *muse* and the word *òrìṣà* as interchangeable. The muse in Western art does in many respects exact from her chosen ones an impotence in the material world which young men might do well to fear. The *akẹ́danwáiyé* exercises a spiritual authority in his power to demand sacrifices and to propitiate Earth in the process of sanctifying the *ẹdan* for use by the initiate. But it is above all in his character of spiritual tutamen of the *ẹdan* image that he must be an elder. A man still in the process of fulfilment of manhood might be fired to extemporise with form in the sacred image, and this could not be tolerated. So we have the picture of the *akẹ́danwáiyé* as a man past his time of propagation, thoroughly familiar with symbol and ritual in the Ogboni system, certain of what is required in Ogboni imagery and rigidly circumscribed by these requirements. He is in no position to take liberties with symbol and meaning in *ẹdan* iconography though his personal instinct for form, proportion and finish would be certain to distinguish his work.

It must be acknowledged that every *akẹ́danwáiyé* does not naturally possess these virtues and that some were traditionally very poor artists; but in the finest examples of the tradition the most elaborate resources of craft have been employed to do honour to the *ẹdan* as the manifestation of

an eternal principle, i.e. as icon. Though succession in the craft tends to be from father to son this is not necessarily always the case. The Apèèna is the final arbiter in the matter of the selection of an Ogboni smith. In this connection the individual smith acquires a reputation in much the same way as does a European painter or sculptor. But it is to the Apèèna to certify the *ẹdan*; in his hands finally lies control over the rectitude of the image and this, after the casting, he might reject for any of a number of reasons, the most obvious being an incorrect rendering of cult insignia or failure on the part of the smith to 'name' a specific attribute of the spirit to a specific end, or simply on technical grounds as being not up to standard.

Apart from this external circumscription in the exercise of his craft represented by the judgment of the Apèèna the smith also faces subjective limitations which he can exteriorise only in his relationship with the Earth-Principle itself. His creativeness therefore at no time involves that deliberate act in the face of nature, that self-determination and exclusiveness of vision which we know to characterise European art and which we have examined in the Bini artist's response to his visual perceptions. In the initial stages of the making of the *ẹdan*, when the image has just been modelled in clay, he holds vigil the first three days and nights during which the clay model is kept by the fire to dry. On it he makes libations of snails' fluid, palm-oil, guinea-corn wine, and the blood of the pigeon, acknowledging by these means the importance of the image in the clay state in its association with Earth. At the stage in which it is invested with its wax coating further sacrifices are made of the pigeon, the tortoise, and the snail, all of which may appear in the imagery of the *ẹdan* and which too are elements in the sacrifices used in the sanctification of the shrine. During the process of the modelling of the wax image intense invocations are made in the names of the *òrìṣà* and at intervals white and red kola nuts are cast by the *akẹ̀danwáiyé* to ascertain *from the image*, through the agency of the Ifá oracle, whether the process is going well. These invocations are offered in the morning, at noon, and in the evening. So that at a very early stage in the process of manufacture the *ẹdan* comes to take on a function distinct from its function as the materialisation of an essence in its primary association with Earth. The image by virtue of this primary association is already sacred in its own right and implies no visual referent. It is capable of response. Anyone who has painted a picture or modelled a piece of sculpture will have experienced this moment when the artist experiences a connection with the inner sources of his work, when the art object itself seems to become not only capable of response but also unerringly dictates each further step in its own facture. In this moment matter passes over into spirit, apprehension yields to certainty, and the subjective conceit acquires physical investment and a voice. Thus in this second function the *ẹdan* image is defined as the vehicle of the spirit, a localisation capable of response standing in a particular and unique relationship to the suppliant.

The relationship exemplified in this second function will be of principal

importance to the initiate once he is a member of the Ogboni. So at its inception we see the image produced in accordance with observances referring to these two principal functions. Its idiom, like the Christian cross, must in the first place convey the iconic theme by which it is to be recognisable from every other plastic rendering; but unlike the Christian cross this idiom is not symbolic, it is actual, referring to nothing outside itself. And here as in so much of the critical terminology necessarily employed in the discussion of African art the usual concept of an image must needs be altered to fit the instance; for the Ogboni image, in referring to nothing particular, is no image at all. It is in this sense of an image which images nothing, but is the vessel or materialisation of an archetypal theme, that we regard the Obgoni bronze as an icon. Secondly, this 'image' must be so handled in the process of its manufacture that after the initial propitiation of Earth and the invocation of the *òrìṣà* it becomes a vehicle capable of controlling the outcome of the process of its own production. This dual function of the *ẹdan* can perhaps be correlated with the working of the Ogboni system itself, principally exclusive and earth-orientated in its judicial aspects, and inclusive of the *òrìṣà* system, which controls natural phenomena, in its religions.

No further address to the god marks the structuring of the mould which, formed and fired, is wrapped in a clean white cloth and placed in a safe place to cool. This is the evening of the sixth day. On the morning of the seventh, towards midday when shadows are shortest, the mould is broken open and the cast revealed. This is carefully done, precaution being taken that no force is used – signifying perhaps the minimal role of human agency in this sculptural epiphany. The cast is washed and rubbed clean with white cloth, the initiate providing bean bread to be crushed over it. Kola is again thrown by the *akẹ́danwáiyé* to ascertain from the *ẹdan* through the Ifá oracle whether it is agreeable to being taken home. If the answer is favourable a sacrifice is made in which the blood of a sheep and a duck is poured over the image along with guinea peppers, a few of which will be chewed by the *akẹ́danwáiyé* while 'speaking' through the kola to the *ẹdan*. At sunset (since *ẹdan* are always kept in the darkness and may not be placed in the sun even for photographing) the *ẹdan* is taken, along with its clay mould, to the shrine. Here it is washed by the Apèèna, who 'certifies' it. The Olúwo then declares it suitable to be taken into the possession of the initiate who will bury the clay mould in his chosen spot in the earthfloor of his house (again symbolising the union with Earth) and here the *ẹdan* will remain for the rest of his life, to be removed from time to time only for ritual. Since throughout its useful days the *ẹdan* is periodically washed with lime juice and herbs to counter oxidation and to remove sacrificial blood, a genuine patina is rare even in examples of authentic age.

Manufactured by exactly controlled processes and subsequently certified in sacred law, the *ẹdan* plays the vital role in the initiation ritual of purifying the initiate in the name of Earth. It is thereafter his personal link with the Earth-Principle and a vehicle for localising this Earth-Principle in his

life. His vital force is identified with it and it is therefore not transferable. The *ẹdan* also plays an important role in his mortuary rites. On the occasion of his death his body is handed over to the Ogboni who preside over his return to Earth. Relatives provide various animal sacrifices whose blood and material essences are poured into the body of the corpse. Marks made round its left wrist signify the removal from the body of spirit imparted to it during life: the symbolic recall of powers conferred by the Ogboni. The *ẹdan* image concretises the 'pure' or eternal self of the member in his relationship with the Earth-Principle, and acts as a vessel of the Earth-Principle, with whom throughout his life he stands in personal relationship, and who at his last rites presides over the transference of his immortal essences back to the Ogboni who control her sanctions. By virtue of its being the vessel through which the Earth-Principle separates itself from itself whilst remaining one and indivisible, the *ẹdan* pair is an icon. Though necessarily identified with the life-course of a given initiate, it yet exists primarily with reference to the Earth-spirit, Ilẹ̀. Not surprisingly, therefore, the *ẹdan* is employed – struck secretly into his doorstep – as the dreaded summons by means of which the Ogboni call a defaulter to justice.

Throughout his life the image binds the cult-member, from the moment of his initiation to the transmission of his vital essences back to the Ogboni after death. It is a function of his daily being and a support. The ritual purity which he continually seeks in his relationship with Earth is objectivised in the *ẹdan* image which as a result is non-temporal, hieratic, and absolute in idiom. In a formal sense the regard, the eye, in *ẹdan* imagery is of importance. With its dominant placing and the consequent frontality of the image this 'drawing in wax', as we might call it, manifests above all the relationship of the Earth-Principle with the initiate.

Ogboni art is in this sense supremely a minature art – an art of dialogue. There is no sense in which the *ẹdan* functions apart from the person of the member. Whether in the recesses of the shrine or in the home of the cult member, it has no public reference and certainly no purely decorative or purely aesthetic intention. Ogboni art therefore possesses nothing of the architectonic relationship of masses so characteristic of Yoruba wood-carving and of the African plastic in general. Examples of the idiom occur also in emblematic form on ritual objects and shrine furniture. In all these renderings the iconographic theme remains constant and identifies the Ogboni icon within the corpus of Yoruba art. Within the *genre* many variations of idiom occur. It is by the isolation and analysis of these that a morphology may come to be attempted for the corpus as a whole.

Isolation and identification by groups on the basis of idiom is today the best that can be hoped for in classifying an object of study which is not homogeneous and pinned to a single region as is the case with the Ifẹ̀ or the Benin corpora, but which exists in thousands of examples scattered throughout Yorubaland and is subject to a variety of style adaptations, sometimes in forms that may be contemporaneous with inquiry. Internal

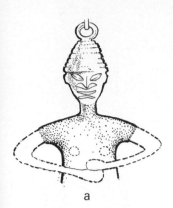

a

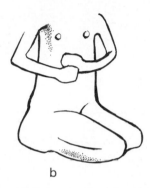

b

181. Construction of the *ẹdan* Ogboni

(*a*) In order to achieve the obligatory clenching of left fist over right which constitutes the sacred sign, the upper limbs need to be spread laterally. As these limbs would be weak in the wax state and likely to collapse under the pressure of the mould, the difficulty is met by extending the shoulders in a winglike mass of a piece with the body on the core form. Arms modelled in wax (dotted line) would then be appended to this wing-like process and be anchored onto the torso by the clenched fists

(*b*) In the squatting posture a solution to the same problem is achieved for the lower limbs by structuring the whole into a pyramidal mass of a piece with the torso

style evidence cuts across geographical regions and embraces seemingly unlikely periods of time, for in style backwaters elements of a given idiom become frozen and continue to be mechanically produced long after the original impulse has died or been transformed. Examples of an idiom associated for instance with the seventeenth or eighteenth century could still be newly cast in the twentieth century, while the idiom itself has yielded to innovation or abridgement.

Oral tradition recalls that *ẹdan* were first whittled from palm branches until 'Ajibówú the first Yoruba smith' came with his knowledge of metals and transferred the *genre* into brass. In certain areas of Yorubaland the autochthones claim that they were conquered by a metal-using people. The earliest rendering of what appears to be a pair of *ẹdan* occurs on a terracotta pot from Ifẹ̀ in the form of a ring on a shaft – a shape not unlike the Egyptian *anhk* symbol but without the bar. *Ẹdan* in this form still in use today carry the face in the circumferential thickness of the ring and are of course cast in brass. In presumably later versions the face takes on autonomy, though still remaining a part of the shaft which, without any attempt at representing the remainder of the body, ends in the customary iron spike. In such renderings distinction between male and female is effected by the addition of the appropriate genitalia at the juncture of head and shaft. At what stage the representation of the complete human figure came to supplant the staff will probably never be known but whenever this occurred *ẹdan* imagery would already have been established as the pole-like structure which it has remained to the present.

Across the variety of styles in *ẹdan* imagery both in space and in time it is possible to draw a line of demarcation between spiked and free-standing forms, the spiked conforming to the requirements of the pole-form, while the free-standing achieves something of the characteristics of three-dimensional sculpture. Technical difficulties faced in treating the clay core led at some stage to an innovation whereby, for the upper limbs, the shoulder and arms became integrated into a continuous mass, while the sitting posture of the lower limbs was abridged to a squat, so that the upper and lower members were fused into a pyramidal mass, fig. 181. This superseding of the pole-form by the squatting posture appears to have taken place in the workshops of Ijẹ̀bú craftsmen; examples are illustrated at figs 182, 183, conceivably, by the same hand or from the same workshop, in which the former is spiked and the latter free-standing. One result of this free-standing revolution was that the *ẹdan*, now conceived on its own pedestal, more truly approached sculpture in its three-dimensional implications rather than remaining the seeming high-relief in space which the pole-form had stimulated. Gone was the need, in use, for the cumbersome shaft and the necessity for finding a place on ground-level for spiking it. Gone too was the need for fashioning together two such aesthetically incompatible metals as brass and iron. The *ẹdan* became formally and aesthetically autonomous. But more than this, it was now free to become larger.

Traditionally the size of the spiked image was limited; beyond certain

182. Spiked *ẹdan* Ogboni

183. Free-standing *ẹdan* Ogboni

proportions it would become top-heavy in a manner a free-standing piece could not. As to the use of brass and iron in a single composition attempts were sometimes made to counter the effects of this unaesthetic combination by sheathing the iron staff in brass. In this solution the wax investment would be laid over the entire iron rod, carrying the required details of cult insignia – pigeon, tortoise, etc. The blank end resulting from the removal of the spike was then given interest, and the staff artistic and physical balance, by the placing of a subsidiary head at the end of the rod opposite the main head. This was possibly the earliest rendering of the bigeminate pair. But the solution does not appear to have been satisfactory; very few examples of the type exist. The aesthetic gain was offset by the loss of both spike and pedestal; connected by its chain the pair in use had to be laid flat on the ground.

The solution to the problem of anchoring the spiked staff and the revolution which it ushered in could not have been easy of achievement when one considers the orthodoxy of the average Apèèna. We may explain the emergence of an entirely different form in *ẹdan* imagery as the corollary to a possible reinterpretation of sacred attitudes; we may read into it a laxity following on the weakening of spiritual authority as one effect of the slave trade. A certain weakening of spiritual integrity is in fact noticeable in the *ẹdan* image as increasing technical virtuosity produces idiomatic variations on the iconic theme. The skill of the craftsman seems to be outstripping tradition as the possibilities of brass-casting are exploited to the full. Style moves into a baroque lavishness as the artist comes to dominate his medium. For want of purely formal development the image develops materially; it multiplies itself upwards in another version of the bigeminate pair, male

and female perched on each other with churrigueresque daring and exuberance; a number of crotals appear; the image proliferates like lights in a bubble: one *ędan* bears in its lap another, smaller, version of itself, which bears in turn a smaller in its lap, and this bears another in its lap, etc. – a sort of sculptural relay race in whose conscious wit we infer the established and stable tradition that in literature gives rise to irony and satire. But plastic rewards had already been reaped, for so long as the *ędan* had continued an extension and development of the staff proper – a pole-form – purely plastic values had remained secondary. Whereas the classical *ędan* was limited to being a projection of drawing into wax, the smith now came to produce sculpture many characteristics of which are indistinguishable from woodcarving technique. In the excessively protruding eyes of fig. 167, its heavily overhanging nose, in the unit construction of torso and limbs (which seem as though carved from a cylindrical block), it recalls processes more properly associated with wood-carving and is in this respect perhaps oblique testimony to the contemporary wood-carving imagery of the period. This freedom to achieve hitherto inconceivable dimensions carried *ędan* imagery along a line of development which culminated in the casting of the largest bronzes of the *genre* in a style associated with a date before 1835 and certainly after *c.* 1640, a date indicated by the appearance in this group of the smoking-pipe.[7]

Though we know brass to have been widely used among the Ijèbú as early as 1506 we have no evidence of a figurative casting there for the period. Despite the obligatory use of brass in all Ogboni cult sculpture it is possible that this came to be the case only with the general availability of the alloy from Portuguese sources after the fifteenth century. We have already noted that no evidence is yet to hand – art-historical or archaeological – which might unequivocally establish a figurative bronze-casting in the Guinea forest before the supplementation of the alloy during the fifteenth century from European sources. The elaborate ritual connected with the clay core in its relationship with Earth may indicate an early period in which the *ędan* was modelled in clay. This is admittedly only a speculation, but it is far from unlikely.

Traditions which speak of the whittling of *ędan* from palm branches do not explain the relationship of the artist with the Earth-Principle in the genesis of form. In the sculptor modelling a lump of clay, however, we see at once the stages by means of which he comes to exteriorise the processes of creative intuition: the propitiation of matter in which spirit is held to be in-dwelling, the forming of his image under the surveillance of the spirit, the autonomy of the image in its transmutation of matter into spirit (which so strongly recalls the Jewish myth of origins) and the final realisation of the image circumscribed on the one hand by the external judgment of the Apèèna – the super-ego which secures law – and on the other by the artist's internal relationship with nature which he sees not merely as formed and expressed in discrete objects as does the European, but as everywhere instinct with the vital force central to African ontological beliefs. In this

apprehension of vital force it is possible once again to compare and contrast the creative process as we observe it in the African and in the European artist. Man as the dependent issue of the union of Heaven with Earth is the natural subject of these bronzes. In the metaphysical interpretation of the human figure which they represent we are at the opposite extreme to the viewpoint of the historical European artist – which Cézanne so thoroughly questioned – in which the human figure is seen only as motif, as object or catalyst whereby the artist's personal vision, his inner apprehension of this vital force, his 'spirit of delight' may be released *to others*. In such a vision the painting, the statue, still-life or figure or object-drawing *represents* a moment, a contingency: represents the object as a pivot of consciousness, as a transitive entity which acts to its end in the awareness of the spectator. It is not meant to contain or embody or realise the force and presence of life itself; the susceptibility of the Other is the end of the existence of the art object.

For the European artist communion with the life force is realised in visual perception: art provides the means of transcending the actual. For the artist of the Yoruba sacred bronze the path towards transcendence is different. He has eyes but does not see. He does not transcend the actual, since to him the actual is inherently self-transcendent. There is no *object*; there is only life in-dwelling in an infinite multitude of forms around him, severally controlled by the pantheon of the *òrìṣà* who manipulate objective matter by virtue of its being possessed of spirit. Man as issue and expression of the union of Earth and Heaven is unavoidably a vehicle of spirit: it is this spirit which is a man, not his flesh and bone; for does not the body return to earth *empty* at death, bereft of spirit, of that vital force which the Ogboni control on behalf of Earth? How therefore could a man be seen or rendered as figure or object or motif in the perceptual sense of the European measuring eye? In concourse with the *òrìṣà* and under the surveillance of Earth, the Ogboni smith attempts *to make a man*, to realise in sacred form man's eternal essence. Ogboni art is therefore an epiphany, an immateriality made manifest, an instinct and pervading presence of eternal spirit to which the initiate addresses his real, his abiding self, with exactly the same sense of reality as he addresses his material brother.

It may seem amazing to a Westerner that a frightened youth should leap from a moving car on beholding in the rear seat a pair of these sacred figurines, yet Western art, too, attempts to convey the transcendent. The immanence of spirit which Le Douanier so bafflingly felt has in our time been realised by that very European sculptor Giacometti; and did not the Cubists feel such an immanence in the brazen manufactured objects of the modern world? The sensibilities of those minor masters of modern Italy – the artists of *Pittura Metafisica* – might perhaps some day lead us to a new understanding in the essentially 'manufactured' art of our time, and to suspend that disbelief which still denies divine speech to the Yoruba sacred bronze.

184. *Ẹdan* Ògún

By stages and processes not now easy to discern the Ogboni bronze bequeathed its forms to Ògún imagery, fig. 184. This god of iron came late to brass, for brass we know in Africa to be an Iron Age phenomenon – to have been apprehended within a pre-existing *òrìṣà* system in which the smith labours under the aegis of the immemorial *òrìṣà* of war. That cluster of cults, which symbolises man in his complex of relationships with the forest as source of victual, of healing, of the productive processes of earth come to be named in the god of iron. And if the apotheosis of Ògún could reasonably be understood in the sating of an ancient iron hunger in the mid sixteenth century we need not look beyond this date for the birth of those forms in brass now sacred to his worship. In the springtime of his cult there is no brass, no brass ceremonial, no ritual staff. But that at some date the *ẹdan* came to be associated with his worship suggests the pivot of a morphology in which forms in brass are added to forms in iron. And to acknowledge the dangers inherent in equating a time-sequence with a form-sequence is not in this instance to deny ourselves a degree of chronological interpretation, for in this form-series a time-direction is implied.

The most primary of type-motifs connected with the cult of Ògún is the pair of symbolic iron spearheads still to be found in many an Ògún shrine, fig. 35. This pair connected by an iron chain is stuck *ẹdan*-wise in the earth-

floor during ritual; it is in fact, like all similar figurations for the cult, called an *ẹdan* Ògún and functions in much the same manner as the *ẹdan* Ogboni, fig. 185a. A similar motif combining an arrow and a spearhead appears at (*b*) while (*c*) represents a partially anthropomorphised version, a development of which at (*d*) is not cast in brass but worked in the sheet with repoussé designs. The emblem of a war-chief at (*e*) achieves full anthropomorphism, and at (*f*) occurs the *ẹdan* Ògún in a form indistinguishable from its prototype – the *ẹdan* Ogboni.

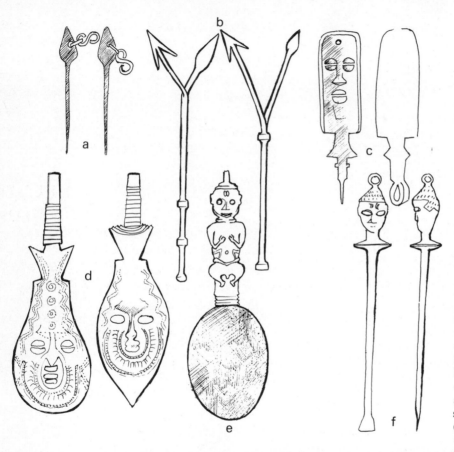

185. Type-motifs in the evolution of the *ẹdan* Ògún. (*a*) Pair of symbolic iron spearheads used in Ògún ritual, for instance stuck into the earth on either side of the head of a dead warrior (from a shrine in Ikoyi, Western Nigeria, ht 23.5 cm); (*b*) Ògún staff with arrow and spear, iron, (ht 70 cm and 67 cm respectively). Possibly from a prototype in which actual arrow- and spear-heads were lashed together on a wooden shaft as suggested by binding rings. (University of Ifẹ̀ Museum); (*c*) Pair of blades used as an Ògún amulet, the anthropomorphic one of brass, the other of iron (13 cm. collection of the author); a similar example in brass is in the British Museum; (*d*) Pair of brass blades with repoussé designs used as Ògún amulets (ht 14 cm; University of Ifẹ̀ Museum); (*e*) Iron blade with brass handle used as an emblem for a war-chief (*balogun*) (ht 20.5 cm; University of Ifẹ̀ Museum); (*f*) Pair of brass *ẹdan* Ògún with iron shafts one of which ends in a blade (ht 22 cm; University of Ifẹ̀ Museum). This example forms part of the Ògún amulet of fig. 39

In the mature brass imagery of the Ògún cult form flowers in that metaphysical interpretation of the human figure already familiar in Ogboni worship. Here is a similar abnegation of matter, a similar indifference to the natural divisions and proportions of the human figure, a similar lack of concern with the idealizing of the human form, a similar frontality and emphasis on the head, and above all that immateriality and spirituality which dominantly characterise the Ogboni sacred image. Such an imagery is adopted too in the rare cult bronzes of Ọ̀bàlùfọ̀n, fig. 168, in which notions of the connection of style influences operating between cults seem admirably borne out, though idiomatic adaptation is in every case qualified by the use of type-motifs characteristic of the particular cult – the everted fist for

Ọ̀bàlùfọ̀n, the bow and arrow, etc., for Ògún. In the adaptation of Ògún imagery from that of the Ogboni we infer a time-direction in which anthropomorphism follows upon non-anthropomorphism, the latter associated with that period in which brass has come into general use among the Yoruba and a mature Ogboni imagery developed – a period which cannot reasonably be placed earlier than the sixteenth century, connected as it is with the apotheosis of Ògún as god of iron. Such a 'date' establishes a starting-point for all brass imagery in the Ògún cult, and very possibly indicates a terminal date for those more elementary forms in iron in which the concept of the pair of spearheads connected by a chain and staked in the earth beside the head of a dead warrior recalls the pair of *ẹdan* Ogboni similarly attached to each other and planted in the earth floor of the shrine. It is possible that the examples at (*b*) and (*c*) represent succeeding forms in which the double image of arrow and spear on a single shaft names the double appellative of the *òrìṣà* – god of war, god of iron – which appears to have been adopted in this period. Since major styles in Ogboni brass imagery can be independently dated to periods following this, the evidence suggests that Ògún brass symbolism succeeded to earlier forms in iron connected with the appellative god of war.

The smiths of these cult bronzes to the Ogboni, to Ògún, to Ọ̀bàlùfọ̀n, are all of southern schools. Among them this remarkable imagery was developed, an imagery whose obscure authorship, as authorship perhaps of these cults themselves, might most plausibly be claimed for the Ijẹ̀bú Yoruba, the mentors of the Abéòkúta school. We must remember that in all the legion *òrìṣà* of the Yoruba each has his particular seat of origin, his individual locus of diffusion, and that these cults are by no means evenly distributed among the tribe. Where some flourish others remain unknown; some hoary with age in a given area may be newly arrived, or still yet in process of arriving, in another – a fact which should provide food for thought in those studies which seek to explain the forms of African art along tribal lines. The Ijẹ̀bú craftsman has drawn on long belief and tested tradition and forms born to his vision are today the lingua franca of several cults throughout Yorubaland in bronzes which for their divine genesis and facture are unique in African art, and perhaps in the art of man. Such forms as they bequeathed to other schools have suffered adaptation, sometimes of brilliance – as in the Abéòkúta workshops – more often of degradation. In the Ọbọ school the Ogboni theme, newly arrived, has been transmuted into poems of light unknown in the workshops of the south, where form is bent to purely sensuous ends. At Abéòkúta alone do we perceive sacred form as intense as that of the parent stock, a town which like Ibadan received settler-refugees from the seat of empire at Ọyọ after its fall around 1835. So that in the Abéòkúta heritage we discern strains of Ijẹ̀bú and of Ọyọ blood,[8] a fact which perhaps explains a certain nervous vigour and unease, a vehemence in the interpretation of sacred form, fig. 177, altogether lacking in the Ijẹ̀bú cult-bronze which in contrast is

resonant and serene and certain and never expressionistic, fig. 168. The Abéòkúta craftsman has inherited tradition at its peak; the autonomy he achieves is diluted here and there by the European presence in the work-shops of the nineteenth century. In his almost conscious avoidance of repetition, in his awareness of the potency of the mature tradition to which he is heir, he is over-bold, but his forms suffer no weakening as a result. This tradition remains active to the present where the Ijèbú achievement is remembered only in masterpieces that have now left the shrines for the store-rooms of our museums.

22 The Ìjèbú Smith and Bini Tradition

Style influences also operate in the secular field. From Benin comes a type of bronze stool of distinctive shape – two concave circular surfaces connected by a pair of coiled pythons serving as a pedestal. Wooden versions, said to have existed, perhaps represent an earlier form. These stools appear to have served a mortuary function in Bini kingship ritual. Whether they were royal stools or not we cannot say, but the royal stool on which the Ọba granted an interview to a Lieutenant King some time between 1815 and 1821 was made of copper, about 18 inches high. The lieutenant tells us: 'Every king on his accession to the throne has a new stool which is placed on his tomb. The shape of the stool varies according to the taste of the monarch.' One of those which Lieutenant King saw on the tomb of a king was supported by copper serpents, of which the heads touched the ground, forming the feet – a description by a member of the 1897 expedition. The serpent is recorded as a Bini motif in the later years of the seventeenth century, occupying a commanding position in the architecture of the palace; as a design motif it appears in bronze and in ivory, and once more mystifyingly recalls a nilotic theme, figs 186a and 187. Another characteristic Bini motif occurring on this stool, the spreadeagled frog, appears at fig. 186b. Palmer records the

186 (*a*). The serpent as an important motif in Bini bronze iconography suggests possible nilotic connections

186 (*b*). The frog motif at Benin. It appears to have been conceived as a symbol of life or of power, for it also occurs clenched between the teeth of faces presumably representing Ọba; see figs 76 (*a*) (*d*) and 151 (*e*)

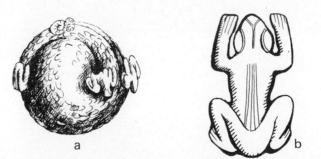

a b

frog as a symbol of life among the Blemmye, fig. 188a. At Meroë it occurs in bronze and appears to have been used in much the same way, fig. 188b. Some of these stools were lying around the palace grounds at the time of the sack of the city in 1897.[1]

A mortuary function does seem indicated in the design motifs at fig. 189 representing wreathed and horned human skulls; the horns in this context confirm their association with the divine king. We have already noted their

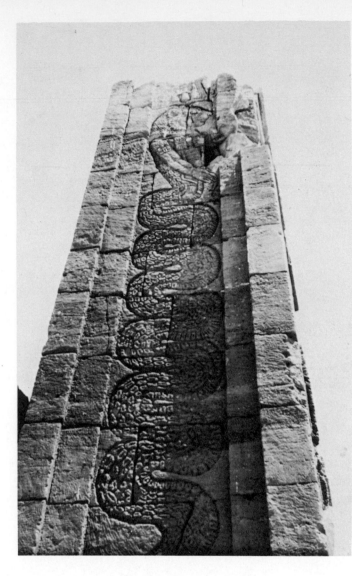

187. Meroë, serpent motif from the Lion temple at Naqa; this motif also occurs at the Meroitic site, Musawwarat-es-Sufra, and very widely in West African art

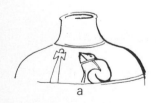

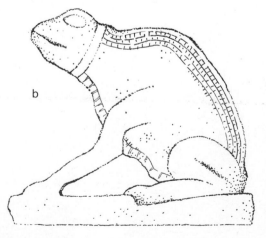

188 (a). The frog motif as a symbol of life on Blemmye pottery (after Palmer)

188 (b). The frog motif in Meroitic bronze. While it is easy to grasp the significance of this motif in the context of parched Nubian or Meroitic cultures, its occurrence in the rain forest of Guinea seems explainable only by diffusion (Wad Ban Naqa excavations, 1960)

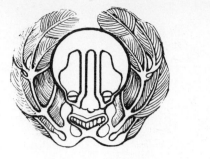
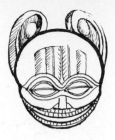

189. Wreathed and horned human skulls from a Bini mortuary bronze stool. The wreath suggests a style development from the theme of horns

occurrence on one of the Jebba-Tada group of bronzes, perhaps of Jukun authorship. The stool at fig. 190, 45 cm (18 in) high as described for the Bini type, appears to have been cast not at Benin but at Ijèbú. It was purchased from a family who made this claim and by whom it is said to have been held for 'several generations'. This seems not unlikely on the evidence of the type-motifs employed – the wreathed human skull and spread-eagled frog of Bini tradition translated into a non-Bini idiom with which are associated a human head and various zoomorphic motifs – shrimp or prawn, and waterbuck, the theme of the 'ram's head' as at Benin and Jebba-Tada, and the coiled python described by Lieutenant King in the early nineteenth century, figs 191–4. Immediately striking is the characteristic Ijèbú treatment of the human face – the distinguishing flared nostrils and

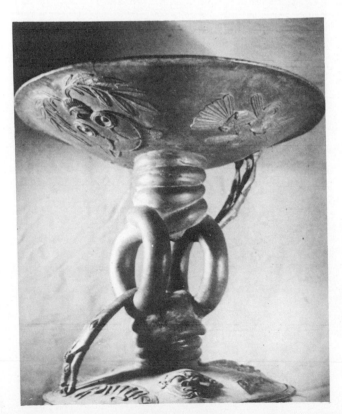

190. Yoruba, bronze mortuary stool

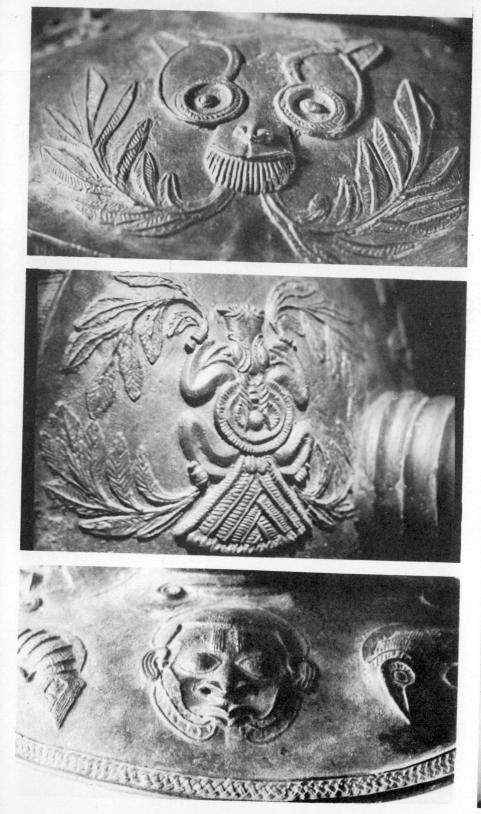

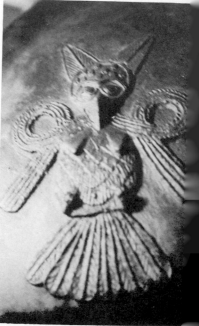

191–94. Motifs from fig. 190: 191, wreathed and horned human skull; 192, frog motif; 193, the motif of everted snakes symbolising the divine king; 194, the 'ram's head' motif as at Benin, Jebba and Tada; see figs 84*a–e*, 169*a–c*.

lips, the heavily lidded eyes, the pair of everted snakes running up the cheeks (occurring also at Benin and perhaps at Ifẹ̀), and the diagrammatic formula for the human ear, all motifs produced by the Ijẹ̀bú craftsman to the present and also characteristic of imagery in the so-called Forcados bells.[2]

Purely on the basis of idiom it is difficult to challenge our informant's claim that this stool is an Ijẹ̀bú artifact; and the conclusion is not without an incidental interest in the question of determining the facture of certain so-called Lower Niger bronzes, for the piece incorporates *par excellence* just those design elements considered characteristic of well-known examples of the group. Here the treatment of the python and of the waterbuck gripped in its jaws is so typically what we find in the 'Lower Niger' *Huntsman* for example as to suggest at least a common workshop if not a common hand! We should not therefore be too surprised to find some elements of the so-called Lower Niger idiom at least partly of Ijẹ̀bú origin. A multitude of shared iconographic motifs bolsters the connection, though such evidence cannot be regarded as conclusive of much when the mobility of design ideas in the Nigerian bronze is taken into account; but we may note among such motifs the theme of three contiguous circles enclosed by a rectangular frame, the already mentioned ram's-head motif, that of the ibis pecking at a decapitated human body (which also occurs at Ifẹ̀), and, as we shall see, the symbolism of the Bini 'mortuary' stool. A degenerate version in the miniature from the Niger delta illustrated at fig. 195 suggests that this stool

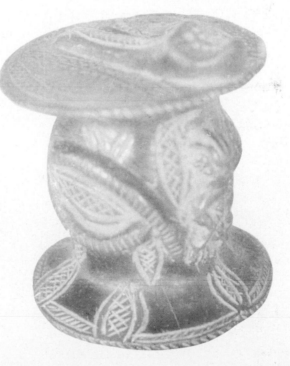

195. Western Ijo, bronze replica of a wooden personal cult object, emblem of Pẹ̀rẹ̀ title holder

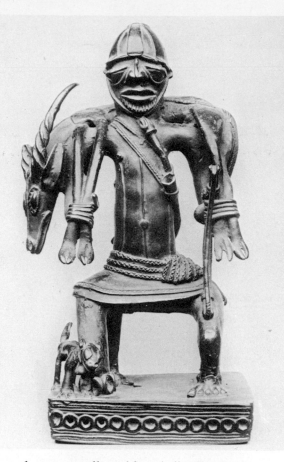

196. Bronze Huntsman
(provenance unknown)
Southern Nigeria

and its associated iconography eventually achieved distribution as a cult
object in the area. Only a vestigial python remains on the piece; the insignia
of the *Pęrę* title of two contiguous Western Ijo villages appears on the seat.
Just as these two Ijo villages share insignia in the same brass objects, so the
symbolism of the Bini stool might have been shared to the limits of the

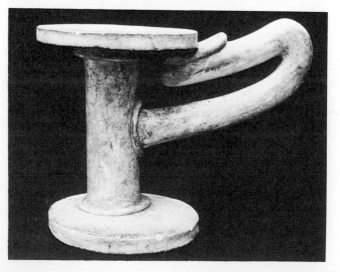

197. Ifẹ̀, quartz stool

Niger delta at Andoni, whose famous bronze chieftain is seated on what seems a similar object, fig. 196.

Comparison of these with the famous royal quartz-stools from Ifẹ̀ spring to mind, though the exact function of the latter has not been determined; according to Frank Willett they are known at Ifẹ̀ as *apere*, fig. 197. To the present day Bini-type brass objects are widely held in shrines and in private collections in villages along the lower reaches of the Niger, along the Warri River for instance. We may likewise remark the Bini origin of several cults in the area, notably evidenced in the subject matter of Ijo and Urhobo sagas.[3] Among the Itsekiri the cult of the right wrist symbolised in the wooden object called an *akaton*, fig. 198, recalls the Bini cult of the right hand,[4] fig. 199, which we also find symbolised on an Ijẹ̀bú bronze bell, the famous *Avbiama* bell collected at Benin, fig. 200, an object which more than

198. Warri, Niger delta. Symbol for the cult of the right wrist, called an *akaton*

199. Type-motifs on a Benin bronze mortuary stool copied in Portugal from a wooden original, mid eighteenth century. Note symbol of the cult of the right hand, and the horned human skull with everted 'legs' which appears on a similar stool from Ijẹ̀bú Òde, among the Yoruba (Benin City Museum)

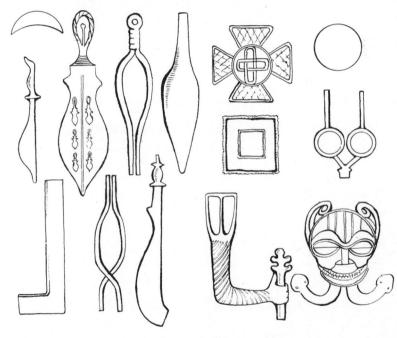

any other seems to link the Ijẹ̀bú industry with the facture of the so-called Forcados bells.

Though it is doubtful that schools of bronze have ever existed in the delta area of the Niger, work of extreme individuality and masterly technical achievement occurs from Andoni to Forcados, to be explained perhaps by an Ijẹ̀bú export trade, by a Bini export trade, by an attested European export trade, or by the as yet unknown source responsible for the fine casts of animals' skulls, already mentioned, ranging from 5 cm to 20 cm, at fig. 72; but it must not be forgotten that from the area, as also from Benin, have come those articulated brass bracelets, fig. 201a, b, of a type dated around the Lakes Region of the Upper Niger to about AD 1000, fig. 201c, and that impulses affecting brass-casting history in the Guinea forest might

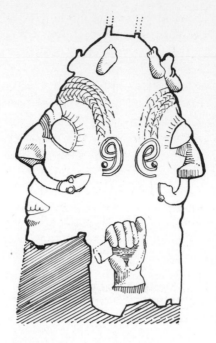

200. *Avbiama* bronze bell, Yoruba (Ìjẹ̀bú?), ht 24 cm (Nigeria Museum, Lagos). Three rows of plaited scarification on each brow, three across each nosebridge, almost circular protruding eyes decorated with a ladder-pattern fillet; everted fish or reptiles from each nostril; gourd centre of each brow flanked by a pair of upturned feet; mouth rendered with bare teeth from which issues a leaping frog. On either side of the neck a clenched right fist holding an object (see fig. 199); the bare upturned feet possibly a sign for the divinity of the Ọba, so charged with life force that his feet may not touch the ground for fear of causing damage to crops; cf. figs 76a–e, 77, 106, 173, 199

have been exercised by now vanished schools such as those no doubt responsible for the three distinct idioms in the Jebba-Tada group. Bronze sites on the map of West African history can hardly be expected to have remained any more stable since the opening of the sixteenth century than have the various peoples who have inhabited the area over the period under the constant exigencies of war and conquest and the impositions of Islam.

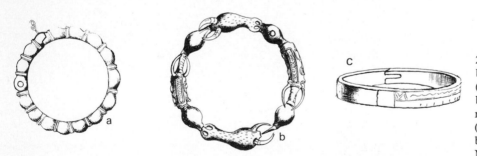

201 (*a*). Articulated silver bracelet, Warri, Niger delta; (*b*) Articulated bronze bracelet from a hoard recovered at Apapa, Lagos; (*c*) Articulated bronze bracelet from Killi, Upper Niger (after Desplagnes)

No two schools of African bronze-casting could be more different one from the other, yet for all its originality we may not appraise the Ìjẹ̀bú tradition in total isolation: in addition to a common casting method, it shares with Benin certain major iconographic motifs. Neither centre has changed its location in five hundred years. Like the city walls of Benin those at Ìjẹ̀bú are still to be traced through the farms and forests of the present day. To both centres brass has been traded from European sources since the first decade of the sixteenth century, and possibly earlier from the north. In which of these first arose a figurative bronze art we do not know, though it is likely that Bini expansion as far west as Lagos at a date before 1700

fathered technique among the Ijẹbú, as much later Ijẹbú was to father technique among the Egba at Abéòkúta to the west of it. This supposition is at least indicated by persistent Bini elements in Ijẹbú culture, particularly to be noted in its bronze iconography. Dapper in the seventeenth century claimed Ijẹbú to be subject to the Ọba of Benin. But influences do not appear to have travelled in one direction only. The Yoruba *òrìṣà* were worshipped at Benin at this time and possibly even earlier, though Benin has produced, even under influence, no cult bronzes to these *òrìṣà* such as distinguish Yoruba imagery within the African plastic.

In our study of the Yoruba Ijẹbú stool of fig. 190 we have noted the occurrence of several Bini motifs, most notable of which is the face with those brow markings noted as exclusive to the Bini in the early sixteenth century, either transferred wholseale from a Bini artifact or consciously symbolic of an Ijẹbú-Benin relationship of some sort – we have at present no means of telling. The everted legs of Bini tradition, symbolic perhaps of the presence of the divine king, also appear in much Ijẹbú work, in bronze and in wood, fig. 202. But this is as far as comparisons can take us in tradi-

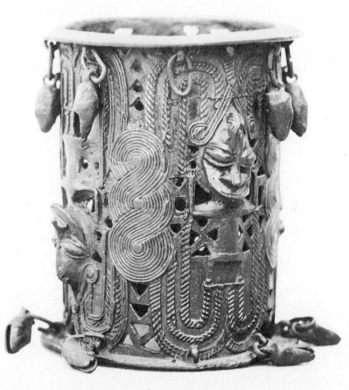

202. Yoruba, bronze armlet

tions where contrasts are more impressive. For if in its ancestral sanctions the Bini bronze is in a sense also a sacred bronze it has nevertheless added nothing to the architecture of sacred form. The forms of the Bini bronze are forms of the mind, of the intellectual and secular attitude in face of objective nature. They are forms through which the act of art completes itself in the mind of the beholder. It is in the cult-icon of the Ijẹbú craftsman

that we find this act of art explicitly negated in that attitude of will-less mediation which bequeathes to him forms of a purely personal reference. In this subjection to the will of the god, in the mechanisms which he has contrived for harkening to imperatives of the Word, such a cult craftsman is granted forms of a unique order, forms which, in this case, uniquely illumine the functions of matter and the meaning of art. No achievement of the Bini plastic can legitimately be invoked to explain the peculiar originality and greatness of Ijèbú art – its explanations lie only within itself, in Yoruba apprehensions of the power of Earth.

23 An Art of Ọyọ-Ilé?

On the extreme northern edge of Yoruba country Ọyọ-Ilé, the Katunga of the early travellers, whose foundation seems to have opened a gateway into the forest regions for some of the political, military and technical ideas of the western Sudan and beyond, is today a deserted ruin largely unvisited and unknown. According to the historian Robert Smith, its early connections with its northerly non-Yoruba neighbours included the Hausa, the Nupe, and Borgu, amongst whom the Hausa were in contact with Arab and Berber cultures across the Sahara.[1] It now seems that brass-casting was among the technical ideas transmitted by the Ọyọ to some of the southern kingdoms. At the height of its power its influence was felt from the Niger bend to the Atlantic coast, but though some remains of its bronze industry have come to light not much is so far known of its bronze artifacts, their distribution or influence.

At a shrine in the nearby town of Igbòhó is kept a brass mask claimed by its present owners to have been taken from Ọyọ-Ilé before its destruction. Its pursuit and recording were involved and expensive and, purely on aesthetic grounds, something of a disappointment; but as a historical document it is important in shedding some light on a hitherto hardly suspected school of casting at a site which has now reverted to almost impenetrable jungle sheltering the ruins of the kings of Ọyọ and the spoor of the elephant.

The Igbòhó mask, of heroic size, is part of regalia which include a full-length red gown and a head-dress of horsehair, figs 203–4. Twenty-eight holes of about 1 cm diameter are punched around its outer edge. The bright yellow surface seems to belie its alleged age (about two hundred years in the opinion of its present owner) though it is claimed that on each occasion of use, once in every three years, it has been traditionally polished with lemon juice and ash; on the inner surface however vivid green patches of copper oxide bloom in an authentic brownish patina.

It is the property of the Alákoro, a one-time court functionary at the seat of empire – the significance of the title seems now forgotten – by whom it is claimed to represent Ṣàngó, the second Alàáfin of Ọyọ. Meyerowitch's claim that figurines on a bronze armlet said to have come from Ọyọ-Ilé[2] might represent Ṣàngó must be understood in the light of a widespread Ṣàngó worship in all north-eastern Yorubaland to the present day where the principal cults seem to be to Ṣàngó, to Òrìṣà Òkò, and occasionally among hunters to Ògún, god of iron. In all this area appear no traditions of bronze-casting, a fact which makes the existence of an industry at Ọyọ-Ilé an interesting possibility. At Ṣaki near by, the local Bàdà (Chief) quoted an

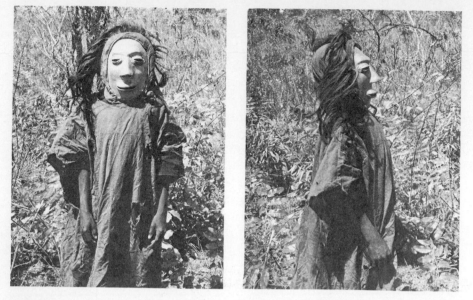

203–4. Yoruba, bronze mask,
Alákoro I

oríkì (praise-song) which seems to explain the lack of casting traditions
there and perhaps elsewhere in this quarter; 'Ṣaki Ògún kò rọ ikin; àgbẹ̀dẹ
kò rọ bàbà' (An iron working Ṣaki neither carves ivory nor works copper),
but this might only indicate (as in the lost knowledge of attested iron
working at Kiama in Borgu country) the short memory of some oral
traditions; no material remains of iron-working were to be found at Ṣaki
either.

On hearing of a similar mask there I later visited the Koso shrine at (new)
Ọyọ – a town some thirty miles north of Ibàdán. This second mask,
Alákoro II, though also associated with the Ṣàngó shrine is not held there,
but by its hereditary guardians in another part of the town, figs 205–6,

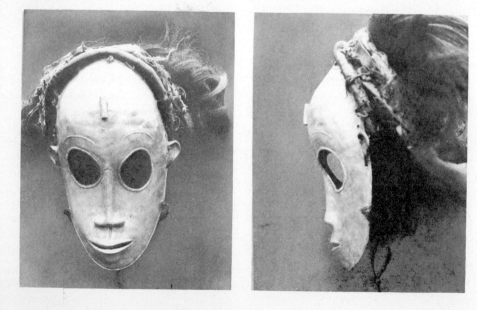

205–6. Yoruba, bronze mask,
Alákoro II

Apart from being of a distinct and individual aesthetic it is beautifully cast, 30 cm high, with a pair of apertures about 6 cm diameter representing the eyes. The borders of the eyes and the mask's outer edge are decorated with a 'ladder-pattern' motif common to many brasses of southern Nigeria. Fifteen holes punched from the inside around this outer edge carry the horse-hair head-dress noted in the earlier mask, which is secured to them by leather thongs. The ears are originally conceived and carefully modelled, each pierced in the lobe. Below the finely modelled lips the lower portion of the *orbicularis oris* bulges slightly forward instead of receding in accordance with anatomical truth, and on this appear three vertical ladder-pattern markings each about 2 cm high. A further group of three similar markings converges towards the lips on either side forming well-known Yoruba tribal marks such as appear for instance on at least one Ifẹ̀ terracotta head and on various Yoruba bronzes. In the temporal region between the outer eye and the ear on each side of the face appears what seems to be another tribal mark – an ovoidal figure surrounded by oblique linear cuts, fig. 207. On the centre of a very bulging forehead is cast a small brass cylinder about 2 cm high, of baffling significance but which might once have held insignia of some sort. As with Alákoro I the regalia includes a long red gown.

The present owner spontaneously affirms that Alákoro II was brought from Ọyọ-Ilé and that it is used annually in the Alàáfin's (King's) *bẹẹrẹ* festival, which marks the season when the grass is burnt in the overgrown fields after the rains, and the thatching on the palace renewed. The Koso shrine, located between the inner and the outer walls of the town, contains several rather poor Ṣàngó carvings presided over by a priest. Ọba Koso (the king does not hang) is the name by which the Alàáfin lives in an oral tradition which denies the ignoble manner of his death, by hanging. The cult associations and regalia of the Alákoro mask with the Ṣàngó shrine seems to confirm its relationship with Ọyọ-Ilé.

Though the Ọyọ historian, Johnson, speaks of '100 brass posts' removed from the palace by the Emir of Ilorin after its fall, and elsewhere of the 'seven silver doors' of the Ọba Onisile[3] who reigned during the first half of the eighteenth century, the only example of brass so far believed to have come from the imperial city is an armlet recorded by Meyerowitch. But the tradition does suggest an efficient brass industry at Ọyọ-Ilé between *c.*1735 and *c.*1835 perhaps producing plaques, as at Benin, for cladding palace doors and pillars. Johnson's account of the Ọyọ cavalry in the early eighteenth century showing the flag from the Niger bend along its course to the coast in an imperial circuit which he claims counted even Benin among its vassals is today regarded as exaggerated; but it remains conceivable that the court at Ọyọ, on this or any other occasion, could have received a plaque tradition from the Bini bronze. Brass-clad pillars would certainly not have been inappropriate in a palace described a hundred years later as covering no less than a square mile! Whether these or the silver doors of Onisile's day ever in fact existed must continue in doubt until the excavation of the

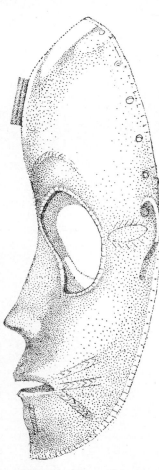

207. The *Alákoro II* bronze mask from Igbòhó, western Nigeria

palace, though it is interesting to note that 'brass doors', possibly inherited from Qyǫ tradition, were observed on Abéòkúta Ogboni houses by a missionary there at the end of the nineteenth century. Silver is extremely rare, perhaps non-existent, in traditional Nigerian metalwork; the traditional smith it seems knew nothing of the extraction of metals from any but iron ores and this as we have seen was in many ways a rather approximate knowledge. The tradition could more plausibly refer to brass, a question unlikely to be settled before the excavation of Qyǫ-Ilé. What may be the remains of a brass-casting furnace was recovered at the town site by Frank Willet in association with fragments of the rectangular clay moulds described by Ibn Battuta. Though we have no reason to doubt the tradition of metal-sheathed doors and pillars at the court of the Qyǫ kings such as we know to have existed at Benin, such embellishments do not appear ever to have been known at the palace of the kings at new Qyǫ, whither the seat of empire was removed after *c*. 1835. This building, at present covering an area of some 1600 square yards, is claimed to have been reproduced from the traditional prototype at Qyǫ-Ilé. Its plan, with the traditional division into various quarters, might therefore shed some light on the domestic organisation of the older palaces of the Qyǫ kings from the sixteenth century. The few carved veranda posts still standing are not covered in metal of any kind and are not particularly noteworthy in their iconography or aesthetic. Old doors in the present palace are of wood carved in a single piece traditional to Yoruba architecture.

Alàkoro I is relatively crude and an altogether inferior casting to Alàkoro II. From the evidence of the direction of the punching of holes bordering both masks (from in outwards) it might be concluded that these were made in the bronze itself and not in the wax model before casting, since the core would still then have been in place. The tool employed would therefore have been of a metal harder than brass, probably iron or even steel. Similar punching occurs on some Ifè bronzes, but from out inwards; in one case among these latter the apparent tool – an iron or steel nail – has been left embedded in one of the holes.

In its effect on more southern practice we have already noted traditions which connect the old Qyǫ industry with that at Abéòkúta. The present family of smiths centred around the name Kehinde at Abéòkúta claims descent from Qyǫ-Ilé. Work produced by these Qyǫ-Abéòkúta smiths is readily distinguishable from work produced by those other Abéòkúta smiths – centred around the name Ògúndipè – who claim an Ijèbú origin of 'about three generations', but an inherent technical difference between the two lies in their respective treatment of the clay cores. For the smith of Qyǫ origin this is mixed with powdered charcoal in a manner appropriately reminiscent of northern practice exemplified in the Qbǫ school already discussed. The Ijèbú group by contrast and in common with all other Yoruba schools in the south, as well as with Benin, admix their clay with dung.

This supports the connection with Qyǫ-Ilé claimed by at least one

family of Abéòkúta smiths. In the matter of bronze cores it aligns their practice with the northern schools already discussed whilst distinguishing it from practice among the southern Yoruba, and the Bini. Though the Alakaro mask at new Ọyọ cannot be dated on the available evidence, the industry which produced it at Ọyọ-Ilé seems to have been continued without interruption by Ọyọ refugees settled at Abéòkúta. A figurative bronze art therefore seems to have been practised at Ọyọ-Ilé until the time it was deserted. Its associations would likely have been with the western Sudan and ultimately the Sahara, for among the remains of the industry so far recovered is the mould of Ibn Battuta's day. The great traditions of this art are probably to be referred to the period of the restitution and expansion of the kingdom during the seventeenth and eighteenth centuries, when the brass pillars and 'silver' doors of tradition may have bedecked the palace, or, on the basis of one local informant's guess, perhaps even earlier.

Genet somewhere speaks of the Negro mulieral brow – an observation already made by Rembrandt, Rubens, Watteau, even here and there by nameless masters of the Alexandrian School, and of course by the image makers of Egypt and the Sahara. It is an important theme in the classical interpretation of the Negro head, and for that matter in the interpretation of that peculiar gravity or nostalgia of which the Negro brow is index and crown. Everywhere it is the pivot of an idealism that runs through the various expression-media of Negro art from the time of the Nok sculptors. It has simply not been bred away. In exercises of pure form the Negro sculptor interpreting this brow at times achieves a thematic rigour lacking in Western art before its contact with Africa in the twentieth century. Certain wood-carved African heads – as distant from each other as those of the Guro and the Fang have a geometric clarity that a Modigliani, a Brancusi, a Gabo, or a Pevsner could have envied. In the exalted idealism of the Ifè heads we also find this serenity of number and of inflection in forms which are all reduced, so to speak, to existence in an eternal moment where the guiding motif of this brow affects every other feature and thus seemingly renders the whole in an infinite present, fig. 73. It is impossible merely in reproduction to experience the contrapuntal subtlety with which in this Ọbàlùfọǹ mask the theme of the brow is rendered through the whole, but the concept provides a means of approaching the recurved simplicity of the Alákoro II mask from Ọyọ. This work is far less fully realised, less dense, less profound, but quite the peer of the Ifè piece in the originality with which, confronting the humdrum human image, it makes use of geometric laws to thematically interpret and reconstruct that order which is the substance of the classical vision. Still tenaciously preserved in a remote shrine and itself preserving a no doubt ancient worship, this Alákoro II mask will yet take its place among the masterpieces of the African bronze.

24 The Maghreb in the African Bronze

Objects traditionally copied by the African smith from the most varied sources, in bronze, in silver or gold, in ivory (and even latterly in aluminium), are rich in suggestiveness of influences and ideas which for the thousand years between the eighth and eighteenth century have been absorbed into native ornament. An interlace design motif appearing on an Italian pottery vase of the fifteenth century for instance will occur on Aṣante basketry, and be widely distributed in all areas of Nigeria to the present day, fig. 208. So too the garlands and tassels of the Aṣante chalice in the British Museum Collection – a contribution of textile art to ornament which occurs at all periods in art history, but in this case so little understood as to have been copied upside down! Moroccan sandals, Danish chairs, Manchester muskets, Moorish swords all figure in the Aṣante gold weights. This chalice is possibly of that exuberant period of Aṣante gold which has given us the Trophy Mask at fig. 65, perhaps of the early nineteenth century, and is in a technical tradition which would have followed the gold trade from the Saharan entrepôts of Old Ghana on the Upper Niger where African and Arab cultures have met and mingled for at least a thousand years. As we have seen, the trade which secured this association and awakened empires to the south may well have transmitted those skills of the goldsmith which are reflected in the growth of bronze industries to the south. The similarity of Habe *cire-perdue* gold weights to those of the Baule and Aṣante can hardly be explained by anything but a common source in the very early caravan trade. Of no intrinsic aesthetic merit, these crude miniatures of human, animal and insect motifs have undoubtedly played a part in the development of *cire-perdue* brass technique to more ambitious ends. The filigree goldwork so characteristic of the area is unknown farther to the east; the technique originates from the Mediterranean where it has been practised since the time of the Greeks.

The secular use of bronze objects in this vast area of the Niger triangle has promoted the wide distribution of certain forms and motifs. The bracelet of the caravan trade has served as an agent in the dissemination of ornamental and technical ideas now common throughout the region. The casting of these bracelets would have borne the open mould of Ibn Battuta's day into the forest regions where it is still employed for the same purpose. Very elaborate types are developed along with types directly cast by the *cire-perdue* process. The casting of such bracelets in two or three tiers has

208. Today widespread in West African ornament, this interlace motif appears on Italian pottery of the fifteenth century. cf. fig. 122

been described for the Chad region,[1] fig. 149. Examples cast in up to six tiers, hinged and jointed by mortice-and-tenon have been excavated at Benin, and similar tiered and hinged types occur in Ghana and throughout the Niger delta. Cast anklets and armlets of extremely fine openwork design or elaborately conceived on human and animal themes are a feature of most southern practice, fig. 202. Many of these, particularly those of the Ijèbú-Abéòkúta school, are propositions in bas-relief which as we have seen might stand comparison in a purely conceptual sense with resolutions in the Benin plaques, which therefore do not represent the African artist's only essays in bas-relief bronze-casting, as is sometimes supposed. The ceremonial brass cutlass of equally wide distribution has functioned too as the bearer of ornamental ideas and techniques into the Guinea forest, for associated with its production is the range of tools and punches used in Arab repoussé work and whose characteristic ornament is today to be found on brasswork in many areas of the forest region, notably at Benin, figs 60, 81, 209, and so far

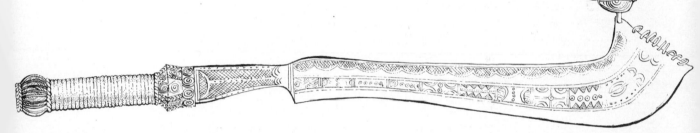

209. Ceremonial brass cutlass

west as the Ivory Coast. The cutlass itself is most commonly of the recurved type 'of Moorish design' already described by sixteenth-century travellers from Senegal to the Niger delta. Items of brass horse equipment have equally carried design and technical ideas into the forest, notably the 'butterfly' chain of nilotic and mediterranean associations linked with a Moorish motif traditional on smiths' work-boxes around the Upper Niger, fig. 210. The Arab-type brass stirrups at fig. 211 are today common in Nigeria,

210. Moorish chain-link motif, Nigeria

as is also the Moslem water-jug of Nupe facture. The Maghreb is present too in certain repoussé gold or silver ornaments worn in pairs by Aṣante priests, identical with those worn as earrings by Arab women in the nilotic Sudan (fidwa), fig. 212. Most striking among African copies of exotic objects is the Aṣante *kuduo* – the brass reliquary vessel already noted – characterised by the union of animal themes with Arab ornament and calligraphy, fig. 67. 'Kufic-inscribed brass pans of early Moroccan or Spanish influence are still to be found in Aṣante.[2]

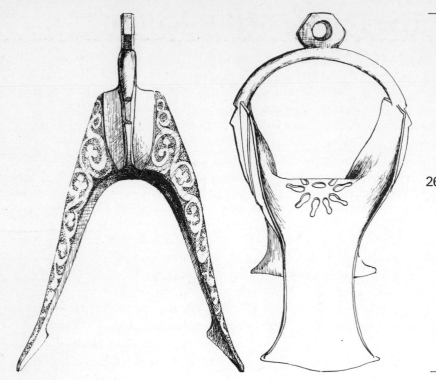

26.5cm

211. Arab-type brass stirrup.
The bare foot is inserted
under the arch (Coll. author)

212. Nilotic design. Known
as a *fidwa* in the Sudan,
where it is a highly valued
ornament among women, in
repoussé gold, according to
Rattray it is also worn
by Aşante priests

25 The Dating of the African Bronze

The crotal

The plastic impulse which within a comparatively small area of tropical Africa has realised masterpieces in bronze conceivably among the finest ever created by the hand of man may perhaps never be fully explained, but wherever a local morphology is possible it permits us to grasp the formal and aesthetic significance of these works in terms of their own intentions and of no other. In our interpretation of the Benin canon it has been necessary to do without the support of chronological data; in the four hundred years or so of its known existence we have few dates with which specific periods can confidently be aligned. Periods can at present only be distinguished in the solutions found by the Bini artist to problems raised in his confrontation with objective visual experience. But since such solutions once found determined the idiomatic basis of all later work, Bini art so far remains resistant to the most determined chronology: as resistant as would European painting since the Renaissance be to chronological interpretation based only on the incidence in it of, say, perspective. As between similar types of object change might be observed in the evidence of increasing technical mastery; but since there is no objective measure for appraising such evidence individual decisions may be made by individual observers only within the general terms of a morphology. We have proposed such a morphology for the Yoruba sacred bronze, but without being in a position to establish a dating for individual pieces. Here we have taken the cult as a unit of inquiry within whose terms the characteristics of idiom may be read, and have arrived at notions of style by examining such idioms in motion, so to speak. It is the style-system, in other words, and not the particular masterpiece resulting from it, which provides the terms of appraisal. Better can hardly be hoped for when we remember the peculiar nature of form in African classical art resulting from the universal apprehension of a spirit-charged world. It is this which governs the approach of the craftsman, sacred or secular, and allows no place for that individualising autobiographical viewpoint of the European artist from which we are able to structure the nature and evolution of the European plastic.

Nevertheless we are in a position to distinguish among a sizeable body of African bronze objects between those cast after 1590 and those possibly cast before this date, for with the British trade mission to Benin of 1590 the

crotal, or hawks'-bell, came into Bini hands and thereafter began to appear in some profusion on these and other bronzes. The English merchant James Welch could hardly have been aware of the significance to the West African bronze which lay in his cargo of 'yron unwrought, bracelets of copper, coral, hawks'-bells, hats and suchlike'. These strange new commodities would henceforth characterise African and particularly Bini bronze iconography and establish a starting point useful to students four centuries later; for this pebble-sized hawks'-bell can now be regarded as establishing a datum-line for the art historian as reliable as are the smoking pipe or gin bottle for the archaeologist – all introduced along the coast at known dates.

The crotal (Gr. *krotalon*: a rattle made of split reed, pottery, or metal, a sort of castanet used in the worship of Cybele) is possibly of classical antiquity. For its early occurrence in Africa we have the word of Pedrizet in the Greek example at fig. 213a, from Upper Egypt, though the author

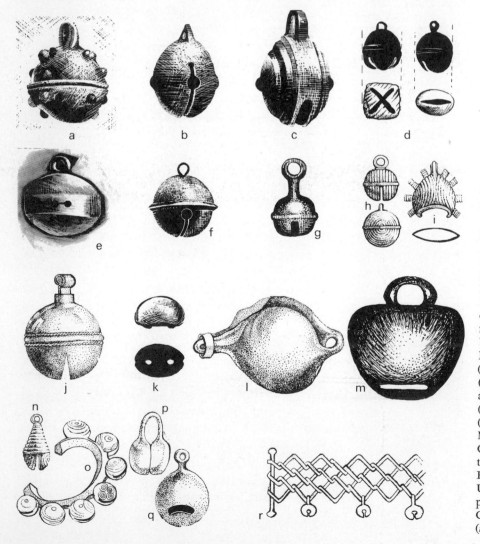

213. Some types of crotal. (*a*) Greek (after Pedrizet); (*b*) Egyptian, Edwards Library University of London; (*c*) Egyptian, Edwards Library; (*d*) Latvian, British Museum; (*e*) from a woodcarving in the Våsterås Cathedral, Sweden; (*f*) modern European; (*g*) Benin, Nigeria Museum Lagos; (*h*) Niger confluence, on a brass vessel from Agbaja; (*i*) Igbo Ukwu, University of Ibadan Institute of African Studies; (*j*) Ethiopia, British Museum; (*k*) Uganda, collection of the author; (*l*) Upper Volta (after Schweegel-Hefer); (*m*) Ruanda-Urundi, British Museum (wood); (*n*) Lake Chad (modern), collection of the author; (*o*) Sierra Leone, British Museum; (*p*) Killi, Upper Niger (after Desplagnes); (*q*) Ghana (Gold Coast; after Barbot); (*r*) Senegal (after Brüe)

does not give his reason for supposing the example ancient.[1] This example is rather larger than the European type, diameter 6 cm; quite large examples of a different type have been recovered in Egypt, fig. 213b, c. Latvian examples of the tenth century were used on horse trappings and amulets, fig. 213d, which may represent the earliest incidence of the crotal in Europe: in Sweden during the eighth century an ornamental copper bell used by women is of tubular design. An English example was recorded as early as 1156. Examples excavated in Denmark are dated at 1204, and later ones occur on the marble cenotaph to the Danish queen Margrethe, carved in 1423. In Sweden crotals are represented on a wood-carving in the Våsterås Cathedral dated at 1430, figs 213e, 214. No Swedish examples are known before the fifteenth century, though by 1568 the crotal was being mass produced in Scandinavian factories in the form in which it is commonly known today, fig. 215. This type, characterised by a ridged waist in which the two constituent hemispheres are clamped together, was manufactured, as the illustration shows, by die-punching and not by casting. It appears as the culmination of a design in which earlier forms were all cast in one piece,

214. Josse Eriksson and St Erik, from the Våsterås Cathedral, Sweden

215. Sixteenth-century mass production of the crotal in Scandinavia. (By the Swiss engraver Jost Amman (1539–1591) in Troels-Lund. . . . *Dagligt liv i Norden i det* 16. *århundrede*, vol. 1, fig. 17. Copenhagen 1929–31)

in one shape or another. It is this article, characteristically punched and clamped, fig. 213f, which made its appearance at Benin in the cargoes of the Elizabethan seaman, James Welch, in 1590, and which served as the prototype for the development of West African forms. The type occurs on unquestionably early Bini bronzes, fig. 81. Subsequent copies continue to reproduce the ridged waist even where the method of *cire-perdue* casting in one piece made such a juncture unnecessary. Certain Bini examples introducing a stem to the suspension ring are conceivably of the very earliest local type for they appear on some of the plaques bearing Portuguese personages in the costume of the mid sixteenth century, and which on

other grounds we have examined as among the earliest bronzes cast there, figs 80, 213g (cf. fig. 81).

Other African crotals assume a variety of shapes; principally the midrib is dropped or is retained only as a decorative motif. Their manufacture in Nigeria has been described as recently as 1918.[2] At some stage the crotal came to be made by winding threads of wax around a spherical or conical core in the manner of the 'spiral' technique which we have noted elsewhere, fig. 213h. On such designs sometimes occurs a three- or four-part division of the sounding chamber presumably devised to affect the quality of tone produced. This is the type which appears for example on the Jebba *Warrior*, on which evidence the piece and its companions are to be dated no earlier than the seventeenth century, granted time for the variant to have evolved, fig. 145. This type has been observed nowhere in Europe, or for that matter anywhere outside the lower Niger valley. Certain versions from the Niger Delta achieve monstrous size, as much as 9 cm high, made up from thick coils of wax. Excavation at Igbo Ukwu in eastern Nigeria has recovered types of this spiral facture occasionally decorated by the addition of helical coils, fig. 213i. Examples in filigree gold from Aṣante are of exquisite foliate design; some of these found their way to Benin by one means or another, possibly in the coastal trade carried by the Portuguese between the Bini and the Gold Coast (Ghana). In the Benaki Museum Collection, Athens, are numerous globules and pendants in filigree silver and gold all characteristic of popular Greek art and which are so similar to Aṣante pieces as to suggest a common design parentage. The Mediterranean connection is once more provocative, but since the Greek pieces are so far undated nothing profitable can be added. At any rate for Aṣante the type would refer to dates hardly earlier than the seventeenth century.

Possibly of modern occurrence in the area the crotal is also used in traditional Ethiopian silverwork; examples recorded are quite large (about 3 cm high) and of four-part division with ridged waist, fig. 213j. Arab types from Mombasa of more normal size (about 1 cm high) are similarly ridged. From Uganda comes a small brass or copper bell (2 cm diam.) comprising two cups beaten from a single sheet and folded together, fig. 213k. As has already been observed, this folded type also occurs so far south as Rhodesia as well as in parts of the Congo and Ruanda Urundi, fig. 213m. To the north the shape occurs in wooden forms as a camel bell among the Somali. Across the continent various types of folded bell occur too within the buckle of the Niger, fig. 213,l; these types, possibly of a common origin, appertain to regions in which the European type has never been locally known; patently they owe nothing to the European clamped design which constitutes the prototype of all crotals known on the rivers and coasts of West Africa.

In considering the reliability of the European type as establishing a datum-line in West African bronze chronology we may oppose the fact of its appearance in the coastal trade at 1590 with the possibility of its having crossed the Sahara in the caravan trade of an earlier date. But as the

map, fig. 220 (p. 296), illustrates, its distribution in West Africa is coastal and riverain with a dense concentration in southern Nigeria whence we know it to have been taken at the end of the sixteenth century. According to Professor Lebeuf its excavator (personal communication), it does not appear in the 'Sao' archaeology of Lake Chad – and this in the heyday of the caravan trade – though modern 'spiral' examples deriving from the European prototype occur in the area, fig. 213n. We have recorded its incidence on the Jebba *Warrior* and on the Jukun *Head-rest*, but in forms typical of the crotal as its variants were developed in the south at post-European dates, and not in the forms of an independent adaptation such as we might have expected were a separate source involved. The crotals on the Jebba *Warrior* are those of the confluence area and the Benue; those of the *Head-rest* are the commonest of all southern types – a bean-like shell cast of a piece with its suspension ring. The spiral type seems confined to eastern Guinea, or more specifically to the Niger valley, where it was probably developed. It is not an independent type but a form determined by technique. On a tambourine from Sierra Leone occur rather large examples in which a spiral motif has been used decoratively, fig. 213o, but here the spiral does not reflect the method of facture typical of examples from the Niger valley. Isolated examples occurring among the Fon of Dahomey suggest modern trade sources. The absence of the crotal in the bronzes of the Upper Niger and the Sahara, and the fact that it is nowhere mentioned in Arab descriptions of the trade, strongly suggests that it never was a commodity on the Saharan route.

But might the crotal not have appeared on the West African coast at a date before 1590?

Egypt, undated. We have already noted the undated Greek type which may or may not be ancient, as well as two known Egyptian types.

Nubia, 6th–15th centuries. A Byzantine-inspired mural in the Rivergate Church at Faras in the Sudan pictures a Nubian bishop whose cope is fringed with what appear to be small jingling bells, and here we may recall Moses' instruction to the Jews for such a robe, fringed with 'pomegranates of blue and of purple and of scarlet round about the hem thereof, and bells of gold between them round about: A golden bell and a pomegranate, a golden bell and a pomegranate, a golden bell and a pomegranate, upon the hem of the robe round about' (Exodus 28: 33–4) – just the arrangement which seems to occur on this Nubian mural, judging from a modern copy (the original having perished). But though these bells may or may not have been crotals they would in any case have been *cast* in gold and therefore of a piece, that is to say with no ridged waist, and it is the model with a ridged waist which we have seen to occur on the earliest West African bronzes, and which provided the prototype for later variants.

Gold Coast, 1484. In West Africa small bells were apparently used for dancing and ceremonial during medieval times. At El Mina in the Gold

Coast the Portuguese were greeted in 1484 by a king wearing a neck-chain with 'many small bells' – objects now of course beyond identification,[3] but possibly the tubular iron bells still widely used to the present and which may be the earliest of all African types.

Gold Coast 1553, 1555, 1561. In 1553 the English merchant Windham did a slight trade there without mentioning the crotal, and while two years later Towerson traded to the same people on separate days 'bells', 'a dozen of bells', and 'seven dozen small bells' their numbers do not suggest that these were crotals either.[4] For his voyage of 1561 he included 'slight bells' among trade goods which included such items as swords, daggers, hammers, small pieces of iron, etc.[5] Still we do not seem to be dealing with the crotal.

Benin 1582, 1588, 1590. Randall Shawe's unpublished 'Instructions for a Voyage to the Benin River' of 1583 mentions 'small dancing bells', a description tantalisingly appropriate but by no means conclusive.[6] According to John Picton of the Nigerian Antiquities Service the dancing bells of the Igbira, further up the Niger, are miniatures of the standard European type. On his first voyage to Benin in 1588, James Welch does not mention bells of any sort in a cargo which included ironwork and the copper manilla.[7] It is not until his second voyage, in 1590, that the crotal or hawks'-bell is unequivocally named – the earliest date which we may regard as marking its appearance on the Guinea Coast.[8]

In the light of the Benin canon outlined above it seems unlikely that the crotal would have been known there much before this date, or at any rate if known would refer to a date much earlier, for it is the Elizabethan English who appear to have been the first to carry the item to Benin, in response to a demand which we see to have existed in parts of West Africa for at least the preceding hundred years. We are yet a good half century or so from the introduction of the iron bar as a standard of exchange along the West African coast from the Senegal to the Niger, and though during the previous hundred and fifty years the copper manilla has served the purposes of a currency it is supplemented by a miscellany of metal and brass piece-goods and odd bits of iron. Since all of these held the value of money, the early traders were at minute pains to record their local exchange values. Such an item as the hawks'-bell, useful as small change in trade transactions, would more rapidly be disseminated in the areas in which it was introduced than perhaps any other single item of trade goods, so that today we find its distribution dense along the coasts and the more important rivers and not affecting such inland bronze schools as Ifẹ̀ and Ọbọ Aìyégúnlẹ̀, where small bells of the ordinary type, identical with examples collected in eastern Nigeria, are still made today.

In view of the evolution of the European type suggested at figs 213, 215, we should hardly expect the crotal with the characteristic ridged waist to have appeared on the West Coast before the sixteenth century from what-

ever source, coastal or Saharan; for in Europe during the fifteenth century the common type was still cast in one piece, fig. 213e, as it had been from the remotest times in Greece, and in Egypt, whence it reached Europe conceivably by way of the Arab sport of hawking.[9] The type with a ridged waist joining two equal hemispheres appears as a late sixteenth-century development, subsequently to be copied at Benin and elsewhere in West Africa in a welter of local variations. Following on Welch's mention of it at the end of the century the crotal continues to be described in West Africa, where it is imported well into modern times.

Gold Coast 1678. Barbot's *Journal*, opening in 1678, mentions brass bells in the Dutch trade. Though no description is given of these a copy of local manufacture is recorded by him in a general description of Gold Coast industries of the day, fig. 213q.

Senegal 1714. Le Sieur Brüe provides too a drawing of the European commodity as traded by the French at Senegal in 1714, these being of silver and weighing between sixty and seventy grains each,[10] fig. 213r. 'Brass bells No. 1, eight hundred and forty-one; No. 2, sixty-two, No. 3, sixty-nine; No. 4, fifty-six', i.e. 1028 bells – these were part of the cargo of a small vessel engaged in a month's trade at New Calabar, Nigeria, in 1698. They may or may not have been crotals.

We are on fairly sure ground in regarding Welch's mention of the crotal in 1590 as a chronological datum-line in the West African bronze. So that for the Bini, the Yoruba, the Jebba-Tada, and Igbo corpora, overwhelmingly the greatest of all African bronzes both in quantity and in quality, we are in a position to look no farther back than the opening years of the seventeenth century for the dating of important works on which the crotal appears.

The chain of iron or of copper

Though the iron bar was not established as a standard unit of trade currency along the West African Coast until the mid seventeenth century, iron in various forms had been bartered there, as we have seen, from much earlier times. This iron currency was supplemented by others, of which the brass bracelet and the cowrie shell are the most notable – currencies which have all left their mark on the art of the area and in its imagery. Very important among these is the copper or brass rod and the brass or iron wire which formed a part of trade cargoes particularly to eastern Guinea from the mid seventeenth century expansion of the slave trade. Wire observed on West African bronzes is either of circular or rectangular section, the former drawn and the latter wrought. The type of circular section is produced either by the drawplate or from paper-thin sheets of the metal hammered into a tube of perhaps 2 mm diameter. In Europe, iron wire was made by

forging until the drawplate was produced in the tenth century; application of water power to wire drawing from the cast-iron drawplate came only in the fourteenth century.[11] The drawplate has been recorded for various parts of tropical Africa, though an early date is provided only for Rhodesia; if this date is reliable, it is possibly to be explained by an Arab or other oriental source affecting the East African seaboard.[12]

In West Africa, even though the domed furnace described was at times capable of generating temperatures in excess of 1500°C, cast iron or steel produced at these temperatures would have been accidental and the product discarded as spoiled. Moreover contemporary smiths' practice in the Guinea forest, both in iron and in brass, furnishes no evidence that the drawplate was ever known, nor is there any in the descriptions of early travellers to the region, who as we have seen were frequently at minute pains to describe these industries and their products. No evidence exists in West Africa of a source of motive power for wire-drawing, and as late as 1926 it was observed in southern Nigeria that wire was made by hammering, a process which the present author has witnessed in today's Yoruba smithy so far north as Ilorin.[13] The traditional chain of double-U linkage would therefore have been forged from locally wrought iron. But the uniform diameter of the metal analysed in some of these chains suggests that they were drawn, and not forged; these latter would have been made up from the imported iron rods or iron wire of the slave trade as indeed their irregular link formation indicates. All chain made from drawn wire, whether of iron or of copper, would have appeared on the West African coast with the seventeenth-century expansion of the slave trade, succeeding to the rectangular-sectioned wire of local facture which can be assumed to be the earlier type.

The design of individual chain links is a useful determinant of influences affecting practice. Thus the 'butterfly' type widespread along the lower Niger and Benue valleys on bronzes from the confluence area, from Igbo in eastern Nigeria, on horse-trappings from northern Nigeria, and which also appears on the Jebba *Warrior*, may be of Mediterranean origin; often associated with it is a Moorish fretwork design in brass already noted as a decorative motif on smiths' workboxes around the Senegal and Upper Niger, fig. 210. This 'butterfly' type is of some antiquity; examples of it appear on bronze artifacts exported from Egypt to Nubia around the fifth to sixth centuries; it also occurs on a bronze censer in the British Museum, probably made in Belgium or Germany in the thirteenth or fourteenth century,[14] and in Greek popular crafts. It is common on bronzes of the lower Niger valley, notably at Igbo Ukwu in eastern Nigeria. Certain types of link are particular to certain schools, as for example a peculiar 'Benin' link represented on several bronzes. A typology of these various chains might contribute to solving many problems of provenance in the West African bronze. We can in any case regard the incidence of drawn wire on bronzes from the Guinea Coast as diagnostic of a date at the mid seventeenth century, when the copious importation of European metal and metal

artifacts appears as a symptom of the organisation of the slave trade after 1640.

The smoking pipe

Various dates in the first half of the seventeenth century are now acknowledged for the introduction of tobacco to particular areas of West Africa, and a slightly earlier period for the western Sudan.

Some of our more recent conclusions hinge on the evidence from a single site – that of Ayawaso, the site of Old Accra, where three pieces of evidence were obtained which are not available at Dawu: (i) A typological development of native-made pipes suggesting that the earliest forms were imitations of the English/Dutch 'clay', (ii) European imported ware dated to 'very early seventeenth century', stratigraphically some distance below the earliest pipes, and (iii) a historically attested terminal date for the site at 1677. This suggests a date of *c.* 1640 for the introduction of smoking in the Accra area. But there is other evidence suggesting that pipe-smoking established itself at the end of the sixteenth century in the Middle Niger area, and that this spread overland and 'met' the coastwise introduction into (modern) Ghana some time in the later seventeenth century. And there are historical records of tobacco in Sierra Leone in 1607, Gambia 1620, Liberia 1623, and for the Congo in 1612. As to the situation in Nigeria with regard to smoking in the seventeenth century, we are largely ignorant. Smoking pipes have been excavated both at Benin and at Ifè, but from undated levels; there were no smoking pipes at Igbo.[15]

The early date for the appearance of tobacco at Sierra Leone, and the hypothesis of a possible northern source for tobacco in the Middle Niger area seem borne out in the *Ruling on Tobacco* of Ahmed Baba of Timbuctu (d. 1627). Ahmed Baba was deported to Morocco after the Moroccan invasion of Songhai, about 1593, but was later permitted to return to Timbuctu; his book was written in Morocco just before his return in 1607.[16]

Several African bronzes show the smoking pipe; though this fact does not in itself help in the dating of individual pieces it is useful as confirming a *terminus a quo* for style-cycles, or for idiom-groups whose other iconographic characteristics, or whose cult-imagery, are known.

The steel file

Mention has already been made of the incidence of casting struts on certain Benin bronzes left in place for want presumably of files of a greater hardness than brass or bronze. Future work on ships' invoices might establish a date for the introduction of the steel file (or steel saw) to West Africa and thus suggest a period after which the chasing of bronze pieces to a high degree of finish became possible. Into periods of quite advanced mastery of the technique these casting struts remain as blemishes on many a superb Bini bronze, most especially on the plaques. Certain leaves are named by the Yoruba smith which traditionally functioned as sandpaper, but whatever

their effectiveness in burnishing or in polishing, the steel file or saw would still be required for cutting through casting struts.

The influence of the European workshop

Finally the coming of European workshops in the late nineteenth century left a mark not so much on technique as on imagery in certain bronze schools of southern Nigeria, notably that at Abéòkúta where, strangely, nuts and bolts, bits, bevelling, riveting and so on appear as decorative rather than structural adjuncts to bràss work. On to brass ceremonial and ritual staffs traditionally cast in a single piece are worked hinges which though of an exact realism are functionally useless, while others carry decorative additions on anthropomorphic and zoomorphic themes, not cast of a piece with the staff in the traditional manner but screwed on by new-fangled methods of tapping the brass. The European steel die is of course implied. One such piece was acquired by the British Museum in 1878.

Part Four

SUMMARY AND CONCLUSIONS

26 Iconology, Technique and the Schools

Our study of the great Nigerian schools embodies all the major problems of technique, dating and chronology to be encountered anywhere in the African bronze. These schools have produced the enduring masterpieces of the medium. Our examination of the range of aesthetic achievement has illuminated phenomena of idiom and style in sacred and secular form which may not always be those to which we are accustomed in the study of the European bronze. We have seen that a properly so-called Bronze Age cannot be described for tropical Africa – that the Bronze Age, if it deserves the name, is here an Iron Age phenomenon, the distribution area of its practice and its major influences being roughly coterminous with the incidence of the domed furnace in West African iron-smelting, and curiously too with the incidence of the very much older *Kwa* group of languages. Where the domed furnace appears to have had origins in Roman metallurgy and therefore could have been employed on the Upper Niger only at a date after the opening of the Christian era or immediately preceding it, the use of bronze is to be referred to the era of the caravan trade of which our earliest record is of eighth century date. We have no reason at all to seek beginnings for bronze at dates earlier than this, though African gold had been traded to the Mediterranean during the course of the previous thousand years. Though copper, and its alloys, are known in the western Sudan presumably from the beginnings of the caravan trade it is not at these dates associated with figurative casting by the *cire-perdue* method. Recent radio-carbon dating of certain bronzes from Igbo Ukwu in eastern Nigeria to AD 840 and 850 seems extremely unlikely, if only in the light of the general history of bronze in the forest cultures; but more than this the presence on several pieces in this corpus of locally cast crotals suggests a date well after 1590 for individual items, granting sufficient time for local variants to have developed from the European trade prototype. Similar evidence relates to the Jebba-Tada warriors and their female *Nude* usually ascribed to the fifteenth or sixteenth centuries – dates difficult to accept in view of the three-part crotals, representing an advanced stage of adaptation, which are cast of a piece with one of these figures. A date connected with the organisation of the slave trade after 1640 is moreover strongly suggested in the copious use on these warriors of the drawn (European) wire which we know to have formed an important part of trade cargoes of the day, though it must be acknowledged that the latterday occurrence of the drawplate

among the Nupe might suggest a traditional drawn wire in the north, possibly from Arab sources. Drawn wire however remains unknown in local production in the Guinea forest to the present.

For the African bronze the antiquity often cherished in oral tradition ought universally to be viewed with scepticism. By its physical longevity

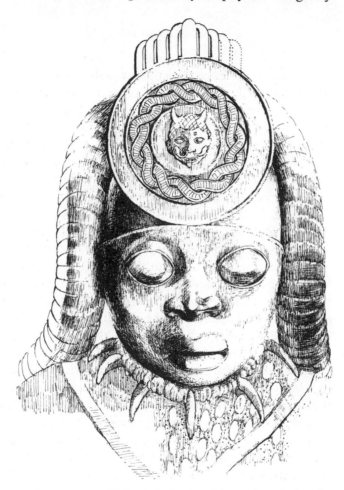

216. Near life-size bronze figure from Tada showing union of sacred and secular elements in the concept of ancestral form

when contrasted with woodcarving, and frequently too on account of the peculiar African view of the nature of time in which religious, courtly or ancestral art objects have their being, the bronze attracts to itself associations of mystery and age not often supported by known fact. Moreover, as in the Igbo Ukwu corpus, a scientific date may conflict with dates arrived at by iconographic evidence; this latter is admittedly meagre in West Africa and the greater part of it relates to the effect of the European presence after *c.* 1500. But though this does not in itself explain the apparent absence of figurative bronze work in the forest regions before the opening of the sixteenth century, it ought to be borne in mind that no excavation to date has produced unequivocal evidence of a figurative bronze art in these areas before the close of the fifteenth century. Oral tradition and recent

opinion which place the Ifẹ̀ bronze prior to *c*.1280, or *c*.1380, may yet be proven correct, but this would be surprising to purely iconographically based opinion; as would of course the attributing of the superlative castings from Igbo Ukwu to the ninth century.

Cire-perdue casting can be assumed to have been employed in the first instance as a function of the gold trade which linked the western Sudan with the Mediterranean. Gold filigree techniques, of Mediterranean origins, transmitted in this trade, are common to the Habe of the Upper Niger and the Baule-Aṣante within its buckle at the limit of a trade route which penetrated to the coast only in the seventeenth century. Not surprisingly, these techniques are unknown farther to the east, in Nigeria and the Congo. Smiths so distant from each other as those on the headwaters of the Niger and those bordering Lake Chad, seem to have felt the earliest influences. These may have followed the great eastern arm of the caravan route from old Ghana, for among the Habe (and those tribes to the south whom their practice has influenced) as well as among the Sao (where crude representational bronze miniatures have recently been recovered) technique is more adapted to the casting of jewellery, bracelets and suchlike, than to the representation of the large-scale human figure in three dimensions. As may be expected where Moslem contact is involved, its decorative properties are great but its purely plastic achievement insignificant. The possibility of remote eastern connections in iconographic motifs shared with the Nile, either by way of the Sahara corridor or through the three established early trade routes from the Mediterranean, cannot reasonably be overlooked. But, as has been seen in the relationship of Benin with the makers of the Jebba-Tada bronzes, a shared iconography does not necessarily imply a technical connection; the *cire-perdue* technique of Benin is not that of the middle Niger. Though the source of the unique casting method common to the Jebba-Tada, the Jukun, the Ifẹ̀ and Ọbọ bronzes remains as yet unidentified, it would be rash to deny them at least a family association and this, by inference from technical and oral grounds, would include Ọyọ-Ilé, the seat of the Yoruba empire. An increased knowledge of the Jukun might relieve us of certain persistent mysteries in this family of the African bronze, for on the established identity and scope of this industry may hinge not only the great question of Ifẹ̀ bronze authorship, but also important aspects of the history of Ifẹ̀ itself, 'the cradle of the Yoruba peoples'.

For the full flowering of the African plastic genius in bronze schools of coherent symbolism, imagery and aesthetic we must await the development of the requisite conditions, most especially in the centralised kingdoms of the Guinea forest. Links of these southern schools with perhaps now vanished centres of bronze to the north are indicated in as yet slight iconographic evidence from Benin, from Ijẹ̀bú and from Ifẹ̀. Links of a more obvious character are suggested for Aṣante and Ọbọ in the northern 'spiral' method of casting which refers to a source distinct from the *cinquecento* method of the southern schools. In West Africa the two methods remain mutually exclusive. Certain evidence indicates that, like

the authors of the Jebba-Tada group, the smith at classical Ifẹ̀ followed northern practice. The earlier of these two distinct sources affecting the African bronze, the northern, has left its influences over vast areas in smithies today still casting bronze ornaments, such as armlets and anklets, and objects of daily use. Lebeuf, the excavator of Sao, has suggested that a dispersal of smiths following the Muslim interdiction against graven images after their conquest of Bornu in the sixteenth century, may have been responsible for the spread of Sao bronze techniques among the Hausa and Kanuri where to the present the itinerant smith is a tradition. In the present author's experience the itinerant smith is known around Ilorin, in northern Nigeria, but not elsewhere in that country. Palmer likewise records that the Hausa, along with the Jukun, the Nupe and the Songhai all owe their smithcraft to old traditions from Kanem-Bornu.[1]

In the south the technical picture is different. Here, so far as present evidence reveals, the *cinquecento* method is employed over a comparatively small area of the total bronze map of West Africa: at Benin, and in the major Yoruba schools. As its name implies, this method of casting was popularised in Europe only in the sixteenth century, which fact, when considered along with its exclusively coastal incidence in West Africa, suggests its introduction by sea, through European agency at known dates. Did Europeans, then, teach *cire-perdue* bronze casting in West Africa? Again we need not be too worried about disturbing old skeletons in discredited cupboards whilst reviewing the known facts.

During the sixteenth and seventeenth centuries, Portuguese missionaries taught a simple bronze art of Christian imagery in the Congo, an art of visual aids executed by an open mould process. A similar bronze idiom was currently known at Benin. Portuguese missions in the Niger delta are thought to have been of such influence as to have planted their language at the Bini court; to the present day, according to Michael Crowder, a section of the court speaks a language unintelligible to the ordinary Bini and allegedly derived from Portuguese. In the Benin Museum is a bronze stool cast in Portugal to a traditional Bini design. Its type is the mortuary stool discussed above, figs 190–194, of obvious importance in Bini kingship ritual. The casting of another, a plain one, is recalled in the oral tradition, of 1897. The same tradition credits the introduction of bronze casting, and the earliest casting of bronze plaques, to a foreign tutor who arrived with the white men and subsequently lived at Benin, with his many local wives, through some part of two successive reigns. At this time the brass or copper manilla, fig. 150, begins to appear plentifully in European trade cargoes to the Guinea coast. Another Bini tradition, of 1823, similarly credits the introduction of bronze casting to a white man 'from the great water'.

So in local memory as well as in fact Europeans were connected with the bronze art of Benin, though the degree of their involvement is not known. The casting technique of the Portuguese mission was not the *cire-perdue* process, but it can be assumed that in the Congo and at Benin during the sixteenth and seventeenth centuries a range of the tools and equipment

employed in the *cire-perdue* process were in the hands of Portuguese instructors – furnaces, bellows, crucibles, anvils and the tools employed in association with these. At Benin the smith's hammer, as represented in the bronzes, is of a design different from smiths' hammers today employed elsewhere in Nigeria, as also are tongs, pincers, tweezers, etc., as a comparison of the drawings of figs 155, 156 with those of fig. 199 shows. In the matter of foreign tutelage, however, nothing in the imagery of the Benin corpus even remotely suggests alien authorship for individual pieces; but the transferring of a technique need not mean the transferring of an imagery. In this connection a bronze miniature bust of a Portuguese, in the idiom of the Renaissance, recently recovered by Horton in the Niger delta, might acquire a certain significance. Indubitably European in facture and imagery, it might equally be intrusive or the work of a foreign craftsman on Nigerian soil.

Of four traditions concerning the coming of bronze to Benin, the two earlier record tutelage by a foreign, white, hand. Unpopular as it may be at the present moment to acknowledge the likelihood of such tutelage, it certainly seems worthwhile to bear in mind Ryder's observation that throughout four hundred years of contact between Benin and various nations of Europe, no record emerges of an Ifè-Benin relationship in bronze until after the conquest, in 1897. It may be added that even on that occasion very responsible evidence – that of the official Court Historian, the Master Brass Caster and other nobles with their witnesses – attested foreign bronze tutelage before members of the Punitive Expedition. The recent and wholly unsupported claim of Ifè tutelage on which major chronologies have been based, ought at least to be examined in the light of the technique supposed to have been taught.

On iconographic grounds, not unsupported by oral tradition and technical observation, we have proposed a morphology for the Benin bronze based on visual problems raised in the casting of the earliest plaques. These problems also presented themselves in the three-dimensional sculpture and were met in terms of solutions already achieved in the casting of the plaques, that is to say, in planar terms. Our morphology places the resolution of these problems well into the seventeenth century and cites, in support, the association of the European trade crotal with characteristic examples, figs 80, 81. This morphology accords with Bini traditions which recall the casting of plaques as amongst the earliest essays of the Bini in bronze art. The matter of tutelage, whether from Ifè or from the Portuguese, remains to be settled. On it rests the question of a firm base for a Benin bronze chronology, and also that of the possible contemporaneity of the Bini and Ifè bronzes at fairly recent dates.

In the forest cultures the heyday of the African bronze may have occurred in a number of masterpieces of the various schools, conceived within a relatively short time of each other as social and military ascendancy, not to be dissociated from the effects of the European presence after the latter fifteenth century, passed from hand to hand, each commanding a source of

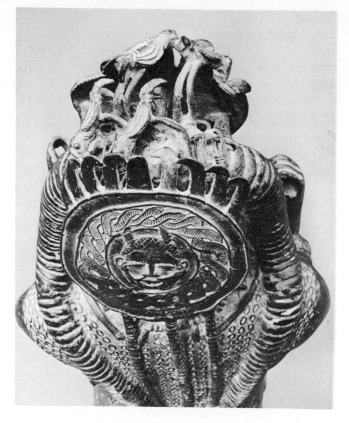

217. Tada bronze

imported brass and expressing its majesty, the sanctions of kingship, the imperatives of the Word in its forms. The needs of cult, court and the propitiation of the ancestor, institutions already well developed in particular cases, came to serve as catalysts in the emergence of various bronze forms at this time, whether influences were exercised from the north or from the coast. The apparent contemporaneity of bronze efflorescence over vast areas of West Africa needs to be examined in the light of the organisation of the slave trade and the social changes flowing from it. The sources of technique appear to have been twofold, that in the north apparently of some age. It is the conjunction of social, economic and religious factors which in particular areas tapped the resources of an available craft to produce works of sudden splendour that a future scholarship might profitably examine. In the religious context the effects of an abundant new supply of iron and its consequent ritualising in sacred forms among the Yoruba have been noted in the related cult sculpture. For bronze, in both sacred and secular form, such a study might explain the unique ease and rapidity with which the mastery of an idiom seems to have been attained; for here schools do not often seem to have served painful apprenticeships of trial and error, but to have produced masterpieces with little apparent effort. It has been seen that iron, though known in certain areas for the better part of the previous thousand years, came into fairly general use

only with the coming of Europeans, in the 'peeces' and 'wedges' of Eliza-
bethan seamen to begin with, and in the iron bar of the slave trade some
time later, while in other areas stone tools continued in use throughout
both periods. Oral tradition among the Yoruba, and the type-motifs
examined in table 1, suggest that iron was ritualised there only during the
sixteenth century, presumably as its benefits in war and the commonweal
came to be fully appreciated. But in all West African societies bronze
working is an Iron Age phenomenon. The alloy has never been indepen-
dently ritualised; there are no separate gods connected with its working to
explain its adoption. That is to say, there nowhere occurs a god of bronze.
Its coming seems to have been apprehended within ritual systems previously
associated with the working of iron. Ògún among the Yoruba and Bini,
and Gu among the Fon of Dahomey, are the deities of iron, as well as of
bronze-workers, notwithstanding the separate identity, status and func-
tions of the latter. These considerations do not suggest a date for bronze
working earlier than that which documentary evidence indicates for the
general availability of iron – the sixteenth century – at least in southern
states practising a figurative bronze art. Oral tradition suggests that for
important groups bronze was apprehended within a pre-existing *òrìṣà*
cult-structure. As the universally standard iron staff of the *òrìṣà* Òkò (god
of agriculture) among the Yoruba, with its associated fertility cult, suggests
its adoption from the digging stick of the farm, so oral tradition recalls
that the brass form of the *ẹdan* Ogboni succeeded a form whittled from
palm branches when Ajibówú, 'the first Yoruba blacksmith' came along
with the knowledge necessary for the transposition. Its traditional pole-
form, appearing in a presumably early rendering on an Ifẹ̀ terracotta pot
and continued to the present day, seems to support the tradition. The
transferring of an established *òrìṣà* idiom into bronze, if ever substantiated,
might go some way towards explaining, in this case, the mastery of a bronze
idiom with such apparent ease.

For the north, a transposition of imagery from stone to bronze is provo-
catively suggested in the identical face-markings compared in fig. 112a–f.
These comprise a stone head and three bronzes. Two of the latter, (*b, c*) are
datable at the seventeenth century or later, whilst another, (*a*) may have
been contemporaneous with events which took place in the later sixteenth
century. The face-markings indicate that the personages represented shared
a common tribe, tradition or polity. The bronze figure of (*c*) the famous
Jebba *Warrior*, has already been interpreted in terms of the ancestor form-
stereotype, exemplified in the 'Tsöede' iron chain preserved along with it
(as in the Badagry configuration at fig. 175). The Esie stone head (*d*) is one of
some eight hundred odd unearthed in the 1930s and now preserved in a
small museum at Esie village near Ilorin in northern Nigeria. While this
corpus remains undated we cannot assume the transposition of its imagery
into bronze, but the possibility that this may have occurred remains provo-
cative in the light of the apparently unheralded maturity of the Jebba-Tada
group of bronzes. On the evidence of these identical face-markings, the

small bronze head from Igbo Ukwu (*b*) is possibly also to be associated by tribe, tradition or polity with the Jebba *Warrior* at a date around the seventeenth century. This tradition, associated with well-furnished tomb burials, may be connected in some as yet unknown manner with the tumulus burials of the western Sudan. The bronze technique certainly seems to derive from the area.

The facial striations of Ifẹ royalty, of northern connections, may not be unrelated to those illustrated in fig. 112a–f. If this once again seems to raise the question of the location of the historic Ogane, it is striking that the rather primitive Ifẹ-type bronze figure in the shrine at Tada, alone of all others the centre of a continuing and apparently old worship, bears what might be the 'staff with a head' of the Ogane. A none too venerable age is suggested for certain of the Ifẹ bronzes if we regard, as scholarship unanimously does, the famous *Seated Figure* in the same collection, fig. 86, as of Ifẹ authorship. For of perhaps similar authorship are the two rather humble pieces (of which the *Staff-Bearer* is one) in the same shrine, both demonstrably cast by the technique which produced the Ifẹ *Seated Figure*, the Jebba-Tada warriors and the type-example of the Jukun bronze. Should the 'Ogboni' piece in the Tada group, fig. 85, ever be associated with the period of Ọyọ hegemony over the Nupe, then it could reasonably be dated no earlier than this event – not a great deal earlier than the middle of the seventeenth century.

The school at Ijẹbú was certainly contemporaneous with that at Benin during a great part of Bini bronze history, and may indeed have been fathered by it, though, in the African bronze no two conceptions in the expression of matter as spirit could be more opposite. From Ijẹbú the *cinquecento* method probably spread to other Yoruba workshops in the south.

The pattern of bronze efflorescence, northern and coastal, awaits detailed study involving every extant workshop on the bronze map of West Africa. The Igbo Ukwu corpus suggests that, in its particular case, a bronze technique of the western Sudan eventually penetrated to the coast, perhaps around the seventeenth century. This also seems to have been the case, by different routes, for the Ivory Coast and Ghana at around the same time. Northern influences seem far the greater in West Africa, accounting for vast areas of the bronze map. This has also been the case for iron furnace types. The northward penetration of the *cinquecento* method appears to have been insignificant, perhaps extending no farther than the forest zone of, say a hundred miles from the coast, or at any rate only marginally farther. It peters out a good way before Ilorin, even among Yoruba populations there.

Within this apparent contemporaneity, bronze chronologies for individual schools need to be attempted. Well-annotated corpora are a first requirement; by means of these it may become possible to support the inevitable guesswork, based only on apparent style affinities, which accompanies the study of such a rich field of bronze work. Data drawn from the study of

bronze casting cores, moulds, comparison with their relative native soils, and of course analysis of the alloys might aid interpretation of such corpora. Work of this nature is still in its infancy, and the techniques are not yet reliable, but its potential for the history of art in tropical Africa seems promising.

27 Icon and Image

Despite this interpretation of impulse responsible for the emergence of the several schools, conclusive affinities between impulse and form are not always easy to establish. To the anonymous craftsman are born forms severally unique in the African bronze. At Benin the secular impulse is realised in an art whose forms are not those of the sacred bronze of the Yoruba nor those of the classicising art of Ifè. The *cire-perdue* technique, though generally restricting the size of the African bronze, yet creates the near life-size pieces at Jebba and Tada. How then should we view the winning of form in the African bronze, sacred or secular, and where is the real line to be drawn between the sacred and the secular? Are Jebba and Tada and Ifè and Benin arts of the ancestor? And does not the concept of the ancestor as forever operating in the here and now of African experience itself constitute an apprehension of the sacred? Might not ancestral form therefore also

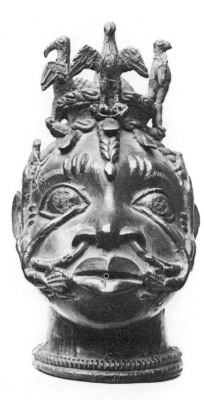

218. Benin bronze

be read as sacred form? Those 'gods and devils in human and brutish images', recorded in the seventeenth century by Dapper among the Bini, hardly represent a metaphysical tradition different from that of any other African; – how could they, given that pervading immanence of spirit central to the African interpretation of experience? The spirit of the ancestor is rendered eternal in the life of his descendants. If beyond death the power of a man can be built up in the spirit world by the devotions of his issue, such devotions live in time and assume utterance in the praise-song, the ancestor sculpture. These utterances, these 'words of power', these sculptural forms connect the living with the dead. The ancestor sculpture is not the ancestor any more than is the praise-song the ancestor. But by virtue of that spirit universally held to be indwelling in all matter the ancestor sculpture may establish communion with its spirit referent. Thus it is addressed; to it are raised sacrifices. For all these artists, even for the artists of classical Ifẹ̀, the human figure in its personal, its merely transitory reference, with its attributes of physical movement, the expression of emotion, the individual character fixed for all time in the conventionally realistic portrait piece, is eschewed in the necessities of a higher form. And what is this higher form but a product of that interaction between universal will and individual will, between law and wilfulness which informs the creation of art, African or any other. On this level distinctions between the sacred and the secular may well disappear in a reality in which universal will is universal spirit and individual will but a function of universal will. The distinction is of value nevertheless if only in acknowledging the particularly sacred or the particularly secular *functions* of African art. If to the Bini smith ancestral form is sacred form his forms are nevertheless those of an Imperial will and act. We may understand the forms of the Ifẹ̀ bronze in just these terms: sacred in the ancestral sense, secular in the functional.

And might these opposed identities of sanction and of function reflect a like opposition in those processes by means of which creative subjectivity comes to be exteriorised? Or might all creation be seen indeed as reasoned response to the will of one deity or another, for the Bini or the Ifẹ̀ artist or the artist of the mysterious Jebba *Warrior* no less than for the masters of the sacred Yoruba bronze constrained by the imperatives of the Word? These are questions whose answers need in each case to be examined in the light of the super-ego of the given artist represented in the operation of a higher law to which technique is mere handmaiden and the school a name. In the creative process the Yoruba artist obeys just such interior necessities in *realising himself*, his personal intuitions, as might a European artist. At some stage in this process the Yoruba artist finds his work taking on autonomy in its response to his questioning of the god. To the European artist likewise comes that creative moment when the work at last, as a result of the interaction between the will of the deity (his concept, his inspiration) and his personal will, answers to his intentions, to that which all along he has been trying to do; it discloses its truth in laws from which he may not thereafter wilfully depart. Both therefore know that moment in the creative

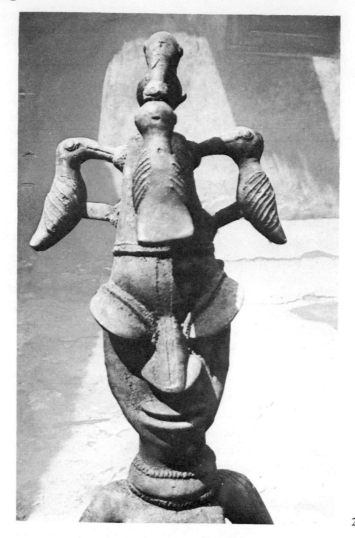

219. Yoruba bronze

process in which truth assumes autonomy in plastic form and the will of the artist is realised in the universal will. If the history of the Bini bronze is to be understood as a history of resolutions in seeing, it is a seeing of the individual artist with the universal eye and the collective mind: his resolutions could mean nothing in a vacuum.

But like as his seeing might be to that of the European artist of the Renaissance in his working out of those schemata by means of which his objective visual experience may be rendered, it is very different in its function. For whereas in Europe since the Renaissance, the artist has functioned as an agent of an ever-expanding view of reality, the Bini artist functions to sustain that most unchanging of realities – the omnipotence of the divine king. Where in Europe the spirit of inquiry is therefore free to open infinitely new frontiers of experience, the Bini artist remains but an agent for the localising of that universal spirit already known to be there and to be subject to no further revelation or interpretation. As in Egyptian art, his

forms are therefore necessarily forms of stasis reflecting that equilibrium ideally existing between the spirits of man and of all creation. His art secures this relationship in the flesh and ancestry of the Bini monarch.

Having at an early stage refined a canon suited to this end, the Bini artist saw no reason to change those forms of art in which it was expressed. In this sense the distinction between the sacred and the secular once more breaks down, for though the Bini bronze is secular in its function, its sanctions remain for ever sacred in the ancestral forms of the stereotype. The forms of the Bini bronze are those of the ivory, the terracotta and the wood, uniformly rendered without adaptation to the demands of the material. But all these secular forms are of sacred sanction, and if the distinction still suits our convenience we acknowledge it as a distinction not so much of processes in realising form but more as a distinction in methods of symbolising experience. For this transitive art of the Bini bronze knows its Other, its beholder to whom its act is addressed and who completes its existence, where the sacred, the intransitive forms of the Yoruba bronze know no Other: they are the forms of that universal spirit in which all being partakes. For the Bini or the Tada or the Ifẹ artist, time in its ancestral reference stabilises the forms of a secular art, while, in the Yoruba experience, time in the life of the person is transcended in sacred form. Where, for the one, ancestral spirit is symbolised in the manipulation of an image, for the other spirit itself secures its manifestation in the forms of an icon. Where the Bini artist continually deals with phenomena that lie outside himself, the Yoruba artist ceaselessly particularises, in the utterances of the spirits, processes essentially interior to himself: it is not the object or 'idol' that moves, but those elements of his own being, over which he seeks control, that move.

Our reading of form in African classical art has left out of account those media of expression which we have as yet no means of treating historically – media such as wood which in tropical conditions is so perishable that 'old' examples may refer to dates in the present century, and such as ivory, terracotta and stone whose remains are few and far between and whose forms do not as yet yield to independent examination; the forms of ivory are the forms of wood and may one day come to be read by techniques developed in the study of wood. Art history must await the compiling of records for African stone and terracotta before the life of forms in these media can be read for those elements of idiom and style which explain them. Our study of the ritualising of iron among the Yoruba has illustrated concepts useful in the interpretation of sacred form and these concepts hold good for our reading of the sacred bronze and for certain forms in the carving arts – concepts of the type, stereotype, archetype and icon which may indeed come to be understood as constants in the creation and interpretation of sacred form in all the media of expression employed in African classical art. We have attached a special meaning to the use of the word *icon* in its numinous reference, and in its opposition to the notation of an

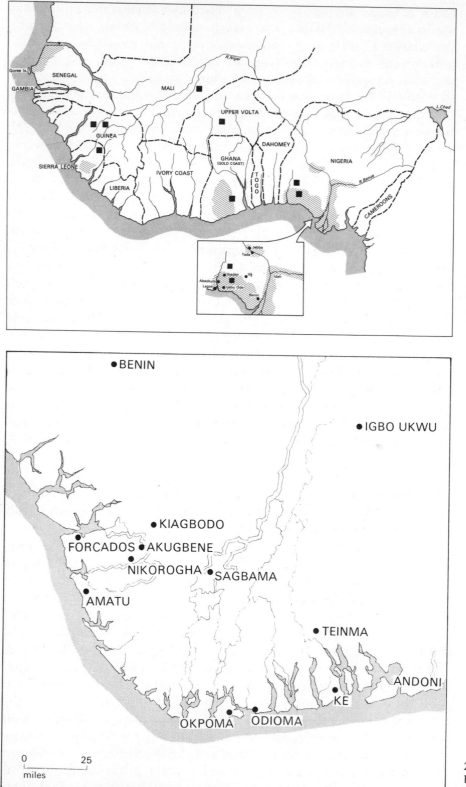

220. Distribution of the crotal and of the domed iron-smelting furnace in West Africa.

▪ The Domed Iron Smelting Furnace

▨ The Crotal or Hawk's-bell

221. Some recent finds of brasswork in the Niger delta. (After Horton)

image in its material reference. Such special meanings are unavoidable in a study where even the concept *art* is intrusive with all its implications of the non-utilitarian and the *artistic*, notions which form no part of the universe inhabited by the African artist, sacred or secular. Special meanings must always burden interpretation where interpretation rest on the terminology of an art criticism essentially alien to the body of work which it attempts to examine. Further research may yet hammer out a more manageable criticism in the interpretation of form in African classical art and the structuring of its 'chronology'.

Appendix

A Yoruba ìjálá chant

Wáwá ni orúko ọdẹ tí ḿbọ̀ l'áiyé,
Olúgbu-èlé ni orúkọ ọdọ tí mbẹ l'ọ́run;
Àwọn méjèjì l'ó ńdarí ọdẹ-ṣíṣe nínú igbó.
Ọ̀ṣọ́ọ̀ṣì nìkan ṣoṣo ni aya Ògún.
Ó ṣèrànwọ́ láti fi iṣé ọdẹ-ṣíṣe-múlẹ̀.
Ṣùgbọ́n lè ṣe ọdẹ fúnrarẹ̀
Iré pín sí ọ̀nà méje.
Ògún sì ní ọwọ́ méje pẹ̀lé.
Ògún ilé kì ík'ọ̀pẹ fún ẹyìn.
Èyí tí ó wà l'óko ńjẹ epo.

Ògún tí ó wà l'óko kì ìf'oju kàn èjẹ̀.
Ògún ọdẹ ḿmu èjẹ̀ púpọ̀.
Ògún ti Ìré sànbébé yàtọ̀
Ọ̀kan ńṣe àgbẹ̀dẹ̀, ọkan yókù kò ṣe.
Ọ̀kan ńkọ́ 'lé màrìwò, ọkan yókù kò kọ́.
Àgbàrá ńṣàn kọjá níwájú ilé ọkan.
Tí ẹnikẹni bá gbà ọ̀nà Àwòyè.
A rí Ògún ilé mi.
Ní ọ̀gangan ilé mi.
Egúnjọbí ẹní ti ilé rẹ̀ wà.
Ní àdúgbò Aremọ bí àmì iná.

[TRANSLATION]

Wáwá is the hunter in charge of the world,
Olúgbu-èlé is the hunter in charge of heaven;
They control hunting in the forests.
Ọ̀ṣọ́ọ̀ṣì is Ògún's only wife,
She helped make him the finest hunter
But could not hunt herself.
Iré is divided into seven –
And Ògún has seven arms.
Ògún of the house does not gather palm-nuts,
Ògún of the farm eats palm-oil.
Ògún of the farm does not see blood.
He of the hunters tastes much blood.
Ògún of Ìrě Sànbébé is yet another.
One builds a smithy, one does not.
One builds a palm-leaf hut, one does not.

The torrent passes before the house of one.
If anyone goes the way to Àwòyè
He will find the Ògún of my house.
In front of my house,
Egúnjọbí whose house stands
At Aremọ quarter like a beacon.

(The ìjálá was kindly accented by S. A. Ọ. Babalọlá, University of Lagos.)

Bibliography

The data on which this study has been based refer to research carried out in East and West Africa and in some European museums between 1957 and 1967. They are divided into three sections: A. *Literary Sources*, B. *Museums, Sites, and Shrines*, C. *Local and Oral Traditions*. Each section is further subdivided for ease of reference.

Abbreviations used in Section A are:

Bull. IFAN *Bulletin de l'Institut Français d'Afrique Noire*
BCAOF *Bulletin du Comité d'Études Historiques et Scientifiques de l'AOF*
IMM *Institution of Mining and Metallurgy Bulletin*
JAH *Journal of African History*
JEA *Journal of Egyptian Archaeology*
JHSN *Journal of the Historical Society of Nigeria*
JRAI *The Journal of the Royal Anthropological Institute of Great Britain and Ireland*
LNR *Lagos Notes and Records – University of Lagos Bulletin of African Studies*
MM *The Mining Magazine*
NA *Notes Africaines*
ODU *University of Ifè Journal of African Studies*
SNR *Sudan Notes and Records*
WAAN *West African Archaeological Newsletter*

Notes and References

(Numbers and letters in square brackets refer to the Bibliography, Section A: Literary Sources)

1. A Critical Terminology

1. A worthwhile reflection it seems to me since the subject has now entered the post-graduate curricula of certain African universities. Its study remains nevertheless very much the responsibility of African university and museum institutions.
2. Fagg, 'The study of African art' [101e].
3. The Nigerian Antiquities Service defines as antique any object which continues in ritual use irrespective of the date of its facture – a good example of the relative and approximate terminology employed in the discussion of African art. But these stereotype forms are the forms of dim tradition and the craftsmen still employing them work with the hand and eye of a high ancestry.
4. Eight hundred or more pieces unearthed at Esie in northern Nigeria thirty-odd years ago, and several hundred soapstone figurines in Sierra Leone still await recording and classification.

2. Ethnological and Aesthetic Factors

1. Maritain, *Creative Intuition in Art and Poetry* [18], p. 43.
2. Trowell, 'The study of African art' [26a].
3. *Ibid.*
4. Fry, *Vision and Design* [7].
5. Boas, *Primitive Art* [1], p. 144.
6. Fagg, *Nigerian Images* [101g], p. 117.
7. Focillon, *The Life of Forms in Art* [5], p. 7.
8. *Ibid.*, p. 3.
9. Paulme, *African Sculpture* [20].

3. The Genesis of Form in African Sacred Art

1. Wingert, Paulme, Trowell, Segy, Goldwater, Leuzinger, Fagg, etc. (see *Literary Sources*).
2. Gerbrands, *Art as an Element of Culture especially in Negro Africa* [8].
3. Schmalenbach, *African Art* [22], p. 40ff.
4. Griaule, *Arts of the African Native* [12b], p. 89ff.
5. Trowell, *Classical African Sculpture* [26b], p. 23ff.
6. Gerbrands, *op. cit.* [8], p. 69ff.
7. Verger, 'The Yoruba High God' [27a]. The *òrìṣà* constitute the pantheon of Yoruba gods.
8. Horton, *Kalabari Sculpture* [13b], pp. 4–8.
9. Williams, 'Iconology of the Yoruba Ẹdan Ogboni' [137a], p. 14.
10. Horton, [13b], p. 15.
11. Griaule, [12b], p. 69.
12. Verger, [27a].

13. True steel was never consciously produced by the African smith, though wrought iron acquired an effective hardening in the smithy by repeated hammering and reheating in the presence of charcoal to remove slag impurities – a process by means of which the metal absorbed small quantities of carbon.

14. A Nigerian journalist writing on 'What is the Purpose of Art', *Daily Express* 14 October 1965, states 'I would assert that it is the emotional expression of a temperamental being. The primary purpose of art is the communication of feeling', an attitude which needless to say would be incomprehensible to the traditional African artist.

4. The Interpretation of Sacred Forms

1. They are claimed in a hunter's praise-song (ìjálá) to be: (1) those who use knives or other iron tools in the house or village, (2) palm-wine tappers, (3) farmers, (4) hunters, (5) Ògún On'Ìrè – the Chief of Ìrè, the village in which Ògún is claimed to be buried, (6) blacksmiths, (7) all other worshippers of Ògún. (See also Appendix 1.)

2. Thomas, 'Time, myth and history in West Africa' [25], pp. 50–92.

3. Rattray, *Religion and Art in Ashanti* [77b], p. 141.

4. Verger, 'The Yoruba High God' [27a].

5. Horton has recorded the function of sculpture as a 'name' for the spirit among the Kalabari, the relationship held to exist between the appropriate assembly of type-motifs and spirit-occupation of the sculpture, and the role of the artist as priest: *Kalabari Sculpture* [13b], pp. 10, 17, 19.

6. Williams, 'Iconology of the Yoruba Ẹdan Ogboni' [137a], p. 141.

7. Verger, [27a].

5. The Forms of the Cult-Object

1. Horton, *Kalabari Sculpture* [13b]. pp. 27–39.

2. Most renderings of the *oṣe* Ṣàngó are in wood, though examples occur in brass and in iron. The symbol ▷◁ might represent a very ancient legacy from the Nile. For the iconography of the thunderbolt sign as it arose in pre-historic Egypt, its development through pharaonic times as the name of the sky-god, Min, his relationship with Amun, Zeus, and sky-gods in Asia Minor, see Wainwright, 'The emblem of Min' [85a], p. 185ff. Wainwright does not distinguish separate symbols for the lightning- and thunder-attributes of these gods; the *labrys* symbol, ⋈ , signifying an archaic Egyptian weapon, was used in the archaic period as a pot mark (*ibid.*, p. 192). We might note that Zeus, worshipped in the thunderbolt, gave birth to Hephaistos, the blacksmith god, one of the twelve great gods of Olympus. Palmer records that the name of the petty market-broker of the Hausa who battens on both buyer and seller, and thus 'faces both ways' to make a living – the market-broker called Dan Baranda – is of similar origin to that of Zeus Labarandeus, the Greek deity of ancient Crete. Both names come from the sacred double-headed axe which by the Hausa is called Barandami: Palmer, *Bornu, Sahara and Sudan* [115b], p. 2.

3. This and other urns reproduced are in the collection of the author. Similar ones remain in use in the Ṣàngó shrine at the palace of the Aláàfin of Ọyọ in western Nigeria.

4. Westcott and Morton-Williams, 'The symbolism and ritual context of the Yoruba Labà Shango' [132].

5. *Ibid.*, p. 34.

6. *Ibid.*, p. 31.

7. Known in Egypt from Predynastic times.

8. Dark, 'Benin: a West African Kingdom' [98a], p. 199.

7. The Conventions of African Art

1. For a detailed treatment of the Egyptian canon see Panovsky, *Meaning in the Visual Arts* [19], p. 55ff.
2. Gombrich, *Art and Illusion* [10], p. 63.
3. Lavachery, *Statuaire de l'Afrique noire* [16], p. 52.
4. Griaule describes an African sculptor *squaring* his tree-trunk before commencing work: *Arts of the African Native* [12b], p. 78.
5. Frankfort, 'On Egyptian art' [6].
6. Gombrich, [10].
7. Griaule, *Arts of the African Native* [12b], p. 70.
8. Horton, *Kalabari Sculpture* [13b], p. 9.
9. Williams, 'Iconology of the Yoruba Ẹdan Ogboni' [137a], p. 147.
10. *Ibid.*, pp. 144–6.
11. Ṣowande, in *Composer*, [23], pp. 25–34.

8. Processes of Style Change

1. Virginia Woolf, *To the Lighthouse*, ch. 1 (4).
2. Schmalenbach, *African Art* [22], p. 86.
3. Remarkable instances of this personal interpretation of the stereotype in modern times are from the hands of Areo-Ògún of Oṣe-Ekiti. Since completing this book Kevin Carroll's impressive *Yoruba Religious Carving* (London, 1967) has appeared. It documents the persistence of the stereotype through three successive generations of Ekiti sculptors in a manner that could not be clearer. Brass-casters of the Ọbọ school (northern Yoruba) could similarly be studied in this respect.

9. Iron in African Antiquity c. 700 BC – AD 500

1. Wainwright, 'Iron in Egypt' [85b].
2. Petrie, *Tanis* [75b], pp. 48, 79.
3. Petrie, *Naukratis* [75a], p. 39.
4. *Ibid.*
5. *Ibid.*
6. Wainwright, 'Iron in the Napatan and Meroitic Ages' [85d], p. 14.
7. Diodorus, 1.67.9.
8. Petrie, *A History of Egypt* [75c], p. 331.
9. Arkell, *A History of the Sudan* [31a], p. 130.
10. Aitcheson, *A History of Metals* [29], p. 137; Forbes, *Studies in Ancient Technology* [56b] viii, 137; T. A. Rickard, *Jour. Royal Anthr. Inst.*, 71, 1941.
11. Arkell [31a], p. 130.
12. Forbes *loc. cit.*
13. Wainwright, 'Iron in the Napatan and Meroitic Ages' [85d], p. 9.
14. Hdt. vii. 69.
15. A lugged axe-head of a type used in Egypt from the XIIth Dynasty to the XXVIth – that founded by Psamtik I. An example from the reign of Amenhotep III is similar to the Nubian specimen in carrying down-turned lug ends to hold the lashing. Originally in bronze the form, according to Petrie, was transferred to iron *c.* 800 BC.
16. Arkell, A History of the Sudan [31a] p. 149.
17. Wainwright, 'Early records of iron in Abyssinia' [85c].
18. *Ibid.*
19. Diagrammatically reconstructed by the author from fragments in the Sudan Museum, Khartoum (acc. nos. 4953, 4954). See also, Williams 'An outline history of tropical African art' [137e], p. 59ff, and Garstang, 'Excavations at Meroë' [59a], *passim.*

20. A proportion of up to 2.0 per cent of carbon absorbed changes the character of wrought iron to steel, an unfamiliar and unworkable metal to the African smith. Reduction commences at around 800°C, and the metal runs liquid at around 1530°C. Molten metal accidentally produced in a traditional Nigerian furnace is in the possession of the author. It was regarded by the smith as spoiled.

21. Dixey, 'Primitive iron ore smelting methods in West Africa' [50], p. 213ff., described nearly a century earlier by A. G. Laing, *Travels in the Timanee . . .* [68].

22. Campbell, 'Native iron smelting in Haute-Guinée' [40], *passim.*

23. Desplagnes, *Le Plateau Central Nigerien* [48] text figure.

24. Francis-Boeuf, 'L'Industrie autochthone de fer' [57], pp. 404, 464.

25. Forbes, 'The black man's industries' [56a], p. 234.

26. Wild, 'An unusual type of primitive furnace' [133a], *passim.*

27. Sayers, 'The funeral of a Koranko chief' [80], p. 19.

28. Goody, 'The Mande and the Akan hinterland' [11], p. 195ff.

29. Desplagnes [48], p. 63.

30. Lewicki, 'L'État nord-Africain de Tahert . . . à la fin du VIIIe-siècle' [108], *passim.*

31. Mauny, 'Histoire des métaux en Afrique Occidentale' [112c], p. 578.

32. Coghlan, *Notes on Prehistoric and Early Iron in the Old World* [44], p. 88.

33. Aitcheson, *A History of Metals* [29] i, 116.

34. See note 26. The type was described by an old smith in the northern Yoruba village of Ìfàkí; there were no remains to examine. The remains of an apparently similar example were examined at the village of Gbadamu, north of Ilorin, but this was in too advanced a state of ruin to be identified with certainty. Verbal description however fitted the type.

35. Frobenius, *The Voice of Africa* [58], ii. p. 116.

36. Nadel, *A Black Byzantium* [72], p. 264.

37. Arkell, *Wanyanga* [31b], p. 15.

38. Fagg, 'Radio-carbon dating for the Nok culture' [53].

39. Cline, *Mining and Metallurgy in Negro Africa* [43], p. 82.

40. Eyo, 'Excavation at Rop rock shelter' [52], p. 9.

41. Ozanne, 'The Iron Age in Ghana' [73a], *passim.*

42. Mauny, *Tableau Géographique de l'Ouest Africain au Moyen Age* [112e], p. 315. See also Wainwright, 'Pharaonic survivals between Lake Chad and the West Coast' [85e], and Palmer, *Bornu, Sahara and Sudan* [115b], p. 193, n. 5. Palmer's observation that the throwing-knife is confined to Bornu and the Lower Shari may be quoted in this connection.

43. Clarke, *The Prehistory of Southern Africa* [42], p. 285ff.

44. Summers, 'The Southern Rhodesian Iron Age' [81], p. 4ff.

45. Arkell, *A History of the Sudan to 1821* [31a], pp. 37, 39.

46. The art of Meroë, like much else in the African plastic, awaits comprehensive study in its various influences, Egyptian, Roman, Byzantine, and of course Negro African. Its technical inheritance embodies bronze-casting, relief stone carving of a high order and a monumental stone sculpture, fine jewellery and gold-leaf work, a now virtually vanished mural decoration in fresco, painted pottery and a high architecture.

10. The Iron Age and the Iron Bar, c.500–c.1650

1. Astley, *New General Collection of Voyages and Travels* [32], iii, p. 582.

2. Fernandes, *Description de la Côte Occidentale d'Afrique* [54], p. 25.

3. Gomes, *De la première découverte de la Guinée* [60], pp. 28, 30, 40.

4. Examples made among the Yoruba of Nigeria a generation ago are described as having been carved from the palm branch and dipped into a concoction made up of the heads of poisonous snakes exactly as described in the twelfth century *Tohfut ul Alabi*, Palmer, *Sudanese Memoirs* [115a], i, 90: 'They shoot arrows poisoned with the venom of a yellow snake; hit with that venom, within an hour the flesh drops

from the bone even in the case of an elephant or other beast.' The Yoruba bow was made of the *Aringo*, or the *Erin*, trees, both noted for toughness and pliability. The potency of the poison was graded according to the size of the quarry, in doses suitable for small birds to those for large animals and human beings. Iron-tipped arrows were used contemporaneously with poisoned ones of reed.

5. Ifemesia, 'British enterprise on the Niger, 1869' [64], p. 19ff. The Turkish swords were later imported by Europeans in the coastal trade in answer no doubt to demand for an already desired article (Dapper, *Description de l'Afrique* [47], p. 301), but sword blades were crossing the Sahara into Nigeria into quite modern times (Nadel, *A Black Byzantium* [72], p. 270).

6. Barbot, *A Description of . . . the Western Maritime Countries of Africa* [33], p. 143.

7. Fernandes, *Description de la Côte Occidentale d'Afrique* [54], p. 77.

8. *Ibid.*, p. 49. It is amusing to note that John Hawkins, in 1597, observing only wooden arrowheads at Sierra Leone, concluded that the only metal weapon known there was a sword owned by the king.

9. Mavrogordato, 'Industries of the Colony and Protectorate' [70].

10. In the funeral obsequies of a Koranko chief, for instance, the dance of the black-smiths precedes that of the king's son. Masks of beaten brass are incidentally mentioned as used in these rites: Sayers, 'The funeral of a Koranko chief' [80], p. 26, and Kamare, 'Koranko funeral customs' [66], p. 153.

11. Ozanne, 'The Iron Age in Ghana' [73*a*], p. 6ff.

12. Jeffreys, 'Some notes on the Kwaja smiths of Bamenda' [65*b*].

13. Arkell, *A History of the Sudan to 1821* [31*a*], p. 166.

14. Wainwright 'Diffusion of -*Uma* as a name for iron' [85*h*] has traced the Jaga (Angola) name for iron from southwest Abyssinia; among the Jaga it appears only in the sixteenth century. See [85, *j*].

15. Clarke, *The Prehistory of Southern Africa* [42], p. 288; see also Cline, *Mining and Metallurgy in Negro Africa* [43], p. 37.

16. Summers, 'The Southern Rhodesian Iron Age' [81], p. 4.

17. Astley, *New General Collection of Voyages and Travels* [32] i, 176.

18. *Ibid.*, i, 152.

19. Howard, ed., *West African Explorers* [62], p. 30. Notwithstanding John Hawkins' association with the early slave trade, Jobson in 1620 rejected it on the Gambia as outside British interests or morality; but by 1651 the British were committed to slaving. (See Guinea Co. to James Pope, letter of 17 Sept. 1651 in [51] i, 26.)

20. A wide range of such currencies is held in the British Museum Collection.

21. Barbot [33], p. 144.

22. *Ibid.*, p. 45. At Warri in the Niger Delta the present author examined a bar 4.5 m long and 8 cm square, claimed to have been trade iron.

23. Donnan, *Documents Illustrative of the History of the Slave Trade to America* [51], i, 217.

24. *Ibid.*, i, 262. Barbot mentions flat iron bars as most acceptable on the Gold Coast 'for the round or square ones will not do' (*ibid.*, i, 295).

25. *Ibid.*, i, 256.

26. *Ibid.*, ii, 396.

27. Astley [32], p. 119. The tablet, 5 cm by 4 cm by 1 cm seems accurate enough, though for this the original division of the bar would have been into more than twelve parts.

28. Donnan [51], i, 421; ii, 96.

29. *Ibid.*, i, 202.

30. The Dutch traveller D. R., in Bosman, *A New . . . Description of the Coast of Guinea* [96].

31. Donnan [51], i, 274.

32. Astley [32], p. 305.

11. The Ritualising of Iron, c. 1530–1900

1. So far back as the seventeenth century the blacksmith's anvil is described as of granite: Bosman, *A New . . . Description of the Coast of Guinea* [96], p. 128.
2. Twenty-one pieces of iron appear among Òrányàn's inheritance from his grandfather Odùduwà, the common ancestor of all Yoruba peoples: Johnson, *A History of the Yoruba* [14], p. 9, though Johnson discredits the tradition.
3. For Senegal see Bodiel, 'Le Dieungue ou anneau de cheville d'esclave' [37], p. 13; and Ivory Coast, Clamens, *ibid.*, [41], p. 46.
4. It is of wrought- and not of cast-iron, as Frobenius's engineer supposed (Frobenius, *The Voice of Africa* [58] i, 302) and is sacrificed to at present along with a block of stone lying beside it. Frobenius records its translation to stone in oral tradition. From the same period, possibly, are the iron eyes in the granite crocodile, or snake, in the Ifè Museum; iron is also embedded in a terracotta fragment in the same collection.
5. Ajayi and Smith, *Yoruba Warfare in the Nineteenth Century* [30], p. 17.
6. Frobenius [58], i. 302.
7. Johnson, *A History of the Yoruba* [14], p. 126.
8. An Oṣogbo tradition collected by the author.
9. Wainwright, 'The coming of iron' [85f], p. 11.
10. Johnson, *A History of the Yoruba* [14], p. 35. The *Nigerian Daily Times* of 16 June 1967 reports a disaster in which two were killed and fourteen injured by lightning. Rescue police needed to break the resistance of Ṣàngó worshippers who claimed 'nobody must remove the victims of the storm until after some ceremonies shall have been performed'. These ceremonies were not allowed.
11. To the present day an important rite in the coronation of an Alàáfin (king) of Ọyọ is his consecration with the iron Sword of Justice of Órányàn. See also Johnson [14], p. 45.
12. Beier, *A Year of Sacred Festivals in one Yoruba town* [35b], p. 42.
13. *Ibid.* It is to be noted too that the *òrìṣà* of the Yoruba pantheon are varied in origin, all having separate local derivations; the areas of their influence are only rarely universal. Thus Òrìṣà Òkò, originating in the tiny rock-bound village of Ìràwò is today worshipped in most parts of Yorubaland, while the far more important Ogboni earth-cult, originating in the south, perhaps at Ijèbù-Òde (where it is today known as Oṣùgbó), is largely unknown among the northern Yoruba. Many cults remain strictly local, with consequent differentiation in art idioms.
14. Or fifteen years to a reign. But it has seriously been pointed out that this method of applying a mean reign to Yoruba king-lists is subject to error where such considerations as changes in the manner of succession are taken into account. The king-list was related to me by the On'Ìrè, supported by his priests and elders. Another for five Ekiti towns including Ìrè is contained in the *Ọye Intelligence Report, 1933*. In this the Ìrè list comprises only twenty-two names, the first seven sovereigns being claimed to have ruled at a nearby site before Ìrè was settled. The names can be collated in only a few cases, different parts of a single king's name having apparently been used for the same monarch in the two versions. The report gives no sources. It was kindly supplied by Mr. John Picton of the Nigerian Antiquities Service.
15. Williams, 'Iconography of the Yoruba Ẹdan Ogboni' [137a], p. 162.
16. Fernandes. 'Description de la Côte Occidentale d'Afrique' [54], p. 85; Read and Dalton, *Antiquities from the City of Benin . . .* [119], p. 11.

12. The Ritual Basis of Sacred Forms in African Iron Sculpture

1. Pierre Verger; verbal communication, December 1965.
2. Johnson, *A History of the Yoruba* [14], p. 66.

3. The pair of pincers in brass or in iron, is known as an amulet in Liberia, on the Ivory Coast, and in Senegal; see *Notes Africaines*, **51**, 1951, p. 80 and **48**, 1950, p. 23.

4. Mistakenly described by Mungo Park as a lashing to prevent cracking of the furnace wall. The Nigerian novelist, Achebe, describes the new palm-frond as a symbol of war among the Ibo (*Arrow of God*, p. 18).

5. Johnson [14], p. 37. The neck-chain would refer to the *gbàna* already discussed as a type-motif of Ògún.

6. Not considered here is the little-known staff of the cult of Ògìnyán – the *òrìsà* of the New Yam.

7. Smith, 'Ijaiye, the western palatinate of the Yoruba' [125*a*].

8. Mercier, *Les Ase de Musée d'Abomey* [71], p. 11ff.

9. Walton, 'Iron gongs from the Congo and Southern Rhodesia' [86].

13. *African Bronze Workers and the Western Sudan, c.* AD *950 – 1484*

1. Herodotus, iv. 196.

2. Mauny, 'Histoire des métaux . . .' [112*c*], p. 565.

3. The famous Afro-Portuguese Ivories, Fagg, *Afro-Portuguese Ivories* [101*j*]. The *genre* seems even older than the date proposed by Fagg (sixteenth century), for at the time of its observation by Fernandes in 1506–10 specialisation was already well developed to Portuguese demand: Ils font des travaux en ivoire vraiment merveilleux de tous les objets qu'on leur demande de faire; d'aucuns font des cuillères, des autres des salières, des autres des poignées pour les dagues et d'autres subtilités: Fernandes, *Description de la Côte Occidentale d'Afrique* [54], p. 97. Though the British Museum considers these objects to have been carved in Portugal, the document indicates that they were made in Africa by Africans, on which grounds the current title of the *genre* hardly seems justified.

4. After comparing the asymmetry of the famous Tada *Seated Figure* with the work of Myron (it could more aptly be compared with the work of the neo-classical French sculptor Maillol) Fagg says of the other bronzes in the same shrine that they have no such special aesthetic interest, being conformable to African aesthetic convention: [101*d*], p. 62.

5. Bovill, *The Golden Trade of the Moors* [2], p. 123. But for a refutation of this as historical fact see Mauny, 'Le Judaisme . . . et l'Afrique Occidentale' [112*a*], p. 359.

6. Law, 'Contacts between the Mediterranean civilisations and West Africa in pre-Islamic times' [106], p. 57.

7. Mauny, 'État actuelle de la question de Ghana' [112*b*], p. 464.

8. Lewicki, 'L'État nord-Africain de Tahert et ses relations avec le Soudan Occidental à la fin de VIIIe siècle' [108].

9. Gibb, *Ibn Battuta* [103], p. 317.

10. Bovill ([2], p. 69) speaks of brass among imports to Ghana in the ninth century, and copper is mentioned in the trade *c*. AD. 950: Mauny [112*c*], p. 565.

11. Desplagnes, *Le Plateau Central Nigerien* [48], p. 15ff.

12. Brouin, 'De nouveau au sujet de . . . Takedda' [97], p. 90.

13. Equivalent to a dinar: Gibb [103], p. 356.

14. Crucibles were recovered among the remains of such a forge near Takedda by Mauny, 'Découverte d'un atelier . . . à Marandet' [112*d*].

15. Astley, *New General Collection of Voyages and Travels* [32], i, 577–80.

16. Bower, 'Native smelting in equatorial Africa' [39], p. 137.

17. Arkell, *A History of the Sudan to 1821* [31*a*], p. 208ff.

18. Mauny [112*d*].

19. *Ibid.*

20. Lebeuf, *Archéologie Tchadienne* [107], p. 126.

21. Howard, *West African Explorers* [62], pp. 60, 64ff.

22. Donnan, *Documents Illustrative of the . . . Slave Trade to America* [51], ii.

23. Astley [32], i. 18. This reference by De Barros (*De Asia*) ought to be considered along with an earlier one of Duarte Pacheco Periera (*Esmeraldo de Situ Orbis* [74]) which locates 'Hooguanee' some 100 leagues inland 'to the east' of Benin. Periera mentions another king nearby called Licasaguou, who was lord of many peoples and possessed great power. Despite his specific location of these rulers to the east of Benin, certain opinion has identified Licasaguou with the Aláfin of the Yoruba empire at Ọyọ Ilé, and Hooguanee with the Oni of Ifẹ, both of which towns lie to the northwest, not east, of Benin. No satisfactory argument has so far been advanced in support of either identification.

24. Lebeuf [107], p. 114.

25. Fagg, *The Sculpture of Africa* [101*d*], p. 64, and *Nigerian Tribal Art* [101*f*], p. 32; Dark and Forman, *Benin Art* [98*c*], p. 18ff.

26. The first Portuguese reached Benin, and thus completed the navigation of Guinea, in 1485. The use of brass in kingship ritual at Benin perhaps pertains to a tradition extant at the same date; see ch. 15, n. 10.

14. The Bronze Schools and their Techniques

1. Horton, 'A note on recent finds of brasswork in the Niger delta' [13*a*], p. 90, n. 1.

2. *Ibid.*

3. Open-mould casting occurs in West Africa, for instance among the Aṣante (see Wild, 'Open-cast moulds . . . in Ashanti' [133*b*], p. 19, but no known schools have resulted from the practice of this technique.

4. Malcolm, 'A note on brasscasting in the Central Cameroons' [110].

5. Desplagnes, *Le Plateau Central Nigerien* [48], p. 367.

15. Ifẹ-Benin

1. The University of Ifẹ archaeologist, the late Oliver Myers: verbal communication.

2. Marquart, *Die Benin Sammlung* [111], p. 52.

3. The oral literature of the Yoruba records at least six locations of the traditional Ifẹ: The first and probably the original one is Ifẹ Oòdáyé. Others are Ifẹ Nlẹẹre. Ifẹ Oòyèlagbòmoró, Ifẹ Wàrà, Otu Ifẹ, and the present site referred to as Ile-Ifẹ; see Abimbola, 'Ifa divination poems as . . . historical evidence' [87], p. 21.

4. On the occurrence of these potsherd pavements at Benin, Owo, Ifaki, Ikerun and Ede: at Ketu and Dassa in Dahomey, and in Togo, Willett concludes that 'the cultural influence of Ifẹ was evidently widely spread' (*Ifẹ in the History of West African Sculpture* [135*b*], p. 304). But, in reviewing this work, Connah (*JHSN* 4, 2.1968) points to the unwisdom of treating the potsherd pavements as a culture indicator of Ifẹ. According to this archaeologist, 'examples have been excavated at Diama in Bornu, and have been observed weathering out of the surface of a mound in the Tchad Republic'. The manufacture of glass beads is today a Nupe industry unique in Nigeria. While it is unknown among the present inhabitants, evidence of glassworking has been recovered at Ifẹ. Nupe connections suggested by this industry, the distribution of the potsherd pavements, and technical evidence in bronze casting which will be examined later, all indicate traditional Ifẹ relations of an important nature with cultures north of the Niger.

5. Read and Dalton, *Antiquities from the City of Benin . . .* [119], p. 6. The information was obtained in Benin City from the Court Historian, the Master Smith, the Master Woodcarver, and the Master Ivory Carver, with three witnesses.

6. Egharevba, *A Short History of Benin* [99], p. 12. In another oral tradition recorded in 1918 the Bini brass-workers claim descent from the kings of Ufe, one of whom had married the daughter of a brass-worker. She bore seven sons all but the youngest of whom became kings. Reflecting that his mother was the daughter of a brass-worker this youngest son himself became a blacksmith. From Ufe he was sent to

greet the king of the Edo (Bini) and he remained there to found the colony of brass-workers: Thomas, 'Nigerian notes', [83*b*].

7. Talbot, *The Peoples of Southern Nigeria* [129], iii. 924; von Sydov, 'Ancient and Modern Art in Benin City' [128*b*].
8. Smith, *Kingdoms of the Yoruba* [125], p. 106.
9. Ryder, 'A reconsideration of the Ifè-Benin relationship' [121], p. 25ff.
10. This tradition was related at the court of the King of Portugal in 1540 by a man then aged 'about seventy years'; it was possibly therefore a tradition of at least the fifteenth century. See chapter 13, note 26.
11. It is strange that Egharevba's *History* [99] does not mention the Ogane, nor the all important brass insignia sanctioning kingship at Benin – remarkable in a work which is a history of kings and little more.
12. Attempts have been made to identify these (Fagg, *Nigerian Tribal Art* [101*f*], p. 10) as corroborating an Ifè-Benin succession in bronze-casting. Fagg, *The Sculpture of Africa*, [101*d*]: 'The tradition states that until the late thirteenth century the necessary memorial head of a deceased Oba could not be made at Benin but had to be obtained from the Oni of Ifè, the Oba's spiritual overlord, to whom also (according to one story) the dead king's head was sent for burial.'
13. Smith, *Kingdoms of the Yoruba* [125*e*], p. 105.
14. Palmer, *Bornu, Sahara and Sudan* [115*b*], pp. 146–7. Archaeological dating for the Sao is around the eleventh century: Lebeuf, *Archéologie Tchadienne* [107], p. 126.
15. *Ibid.*, p. 146.
16. *Ibid.*, p. 138. At Ifè the five-metre granite obelisk to the Yoruba culture hero, Òrányàn, bears a trident design of iron nails driven into the stone. Palmer deals at some length with the symbolism of the trilith among the Teda, the Tuareg, the Hausa, etc. (p. 202).
17. According to Dark (*Benin Art* [98*c*], p. 39) the motif is always associated in Benin with the Oba Ohē who is identified with the sea, with the great waters of the earth, hence the mud-fish feet. To Fagg and Plass (*African Sculpture* [102]) the god Olokun, god of salt water, is represented in such plaques as an Oba, perhaps the Oba Ohen of the fourteenth century, who becoming paralysed, gave out that he had become the sea god (p. 105).
18. Egharevba [99], p. 54; Fagg [101*f*].
19. This face marking is still to be observed at the present day; informants at Ifè claim it to be produced by the application of a natural juice.
20. Ryder, 'A reconsideration of the Ifè-Benin relationship' [121], p. 34.
21. One tradition credits Esigie with the development of bronze casting and with first organising the bronze casters into ward guilds, Bradbury, 'Chronological problems in Benin history' [94*b*], p. 274.
22. Ryder [121], p. 34ff.

16. The Benin Bronze Chronologies

1. Fagg, *The Sculpture of Africa* [101*d*] and *Nigerian Tribal Art* [101*f*]; Dark and Forman, *Benin Art* [98*c*].
2. Luschan, *Die Altertümer von Benin* [109]; Struck, 'Chronologie der Benin-Altertümer' [127].
3. Fagg, *Nigerian Images* [101*g*], p. 32, and *Nigerian Tribal Art* [101*f*]; the date persists in a still later publication, Fagg, 'The restoration of a bronze bowman from Jebba' [101*h*] in which Ifè is assigned to 'perhaps about the twelfth to fourteenth centuries'; see also Willett, *Ifè in the History of West African Sculpture* [135*b*].
4. Dapper, *Description de l'Afrique* [47], p. 308.
5. Bosman, *A New . . . Description of the Coast of Guinea* [96].

6. This terminal date is crucial to the author in establishing the 'sheet anchor' of his chronology, for it defines a putative 'middle period' to which all other sculptures of similar style-characteristics are assigned: Fagg [101*g*], p. 33, and [101*f*].
7. W. Fagg, verbal communication, July 1966.
8. Roth, *Great Benin . . .* [120], p. 175ff.
9. Letter from W. Fagg, 24 June, 1966.
10. Read and Dalton, *Antiquities from the City of Benin* [119], p. 9.
11. Roth [120], p. 176.
12. Dark and Forman [98*c*], p. 19ff. The notion that the plaques were ripped down from the palace pillars is offered by Segy (Segy, *African Sculpture Speaks* [21], p. 181) as admitted conjecture based on the reports of Dapper and van Nyendael.
13. Gerbrands, *Art as an Element of Culture . . .* [8], p. 114.
14. By a local smith, for the installation of Oba Akenzua II. A neo-traditional industry continues there to the present day, producing a much sought after and expensive tourist art.
15. In the Portuguese method taught in the Congo a model of the object to be cast is pressed into a clay matrix which when dry serves as a mould for receiving the molten alloy. For other open moulds see Wild, 'Open-cast moulds . . . in Ashanti' [133*b*]; Torday, *On the Trail of the Bushongo* [84*b*], p. 211; but the figurative bronze art of West Africa is universally based on the practice of the *cire-perdue* method.

17. The Benin Canon and the Basis of a Benin Bronze Chronology

1. An art of secular portraiture is sometimes claimed for the Bushongo connected with the court of Shamba Bolongongo, around 1600, but the claim cannot seriously be entertained.
2. Gombrich, *Art and Illusion* [10].
3. Kielland, *Geometry in Egyptian Art* [15], p. 23.
4. An estimate of William Fagg's (personal communication). If correct the figure does not suggest a much longer history for the Benin bronze than the four hundred years proposed above, for even on this reckoning they would have been cast at the average rate of less than two a month. It seems unlikely that significant new hoards of Bini bronze art will ever come to light; excavation of the palace area has been thorough. A bronze caster's belongings, recently recovered, comprised scraps of old objects ready for the crucible – a preparation still familiar to today's smith. Other unsatisfactory castings apparently found their way out of Benin, for example a mask associated with Ajàká in an Ògún shrine at Omuo village.
5. Underwood, *Bronzes of West Africa* [130], p. *v*.

18. Technique and the Ifẹ̀-Benin Relationship

1. For a more detailed description of the process see Williams, 'Lost-wax brasscasting in Ibadan' [137*c*].
2. These analyses were kindly made by Dr S. Oke of the University of Ifẹ̀, and by Mr Mowete of the University of Ibadan, to both of whom I again offer thanks. Analyses of a very wide range of samples are indispensable to further study.
3. Baker, 'Examination of the Ifẹ̀ bronze heads' [92].
4. Fagg, 'The examination of the Ifẹ̀ bronze heads' [101*i*].
5. A brass smith from Asude Compound, Isalejebu, Ibadan: Copper is very difficult to cast; it is very heavy and does not run easily. Zinc is required to help it to run. Zinc melts more easily than copper. When mixed with copper it makes brass. To protect the zinc inside the crucible it is packed around with copper. At the last moment before pouring, more zinc is added to the molten copper. As soon as this melts a few more bits of copper are thrown in. Everything is stirred, and at once the

crucible is poured. Tin is black iron so it cannot be mixed with copper; it is for blacksmiths.

Tin:	irindudu	Brass:	ideh
Zinc:	dotia	Bronze:	(no name, no know-ledge)
Copper:	baba	Aluminium:	bèlèjé

6. This sample, the door-pull of an old motor-car, in fact contained a high percentage of cadmium.
7. Gomes, *De la premiere découverte de la Guinée* [60], pp. 34, 38.
8. Pereira, *Esmeraldo de Situ Orbis* [74], p. 131ff.
9. Read and Dalton, *Antiquities from the City of Benin . . .* [119], p. 17.
10. Oliver Myers, personal communication. (See also WAAN **6**, 1967.)

19. The Ọbọ School

1. Though we hope that core analyses might one day suggest affinities or differences, since a relationship might be held to exist between the chemical composition of the core-stuff of a given bronze and its relative native soil, a relationship which might be expressed in the presence of common elements.
2. Hamelin ('Les bronzes du Tchad' [104], p. 390) has attributed the incredible thinness of certain Sao calabash castings to the use of this method.
3. From a local church record I have established that he died 24 July 1938.
4. Cline, *Mining and Metallurgy in Negro Africa* [43].

20. The Jebba-Tada Bronze

1. Fifteenth century, in a recent Nigeria Museum attribution.
2. At some future date these bronzes might all be X-rayed to establish the exact role of iron in cores where iron has been used. A number of small Yoruba bronzes have been successfully X-rayed for this purpose, using medical equipment. Bini bronzes X-rayed with the same equipment could not be penetrated. For results on even larger pieces in the 'Ifè' group at Tada and on the large warriors in the same collection industrial apparatus, not at present available in Nigeria, would be required. More detailed work on cores is possible in establishing groupings, not only in their relationships to each other, but also in their relationship with their native soils. Measurements concerned with the geometry of proportion as expressed in ideal rectangles might profitably be applied to such groups, most obviously to such as the Jebba-Tada warriors and their female companion piece.
3. Palmer, *Bornu, Sahara and Sudan* [115b], p. 65.
4. *Ibid.*, pp. 125, 135–6.
5. *Ibid.*, p. 95.
6. Arkell, *A History of the Sudan to 1821* [31a], p. 210, fig. 26.
7. Baumann and Westermann, *Les Peuples et les civilisations de l'Afrique* [93], p. 76, fig. 20.
8. Fagg, *Nigerian Images* [101g].

21. The Yoruba Sacred Bronze

1. For political and judicial functions of the Ogboni among the Egba: Biobaku, *The Egba and Their Neighbours* [95b], p. 5ff, and 'Ogboni, the Egba Senate' [95a], p. 257; for the cult organisation among the Ọyọ: Morton-Williams, 'The Yoruba Ogboni cult in Ọyọ' [113].
2. Beier, *A Year of Sacred Festivals in One Yoruba Town* [35b], p. 8.
3. Morton-Williams [113]. This I have personally witnessed.

4. Smith, 'African symbolism' [24],

5. Morton-Williams [113].

6. Williams, 'Iconology of the Yoruba Edan Ogboni' [137a], p. 162.

7. As a diagnostic in the dating of West African bronzes the smoking pipe will be considered later, ch. 25.

8. A possible school at Ọyọ-Ilẹ̀ will be discussed presently, ch. 23.

22. The Ijẹbú Smith and Bini Tradition

1. Roth, *Great Benin . . .* [120], p. 113.

2. This motif of everted snakes running up each cheek has already been noted for Ifẹ̀, Benin and Ijẹbú. It might perhaps represent a transposition of the theme of everted legs symbolising a royal earth-taboo which appears widely in Benin bronze iconography; and that it is an Ijẹbú motif of some age is indicated by its appearance on the crowns of Ijẹbú kings – a tradition orally claimed to go back to the sixteenth century (114, *passim*). These crowns are interesting too in carrying the face-veil of northern associations.

3. J. P. Clark, *Ozidi* (Ijo), and Udje (Urhobo). A play based on the Ijo saga Ozidi, was published by Clark, Oxford, 1966.

4. In the shrine of Chief Pessu to the memory of his father. The symbolism of the Bini cult of the right hand occurs in representations from a mortuary stool claimed to have been in use in 1740, fig. 199. Note the conjunction of royal symbols in the horns and the everted legs.

23. An Art of Ọyọ-Ilé?

1. Smith, *Kingdoms of the Yoruba* [125e], pp. 35, 46.

2. *Man*, Mar-Apr. 1941.

3. Johnson, *A History of the Yoruba* [14], pp. 176, 259.

24. The Maghreb in the African Bronze

1. Hamelin, 'Les bronzes du Tchad' [104], p. 382ff.

2. Wilks, *The Northern Factor in Ashanti History* [134], p. 8.

25. The Dating of the African Bronze

1. Pedrizet, *Bronzes grecs d'Egypte . . .* [116], p. 86, no. 148. I am indebted to Mr D. C. Haynes, Keeper of the Department of Greek and Roman Antiquities of the British Museum for his patience in my quest of the crotal, and for unearthing this reference to it.

2. Thomas, 'Nigerian notes' [83b] pp. 184–6.

3. Astley, *New General Collection of Voyages and Travels* [32], i, 17.

4. *Ibid.*, i, 152.

5. *Ibid.*, i, 176.

6. Public Records Office, London, *State Papers* [118] 12, 153. I am indebted to Professor Alan Ryder of the University of Ibadan for this information and reference.

7. Astley [32], i, 199.

8. Hakluyt, vi. p. 467.

9. Though it must be noted that the Arab examples, already mentioned, from Mombasa (Fort Jesus Museum) in silver, bear the simulated mid-rib with suspension ring cast of a piece typical of copies of a late European model. In the modern European type the suspension ring is independently attached.

10. Astley [32], p. 17.

11. Aitchinson, *A History of Metals* [29], ii, 75.

12. Wire-drawing is recorded by Cline for East Africa. Two wire-drawing plates from Ingombe Ilede in Southern Zambia are carbon-dated to the 9th–10th centuries AD (*Inventaria Archaeologica Africana* Z.2 16 & 19) for which reference I am indebted to Professor Thurstan Shaw of the University of Ibadan. Wire drawing has also been recorded by Stanners [126] in Nyasaland (Malawi) and by Nadel among the Nupe [72].
13. Talbot, *The Peoples of Southern Nigeria* [129], iii, 924.
14. BM 73, 7–15, 1.
15. Professor Thurstan Shaw, University of Ibadan, Nigeria. Personal communication.
16. Ahmed Baba, *Ḥukm al Tabgh* [91]. For this information I am indebted to Mohammed al-Hajj of Ahmadu Bello University Nigeria.

26. *Iconology, Technique and the Schools*

1. We may regard the modern Aṣante use of beeswax as a corruption of more ancient practice in which the traditional northern 'spiral' method associated with the mould-cum-crucible casting technique continues to be employed with beeswax more easily obtained in southern practice than would be the latex. Himmelbeber (*Negerkunst und Negerkunstler* [105], pp. 242–3) observed Aṣante smiths using a feather for the application of the clay mould in the manner I have described for northern practice as exemplified in the Ọbọ school; but the coarseness of the wax thread employed by the Aṣante (diam. 2 mm) no longer merited the delicate treatment. The same method (thick wax coils and liquid mould applied with a feather) is described for British Museum Aṣante examples – traditions which point persuasively to northern connections in Aṣante casting.

A. Literary Sources

GENERAL

1. Boas, F., *Primitive Art*, New York, Dover, 1955
2. Bovill, E., *The Golden Trade of the Moors*, Oxford Univ. Press, 1958
3. Cordwell, J., 'Naturalism and stylization in Yoruba art', *Magazine of Art*, 1953
4. Delafosse, M., *Haute-Senegal-Niger*, Paris, 1912
5. Focillon, H., *The Life of Forms in Art*, New York, 1948
6. Frankfort, H., 'On Egyptian Art', *JEA*, **18**, 1932
7. Fry, R., *Vision and Design*, London, Chatto & Windus, 1920
8. Gerbrands, A., *Art as an Element of Culture Especially in Negro Africa*, Leiden, 1957
9. Goldwater, R., *Bambara Sculpture*, New York, Museum of Primitive Art, 1960
10. Gombrich, E., *Art and Illusion*, rev. edn., London, Phaidon, 1962
11. Goody, J., 'The Mande and the Akan hinterland', *The Historian in Tropical Africa*, Oxford Univ. Press, 1964
12. Griaule, M., (*a*) *Masques Dogon*, Paris, 1938; (*b*) *Arts of the African Native*, London, Thames & Hudson, 1950
13. Horton, R., (*a*) 'A note on recent finds of brasswork in the Niger delta', *ODU*, **1**, 1965; (*b*) *Kalabari Sculpture*, Lagos, 1965
14. Johnson, S., *A History of the Yoruba*, Lagos, 1957; London, Routledge
15. Kielland, E., *Geometry in Egyptian Art*, London, Tiranti, 1955
16. Lavachery, H., *Statuaire de l'Afrique Noire*, Paris, 1954
17. Leuzinger, E., *The Art of Negro Peoples*, London, Methuen, 1960
18. Maritain, J., *Creative Intuition in Art and Poetry*, London, Collins, 1960
19. Panovsky, I., *Meaning in the Visual Arts*, New York, 1955
20. Paulme, D., *African Sculpture*, Paris, 1956; London, Elek, 1962
21. Segy, L., *African Sculpture Speaks*, New York, Dover, 1952
22. Schmalenbach, W., *African Art*, New York, 1960
23. Ṣowande, F., *Composer*, Spring, 1966
24. Smith, E., 'African symbolism', *JRAI*, **82**, 1952
25. Thomas, L., 'Time, myth and history in West Africa', *Présence Africaine*, ii, no. 39
26. Trowell, M., (*a*) 'The study of African Art', *Man*, **116**: 56; (*b*) *Classical African Sculpture*, 2nd edn., London, Faber, 1964
27. Verger, P., (*a*) 'The Yoruba High God – a review of the sources', *ODU*, **2**, 1966; (*b*) 'Oral tradition in the cult of the Orishas and its connections with the history of the Yoruba', *JHSN*, **1**, 1956
28. Wingert, P., (*a*) *Sculpture of Negro Africa*, New York, 1950; (*b*) *Primitive Art*, New York, Oxford Univ. Press, 1962

IRON

29. Aitchison, L., *A History of Metals*, 2 vols, London, Macdonald & Evans, 1960

30. Ajayi, A. and Smith, R., *Yoruba Warfare in the Nineteenth Century*, Cambridge Univ. Press, 1964

31. Arkell, A. J., (*a*) *A History of the Sudan to 1821*, 2nd edn., London, Athlone Press, 1961; (*b*) *Wanyanga; an archaeological reconnaissance of the south-west Libyan desert*, Oxford Univ. Press, 1964

32. Astley, T., *New General Collection of Voyages and Travels*, 4 vols, London, 1745

33. Barbot, J., *A Description of the Coasts of North and South Guinea, and of Ethiopia Inferior, Vulgarly called Angola, being a New and Accurate Account of the Western Maritime Countries of Africa;* ed. Churchill, London, 1732

34. Barth, H., *Travels in North and Central Africa*, vol. iv, London, 1858

35. Beir, H. U., (*a*) *The Story of Sacred Wood Carvings from One Small Yoruba Town*, Lagos, 1957; (*b*) *A Year of Sacred Festivals in One Yoruba Town*, Lagos, 1959; (*c*) 'Before Oduduwa', *ODU* (*Old Series*) no. 3, (undated); (*d*) *African Mud Sculpture*, Cambridge Univ. Press, 1963

36. Bellamy, G., 'A West African smelting house', *Jour. Iron and Steel Institute* **66** (2), 1904

37. Bodiel, T., 'Le Dieungue ou anneau de cheville d'esclave', *NA*, **58**, 1953

38. Bowditch, T., *Mission from Cape Coast Castle to Ashanti*, London, 1819

39. Bower, J., 'Native smelting in equatorial Africa', *MM*, **3**, 1927

40. Campbell, J., 'Native iron smelting in Haute-Guinée', *IMM*, **7**, 1910

41. Clamens, G., 'Le Dieungue ou anneau de cheville d'esclave', *NA*, *58*, 1953

42. Clark, J. D., *The Prehistory of Southern Africa*, Harmondsworth, Penguin Books, 1959

43. Cline, W., *Mining and Metallurgy in Negro Africa*, Wisconsin, 1937

44. Coghlan, H., *Notes on Prehistoric and Early Iron in the Old World*, Oxford, Pitt Rivers Museum, 1956

45. Cozens, A., 'A village smithy in the Cameroons', *Nigerian Field*, **19–20,** 1954–55

46. Crawhall, T., 'Iron working in the Sudan', *Man*, **48,** 33

47. Dapper, O., *Description de l'Afrique*, Paris, 1676

48. Desplagnes, L., *Le Plateau Central Nigerien*, Paris, 1907

49. Dérendinger, Le Général, 'Les curieuses mines de fer, Télè-Nugar', *Jour. Soc. des Africanistes*, **6**, 1936

50. Dixey, F., 'Primitive iron ore smelting methods in West Africa', *MM*, Oct. 1920

51. Donnan, E., *Documents Illustrative of the History of the Slave Trade to America*, 4 vols, Washington, 1930–35

52. Eyo, E., 'Excavation at Rop rock shelter', *WAAN*, **3**, 1965

53. Fagg, B., 'Radio-carbon dating for the Nok culture, Northern Nigeria', *Africa*, **1,** 1965

54. Fernandes, V., *Description de la Côte Occidentale d'Afrique*, Bissau, 1956

55. Foa, E., *Le Dahomey*, Paris, 1895

56. Forbes, R., (*a*) 'The black man's industries', *Geog. Review*, **23,** 1933; (*b*) *Studies in Ancient Technology*, Leiden, 9 vols, 1964

57. Francis-Boeuf, C., 'L'Industrie autochthone de fer', *BCAOF*, **20,** 1937
58. Frobenius, L., *The Voice of Africa*, 2 vols, London, 1913
59. Garstang, J., (*a*) 'Excavations at Meroë, *Guide to the 11th Exhibition*, Khartoum, 1911; (*b*) *Meroë*, Oxford, 1911
60. Gomes, D., *De la première découverte de la Guinée*, Bissau, 1959
61. Grenier, A., 'Archaeologie Gallo-Romaine', *Manuel d'Archeologie*, Paris, 1934
62. Howard, C., ed. *West African Explorers*, Oxford Univ. Press (Worlds Classics), 1951
63. Huard, P., (*a*) 'Contribution à l'étude du cheval, du fer et du chameau au Sahara Oriental', *Bull. IFAN*, **12,** 1960; (*b*) 'Introduction et Diffusion du Fer au Tchad', *JAH*, **3,** 1966
64. Ifemesia, C., 'British Enterprise on the Niger, 1869', unpublished Ph.D. thesis, Univ. of London, 1959, by permission
65. Jeffreys, M., (*a*) 'Some notes on the Bikom blacksmiths', *Man*, **52,** 75; (*b*) 'Some notes on the Kwaja smiths of Bamenda', *Man*, **62,** 236
66. Kamara, K., 'Koranko funeral customs', *Sierra Leone Studies*, **30,** 1933
67. Kirk-Greene, A., 'Major currencies in Nigerian history', *JHSN*, **1,** 1960
68. Laing, A. G., *Travels in the Timanee, Kooranko and Soolima Countries of West Africa*, London, 1825
69. Lander, R., *Travels in Africa*, London, 1836
70. Mavrogordato, M., 'Industries of the Colony and Protectorate', *Sierra Leone Studies*, Feb. 1919
71. Mercier, P., *Les Ase de Musée d'Abomey*, Catalogue 8, *IFAN*, 1952
72. Nadel, F., *A Black Byzantium*, Oxford Univ. Press, 1942
73. Ozanne, P., (*a*) 'The Iron Age in Ghana', unpublished MS (by permission); (*b*) 'An earthenware oil lamp from near Nsawam, Ghana', *Trans. Hist. Soc. Ghana*, **5,** ii, 1962
74. Pereira, D., *Esmeraldo de Situ Orbis*, Bissau, 1956
75. Petrie, F., (*a*) *Naukratis*, London, 1886; (*b*) *Tanis*, London, 1888; (*c*) *A History of Egypt*, London, 1905; (*d*) *Tools and Weapons*, London, 1917; (*e*) *Objects of Daily Use*, London, Quarilob, 1927
76. Phillipson, D., 'Excavation of an iron smelting furnace in the Livingstone district of Rhodesia', *Man*, **64,** 64
77. Rattray, R., (*a*) 'The iron workers of Akpafu', *JRAI*, **46,** 1916; (*b*) *Religion and Art in Ashanti*, London, 1923
78. Roscoe, J., *Baganda*, London, 1911
79. Sassoon, H., 'Iron smelting in the hill village of Sukur, Northern Nigeria', *Man*, **64,** 64
80. Sayers, E., 'The funeral of a Koranko chief', *Sierra Leone Studies*, **8,** 1925
81. Summers, R., 'The Southern Rhodesia Iron Age', *JAH*, **1,** 1961
82. Temple, O., *Notes on the Tribes, Emirates and States of the Northern Province of Nigeria*, Cape Town, 1919
83. Thomas, N., (*a*) 'Iron smelting in Northern Nigeria', *Man*, **18,** 1918; (*b*) 'Nigerian Notes, II. Metal', *Man*, **18,** 1918
84. Torday, E., (*a*) 'Iron figurines of the Bushongo', *Man*, **13,** 1924; (*b*) *On the Trail of the Bushongo*, London, 1925
85. Wainwright, G., (*a*) 'The emblem of Min', *JEA*, **17,** 1931; (*b*) 'Iron in Egypt', *JEA*, **18,** 1932; (*c*) 'Early records of iron in Abyssinia', *Man*, **43,** 1942; (*d*) 'Iron in the Napatan and Meroitic Ages', *SNR*, **1,** 1945; (*e*) 'Pharaonic

survivals between Lake Chad and the West Coast', *JEA*, **35**, 1949; (*f*) 'The coming of iron', *Antiquity*, **10**, 1951; (*g*) 'Egyptian origins of the ram-headed breastplate from Lagos', *MAN*, **231**, 1951; (*h*) 'Diffusion of *Uma* as a name for iron', *Uganda Jour.*, **18**, 1954; (*i*) Some aspects of Amun', *JEA*, **20**, 1934; (*j*) 'Jaga and their name for iron', *Man*, **55**, 62

86. Walton, J., 'Iron gongs from the Congo and Southern Rhodesia', *Man*, **55**, 30

BRONZE

87. Abimbola, W., 'Ifá divination poems as sources for historical evidence', *LNR*, **1**, 1967

88. Africanus, L., *Hakluyt*, ed. Brown, London, 1844

89. Akinjogbin, A., *Dahomey and its Neighbours, 1708–1818*, Cambridge Univ. Press, 1969

90. Aldred, C., 'Bronze cult objects from Southern Nigeria', *Man*, **47**, 1949

91. Baba, Ahmed, *Ḥukm al Tabgh*, 12 vols, 1607

92. Baker, H., 'Examination of the Ifè bronze heads', *Man*, **10**, 1965

93. Baumann, H. and Westermann, D., *Les Peuples et les civilisations de l'Afrique*, Paris, 1962

94. Bradbury, R., E. (*a*) *The Benin Kingdom and the Edo Speaking Peoples of South Western Nigeria*, Ethnographic Survey of Africa, Western Africa, Pt 13. London, International African Institute, 1957; (*b*) 'Chronological problems in Benin History', *JHSN*, **4**, 1959

95. Biobaku, S., (*a*) 'Ogboni the Egba senate', *Proc. IIIrd International West African Conference*, Ibadan, 1949; (*b*) *The Egba and Their Neighbours*, Oxford Univ. Press, 1957

96. Bosman, W., *A New and Accurate Description of the Coast of Guinea*, London, 1705

97. Brouin, G., 'De nouveau au sujet de la question de Takedda', *NA*, **47**, 1950

98. Dark, P., (*a*) 'Benin: a West African kingdom', *Discovery*, **18**, 1957; (*b*) *The Art of Benin*, Chicago Nat. Hist. Museum, 1962. (*c*) *Benin Art* (photographs by W. and B. Forman), London, Hamlyn, 1960

99. Egharevba, J., *A Short History of Benin*, Ibadan, 1960

100. Emery, W. and Kirwan, G., *Ballana and Qustul*, London, 1935

101. Fagg, W., (*a*) '40,000 years of modern art' (review), *Man*, **49**, 13; (*b*) 'L'art Nigerien BC', *Presence Africaine*, 1951; (*c*) 'De l'art des Yoruba', *Presence Africaine*, 1951; (*d*) *The Sculpture of Africa* (photographs by E. Elisofon), London, Thames & Hudson, 1958; (*e*) 'The study of African art', *Cultures and Societies of Africa*, ed. Ottenberg, S. New York, Random House, 1960; (*f*) *Nigerian Tribal Art*, Arts Council of Great Britain, Exhib. Catalogue, London, 1960; (*g*) *Nigerian Images*, New York, Praeger 1963; (*h*) 'The restoration of a bronze bowman from Jebba, Nigeria,' *British Museum Quarterly*, **28**, 1964; (*i*) 'The examination of the Ifè bronze heads: Hon. Editor's note', *Man*, **10**, 1965; (*j*) *Afro-Portuguese Ivories*, London (undated)

102. Fagg, W. and Plass, M., *African Sculpture*, London, Studio Vista, 1964

103. Gibb, H., *Ibn Battuta*, London, 1957

104. Hamelin, P., 'Les bronzes du Tchad', *Tribus*, Stuttgart, 1952–53

105. Himmelheber, H., *Negerkunst und Negerkunstler*, Klinkhardt und Biermann, 1960

106. Law, R., 'Contacts between the Mediterranean civilisations and West Africa in pre-Islamic times', *LNR*, **1**, 1967

107. Lebeuf, J. P., *Archéologie Tchadienne*, Paris, 1962

108. Lewicki, T., 'L'État nord-Africain de Tahert et ses relations avec le Soudan Occidental à la fin du VIIIe Siècle', *Cahiers d'Études Africains*, **8**, 1962

109. Luschan, F. v., *Die Altertümer von Benin*, Berlin, 1919

110. Malcolm, L., 'A note on brasscasting in the Central Cameroons', *Man*, **1**, 1923

111. Marquart, J., *Die Benin Sammlung*, Leiden, 1912

112. Mauny, R., (*a*) 'Le Judaisme, les Juifs et l'Afrique Occidentale', *Bull. IFAN*, **11**, 1952; (*b*) 'État actuelle de la question de Ghana', *Bull. IFAN*, **13**, 1952; (*c*) 'Histoire des métaux en Afrique Occidentale', *Bull. IFAN*, **11**, 1952; (*d*) 'Découverte d'un atelier de fonte du cuivre à Marandet (Niger)', *NA*, **58**, 1953; (*e*) *Tableau geographique de l'Ouest Africain au moyen age*, Dakar, 1961

113. Morton-Williams, P., 'The Yoruba Ogboni cult in Ọyọ', *Africa*, **4**, 1960

114. Ogunba, O., 'Crowns and Okute at Idowa', *Nigeria Magazine*, **83**, 1964

115. Palmer, R., (*a*) *Sudanese Memoirs*, Lagos, 1928; (*b*) *Bornu, Sahara and Sudan*, London, 1936

116. Pedrizet, P., *Bronzes grecs d'Égypte de la Collection Fouquet*, Paris, 1911

117. Pitt-Rivers, Lt. General, *Antique Works of Art from Benin*, London, 1900

118. Public Records Office, London, *State Papers*

119. Read, H. and Dalton, O., *Antiquities from the City of Benin and from other parts of West Africa in the British Museum*, London, 1899

120. Roth, H. Ling., *Great Benin, Its Customs, Art and Horrors*, Halifax, 1903

121. Ryder, A., 'A reconsideration of the Ifẹ̀-Benin relationship', *JAH*, **1**, 1965

122. Shaw, T., (*a*) 'Excavations at Igbo-Ukwu, Eastern Nigeria: An Interim Report', *Man*, **50**, 1950; (*b*) *Excavations at Dawu*, London, Collins 1961; (*c*) 'Excavations at Dawu', *Man*, **62**, 217; (*d*) 'The regalia and ritual instruments of a Nigerian priest-king: the Treasure House of Igbo', *Illus. London News*, **2101, 2102**, 1962

123. Shinnie, P., (*a*) *Medieval Nubia*, Khartoum, 1954; (*b*) 'The fall of Meroë', *Kush*, **3**, 1955

124. Smith, R. and Williams, D., 'A reconnaisance visit to Ọyọ-Ile', *ODU*, **1**, 1966

125. Smith, R., (*a*) 'Ijaiye, the western palatinate of the Yoruba', *JHSN*, **3**, 1962 (*b*) 'The Alafin in exile', *JAH*, **1**, 1965; (*c*) 'The Bara, or royal mausoleum, at New Oyo', *JHSN*, **2**, 1965; (*d*) 'Yoruba armament', *JAH*, **1**, 1967; (*e*) *Kingdoms of the Yoruba*, London, Methuen, 1969

126. Stanners, H., 'Notes on some tribes of British Central Africa', *JRAI*, **40**, 1910

127. Struck, B., 'Chronologie der Benin-Altertümer', *Zeitschrift fur Ethnologie*, **55**, 1923

128. Sydov, E. v., 'African sculpture', *Africa*, **2**, 1928; (*b*) 'Ancient and modern art in Benin city', *Africa*, **1**, 1938

129. Talbot, A., *The Peoples of Southern Nigeria*, 3 vols, London, 1926

130. Underwood, L., *Bronzes of West Africa*, London, Tiranti 1949.

131. Urvoy, Y., 'Histoire de l'Empire du Bornu', *Bull. IFAN*, **7**, 1949

132. Westcott, J. and Morton-Williams, P., 'The symbolism and ritual context of the Yoruba Labà Shango', *JRAI*, **92**, i, 1962

133. Wild, R., (*a*) 'An unusual type of primitive iron smelting furnace at Abom-

posu, Ashanti', *Gold Coast Review*, **2,** 1931; (*b*) 'Open-cast moulds from cuttlefish bone in Ashanti', *Gold Coast Review*, **2,** 1931

134. Wilks, I., *The Northern Factor in Ashanti History*, Univ. College, Ghana, 1961

135. Willett, F., (*a*) 'Investigations at Old Oyo, 1956–57 – an interim report', *JHSN*, **1,** 1960; (*b*) *Ifè in the History of West African Sculpture*, London, Thames & Hudson, 1967

136. Willett, F. and Fagg, W., 'Ancient Ifè', *ODU* (old series) **8,** 1960

137. Williams, D., (*a*) 'Iconology of the Yoruba Ędan Ogboni', *Africa*, **2,** 1964; (*b*) 'The Arts in African Studies', *Report* on the Conference organised by the International African Institute in conjunction with the University of Ibadan, ed. Forde; *Africa*, **1,** 1965; (*c*) 'Lost-wax brasscasting in Ibadan', *Nigeria Magazine*, **84,** 1965; (*d*) 'The Nigerian image', *ODU*, **2,** 1965; (*e*) 'An outline history of tropical African art', *Africa in the Nineteenth and Twentieth Centuries*, ed. J. C. Anene and G. Brown, London, Nelson & Ibadan University Press 1966; (*f*) 'A corpus of Yoruba bronze art: Report on field work', *Africa*, **2,** 1966; (*g*) 'Bronzecasting moulds, cores and the study of classical techniques', *LNR*, **1,** 1967; (*h*) 'African iron and the classical world', *Africa in Classical Antiquity*, ed. J. Ferguson, and L. Thompson, Ibadan, 1969; (*i*) 'Yoruba bronze and iron', *A Sourcebook of Yoruba History*, ed. Biobaku (in preparation)

B. Museums, Sites, and Shrines

1. MUSEUMS (* correspondence only)

East Africa

Kenya: Fort Jesus Museum, Mombasa – Arab metalwork in Africa

Uganda: Ethnographic Museum, Kampala – African iron

Tanzania: Ethnographic Museum, Daresalam; Historical Museum, Zanzibar – general

Sudan: Khartoum Museum – Meroitic antiquities; Sudan Museum – ethnographic; Antiquities Museum, Merowe – Napatan antiquities

Europe

Denmark:* National Museet, Copenhagen – the crotal

France: Musée de l'Homme, Paris – general; Musée d'Art Moderne, Paris – twentieth century Art; Musée du Louvre, Paris – general; Jeu de Paume, Paris – Impressionism

Greece: Acropolis Museum, Athens – Greek sculpture, Benaki Museum, Athens – Greek popular crafts; National Museum, Athens – Greek bronze

Italy: Vatican Museum, Rome – general

Sweden:* Historiska Museet, Stockholm – the crotal

United Kingdom: British Museum, London – general; National Gallery, London – general; Segontium Museum, Caernarvon – Roman iron; Victoria and Albert Museum, London – library correspondence: Wallace Collection, London – Aṣante iron, Aṣante gold mask

United States

New York: Museum of Modern Art – twentieth century art; Metropolitan Museum – general

West Africa

Nigeria: African Studies Museum, University of Ifẹ̀ – Yoruba bronze, general; Antiquities Museum, Ilé-Ifẹ̀ – Ifẹ̀ bronze; Antiquities Museum, Jos – Nigerian bronze, general; Benin City Museum – Benin bronze; Antiquities Museum, Owo – bronze bells; Nigeria Museum, Lagos – Nigerian bronze, general; University Museum, University of Ibadan – Yoruba bronze, general; African Studies Teaching and Research Museum, University of Lagos – Register of Analyses: bronze casting moulds, cores, alloys; Sierra Leone:* Sierra Leone Museum – bronze

2. SITES AND SHRINES

Meroitic

In the study of Meroitic art, sites were visited between 1957 and 1964 of Meroitic locations and settlements in the Butana region of the Sudan. Most important of these for iron-working is the Meroitic capital at Begrawiyeh. For *in situ* relief sculpture the royal pyramids at Begrawiyeh. For Meroitic architecture the Palace of Amanishakete at Wad Ban Naqa as well as the sites at Naqa and Musawarrat es Sufra. A masterpiece of Late Meroitic art is the rock engraving at Jebel Qeili (first century), important in a use of perspective and foreshortening in rendering the human figure in violent motion. This will occur nowhere else in the art of Tropical Africa.

Napatan

The Bayuda Desert was crossed from Metemma to Merowe and remains of the Napatan period of the Kingdom of Kush studied at Jebel Barkal, el Kurru (frescoes), Nuri (pyramids); of the Christian period at the monastery at Ghazali and farther south along the Dongola Reach; of Middle Kingdom architecture in the mudbrick Deffufas at Kerma on the Third Cataract. (According to Arkell Kerma is probably the original location of Kush, the most important native kingdom in the northern Sudan.) Heroic-size stone statues of possibly Old Kingdom date remain in the granite quarries of Tumbus nearby. Various Napatan remains are held in the small Antiquities Museum at Merowe.

East Africa

In 1958, 1964 and 1966 the region was worked from Zanzibar in the east to the Ruwenzori mountains in the west, and as far south as Zambia for traditions of bronze and iron. The 'Egyptian' bowl bellows and not the Arab bag bellows are used, associated in Uganda with the 'Meroitic'-type shaft furnace in iron smelting.

West Africa

With the historian Robert Smith a reconnaissance visit was made to the ruins of the capital of the Yoruba Ọyọ empire at Ọyọ-Ilé in February 1965, at the height of the dry season, when for the first time it was possible to cross stream, marsh and forest by Land Rover. The site has been visited by a mere handful of travellers since the destruction of the town *c.* 1835 and awaits full-scale excavation.

(*a*) *Bronze*. Between 1962 and 1965 bronze casting techniques were observed in workshops at Benin, Ibadan, Iwo, Abéòkúta, Ijèbú-Òde and Ọbọ Aiyégúnlẹ in Nigeria. In this latter workshop the author lived and worked with the chief smith for a period of a month with occasional visits to other smiths practising in the village. Data recorded in this practice were later fruitfully applied to reading the behaviour of cores in the bronzes of the Jebba-Tada group and the *Lafogido* bust at Ifẹ.

The shrine at Igbòhó which holds the *Alákoro I* bronze mask was visited in January 1965, in fieldwork extending so far north as Busa on the Niger. Shrines at Jebba and Tada holding the famous Tsoëde bronzes were visited March–April 1965, in fieldwork extending so far east as Idah in the confluence area, and

south to the Niger delta. On a grant from the International African Institute, London, this fieldwork covered private and trade collections throughout the area bounded to east and north by the course of the Niger and to south and west by the Guinea littoral and Dahomey. Bronze samples were taken wherever possible for analysis.

(*b*) *Iron*. Between 1963 and 1965 a survey was made of extant iron-working furnaces and mining sites in Nigeria. The most important of these are at Ọyọ, Ìsúndùnrin, and Erhurun-Uneme (Afemai Division). At all these sites furnaces are in an advanced state of ruin, that at Ọyọ being the location of a smelting village, of around the twenties, now completely reverted to bush. The furnace at Ìsúndùnrin, typical of those of the western Sudan recorded in the literature, was rebuilt and acquired by the University of Ifẹ̀. Iron was successfully smelted there in 1964. At the same site the processes of mining iron ore and the production of charcoal were filmed. (The document is held at the University of Ibadan Photographic Unit.) Temperatures inside the smelting furnace were recorded by the Department of Physics of the University of Ifẹ̀.

The various types of iron-smelting furnace found in Tropical Africa were all recorded in Nigeria and found to fall into the three types discussed in the text.

(*c*) *Informants*. Informants were predominantly smiths and smelters still in practice or yet holding memories of tradition. Cross checking was relatively simple, and information in most cases could be further checked with the written sources, and in all cases proven in practice. Other informants were cult elders, and local kings or chiefs. A certain amount of data emerged from these accounts on the nature and training of the traditional artist and his aesthetic attitudes, but these do not fall within the framework of the present study.

The author speaks no African language and found this no great handicap in the field in view of the articulateness of the language of practical demonstration. (A minor field of future research might be the linguistic comparison of all terms used in iron working and bronze casting in West Africa with a view to establishing lines of influence.) It must be recorded however that none of this fieldwork would have been possible without the help of intelligent and literal-minded field assistants, in particular that splendid Yorubist and friend, David Adeniji, of the University of Ifẹ̀.

C. Local and Oral Traditions

High Court and Customary Court records in Nigeria provided a certain amount of evidence on the role of cult-sculpture in securing or maintaining title to land, and in oath-taking in this connection. Records were examined for the High Court of Eastern Nigeria (Appeal no. C/42A/63 of 27 April 1964); Suit no. 0/77/61 of 20 April 1964; Suit no. 0/108/63 of 27 January 1964; in the Ondo Customary Court, Grade B, Suit no. 83/C1/63 (undated). Photostat copies of these cases are in the collection of the author. This is a fertile and hitherto untapped field of source material.

In the matter of the coming of metals local traditions have not been rewarding: they are usually variations on the theme of 'from time immemorial' or, specifically among the Yoruba, 'from Ifè'. The propensity of many African peoples to personalise historical events or the processes of adaptation to their environment has however produced myths which might be examined historically. Such are the persistent association of iron with the town of Ìrè, the double appellative of the god Ògún – god of war, god of iron, the Ifè-Benin relationship in bronze casting, the stories of culture-heroes such as Ògún-Ladin, the 'first blacksmith' of Ifè when contrasted with Ajíbówú, the 'first blacksmith' of the other Yoruba, the association of Tsoëde among the Nupe with the Igala, of Àjàká (at Òmùò) with a classical Benin brass mask, of Òrányàn (at Ifè) with an obelisk bearing a trident of Tuareg associations, etc.

The rendering of such traditions in a foreign language raises difficulties of distortion enough, but these are by no means the greatest. The very concept under discussion might be resistant to translation, and in the field one can never be certain how often this is the case. At the palace of the Alàáfin at Ọyọ, for example, hoary tradition surrounds the iron Sword of Justice of Òrányàn which sanctions the king's power of life and death and which is sent to the Oni of Ifè to be used in the coronation of each new Alàáfin. After the coronation it is held not by the king, but by the high-priestess of the cult of Òsányin – god of healing. But, on examination, the brass mount of this sword proves recent, and the iron blade shows no signs of age. Where informants insist on its age it eventually becomes obvious that the object can be considered old only in the sense in which a smoker who has replaced every part of his pipe during a lifetime of enjoying it yet considers it old. Where the student is discussing the age of the particular object, his informant as a matter of course needing no explanation is discussing only that which matters in the object – that in it which connects it for ever with the ancestor no matter how frequently it may be renewed. It is fortunate when revelation occurs in this way, since conclusions might easily be drawn on incompatible concepts, the student being necessarily constrained within the 'reasoning' of his own culture. Many conclusions in field-work are subject to this condition – a condition which one can never be certain has been mutually resolved.

Local and oral traditions are most revealing on the nature, distribution and

interrelation of the cults. Both in interview and in the body of oral literature this type of information is rich indeed. As Verger has pointed out among the Yoruba [27*b*], and as one readily finds in the field, this type of source might be found to be consistent over great distances and cutting across many dialects. In the functioning of the cults proper, meanings not always volunteered by the informant (and a given line of questioning might never occur to the student) might be gratuitously revealed in the ceremonial of the various cult-festivals. These are a visual diction-ary of great resource and the study of no cult can be considered significant without an experience of them.

Certain ritual objects, such as the Şàngó urns or the hunter's doublet illustrated in the text are also of the greatest importance to the art historian as repositories of attitudes and beliefs which have no purely verbal equivalents.

Index

Abéòkúta, *see* Yoruba
Aesthetics, 24–6, 105
African Art:
 classification, 13–15, 25
 conventions, 41–5
 unities, 41–4
Ajàgbó-Ekun, *see* Yoruba
Al Hussein, 112
Amanishakete, *see* Meroë
Ancestor, 229, 230
 ancestral form, 223–4, 229–30, 289
 sculpture, 16–17, 25, 44, 289, 292–31
Arab, 107, 108–9, 110, 266–8, 273, 275–6, 277
Archetype, 15, 24, 47
Artist:
 as priest, 22, 25, 44, 47
Asante, 21, 117, 176, 179, 266, 267, 273, 285
 bronze, 184–6
 gold, 266
 iron, 60, 75
Axum, -ites, 36, 53–4, 65, 71
Azande, 66

Bambara, *see* Mali
Baule, 117
Beniń, 106, 112, 114, 123, 130–5, 145, 206, 213, 225, 269, 272, 276; bronze canon, 131–178; bronze chronologies, 136–43, 149–78; bronze dating, 176, 274–6; bronze morphology, 154–76, 287; bronze motifs, 125–35, 251–5; bronze technique, 179–82, 189–94, 200, 206; cult of the right hand, 257; Ọba Esigie 123, 133; foreshortening, 159–67; form 177; Hieratic period, 169, 175, 178; -Idah, 232; idealism, 171, 176, 178; -Ifẹ̀, 112–23, 121–33, 137, 179–203; -Ijẹ̀bú, 249–50, 251–60; iron, 76, 86, 106, 125; ivory, 104; metallurgy, 206; nilotic motifs, 225,

Benin, (*contd.*)—
 251; -Nubia, 225; Nupe, 133; oṙìṣà, 259; Ọba Oguola, 124; Ọba Ọrhọgbua (Osogboa), 124, 133; Ọba Osẹmwẹde, 226; perspective, 129, 156, 159; stereotype, 147–8; pictorial space, 169, 172; -Tada, 126, 128–32, 134, 142, 218, 221, 224–5, 233; terracotta, 3
Borgu, 262
Bornu, 127, 130
Brass, 67, 87, 106, 107
 functions, 18–19, 112
 manilla, 73, 109, 205
 metallurgy, 203–6
 smith, 78, 123–4
Bronze, 106, 119–20
 charcoal, 213; cire-perdue, 108–9, 113, 115, 117, 145, 179–80, 217, 227; cinquecento method, 180–3; 'spiral' method, 183, 188, 212, 214–17; dating, 269–79; distribution area, 105, 115–20; itinerant smith, 105, 114, 119, 285; variant methods, 217
Bushongo, *see* Congo
Butana, 57

Ca da Mosta, 110
Cameroons:
 bronze, 117
 iron, 70
Carthage, -inians, 62, 106
Cellini, 180, 228
Cézanne, 1, 38, 39, 99, 150, 232
Chad, 106, 127, 274
Chain, 231, 267
Chiaroscuro, 36, 150
Classification:
 by cult, 15; by meaning, 14; by motif, 25; by tribe, 13–14;
Congo (Zaire), 65, 73, 273, 278; Baluba, 43; bronze, 104, 115, 145, 217, 285, 286 Bushongo, 94; iron, 65, 94, 98–9

Copper, 104, 106, 107, 110–11, 145, 182, 205–6; currency 109, 205–6; crucibles, 110, 208; mines, 110; moulds, 110, 145, 228

Crotal, 109, 130, 168, 176, 206, 222, 230–1, 245, 269–76; and idiom, 15, 20–32; and medium, 18–19, 87–93; -priest, 44, 47

Dahomey, 15, 24, 75, 93; bronze, 117, 274; iron, 75, 93–4, 99

Dogon, 14, 16, 43, 97

El Bekri, 68

Egypt, -ian:
art, 265
bronze, 68, 122, 270, 274
iron, 51–4, 57, 82
wood, 66, 103, 226

El Greco, 221

Ekine, *see* Kalabari

Erinlẹ̀, *see* Òrìṣà

Esigie, *see* Benin

Èṣù, *see* Òrìṣà

Ethiopia:
iron, 54, 65
silverware, 273

Ethnology:
Ethnological and aesthetic factors 4–6, 12

Euphemerism:
among the Yoruba, 21, 234

Europe:
contrasts with African sculpture, 36, 38–9, 46–50, 150–1, 174, 294
influence of African art in, 39
unities in European art, 41

Expressionist, -ism, 35

Face-veil, 127

Filigree, 108, 117, 273

Forcados, 255, 257

Form:
and meaning, 2, 4, 13–19; sacred, 20–32, 230; -stereotypes, 223

Funj of Senaar, 132

Ibn Battuta, 68, 109–10, 145, 208

Icon, 7–9, 20, 24

Idiom, 8, 11; and style, 9, 146–7; variation, 25–30

Ifa, *see* Òrìṣà

Ifẹ̀, *see* Yoruba

Igala, 63, 133

Igbo-Ukwu, 168; bronze, 119, 184, 211–12, 273, 276, 277, 290

Ijẹbú-Ode, *see* Yoruba

Ijo, 68–9, 205, 256

Ilé, *see* Yoruba

Impressionist, -ism, 8, 35, 37, 150

Ire, *see* Yoruba

Iron, 36; -bar 68, 72–4, 79, 288–9, Catalan furnace, 63–4; cults, 70–1, 87–93, 288–9; currency, 70, 73, 79; dating, 77–84; domed furnace, 58–61, 107; distribution of furnace types, 60–3; Egypt, 51–4, 82; furnace types, 54–64, 69–71; gongs, 96–7; hunger, 67, 72–4; magical uses, 84–6; mines, 61; ritualising of, 70, 78–82, 87–93, 104; sculpture, 78; and the slave trade, 72–5; smelting techniques, 59–60; voyage iron, 73–4

Italian art, 39, 117, 149, 166, 173, 176, 180, 246

Ivory Coast, 69, 116, 117, 267

Jalof, *see* Senegal

Jebba, 118, 130–3, 218–33; ancestor concept, 229–31; bronze dating, 231; bronze technique, 197–202; -Ifẹ̀, 195–203; Tada, 197–202

Jukun, 127, 128, 129, 130, 200, 221–2; -Tada, 222; bronze dating, 222; bronze technique, 200–1; -Ifẹ̀, 221–2

Kalabari, 18, 25, 43, 44, 105; ancestor sculpture, 44; Ekine society, 16

Kush, -ites, 57, 66

Liberia:
iron, 73
tobacco, 278

Maghreb, 108, 109, 266–8

Mali, 6

Manilla, *see* brass

Matter, as spirit, 15–16

Meaning, and function 5; and critical terminology, 1, 295–7; in cult symbolism, 22, 23, 27, 32, 154, 164, 169, 229–230, 292–3

Meroë, -itic, 53, 54, 57
iron, 55–8, 64, 71; Island of, 57; sculpture, 66, 71, 172, 226

Metals:
attributes in cult usage, 18, 289

Napata, *see* Nubia

Nigeria:
 bronze, 115, 286; iron, 60–3, 65, 78–86; stone, 2, 289
Nubia, 57, 64, 225, 227, 274, 277; bronze, 182; iron, 52–3; Napata, 52, 53, 54–6, 72, 96
Nupe, 65, 84, 130, 133–4; bronze, 213, 218; iron, 197

Ọbọ Aiyégúnlẹ̀, 84, 117, 179, 183–8, 211–17; bronze technique, 186–8, 195, 204, 214
Ogane, 112, 121, 126–7, 133, 222, 224, 233, 290
Ogoni, *see* Yoruba
Òkò, *see* Òrìsà
Oldódùmarè, *see* Yoruba
Olórun, *see* Yoruba
Onílé, *see* Yoruba
Oranyan, *see* Yoruba
Ọrhọgbua, *see* Benin
Òrìsà, 15, 20–1, 24–5, 78, 79, 82, 83, 86–90, 92, 150, 234, 241; Erinlẹ̀, 18, 87, 88, 90–1; Eṣù, 27, 28, 29, 31; Ifa, 30, 89; Òbàlùfọv, 122, 223, 248, 249; Oginyan, 88, 92; Ògún, 18, 20–1, 31, 34, 78–86, 87–92, 129, 214, 218; bronze chronology, 247–9; Òkò, 18, 88, 91, 92, 261; Osanyin, 18, 87–92; Ọ̀ṣun, 18, 21; Oya, 21; Sàngó, 15, 16, 20–3, 26, 27–32, 78–9, 82–3; Sopona, 20, 21
Osemwede, *see* Benin
Ọ̀ṣọ́ọ̀ṣì, *see* Yoruba
Ọyọ-Ilé, *see* Yoruba

Perspective, 36–7, 149, 150
Portugal, -uese, 72, 104, 112, 113, 121, 125, 126, 133, 145, 167–8, 205, 206, 213, 286, 287

Rhodesia, 66, 72

Sao, 111, 112, 117, 130, 179, 183–4
Sculpture:
 as a name, 16, 20; spirit-, 229
Senegal, 68, 79, 115, 276; iron, 73; Jalof, 68, 69
Senufo, 117
Sierra Leone, 73, 86, 115; bronze, 118, 274; god of war, 86; iron, 69–70; ivory, 104; stone, 2; tobacco, 278
Spirit, localising of in sculpture, 16–17, 229, 240–2; -archetypes, 24; water-, 25

Steel, traditional African, 66
Stereotype, 20, 21–4, 44, 47; Bini bronze, 169; literary-, 44; musical-, 44; and spirit occupation, 47
Style, 7–8, 46, 144, 146–7; and cult, 33; and idiom, 8–11; succession, 32–3; Tada, 118, 129, 130–3, 134–5, 176, 195–9, 218–25, 227, 230–3; ancestor concept, 229–30; bronze dating, 231; bronze technique, 197–201; -Ifẹ̀, 135; -Jebba, 218–33; -Jukun, 221

Timbuctu, 68
Tiv, 11
Togo, 70
Tribe, 13–14, 114
Tsoede, 63, 218, 229, 231–2
Tuareg, 127, 225
Type-motif, 20, 25, 26, 31; meaning in, 27; and the stereotype, 26, 29, 32; and style succession, 33

Uganda, 96, 273; iron, 71

Vodun, 15, 24

Weapons, 68–9, 72–3, 75, 78–9, 103
Wood, spiritual attributes, 18; -carving, 2, 48, 66–7, 99, 103

Yoruba, Abéòkúta, 204, 227, 249–50; bronze technique, 189, 259, 265; Ajàgbó, 235, 238; blacksmith, 78; bronze technique, 189, 200, 243–4; Egungun, 229; Èpà, 44; firearms, 79; Ifẹ̀, 36, 79, 106, 112–13, 117, 120–35, 227; -Benin, 121–48, 179–204, 206–7; bronze dating, 206–7, 231–2; bronze metallurgy, 203–6; bronze technique, 188–202; -Junkun, 221–2, 233; -Obo Aiyégúnlẹ̀, 212; -Tada, 222, 232; -Ijèbú-Ode, 106, 117, 127, 158, 175, 227, 234, 249–60; Ilé, 16, 22, 24, 44; Ire, 83–4; Ogboni, 16, 22, 24, 34, 44, 134, 223; bronze iconology, 234–46; Onílé, 16, 235; Olódùmarè, 20, 21; Olórun, 24; Oranyan, 79, 128, 225; Ọ̀ṣọ́ọ̀ṣì, 90; Ọyọ-Ilé, 82, 84, 92, 261–5, 285; bronze perspective, 158–9; second burial, 43

Zambia, 71
Zimbabwe, 96